W9-BKX-000

ANCIENT GEMS
AND FINGER RINGS

Jeffrey Spier

CATALOGUE OF THE COLLECTIONS

THE J. PAUL GETTY MUSEUM

MALIBU · CALIFORNIA

1992

© 1992 The J. Paul Getty Museum
17985 Pacific Coast Highway
Malibu, California 90265-5799
(310) 459-7611

Mailing address:
P.O. Box 2112
Santa Monica, California 90407-2112

Christopher Hudson, Head of Publications
Cynthia Newman Helms, Managing Editor
Deenie Yudell, Design Manager
Karen Schmidt, Production Manager

LIBRARY OF CONGRESS CATALOGING-IN-PUBLICATION DATA:

Spier, Jeffrey.
 Ancient gems and finger rings : catalogue of the collections /
 Jeffrey Spier.
 p. cm.
 Includes bibliographical references and index.
 ISBN 0-89236-215-4 :
 1. Gems, Classical—Catalogs. 2. Gems—California—Malibu—
 Catalogs. 3. J. Paul Getty Museum Catalogs. I. J. Paul Getty
 Museum. II. Title.
 NK5565.S68 1992
 736'.2'093807479493—dc20 91-44150
 CIP

Project staff:
Benedicte Gilman, Manuscript Editor
Jean-Claude Muller, Designer
Elizabeth Burke Kahn, Production Coordinator
Elisa Mandell, Photograph Coordinator
Ellen Rosenbery, Photographs
Martha Breen and Tim Seymour, Drawings

Typography by Wilsted & Taylor, Oakland, California
Printed by Nissha Printing Co., Ltd., Kyoto

Cover: Dark green chalcedony in large
gold ring showing the head of the Doryphoros of
Polykleitos. Catalogue number 221 (75.AM.61).

CONTENTS

FOREWORD

The preparation of this catalogue of ancient gems and finger rings in the collection of the J. Paul Getty Museum was begun by Jeffrey Spier when he was a visiting scholar in the Department of Antiquities in 1984. Working with Arthur Houghton, then Associate Curator, and Carol Elkins, a departmental intern, Spier studied and classified all the gems and finger rings in the collection. Under the auspices of Curator Marion True, he has returned often to the Museum to continue his work and to examine the recent acquisitions in order to incorporate them into his text. The exacting process of making precise latex impressions of each piece was begun in 1984 by Ms. Elkins and has continued under Douglas Doughty, who provided most of the casts illustrated here.

Two well-documented groups of gems and rings in the Museum's collection are not included in this catalogue. The first, 215 gems purchased in 1981 (81.AN.76) from a private collection, was published by John Boardman in *Intaglios and Rings, Greek, Etruscan and Eastern, from a Private Collection* (London, 1975). The second, seven finger rings, is part of an important complex of Late Roman jewelry. The entire complex, which is said to have been found together as a hoard, will be published by Barbara Deppert-Lippitz in her article "A Group of Late Antique Jewelry in the Getty Museum," *Occasional Papers on Antiquities* 8 (forthcoming).

Our collection of ancient gems and finger rings has grown significantly since the first example entered the Museum in 1973. Following the acquisition in 1981 of the major private collection mentioned above, 98 gems were acquired in 1984 (84.AN.1) and 91 more in 1985 (85.AN.370). The generosity of donors has been especially important in this area of the collection. Stanley Ungar presented the Museum with a collection of 102 gems and cameos in 1982 (82.AN.162). Jonathan Kagan and Damon Mezzakappa gave a group of sixty gems and four seal impressions in 1983 (83.AN.437). Mr. Kagan also offered as his own donation nine gems in 1984 (84.AN.987–995) and thirty-three gems in 1985 (85.AN.444). Others who have our thanks for their gifts are Lenore Barozzi, Jane Cody, David Collins, Eli Djeddah, William Eagleton, Ira Goldberg, Sylvia Hurter, Dennis Kapp, Monique Lanel, Harvey Sarner, Michael Shubin, Dr. L. S. Shulka, Herbert Solow, Jerome Spier, Seymour Weintraub, and George Zographos.

The accurate identification of the stones included here would not have been possible without the assistance of Jerry Podany and Lisbet Thoresen of the Museum's Department of Antiquities Conservation, David Scott of the Museum Services Department of the Getty Conservation Institute, and Chuck Fryer of the Gemological Institute of America in Los Angeles. Though most of the gems could be identified visually by the author, the problematic pieces required analysis, usually noninvasive; in a few exceptionally difficult cases, minute samples were taken and analyzed by means of X-ray fluorescence and X-ray diffraction. Identifications confirmed by these examinations and analyses are incorporated into the individual entries. The testing processes are not discussed, however, since these will form part of a future publication on the identification and taxonomy of gems.

Since the images on the gemstone and engraved rings are an essential part of the interest of the material, particular thanks go to Charles Passella, head of the Museum's Photographic Services, and Ellen

Rosenbery, the photographer in that department who provided all the black-and-white and color photographs. Karol Wight, Assistant Curator of Antiquities, coordinated the object photography and the preparation of the gem impressions. Kenneth Hamma, Associate Curator of Antiquities, has overseen all aspects of the production of this volume.

John Walsh
Director

ACKNOWLEDGMENTS

The author is grateful to many past and present members of the Department of Antiquities of the J. Paul Getty Museum. Jiří Frel, Arthur Houghton, Marion True, and Kenneth Hamma all took a special interest in this catalogue. Special thanks are owed to Carol Elkins, who contributed greatly to the study and organization of the gem collection, and to Martha Breen and Timothy Seymour for the fine drawings.

Sir John Boardman and Martin Henig read the manuscript and provided many corrections and further references. William Veres, Derek Content, and Christine Insley Green provided helpful information.

ABBREVIATIONS

AA	*Archäologischer Anzeiger*
AK	*Antike Kunst*
Aquileia	G. Sena Chiesa, *Gemme del Museo Nazionale di Aquileia* (Associazione Nazionale per Aquileia, Padua, 1966)
Babelon, *Traité*	E. Babelon, *Traité des monnaies grecques et romaines*, vol. 2, part 2 (Paris, 1910)
Beazley, *Lewes House*	J. D. Beazley, *The Lewes House Collection of Ancient Gems* (Oxford, 1920)
Belgrade	I. Popovič, *Les Camées romains au Musée National de Beograd* (Belgrade, 1989)
Berlin	E. Zwierlein-Diehl, *Antike Gemmen in deutschen Sammlungen*, vol. 2, *Staatliche Museen Preußischer Kulturbesitz, Antikenabteilung* (Munich, 1969)
Berry coll.	B. Y. Berry, *Ancient Gems from the Collection of Burton Y. Berry* (Bloomington, Indiana, 1968)
Bibliothèque Nationale	E. Babelon, *Catalogue des camées antiques et modernes de la Bibliothèque Nationale* (Paris, 1897)
BMC Gems	H. B. Walters, *Catalogue of the Engraved Gems and Cameos, Greek, Etruscan and Roman, in the British Museum* (London, 1926)
BMC Rings	F. H. Marshall, *Catalogue of the Finger Rings, Greek, Etruscan and Roman, in the British Museum* (London, 1907)
BMC Stamp Seals	A. D. H. Bivar, *Catalogue of the Western Asiatic Seals in the British Museum: Stamp Seals*, vol. 2, *The Sassanian Dynasty* (London, 1969)
BMC Tharros	R. D. Barnett and C. Mendleson, eds., *Tharros: A Catalogue of Material in the British Museum from Phoenician and other Tombs at Tharros, Sardinia* (London, 1987)
Boardman, *AGG*	J. Boardman, *Archaic Greek Gems* (London, 1968)
Boardman, *AK*	"Archaic Finger Rings," *AK* 10 (1967), pp. 3–31
Boardman, *Escarabeos*	J. Boardman, *Escarabeos de piedra procedentes de Ibiza* (Madrid, 1984)
Boardman, *GGFR*	J. Boardman, *Greek Gems and Finger Rings: Early Bronze Age to Late Classical* (London, 1970)
Boardman, *Intaglios and Rings*	J. Boardman, *Intaglios and Rings, Greek, Etruscan and Eastern, from a Private Collection* (London, 1975)
Boardman, *Island Gems*	J. Boardman, *Island Gems: A Study of Greek Seals in the Geometric and Early Archaic Periods* (London, 1963)
Bologna	A. R. Mandrioli Bizzarri, *La collezione di gemme del Museo Civico Archeologico di Bologna* (Bologna, 1987)
Braunschweig	V. Scherf, *Antike Gemmen in deutschen Sammlungen*, vol. 3, pp. 1–61, *Herzog-Anton-Ulrich-Museum* (Braunschweig) (Wiesbaden, 1970)
Caesarea	A. Hamburger, "Gems from Caesarea Maritima," *'Atiqot* 9 (1968)
CMS	*Corpus der minoischen und mykenischen Siegel*
Cologne	A. Krug, "Antike Gemmen im Römisch-Germanischen Museum Köln," *Bericht der Römisch-Germanischen Kommission* 61 (1980), pp. 151–260
Content coll.	M. Henig, *The Content Family Collection of Ancient Cameos* (Oxford and Houlton, Maine, 1990)
Cook coll.	C. H. Smith and C. A. Hutton, *Catalogue of the Antiquities in the Collection of the Late W. F. Cook* (London, 1908)
Crawford, *RRC*	M. Crawford, *Roman Republican Coinage* (Cambridge, 1974)
CVA	*Corpus Vasorum Antiquorum*
De Clercq coll.	A. de Ridder, *Collection de Clercq*, vol. 7, pt. 2, *Les pierres gravées* (Paris, 1911)
Frye, *Qasr-i Abu Nasr*	R. N. Frye, ed., *Sasanian Remains from Qasr-i Abu Nasr* (Cambridge, Massachusetts, 1973)

Furtwängler, *AG* A. Furtwängler, *Die antiken Gemmen*, vols. 1–3 (Leipzig, 1900)

Furtwängler, *Beschreibung* A. Furtwängler, *Beschreibung der geschnittenen Steine im Antiquarium, Königliche Museen zu Berlin* (Berlin, 1896)

Furtwängler, *Kleine Schriften* J. Sieveking and L. Curtius, eds., *Kleine Schriften von Adolf Furtwängler*, vol. 2 (Munich, 1913)

Geneva M.-L. Vollenweider, *Catalogue raisonné des sceaux, cylindres, intailles et camées, Musée d'Art et d'Histoire de Genève*, vol. 1 (Geneva, 1967), vol. 2 (Mainz, 1979), vol. 3 (Mainz, 1983)

GettyMusJ *J. Paul Getty Museum Journal*

Göbl, *Siegelkanon* R. Göbl, *Der sassanidische Siegelkanon* (Braunschweig, 1973)

Göttingen P. Gercke, *Antike Gemmen in deutschen Sammlungen*, vol. 3, pp. 63–176, *Sammlung im Archäologischen Institut der Universität Göttingen* (Wiesbaden, 1970)

Greifenhagen, *Schmuckarbeiten* A. Greifenhagen, *Schmuckarbeiten in Edelmetall, Staatliche Museen Preußischer Kulturbesitz, Antikenabteilung*, vol. 2 (Berlin, 1975)

Guilhou coll. S. De Ricci, *Catalogue of a Collection of Ancient Rings Formed by the Late E. Guilhou* (Paris, 1912)

Guiraud, *Gaule* H. Guiraud, *Intailles et camées de l'époque romaine en Gaule* (Paris, 1988)

The Hague M. Maaskant-Kleibrink, *Catalogue of the Engraved Gems in the Royal Coin Cabinet, the Hague: The Greek, Etruscan and Roman Collections* (The Hague, 1978)

Hannover M. Schlüter, G. Platz-Horster, and P. Zazoff, *Antike Gemmen in deutschen Sammlungen*, vol. 4, *Kestner-Museum, Hannover, und Museum für Kunst und Gewerbe, Hamburg* (Wiesbaden, 1975)

Harari coll. J. Boardman and D. Scarisbrick, *The Ralph Harari Collection of Finger Rings* (London, 1977)

Henig, *Roman Engraved Gemstones* M. Henig, *A Corpus of Roman Engraved Gemstones from British Sites*, 2nd ed., British Archaeological Reports, British Series 8 (Oxford, 1978)

Henkel, *Römische Fingerringe* F. Henkel, *Die römischen Fingerringe des Rheinlandes und der benachbarten Gebiete* (Berlin, 1913)

Hoffmann and Davidson, *Greek Gold* H. Hoffmann and P. F. Davidson, *Greek Gold: Jewelry from the Age of Alexander*, exh. cat., Museum of Fine Arts, Boston, and other institutions, November 1965–May 1966 (Mainz, 1965)

Horn and Steindorff, *Sassanidische Siegelsteine* P. Horn and G. Steindorff, *Sassanidische Siegelsteine. Königliche Museen zu Berlin: Mitteilungen aus den orientalischen Sammlungen*, vol. 4 (Berlin, 1891)

JHS *Journal of Hellenic Studies*

Jucker and Willers, *Gesichter* H. Jucker and D. Willers, eds., *Gesichter: Griechische und römische Bildnisse aus Schweizer Besitz*, exh. cat., Bernisches Historisches Museum (Bern, 1982)

JWalt *Journal of the Walters Art Gallery*

Karapanos coll. J. N. Svoronos, *Journal international d'archéologie numismatique* 15 (1913), pp. 147–184

Kassel P. Zazoff, *Antike Gemmen in deutschen Sammlungen*, vol. 3, pp. 177–261, *Staatliche Kunstsammlungen Kassel* (Wiesbaden, 1970)

Leningrad Cameos O. Y. Neverov, *Antichnye kamei v sovranii Ermitazha* (Leningrad, 1988)

Lewis coll. M. Henig, *The Lewis Collection of Engraved Gemstones in Corpus Christi College, Cambridge* (Oxford, 1975)

LIMC *Lexicon Iconographicum Mythologiae Classicae*

Maaskant-Kleibrink, *Doliché* M. Maaskant-Kleibrink, "Cachets de terre de Doliché(?)" *Bulletin antieke beschaving* 46 (1971), pp. 23–63

Maddoli, *Cirene* G. Maddoli, "Le cretule del Nomophylakion di Cirene," *Annuario della Scuola archeologica di Atene e della Missioni italiane in Oriente* 41–42 (1963–1964), pp. 39–145

Martini, *Etruskische Ringsteinglyptik* W. Martini, *Die etruskische Ringsteinglyptik* (Heidelberg, 1971)

Megow, *Kameen* W.-R. Megow, *Kameen von Augustus bis Alexander Severus* (Berlin, 1987)

Munich E. Brandt, E. Schmidt, A. Krug, and W. Gercke, *Antike Gemmen in deutschen Sammlungen*, vol. 1, *Staatliche Münzsammlung München*, pt. 1 (Munich, 1968), pt. 2 (Munich, 1970), pt. 3 (Munich, 1972)

Naples U. Pannuti, *Museo Archeologico Nazionale di Napoli: Catalogo della collezione Glittica*, vol. 1 (Rome, 1983)

New York G. M. A. Richter, *Catalogue of Engraved Gems, Greek, Etruscan and Roman, in the Metropolitan Museum of Art* (Rome, 1956)

Oxford Gems J. Boardman and M.-L Vollenweider, *Catalogue of the Engraved Gems and Finger Rings in the Ashmolean Museum*, vol. 1, *Greek and Etruscan* (Oxford, 1978)

Oxford Stamp Seals B. Buchanan and P. R. S. Moorey, *Catalogue of Ancient Near Eastern Seals in the Ashmolean Museum*, vol. 3, *The Iron Age Stamp Seals* (Oxford, 1988)

Philipp, *Mira et Magica* H. Philipp, *Mira et Magica: Gemmen im Ägyptischen Museum der Staatlichen Museen Preußischer Kulturbesitz, Berlin-Charlottenburg* (Mainz, 1986)

Richter, *Engraved Gems of the Romans* G. M. A. Richter, *The Engraved Gems of the Romans* (London, 1971)

Romania M. Gramatopol, *Les Pierres gravées du Cabinet Numismatique de l'Académie Roumaine. Latomus* 138 (1974)

Sa'd Collection M. Henig and M. Whiting, *Engraved Gems from Gadara in Jordan: The Sa'd Collection of Intaglios and Cameos* (Oxford, 1987)

Sena Chiesa, *Luni* G. Sena Chiesa, *Gemme di Luni* (Rome, 1978)

Sofia A. Dimitrova-Milcheva, *Antique Engraved Gems and Cameos in the National Archaeological Museum in Sofia* (Sofia, 1981)

Southesk coll. Lady Helena Carnegie, *Catalogue of the Collection of Antique Gems, formed by James, Ninth Earl of Southesk* (London, 1908)

Thorvaldsen P. M. A. Fossing, *The Thorvaldsen Museum: Catalogue of the Antique Engraved Gems and Cameos* (Copenhagen, 1929)

Vienna Cameos F. Eichler and E. Kris, *Die Kameen im Kunsthistorischen Museum (Vienna)* (Vienna, 1927)

Vienna Gems E. Zwierlein-Diehl, *Die antiken Gemmen des Kunsthistorischen Museums in Wien*, vol. 1 (Munich, 1973), vol. 2 (Munich, 1979)

Vollenweider, *Deliciae Leonis* M.-L. Vollenweider, *Deliciae Leonis: Antike geschnittene Steine und Ringe aus einer Privatsammlung* (Mainz, 1984)

Vollenweider, *Porträtgemmen* M.-L. Vollenweider, *Die Porträtgemmen der römischen Republik* (Mainz, 1974)

Vollenweider, *Steinschneidekunst* M.-L. Vollenweider, *Die Steinschneidekunst und ihre Künstler in spätrepublikanischer und augusteischer Zeit* (Baden-Baden, 1966)

Zazoff, *AG* P. Zazoff, *Die antiken Gemmen* (Munich, 1983)

Zazoff, *ES* P. Zazoff, *Etruskische Skarabäen* (Mainz, 1968)

CATALOGUE

GUIDE TO THE CATALOGUE DESCRIPTIONS

Drawings of the shapes are actual size, while the drawings of the inscriptions may be enlarged to show details. The photographs and impressions are enlarged 2:1 unless otherwise indicated. The find sites, when given in the provenance, are merely alleged and cannot be confirmed. In most cases only a general geographical area has been suggested. Where no provenance is given for an object, none is known.

When nothing else is stated, length is followed by width, which is followed by height in the measurements.

SHAPES

In the Minoan and Mycenaean periods, gems were usually of lentoid (lens) or amygdaloid (almond) shape (fig. 1); the amygdaloid shape often had two long grooves on the back. The seventh-century-B.C. Island Gems also took these shapes, probably copied from stray finds of the much earlier Minoan examples.

Most Archaic gems were cut as scarab beetles with various degrees of modeling and detail on the backs; they are derived from Egyptian and Phoenician prototypes (see fig. 2, for the varieties, and Boardman, *AGG*, pp. 13–17, for a discussion). Graeco-Phoenician scarabs in green jasper are usually simple, without carination, and plump. The Etruscan scarabs are more elaborate, with careful detailing of the back and head and often decorated plinths.

The scaraboid (see fig. 3 for the varieties) was a common shape for Near Eastern seals and was occasionally copied for Early Archaic gems. In the Late Archaic and Early Classical periods a variety with high, straight sides was used. By the end of the fifth century B.C. the Archaic shape was replaced by three varieties with slanting sides and low, medium, or high dome (Types A, B, and C).

These last three varieties of scaraboids were the most common shapes in the Graeco-Persian series, although the octagonal pyramid, the tabloid, and the pendant were also employed (fig. 4). The devices were usually engraved on the flat side of the scaraboids, but during the Late Classical and Hellenistic periods there was a preference for engraving the convex side. This fashion led to a change in the scaraboid shape to thinner but larger and more elongated ringstones engraved on the convex side (see Boardman, *Intaglios and Rings*, nos. 54–57). Garnet was a favorite stone in the Late Hellenistic period and was usually cut in a distinctive shape with a convex top and concave back (see fig. 5, curved shape 8).

The preference for ringstones in the Hellenistic period led to a large variety of shapes, dictated partly by the conventional shapes assigned to each type of stone (a remarkable variety of unengraved stones, which were cut in the same shapes as are found on contemporary intaglios, decorated the walls of a first-century Roman villa, see M. Cima and E. La Rocca, *Le tranquille dimore degli dei* [Venice, 1986], pp. 105–150) and partly by the current fashion of ring shapes. Figure 5 shows a numbering system for the shapes of Roman ringstones, which was devised by Boardman and Zwierlein-Diehl and used by Henig (there is, however, a discrepancy between the numbers here and those in *The Hague*, p. 60, fig. 2).

Archaic and Classical Greek rings, whether in gold, silver, or bronze, usually fall into clearly distinguishable types. These shapes have been categorized by Boardman, whose terminology is followed here (fig. 6, for Archaic rings; fig. 7, for Classical rings).

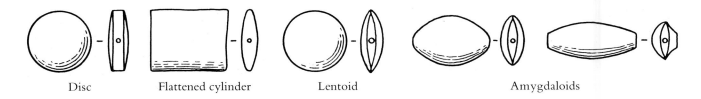

Disc Flattened cylinder Lentoid Amygdaloids

Figure 1. Lentoid and amygdaloid gem shapes (from Boardman, *GGFR*, p. 37, fig. 59).

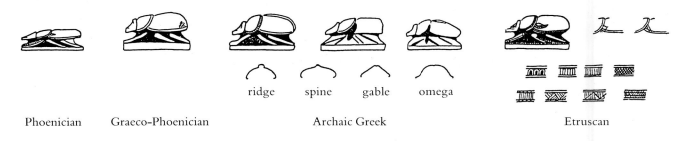

ridge spine gable omega

Phoenician Graeco-Phoenician Archaic Greek Etruscan

Figure 2. Scarab shapes (from Boardman, *AGG*, p. 15, fig. 1).

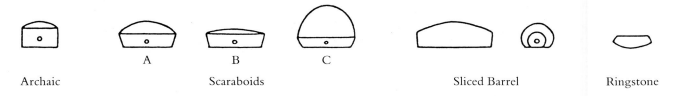

A B C

Archaic Scaraboids Sliced Barrel Ringstone

Figure 3. Scaraboid gem shapes (from Boardman, *GGFR*, p. 191, fig. 200).

Figure 4. Octagonal pyramid, tabloid, and pendant gem shapes (= cat. nos. 109, 122, and 114).

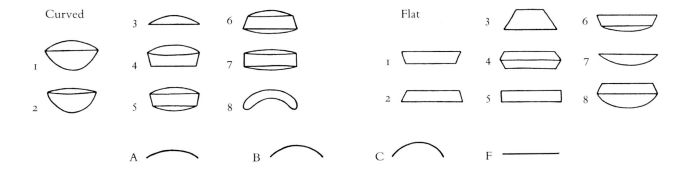

Figure 5. Curved and flat gem shapes (from Henig, *Roman Engraved Gemstones*, p. 35).

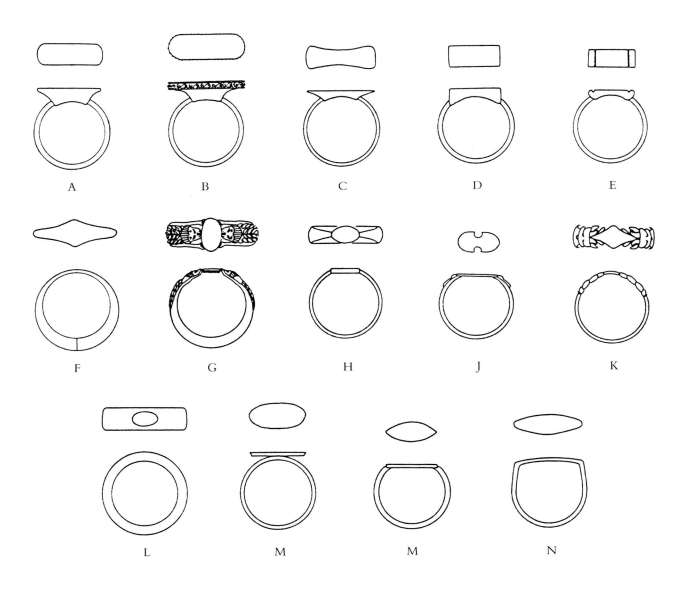

Figure 6. Archaic ring shapes (from Boardman, *GGFR*, p. 156, fig. 198).

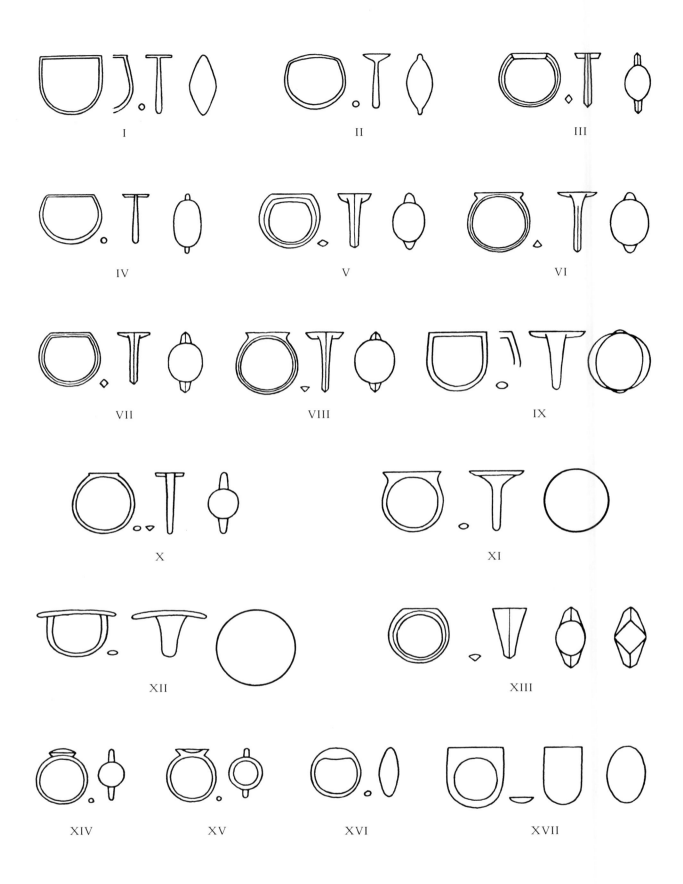

Figure 7. Classical ring shapes (from Boardman, *GGFR*, p. 213, fig. 217).

MATERIALS

The best surviving ancient studies of gemstones are by the fourth-century-B.C. philosopher Theophrastos (*On Stones*) and by Pliny the Elder, who wrote in the first century A.D. (*Naturalis Historia*, Book 37). It is not always possible to match the ancient terms with known gemstones, but further study would be productive (for ancient sources, see O. Rossbach, in *Real-Encyclopädie der klassischen Altertumswissenschaft*, vol. 7, pt. 1, s.v. Gemmen, cols. 1052–1115; and for reviews of the variety of stones, see Furtwängler, *AG*, vol. 3, pp. 383–397; *BMC Gems*, pp. xii–xvii; G. M. A. Richter, *The Engraved Gems of the Greeks and the Etruscans* [London, 1968], pp. 8–13; Boardman, *GGFR*, pp. 374–379, 447–448; and *Oxford Gems*, pp. 70–71, for the variety of Hellenistic gemstones). The wide variety of stones used for ancient intaglios has seldom been studied scientifically (the best study is of the magic gems in the Ägyptisches Museum in Berlin, Philipp, *Mira et Magica*, pp. 127–146), and many of the conventional names for gemstones are not technically correct, although for the sake of clarity, the common names are usually followed here.

Most ancient gems are of some variety of quartz, the most common being *carnelian* (yellow, orange, or red in color; when brown, it is termed *sard*). Carnelian is used in all periods, from Minoan to Roman, and perhaps half of all known gems are in this material. Of the same mineralogical group is *chalcedony* (milky blue, gray, green, or white), *agate* (with different-colored wavy bands, which may be black, brown, white, and gray), and *sardonyx*, which here is used to describe stones with straight bands, usually of blue, brown, and white, which were especially preferred for Roman cameos. The term *nicolo* is used to describe a Roman banded agate intaglio with a blue top layer and a dark brown bottom layer; it is almost always of shape F 4. Green stones, often with dark inclusions, are called *plasma* (an incorrect term) in the catalogue, but several different types of stones, including *prase*, *chrysoprase*, and *aventurine*, are included in this term; all examples in the Getty Museum are varieties of chalcedony.

Very close mineralogically but different in appearance is the *jasper* group. These stones are opaque and usually red, green (called *plasma* in Philipp, *Mira et Magica*, p. 128, but not in this catalogue, see below), yellow, brown, or black, but sometimes several blotches of color are found in the same stone. The mottled jaspers were often used for Minoan and Classical Greek gems. Phoenician scarabs usually appear to be of green jasper, but analysis has shown that a variety of materials similar in appearance were used (see *BMC Tharros*, pp. 106–107). Red, green, and yellow jaspers became especially fashionable for Roman gems in the second and third centuries A.D. Also found in that period is green jasper with small red spots, usually highly polished, termed *heliotrope* and also known as *bloodstone*.

Two frequently used types of fine crystalline quartz are *rock crystal*, a colorless stone that appears to have been highly valued and used in all periods, from Minoan through Roman times, and *amethyst*, of violet color, which was occasionally used in the Minoan period, but rarely in the Archaic and Classical periods and most commonly in the Hellenistic and early Roman imperial age. *Citrine*, yellow in color and resembling topaz, was sometimes used in the early Roman imperial period, and the engravings on these gems are usually of fine quality, suggesting the stone was valuable.

Some rarer and presumably more precious stones were not of the quartz family. *Garnet* (either deep red or purple in hue) was not used until the Hellenistic period, when it became especially fashionable; it fell out of fashion, at least for intaglios, during the Roman period, but in the fifth century A.D. it became the favorite gemstone for jewelry of the Migration period. Other precious gems of the Hellenistic and early Roman imperial periods include *peridot*, *emerald*, *aquamarine*, *sapphire*, and *tourmaline*, but they are

found only rarely. *Lapis lazuli*, deep blue and sometimes with gold pyrite inclusions, was found in Afghanistan and evidently highly prized in Greece; it was used only rarely for Greek and Roman intaglios. From the same region but even less commonly used was *turquoise*.

Obsidian, a black volcanic glass, was occasionally used for gems since Archaic Greek times, and Pliny mentions statues made of the material (see D. B. Harden et al., *Glass of the Caesars*, exh. cat. [London, 1987], no. 6, for a fragmentary statue of a horse in obsidian). *Glass* and glass paste gems were used in all periods and usually imitate the color and shape of gemstones (see Philipp, *Mira et Magica*, pp. 141–142, for the chemical analysis of some glass gems). Seals of glazed quartz frit, termed "Egyptian Blue," were made at the Greek colony Naukratis in Egypt (see *BMC Tharros*, pp. 106–107, for chemical analysis).

Haematite, an iron oxide, was frequently used for Near Eastern and Minoan seals, but rarely thereafter until the Roman imperial period. In Roman times it was regarded as having magical properties, and its use for intaglios was almost entirely confined to magic gems.

Some early seals, including Near Eastern, Minoan, Mycenaean, and Island Gems, are in stones conventionally called *steatite*. The term is incorrect, however, and most gems are rather of *chalcedony* or *serpentine*, which is usually opaque black, brown, green, or mottled. *Serpentine* is much softer than quartz and rarely used after the Early Archaic period. *Ivory*, also very soft and easy to cut, was most popular in the Peloponnesos in the Early Archaic period.

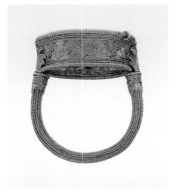

Cat. no. 70

Plate 1

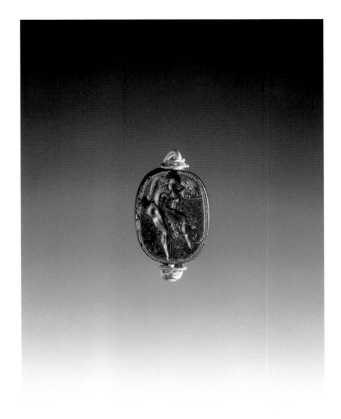

Cat. no. 17

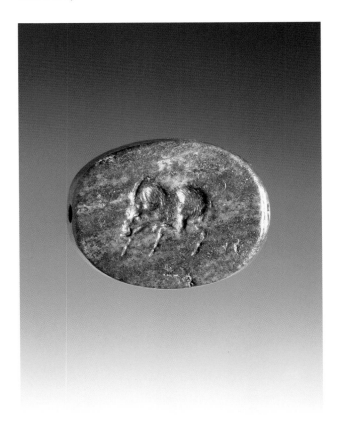

Cat. no. 19

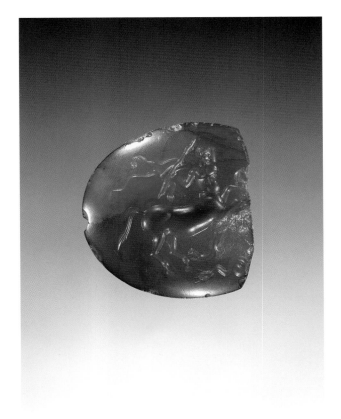

Cat. no. 20

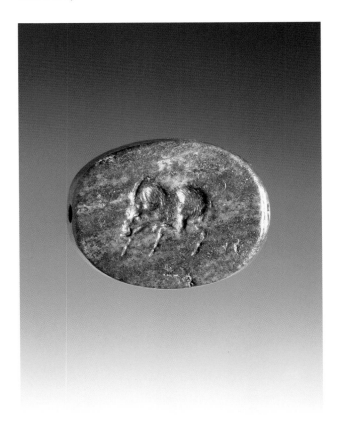

Cat. no. 111

Plate 2

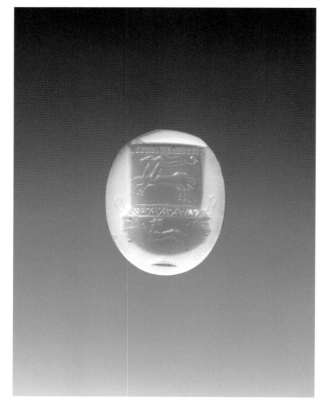

Cat. no. 185

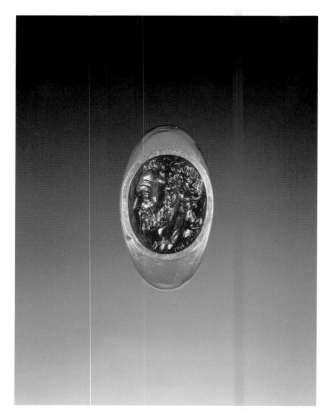

Cat. no. 220

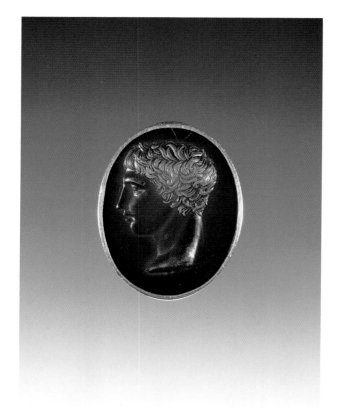

Cat. no. 221

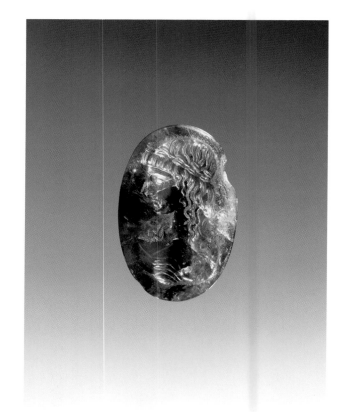

Cat. no. 222

Plate 3

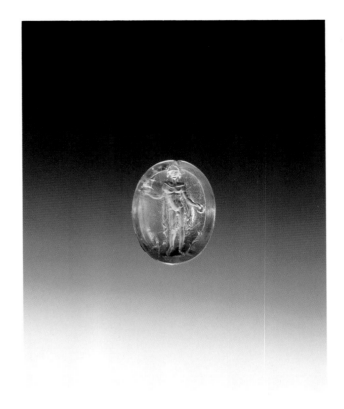

Cat. no. 259

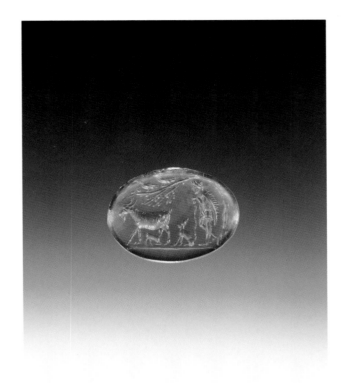

Cat. no. 290

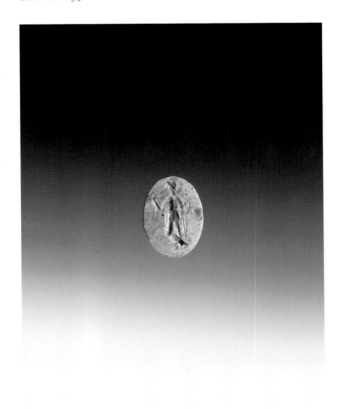

Cat. no. 294

Cat. no. 334

Plate 4

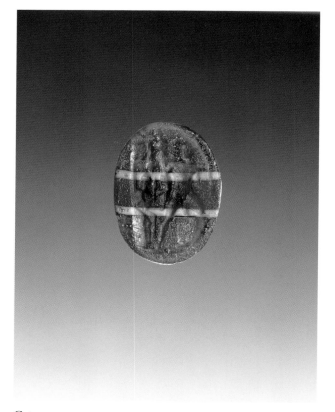

Cat. no. 414

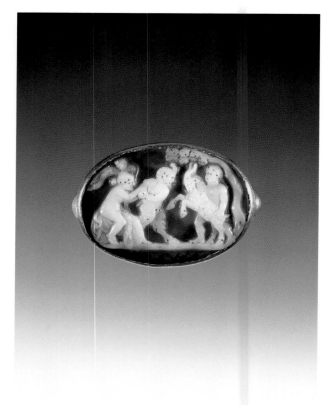

Cat. no. 428

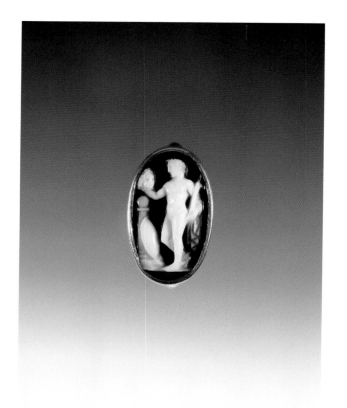

Cat. no. 429

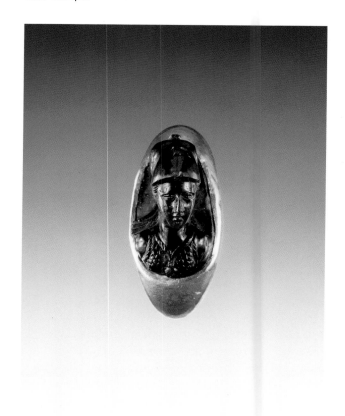

Cat. no. 435

Plate 5

GREEK GEMS

The engraved gems of the Minoans and Mycenaeans have only been studied since the late nineteenth century, when they were discovered in large numbers on Crete and at Mycenae and other sites in Greece. Since that time many publications have appeared, including the extensive *Corpus der minoischen und mykenischen Siegel* (for a good survey of the gem types, see Boardman, *GGFR*, pp. 19–65; and the comprehensive bibliography and summary of scholarship, Zazoff, *AG*, pp. 25–39; also the most recent analysis of the material by J. G. Younger in a series of articles, *Kadmos* 21–24 [1982–1985]). The five Minoan and Mycenaean stones in this catalogue join two others in the Getty published by Boardman (*Intaglios and Rings*, nos. 4–5).

The most significant studies of Greek gems, from their reappearance at the end of the Greek Dark Ages through the Archaic and Classical periods, are by Boardman, who has compiled nearly complete lists of these gems and assigned them to stylistic groups. The earliest group of gems, usually in soft stone or ivory, belongs to the Late Geometric period and was probably made in the Peloponnesos and the Cycladic Islands (Boardman, *Island Gems*, pp. 110–144; Boardman, *GGFR*, pp. 399–400; and Zazoff, *AG*, p. 51, for further literature). An unusual seal in ivory (cat. no. 6) is the sole example in the Getty collection.

During the seventh century, ivory was the favorite material for seals in the Peloponnesos; they usually took the form of discs and displayed a wide variety of devices in fine style; most have been found at Perachora, Sparta, and Argos (see Boardman, *Island Gems*, pp. 145–153; Boardman, *GGFR*, p. 400). Apparently related to these seals are two unusual scaraboids in the Getty, one in ivory (cat. no. 10) and the other in red jasper (cat. no. 9), which may be rare examples of the successors to the early ivory discs. Also belonging to the seventh century B.C. is a large number of serpentine seals, which were made in the Cycladic Islands (probably on Melos) and have been named "Island Gems" (Boardman, *Island Gems*, pp. 12–108; idem, *JHS* 88 [1968], pp. 1–12). Two examples are in Malibu (cat. no. 7, and Boardman, *Intaglios and Rings*, no. 6). Another Early Archaic Greek gem is a product of a workshop at the Greek settlement at Naukratis in Egypt (cat. no. 8).

The main series of Archaic Greek gems is composed of hard-stone scarabs and scaraboids (primarily carnelian, agate, and rock crystal), which have been studied in depth by Boardman (*AGG*; and *Intaglios and Rings*, nos. 1–3, 8, 10–16, 18–28, in the Getty Museum). They developed over the second half of the sixth century B.C., probably introduced to Greece by Phoenicians via Cyprus, and appear to have been the speciality of East Greece and the Ionian Islands. Notable Archaic scarabs and scaraboids in the Getty include two by one of the finest Late Archaic artists, Epimenes (cat. no. 17, and Boardman, *Intaglios and Rings*, no. 22), and a post-Archaic scaraboid by a previously unknown anonymous master (cat. no. 18).

The gems of the Classical period have also been categorized by Boardman (*GGFR*, pp. 407–416, for a nearly complete catalogue). Most of the examples in Malibu have already been published (Boardman, *Intaglios and Rings*, nos. 29–53), and only a few are added in this catalogue, including a remarkable scaraboid depicting a Centaur (cat. no. 20) and a series of glass scaraboids. Early Hellenistic gems have been less fully studied (see Zazoff, *AG*, p. 193, for literature), and the only important addition here is the garnet (cat. no. 21) that belongs to a Ptolemaic workshop (other distinctive Hellenistic types in the Getty are Boardman, *Intaglios and Rings*, nos. 54–57).

The extensive series of engraved Greek finger rings in gold, silver, bronze, and iron begins around 600 B.C. and continues straight through the Hellenistic period. There is a range of shapes and styles, but they fall into easily distinguishable groups, which have been identified by Boardman (*AK*, pp. 3–31, for Archaic rings; *GGFR*, pp. 212–233, 416–428, for a catalogue of Classical rings; *Intaglios and Rings*, nos. 60–82, for other rings in the Getty). A large number of rings has been acquired by the Getty, including a group of thirteen Archaic silver rings said to be from Gela in Sicily, several fine style gold rings of fourth-century-B.C. date, some distinctively Western Greek and Etruscan rings, a South Italian ring set with a gold scarab, a series of bronze and iron rings notable for their iconography, and a group of Ptolemaic rings in bronze.

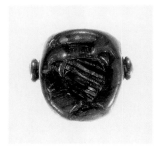
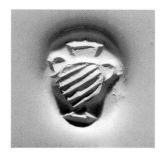

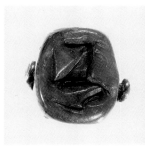
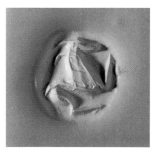

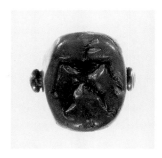

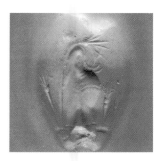

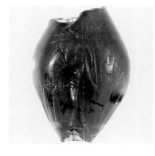

2 Carnelian grooved amygdaloid

19.3 × 13.5 × 7.7 mm
Late Helladic II–III A, circa 1450–1300 B.C.
84.AN.1.1

Description: Male figure standing left, wearing a short skirt with belt and boots, uprooting a tall papyrus stalk. Two papyrus stalks stand before him and two behind on groundline.

Chipped around both string holes.

Discussion: The scene, a human figure with papyrus stalk, is very unusual, and the meaning is uncertain. However, a Middle Minoan III three-sided amygdaloid in Berlin (*Berlin*, no. 12) similarly depicts a woman carrying a stalk. The Berlin gem is earlier, and the style is more schematic and not closely related to the Getty example.

The fine style of the human figure on the Getty gem is distinctive but has no particularly close parallel. It recalls figures on the Late Minoan I sealings from Agia Triada (D. Levi, *Annuario della Scuola archeologica di Atene e della Missioni italiane di Oriente* 8–9 [1925–1926], p. 155, fig. 164) but does not belong to that group and appears somewhat later in date. A figure of a fisherman in similar pose and costume is seen on a Late Minoan II–III A amygdaloid in London (*BMC Gems*, no. 40 = Boardman, *GGFR*, pl. 107 = V. E. G. Kenna, *CMS*, vol. 7, *Die englischen Museen*, pt. 2 [Berlin, 1967], no. 88), but the treatment of details is considerably different. Closest in style is the figure of a woman on a Late Helladic agate amygdaloid in Athens from Vaphio (A. Sakellariou, *CMS*, vol. 1, *Athen, Nationalmuseum* [Berlin, 1964], no. 226 = Boardman, *GGFR*, pl. 162; see J. G. Younger, *Kadmos* 23 [1984], p. 55), notably in the treatment of details, such as the face and belt, and in the body modeling.

Provenance: From Greece.

1 Brown serpentine three-sided prism

Each face measures circa 12.3 × 11.7 mm
Middle Minoan I, circa 2000–1700 B.C.
85.AN.370.1

Description: Side A: Two-handled vase. Side B: Goat right. Side C: Male figure walking left.

Provenance: Ex-Dr. Joseph Bard collection; Sotheby's, London, July 11, 1977, lot 80.

Bibliography: V. E. G. Kenna, *CMS*, vol. 8, *Die englischen Privatsammlungen* (Berlin, 1966), no. 100; H.-G. Buchholz and V. Karageorghis, *Altägäis und Altkypros* (Tübingen, 1971), p. 114, no. 1373.

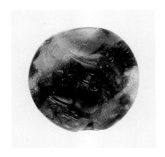
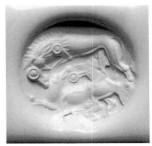

3 Mottled red, pink, white, and brown agate lentoid

14.3 × 15.1 × 7.0 mm
Late Minoan/Late Helladic III, circa 1400 B.C.
83.AN.437.1

Description: Lion attacking a calf.

There are several chips from the face.

Discussion: Gems with similar scenes and perhaps by the same hand are in Paris (H. and M. van Effenterre, *CMS*, vol. 9, *Paris, Cabinet des Médailles* [Berlin, 1972], no. 142, provenance unknown) and Oxford (V. E. G. Kenna, *Cretan Seals, with a Catalogue of the Minoan Gems in the Ashmolean Museum* [Oxford, 1960], pp. 148–149, no. 6 P).

Provenance: Ex-Bank Leu and Co., Zurich.

Bibliography: J. H. Betts, *CMS*, vol. 10, *Die schweizer Sammlungen* (Berlin, 1980), no. 271; J. G. Younger, *Kadmos* 25 (1986), p. 135, Spectacle-Eye Group.

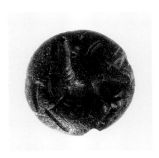
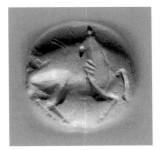

4 Black serpentine lentoid

15.3 (diameter) × 6.5 mm (thickness)
Late Minoan/Late Helladic III, fourteenth century B.C.
85.AN.370.2

Description: Wounded bull facing right, head thrown back.

Discussion: The motif already occurs on a gem from Grave Circle B at Mycenae (A. Sakellariou, *CMS*, vol. 1, *Athen, Nationalmuseum* [Berlin, 1964], no. 8) but continues throughout the Mycenaean period. For the style, compare the Late Minoan III A lentoid, V. E. G. Kenna, *CMS*,

vol. 8, *Die englischen Privatsammlungen* (Berlin, 1966), no. 77, and another in Oxford, V. E. G. Kenna, *Cretan Seals, with a Catalogue of the Minoan Gems in the Ashmolean Museum* (Oxford, 1960), no. 385.

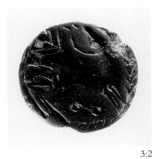
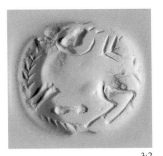

3:2 3:2

5 Black serpentine lentoid

20.5 × 21.6 × 8.2 mm
Late Helladic III, late fourteenth–thirteenth century B.C.
84.AN.1.2

Description: Bull left with head turned back, three branches and a stylized figure-eight design in field.

There is a small chip from the edge.

Discussion: The rough modeling, linear details, and branchlike filling ornaments are typical of the last few series of Mycenaean gems (for the latest types, see Boardman, *GGFR*, p. 62; J. G. Younger, *Kadmos* 26 [1987], pp. 65–66, Mainland Popular Group, with comments on an earlier chronology than usually cited).

Provenance: Said to be from Israel.

3:2

3:2

6 Ivory tabloid

27.1 × 23.2 × 7.3 mm
Late Geometric, late eighth or early seventh century B.C.
83.AN.437.2

Description: Two recumbent animals, inverted, with irregular geometric patterns in the field. One animal appears to be a goat with head turned back, and the other a dog(?) facing forward.

Pierced through the short side; the face flat; the back is carved to form two convex rows separated by a double-ridge in the center and two ridges at the ends; the profile resembles a bead-and-reel pattern. Half of the back is broken away.

Discussion: Although the shape of the back and the design itself have no close parallel, there are general similarities to a series of Late Geometric square seals in soft stone and ivory discussed by Boardman, who suggests connections with the Islands and Argos (Boardman, *Island Gems*, pp. 112ff.). A limestone seal from Melos, now in Oxford (Boardman, *Island Gems*, A 4 = *Oxford Gems*, no. 1), is notable for its similar filling ornament, and a square ivory seal with decorated back from Crete is of similar shape (Boardman, *Island Gems*, p. 115, A 7, fig. 11). A large serpentine lentoid seal, apparently an Island work, is in London and depicts a motif similar to the Getty example (*BMC Gems*, no. 193 = Boardman, *Island Gems*, p. 97, no. 2, the date is uncertain but probably Late Geometric).

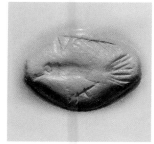

3:2 3:2

7 Green serpentine amygdaloid

21.2 × 15.5 × 6.5 mm
Island Gem, late seventh century B.C.
85.AN.370.4

Description: Bird flying left.

Worn but intact.

Discussion: The gem belongs to a distinctive group of seventh-century-B.C. seals probably made on Melos, which are comprehensively discussed by Boardman (Boardman, *Island Gems*). The pose of the bird, with wing raised and foot lowered, is unusual but seen on another example from Melos, now in Kassel (Boardman, *Island Gems*, pp. 39, 40, no. 122 = Furtwängler, *AG*, pl. 5.19 = *Kassel*, no. 13). Furtwängler, followed by Zazoff, describes the bird as a seagull, but a sea eagle, like those seen in a similar pose on the fifth-century coins of Sinope on the Black Sea (see Babelon, *Traité*, vol. 2, pl. 184.5–19) and on a silver ring in Munich (Boardman, *GGFR*, pl. 755), seems more likely.

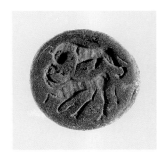 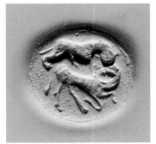 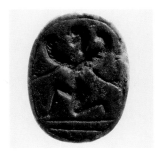
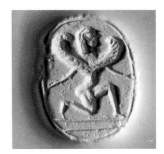

9 Red jasper scaraboid

17.9 × 13.7 × 8.6 mm
Greek (Peloponnesian), circa 600 B.C.
84.AN.1.6

Description: Winged, nude male figure kneeling right on double groundline; linear border. The two curved wings are joined in front at the waist; his arms are outstretched but hold nothing; his hair is long, and he is unbearded.

Discussion: A similar figure is seen among the series of seventh-century Peloponnesian ivory discs from Perachora (Athens, National Museum 16576; T. J. Dunbabin, ed., *Perachora*, vol. 2 [Oxford, 1962], p. 416, no. A 32, pl. 176 = G. M. A. Richter, *Engraved Gems of the Greeks and the Etruscans* [London, 1968], no. 76 = *LIMC*, vol. 3, p. 129, no. 34b, as perhaps a Boread) and on another ivory seal from Olympia (A. Furtwängler, *Olympia: Die Ergebnisse der von dem deutschen Reich veranstalteten Ausgrabungen*, vol. 4, *Die Bronzen* [Berlin, 1890], p. 188, no. 1194). The motif is also seen on a series of Ionian electrum coins of the late seventh century B.C. (see L. Weidauer, *Probleme der frühen Elektronprägung* [Fribourg, 1975], nos. 175–177).

Greek stone scaraboids in Archaic style are rare before the mid-sixth century, but some appear to be local works continuing the motifs of the ivories of the seventh century (see another jasper scaraboid with the device of a griffin from Olympia, *Furtwängler* [above], p. 188, no. 1193).

Provenance: Surface find from the Argive Heraion. Sternberg, Zurich, auction 11, November 21, 1981, lot 1082.

8 Blue frit ("Egyptian Blue") seal, the back in the shape of a negro head

15.2 × 14.0 × 8.8 mm
Naukratis, Egypt, early sixth century B.C.
85.AN.370.5

Description: Lion attacking a bull(?); linear border. Worn but intact.

Discussion: The factory for manufacturing a variety of faience scarabs and seals, including this type, was discovered in the excavations of the Greek trading colony of Naukratis in Egypt (W. M. Flinders Petrie, *Naukratis*, vol. 1 [London, 1888], pp. 36–37, pl. 37.145 for the device, and pl. 38.11 for the back). A clay mold from Naukratis for forming a seal back of this head type is in Oxford (J. Boardman, *The Greeks Overseas* [London, 1980], p. 128, fig. 151). Scarabs made at Naukratis with the same device as the Getty piece include examples from Cyprus (E. Gjerstad, *The Swedish Cyprus Expedition*, vol. 2 [Stockholm, 1935], pl. 249.2667) and Berezan on the Black Sea (A. O. Bol'sakov and Ju. I. Ilj'ina, *Vestnik drevnei istorii* 186 [1988], p. 59, fig. 4, pl. I.6) and another in Hannover (*Hannover*, no. 12). For the material ("Egyptian Blue"), compare *BMC Tharros*, p. 106.

Provenance: From Athens.

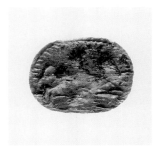
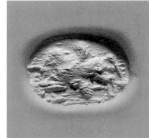

10 Ivory scaraboid of greenish color

14.2 × 10.8 × 5.9 mm
Greek, first half of the sixth century B.C.
84.AN.1.5

Description: Winged horse flying left, one wing lowered; tooth border.

Some losses of splintering ivory from the face.

Discussion: The pose with one lowered wing is unusual but paralleled on a mid-sixth-century-B.C. Greek silver ring from Sicily (Boardman, *Intaglios and Rings*, p. 21, no. 68 = Getty Museum 81.AN.76.68, where the unusual and presumably early pose is noted). The scaraboid shape, although very common in Near Eastern glyptic and in Greek hard-stone gems of the later sixth and fifth centuries, appears to be otherwise unattested in ivory. However, the material and the use of the tooth border are both typical of the extensive series of seventh-century-B.C. Peloponnesian ivory seals and, as in the case of the previous gem, suggest that this piece is a rare sixth-century successor of the earlier Peloponnesian ivories.

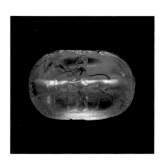
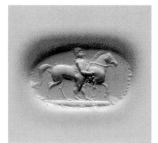

11 Rock crystal scaraboid

14.1 × 9.8 × 7.8 mm
East Greek, late sixth century B.C.
85.AN.164

Description: Nude youth leading a horse right; he holds the reins with his left hand and a branch in his right hand; his hair is long and hangs straight down in the back; hatched exergue and dotted border.

The beetle is simple, carinated (spine) and with hatched forelegs.

There are some chips from around the base and in the device.

Discussion: The type, a youth leading a horse, is not unusual on Archaic Greek gems (see Boardman, *AGG*, nos. 137, 246, 330–332; no. 330 is in Peronne, Danicourt collection, Boardman, *GGFR*, pl. 349), although in no other example does he hold a branch. The style of the gem, however, is distinctive. The modeling and fine detail are exceptional and relate the piece to a series of gems, most likely of East Greek manufacture, distinguished by Boardman and named the Sphinx-and-Youth Group I (Boardman, *AGG*, pp. 65–71). The features of the youth, most notably the sharply receding forehead and slanting eye, are characteristic of the group, and his hair style and fleshy body are typical of East Greek stylizations of the period.

Certain details of the gem suggest it may be by the same hand as one of the finest gems of the Sphinx-and-Youth Group I, the plasma scarab in London depicting a walking ram accompanied by the inscription "Man-dronax" (Boardman, *AGG*, no. 131 = *BMC Gems*, no. 445). The careful attention to the body modeling of the animal and the details of the face are shared by both gems, and the treatment of the legs of both animals is identical and distinctive. Both gems also share the hatched exergue, although this is not an unusual feature on Archaic gems. However, the carving of the backs of both beetles is strikingly similar, both having the same shape with spine carination and hatched forelegs (see the back of the Mandronax gem, Boardman, *AGG*, pl. 40.131). The "Mandronax" inscription, as Boardman notes (*AGG*, p. 69), is clearly Ionian and supports the East Greek attribution.

Provenance: From Etruria? Ex-Southesk, Howel Wills (lot 114), and W. Talbot Ready (1894) collections.

Bibliography: *Southesk coll.*, no. A 37.

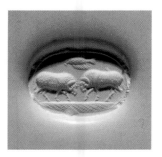

12 Carnelian scarab

14.7 × 10.8 × 8.9 mm
East Greek, late sixth century B.C.
85.AN.122

Description: Two rams butting heads; bird flying left overhead; cross-hatched exergue and linear border.

The beetle is simple with ridge carination.

Discussion: This gem also belongs to Boardman's Sphinx-and-Youth Group I. The rams are closely related to the one on the Mandronax gem (see cat. no. 11, above) but do not appear to be by the same hand. The stippling is a technique typical of the entire series (see Boardman, *AGG*, p. 67), and the cross-hatched exergue is seen also on the Mandronax gem and on the gem catalogue number 11. A very similar flying bird is depicted on a late sixth-century-B.C. Greek silver ring from Sicily (Boardman, *Intaglios and Rings*, no. 63 = Getty Museum 81.AN.76.63).

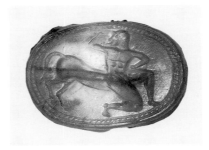

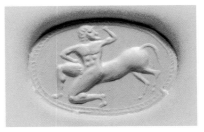

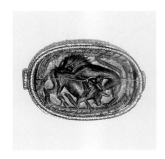 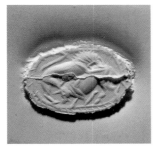

14 Rock crystal scarab

22.2 × 15.6 × 11.8 mm
Greek, late sixth century B.C.
84.AN.177

Description: Centaur left, his head turned back; his right hand is on his waist, and the left holds a small branch(?) above his head. The Centaur's forelegs are human rather than equine; hatched border.

Large but simple beetle with ridge carination.

Discussion: Elkins has noted the similarity in the treatment of musculature to that of a Herakles on a scaraboid in Munich (Boardman, *AGG*, no. 269), but the two are not by the same hand. A similar Centaur, with equine rather than human forelegs, is in Munich (Boardman, *AGG*, no. 199 = *Munich*, pt. 1, no. 254).

Provenance: From South Italy, possibly Taranto.

Bibliography: C. Elkins, *GettyMusJ* 13 (1985), pp. 23–26; *GettyMusJ* 12 (1984), p. 173, no. 34.

13 Carnelian scarab in Etruscan gold mount

Scarab, 14.5 × 10.7 × 6.6 mm
Greek, second half of the sixth century B.C.
77.AO.77.1

Description: Lion attacking a bull; hatched border.

Carefully worked beetle with carination (spine). It forms the central pendant of a necklace composed of alternating granulated gold and amber beads.

Scarab broken in half lengthwise but held in place by the gold mount.

Discussion: Zazoff has already seen that the gem, although mounted in an Etruscan necklace, is Greek. The motif is a very popular one on Archaic Greek gems. The style of the piece best fits into Boardman's Common Style (Boardman, *AGG*, pp. 125ff.) and corresponds to his Scheme C (see Boardman, *AGG*, p. 123).

Bibliography: P. Zazoff, *GettyMusJ* 6–7 (1978–1979), pp. 196–198.

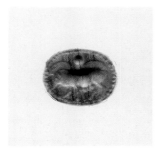
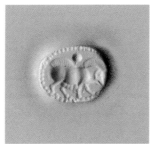

15 Banded agate scarab, green/white/black

10.8×8.9×6.5 mm
Greek, late sixth century B.C.
82.AN.162.1

Description: Sow right, a large pellet above; dotted border. The beetle is simple with ridge carination.

Worn and partially discolored.

Discussion: For other boars and sows, which are especially popular on Archaic Greek gems, compare Boardman, *AGG*, p. 152, nos. 533–555.

Bibliography: Furtwängler, *AG*, pl. 7.62; Boardman, *AGG*, no. 544.

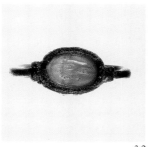 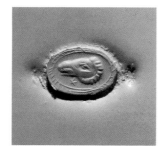

3:2

16 Carnelian scarab set in silver ring

Mount, 14.6×9.0×4.8 mm; greatest diameter of hoop, 22.8 mm
Greek, late sixth century B.C.
83.AN.437.4

Description: Ram's head facing left with star below; carelessly hatched border.

The gem is in a silver mount, which swivels within a tapering solid silver hoop. The scarab is simple but carefully worked, with a low ridge carination.

The silver is covered with a silver chloride deposit.

Discussion: Other ram's heads occur on Archaic gems (Boardman, *AGG*, nos. 519–520). For the ring shape, compare Greifenhagen, *Schmuckarbeiten*, pl. 62.7–9.

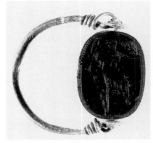 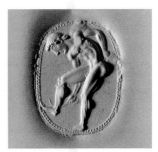

3:2

 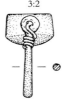

17 Obsidian scaraboid by the engraver Epimenes

16.2×12.9×7.0 mm (as preserved)
Greek, circa 500 B.C.
85.AN.370.6 (Color plate 2)

Description: Nude youth standing left scraping his right leg with a strigil. His upper body is shown facing in three-quarter view; his hair is cross-hatched with a row of pellets representing the curls along the brow and back of the neck. The strigil terminates in a stylized duck's head; hatched border.

The scaraboid is set in a modern gold ring. Enough of the back of the scaraboid is preserved to reconstruct the profile, which is of conventional Archaic shape; the original height was circa 8.5 mm.

There are small chips from the top and left of the face. Nearly all of the back is broken away and lost.

Discussion: This is the fifth known work of the artist Epimenes, whose signature is found on a gem in Boston, a chalcedony scaraboid on which a youth restrains a horse (Boardman, *AGG*, no. 246; Beazley, *Lewes House*, no. 28). The other examples include a chalcedony scaraboid in New York showing a kneeling youth testing an arrow (Boardman, *AGG*, no. 248); a carnelian scarab with a youth adjusting his sandal, now in the Getty Museum (Boardman, *Intaglios and Rings*, no. 22 = Getty Museum 81.AN.76.22); and, less certainly, a second chalcedony scaraboid in Boston depicting a youth shooting an arrow (Boardman, *AGG*, no. 247; Beazley, *Lewes House*, no. 27). The most thorough discussions of the artist and related works are by Boardman (Boardman, *Intaglios and Rings*, pp. 12–13; idem, "Greek Gem Engraving: Archaic to Classical," in C. G. Boulter, ed., *Greek Art, Archaic into Classical*. Cincinnati Classical Studies, vol. 5 [Leiden,

1985], pp. 87–88; Boardman, *AGG*, pp. 92–94), who attributed the Getty carnelian scarab to Epimenes.

The new scaraboid in the Getty can be assigned with confidence to Epimenes, and it in turn lends further cohesion to the entire group of gems. The heads of the youths on the new Getty piece and on the signed work in Boston are nearly identical and extremely close to the example in New York (see Boardman, *Intaglios and Rings*, pls. A–B, for enlarged illustrations). The obsidian scaraboid, clearly by Epimenes, strongly supports Boardman's attribution of the Getty carnelian scarab, for although the head on the latter piece differs somewhat from the other, the detailing of the body, notably the musculature of the legs and arms and the treatment of the knees and feet, is identical. The more angular features of the youth on the Getty carnelian scarab resemble those of the archer on the second scaraboid in Boston, although the latter work is less careful than any of the others.

The two gems in the Getty differ in several respects from the three previously known gems. The carefully worked carnelian scarab and the scaraboid in the rarely used material obsidian are new to Epimenes' works, which had consisted only of chalcedony scaraboids. All five of his gems depict nude youths, but the poses of the two Getty gems are new. The gems in Boston and New York all show the youths in three-quarter rear view, an innovative pose that became popular in sculpture and vase-painting late in the sixth century (see the discussion by Beazley, *Lewes House*, pp. 21–22) and that was especially ambitious for a gem engraver. On the two gems in the Getty the youths are shown in three-quarter front view, which is not an unusual pose on Archaic gems, although seldom skilfully accomplished. The two works by Epimenes show different degrees of success. The carnelian scarab is the better of the two, with the chest shown in correct three-quarter view, although the lowered right arm is unnaturally elongated. The youth on the obsidian scaraboid twists so that his upper chest faces entirely to the front, a typical but awkward Archaic stylization, while the lower torso is shown in accurate three-quarter view. The carnelian scaraboid appears to be the more developed of the two works.

Two of Epimenes' gems were found in Egypt, a third on Aegina, and the Getty obsidian scaraboid allegedly in Sicily. However, the letter forms of his signature suggest he was from one of the Cycladic Islands, and the long tradition of gem engraving in the Islands supports this attribution (see Boardman, *AGG*, pp. 93–94; Boardman [above], pp. 87–88).

For the motif of a youth with strigil on a number of Archaic gems, see Boardman, *Intaglios and Rings*, no. 18 = Getty Museum 81.AN.76.18, a carnelian scarab; also Boardman, *AGG*, nos. 190, 259, and 310.

Provenance: From Sicily.

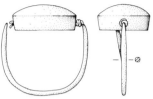

18 Blue chalcedony scaraboid in silver ring

16.9 × 14.0 × 7.6 mm; greatest diameter of hoop, 22.9 mm
Greek, circa 470 B.C.
84.AN.1.12

Description: Zeus seated left on a four-legged chair, which rests on a groundline. His hair is short and held by a taenia. A mantle is draped over his lap and legs, but his torso is nude. He holds a long, eagle-tipped scepter upright in his right hand and a fulmen(?) at his left side. The inscription XAPON in small letters is in the field to the left, reading upward; hatched border.

The ring is a thin wire hoop that passes through the stone and is wound around the terminals.

Discussion: Gems dating from the transitional period between Late Archaic and Classical are rare, and this example has no close parallel. Epimenes and his circle are Late Archaic, probably circa 500 B.C. in date, and are followed by the fine Anakles Group (Boardman, *AGG*, pp. 110–111, nos. 333–337), which is composed of a series of scaraboids depicting satyrs and youths who are more advanced in pose and execution than the figures of Epimenes but share many of the stylizations of musculature. The Getty scaraboid, however, is more advanced than the Anakles Group and even further removed from the Archaic. The relief is very low and somewhat sketchy, with little attention given to the facial features, yet the modeling of the upper body is superb and free of the heavy linear stylization typical of Archaic works. The drapery is rendered as a heavy mass with few folds, rather than the conventional rows of parallel lines, in a notable, although not especially successful, attempt to achieve a more realistic representation. The Getty gem perhaps stands closest to the two finest works of another group of Late or post-Archaic gems, the Group of the Beazley Europa: a scaraboid in Oxford depicting Europa on the bull and another in London showing a satyr and maenad (Boardman, *AGG*, p. 108, nos. 305–306; the latter recognized as a post-Archaic work by Zazoff, *AG*, pp. 142–143 n. 81). They also are in low relief, have less of the

Archaic linear stylization, and are freer in pose.

The inscription *Charon* is probably the name of the owner rather than the artist. The letter forms recall those of Epimenes and Anakles, and the substitution of *omicron* for *omega* is consistent with an Island origin (see Boardman, *AGG*, p. 93), although not distinctive enough for a certain attribution. The artist may be another in a long line of Cycladic gem engravers.

Except for one instance on a Late Classical scarab (Geneva; Vollenweider, *Deliciae Leonis*, pp. 21–22, no. 32), representations of a seated Zeus appear to be unattested on Greek gems. Similar pose and details, including the eagle-tipped scepter, are found on a red-figure amphora of circa 500 B.C. by the Nikoxenos Painter (J. D. Beazley, *Attic Red-figure Vase-painters*, 2nd ed. [Oxford, 1963], p. 220, no. 1; *Corpus Vasorum Antiquorum*, Germany 12, Munich 4, pl. 180.1) and on a coin of Aitna in Sicily of circa 475 B.C. (C. M. Kraay, *Archaic and Classical Greek Coins* [London, 1976], pp. 212–213, fig. 837), but the origin of the type is difficult to determine.

Bibliography: *The J. Paul Getty Museum: Handbook of the Collections* (Malibu, 1988), p. 61, B.

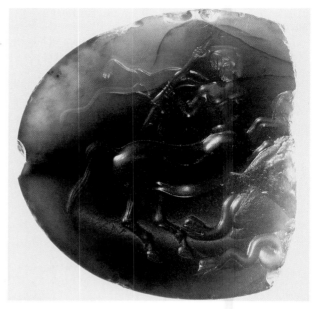

CLASSICAL AND HELLENISTIC GEMS: FIFTH–SECOND CENTURY B.C.

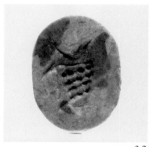 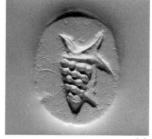

3:2 3:2

19 Mottled green and yellow jasper scaraboid

23.3 × 16.8 × 8.7 mm
Greek, late fifth–early fourth century B.C.
85.AN.370.7 (Color plate 2)

Description: Murex shell.

There are a few chips from the sides and back.

Discussion: The treatment of the murex shell is close to that on a Greek bronze ring in London, where the shell is combined with a human head (*BMC Rings*, no. 1256; Boardman, *GGFR*, fig. 258).

Provenance: From Athens.

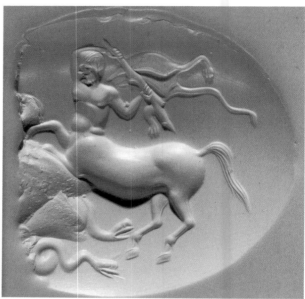

20 Brown chalcedony scaraboid, engraved on the convex side

41.8 × 37.9 × 12.7 mm (as preserved)
Greek, first quarter of the fourth century B.C.
85.AN.370.8 (Color plate 2)

Description: Centaur, wielding a branch, advancing left, fighting an uncertain adversary, of whom only a trace is visible along the break above the Centaur's raised foreleg. Two coiled snakes face right below the Centaur.

The Centaur has equine ears and is bearded and balding; he wears an animal skin around his neck.

Approximately one-quarter of the stone is broken away from the right side; traces of an iron pin remain in the drill hole.

Discussion: Centaurs are popular on Archaic and Classical gems (for other Classical examples, see *BMC Gems*, no. 557 = Boardman, *GGFR*, pl. 478, chalcedony scaraboid, a Centaur struck in the back; Boardman, *GGFR*, pl. 607, chalcedony, carved on the convex side, Centaur with branch; *New York*, no. 67, agate scarab, Sagittarius with stars), but the exact scene of this gem is unparalleled and uncertain. The Centaur is certainly defeating his foe, who collapses in the left corner of the gem, but who can it be? Centaurs fighting Herakles are often seen, but it is always Herakles who is the victor. Battles with Lapiths, who occasionally are defeated, are also popular, and the missing area could accommodate the Lapith Kaineus being pounded into the ground (cf. *LIMC*, vol. 5, pp. 884–885, nos. 1, 3, 7, s.v. Kaineus, where Kaineus is beaten by a single Centaur wielding a branch); however, this reconstruction leaves the presence of the snakes unexplained. It has been suggested that snakes accompany a Centaur on an Archaic scarab in Cambridge (Boardman, *AGG*, no. 327), but this identification is unlikely. However, a snake does coil below what appears to be a Centaur on a provincial (and also rather inexplicable) relief in Greek style from Pozo Moro in Spain (see M. Almagro Gorbea, "Pozo Moro," *Madrider Mitteilungen* 24 [1983], pp. 206–207, pl. 28a).

The two coiled snakes bring to mind the legs of a giant, and a collapsing giant would fit satisfactorily into the missing area of the stone (in the manner of the giants collapsing before the advancing quadriga of Zeus on a Late Hellenistic cameo signed by Athenion, now in Naples, Furtwängler, *Kleine Schriften*, pp. 207–208, 288–290; Furtwängler, *AG*, pl. 57.2). Although a battle between a Centaur and a giant would be extremely unusual and nearly unattested, a Roman glass paste intaglio does depict such a scene (*Munich*, pt. 3, no. 3069). Other unusual representations of Centaurs also exist on Roman gems, including fights with a griffin (*BMC Gems*, nos. 1823, 1824) and a lion (*BMC Gems*, no. 1825). They probably reflect Late Classical and Hellenistic motifs of fanciful scenes involving mythical creatures, such as the famous lost painting by the early fourth-century painter Zeuxis depicting a Centaur and his family (Lucian, *Zeuxis or Antiochos*, 3).

Despite its Iranian provenance, the gem is certainly not from a Graeco-Persian workshop but is rather a Greek work of the early fourth century. It is especially close in style to the lost gem depicting a seated youthful Eros and inscribed Phrygillos, perhaps the name of the engraver (Boardman, *GGFR*, p. 200, pl. 529; once Blacas collection). Details such as the shape of the head and the treatment of the facial features, hair, and hands are very similar on both gems. They could be by the same hand.

Provenance: From Iran.

21 Garnet (almandite) with flat face and convex back

16.2 × 12.9 × 4.4 mm
Ptolemaic, circa late second–first century B.C.
85.AN.444.22

Description: Head of Dionysos wearing ivy wreath to right.

There is a small chip from the edge.

Discussion: The distinctive style, shape, and material of the gem place it with an extensive series of intaglios which are most likely products of an official Ptolemaic workshop (see J. Spier, *JWalt* 47 [1989], pp. 21–38; and Vollenweider, in *Oxford Gems*, pp. 82–83, no. 290). Nearly all are engraved with a head of a ruler or deity. Most portraits in the group depict a late Ptolemy, probably Ptolemy IX (who ruled twice, 116–107 and again 88–80 B.C.). The other heads of deities include Aphrodite, Isis, Isis and Sarapis, Tyche, Demeter, Apollo, Artemis, Athena, and the Dioskouroi, all of whom had special ties to Ptolemaic royal cult.

Only one other garnet in this series bears the head of Dionysos, but the god's presence is to be expected in view of his popularity in royal Ptolemaic imagery. Both Ptolemy IV (222/221–205/204 B.C.) and Ptolemy XII (80–51 B.C.) took the epithet *Neos Dionysos*, and Ptolemaic coins and bronze rings sometimes depict a bust of Dionysos. An earlier Ptolemaic garnet of exceptional quality set in a gold ring, now in Baltimore, also shows a bust of Dionysos, and Vollenweider has suggested that it may have been intended to represent Ptolemy IV (M.-L. Vollenweider, *Museum Helveticum* 15 [1958], p. 30, no. 4).

Provenance: From Iran.

Bibliography: J. Spier, *JWalt* 47 (1989), p. 29, no. 48, fig. 31.

GLASS SCARABOIDS

A large number of glass scaraboids with cast intaglio devices of the later fifth and fourth centuries survives (for a full discussion and list of examples, see Boardman, *GGFR*, pp. 210–211, 415–416; Boardman, *Intaglios and Rings*, nos. 52–53, the first a rare blue glass scarab). There is a variety of types, which on the whole correspond to contemporary gem engraving, and duplicates are often found. The scaraboids are usually clear or very pale green in color and appear to be imitating rock crystal. Most of the examples with provenance are from Greece, while a few are from the Middle East, Egypt, and South Russia; Western finds are rare. The Getty examples add a number from Asia Minor.

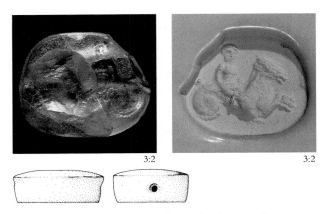

3:2 3:2

22 Pale yellow, nearly colorless, glass scaraboid

24.3 × 19.9 × 9.1 mm
Greek, early fourth century B.C.
84.AN.1.18
Description: Bearded man riding a hippocamp right. There are some chips from the sides.
Discussion: A nearly identical example is in Leningrad (Boardman, *GGFR*, p. 416, no. 437, pl. 652). See also catalogue number 23, below.
Provenance: From Asia Minor.

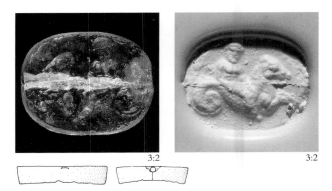

3:2 3:2

23 Pale yellow glass scaraboid

24.0 × 19.3 × 5.2 mm
Greek, early fourth century B.C.
83.AN.437.10
Description: A near duplicate of catalogue number 22, above.
Broken in half lengthwise.
Provenance: From Asia Minor.

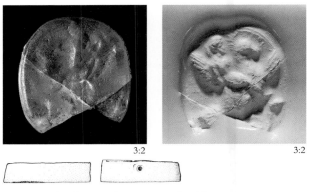

3:2 3:2

24 Colorless glass scaraboid

21.5 × 21.2 × 5.9 mm
Greek, early fourth century B.C.
85.AN.370.11
Description: Youth riding a cock(?), a coiled snake below.
The scaraboid was broken in two places and repaired, but a part, including the bottom of the device, is missing.
Discussion: It is unclear what type of bird is intended, but it appears to have a comb and would thus be a cock. The motif is rare but occurs, for example, on a red-figure plate signed by Epiktetos (J. D. Beazley, *Attic Red-figure Vasepainters*, 2nd ed. [Oxford, 1963], pp. 77, 92, now in New York). For a duplicate glass scaraboid, see Sternberg, Zurich, auction 11, 1981, lot 1087.

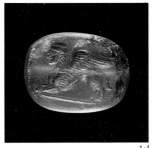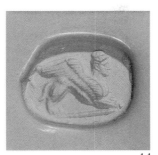

1:1 1:1

25 Pale green glass scaraboid

29.7 × 23.2 × 11.9 mm
Greek, early fourth century B.C.
84.AN.1.17

Description: Sphinx, wearing polos, standing right on groundline.

Discussion: The type was previously unattested on glass scaraboids, but the style is very close to an example in Oxford (Boardman, *GGFR*, pl. 654 = *Oxford Gems*, no. 125), which depicts a hippocamp with similar straight wings, and another in Copenhagen, which shows a griffin (*Thorvaldsen*, no. 8 = Boardman, *GGFR*, p. 416, no. 447). A seated sphinx on a glass scaraboid in Copenhagen (*Thorvaldsen*, no. 7; Boardman, *GGFR*, p. 415, no. 390) has curved wings but is otherwise also close in style.

Provenance: From Asia Minor.

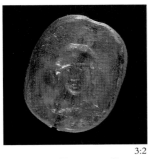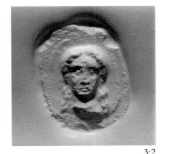

3:2 3:2

26 Colorless glass scaraboid

22.2 × 17.9 × 5.2 mm
Greek, early fourth century B.C.
85.AN.370.9

Description: Facing female head with long hair falling in tresses at her shoulders; she wears a necklace.

Discussion: Examples of facing women's heads in similar but not identical style are seen on several other glass scaraboids (Boardman, *GGFR*, p. 416, nos. 429–431; and Boardman, *Intaglios and Rings*, no. 52 = Getty Museum 81.AN.76.52, a blue glass scarab). The motif becomes

especially popular during the fourth century on engraved rings (see Boardman, *GGFR*, pls. 678, 729, 752, 773, 784, and cat. no. 61, below).

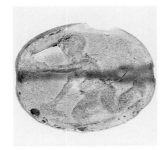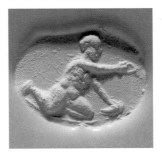

27 Colorless glass scaraboid

19.4 × 15.6 × 4.1 mm
Greek, early fourth century B.C.
85.AN.370.10

Description: Baby sitting right on a groundline; he holds a bird in his left hand and a wreath(?) in his outstretched right hand.

Discussion: A baby Eros on a carnelian gem is in an identical pose and holds the same objects (once Heyl collection, Darmstadt, Furtwängler, *AG*, pl. 61.29; Boardman, *GGFR*, p. 413, no. 286), and other baby erotes on gems also sit in the same manner (see the Phrygillos gem, Boardman, *GGFR*, pl. 529, and another, pl. 604). A baby in the same pose holds a bird in his outstretched hand on a contemporary gem in London (Boardman, *GGFR*, pl. 615; *BMC Gems*, no. 564).
A Graeco-Persian example depicting a baby is also known (Boardman, *GGFR*, pl. 848; *BMC Gems*, no. 609), and the type is seen on coins of Kyzikos (Babelon, *Traité*, vol. 2, pl. 174.29) and Ophrynion in the Troad (ibid., pl. 167.13–15).

Provenance: From Athens.

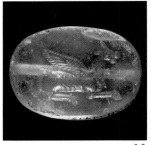 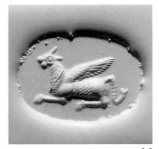

3:2 3:2

28 Colorless glass scaraboid

23.6 × 17.3 × 7.7 mm
Greek, early fourth century B.C.
85.AN.444.15
Description: Winged bull left.
There is a slight chip from the face.
Discussion: The stylization is odd and appears Eastern
rather than Greek, but the shape and technique place
it with the Greek scaraboids. Winged bulls are more
typical of East Greek art and do appear frequently on
Graeco-Persian gems (Boardman, *GGFR*, pls. 918–922),
although this style is not matched on any published
example.
Provenance: From Asia Minor.

GREEK RINGS

Thirteen silver rings, catalogue numbers 31–43,
were purchased together, and are all said to come
from Gela in Sicily along with a silver bracelet and
spiral hair ornament. They were first published
by E. T. Buckley (*GettyMusJ* 1 [1974], pp. 27–32)
and later reviewed by B. Strelka, who added further
information on metal analysis, identification of
two distinct hands, and two further silver rings
allegedly from the same find that did not come to
Malibu (*GettyMusJ* 8 [1980], pp. 167–170). All the
rings are closely related in style and all date from the
second half of the sixth century B.C. They are Type
F rings, which are made from a silver bar, circular in
section, with the center drawn out and flattened to
produce the bezel, and the ends joined to complete
the hoop opposite the bezel (see Boardman, *AK*, pp.
18–19). These rings from Gela join another group
of very similar rings in the Getty Museum that are
said to come from Selinous in Sicily (Boardman,
Intaglios and Rings, pp. 20–21, 93–94, nos. 60–69,
now Getty Museum 81.AN.76.60–69). The Selinous
group includes silver rings of different shapes, but
four of the rings (nos. 64–67) are Type F and are
especially close in style to the Gela rings; some share
the same devices.

ARCHAIC RINGS

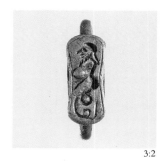 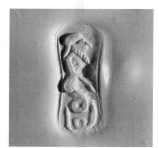

3:2

29 Silver ring, Type C, with gold stud in the bezel

Bezel, 16.9 × 6.9 mm; greatest diameter of hoop, 24.4 mm
Greek, circa 550 B.C.
81.AM.24

Description: Bearded male with serpent's lower body standing to right; linear border.

Discussion: The figure is probably intended as a Triton, although the tail is more like that of a snake than a fish. He seems not to be a giant, who usually has two snake legs, even at this early date.

Type C rings are relatively early, already attested in the first half of the sixth century, and have a wide distribution, including mainland Greece, East Greece, and Italy (see Boardman, *AK*, p. 16).

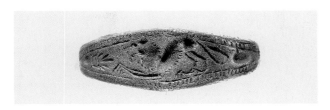

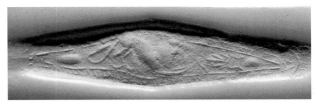

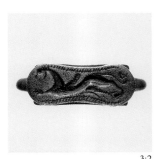 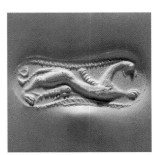

3:2

30 Silver ring, Type C

Bezel, 19.6 × 7.9 mm; greatest diameter of hoop, 25.2 mm
Greek, circa 550 B.C.
81.AM.25

Description: Griffin to right with small dolphin below; hatched border.

Discussion: Probably from the same workshop as catalogue number 29, above.

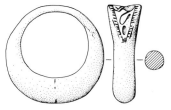

31 Silver ring, Type F

Greatest diameter of hoop, 26.7 mm; weight, 16 g
Greek (Sicily), second half of the sixth century B.C.
72.AM.36.1

Description: Lion crouching right; a palmette is in the field to right and an oval pellet to left; hatched border.

The alloy is 84% silver and 15% tin.

Discussion: Lions are one of the most popular motifs on rings and gems (other Type F rings with lions include Boardman, *AK*, F 1–4; Boardman, *Intaglios and Rings*, no. 64, and cat. no. 34, below), and palmettes are often seen accompanying the device on Type F rings (see Boardman, *AK*, p. 19). Strelka has noted that this ring and the following can be assigned to the same hand, and both are unusually large and heavy.

Provenance: From Gela.

Bibliography: E. T. Buckley, *GettyMusJ* 1 (1974), pp. 27–28, no. 1, fig. 1 (there published as 72.AI.36.1); B. Strelka, *GettyMusJ* 8 (1980), pp. 167–170.

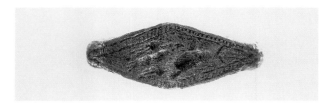

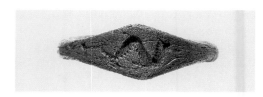

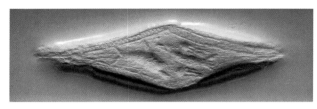

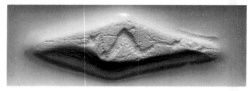

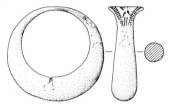

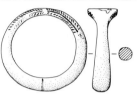

32 Silver ring, Type F

Greatest diameter of hoop, 26.1 mm; weight, 12.3 g
Greek (Sicily), second half of the sixth century B.C.
72.AM.36.2

Description: Eagle flying left, facing a dolphin right;
hatched border.

The alloy is 83% silver and 16% tin.

Discussion: Another flying eagle is seen on one of the
silver rings from Selinous (Boardman, *Intaglios and Rings*,
no. 61 = Getty Museum 81.AN.76.61), and dolphins are
seen on two Type F rings (Boardman, *AK*, F 10–11,
probably both Western Greek) and once facing a ram
(ibid., F 27).

Provenance: From Gela.

Bibliography: E. T. Buckley, *GettyMusJ* 1 (1974), p. 28,
no. 2, fig. 2 (there published as 72.AI.36.5); B. Strelka,
GettyMusJ 8 (1980), pp. 167–170.

33 Silver ring, Type F

Greatest diameter of hoop, 23.1 mm; weight, 6.1 g
Greek (Sicily), second half of the sixth century B.C.
72.AM.36.3

Description: Hippocamp(?) with horse's head and forelegs
and fish tail (no wings) to right. The upper edge of the
bezel is engraved with a herringbone pattern.

Discussion: Buckley identified the device as a *ketos*, but the
head appears distinctly equine (see Boardman, *AK*, F 9).
The engraved upper edge of the bezel is found on two
other rings in this group (cat. nos. 34 and 39, below) and
on one ring in the Selinous group (Boardman, *Intaglios and
Rings*, no. 65 = Getty Museum 81.AN.76.65).

Provenance: From Gela.

Bibliography: E. T. Buckley, *GettyMusJ* 1 (1974), p. 28,
no. 3, figs. 3a–b (there published as 72.AI.36.7); B.
Strelka, *GettyMusJ* 8 (1980), pp. 167–170.

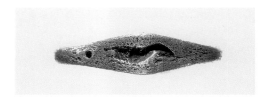
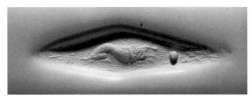
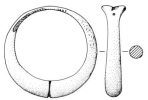

34 *Silver ring, Type F*

Greatest diameter of hoop, 24.4 mm; weight, 6.2 g
Greek (Sicily), second half of the sixth century B.C.
72.AM.36.4

Description: Lion crouching right. The upper edge of the bezel is engraved with a herringbone pattern.

There is a hole for a gold stud, which is now missing. The alloy is 78% silver and 21% tin.

Provenance: From Gela.

Bibliography: E. T. Buckley, *GettyMusJ* 1 (1974), p. 28, no. 4, fig. 4 (there published as 72.AI.36.11); B. Strelka, *GettyMusJ* 8 (1980), pp. 167–170.

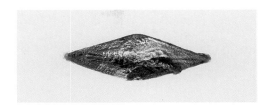
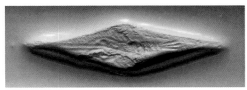

35 *Silver ring, Type F*

Greatest diameter of hoop, 22.2 mm; weight, 2.8 g
Greek (Sicily), second half of the sixth century B.C.
72.AM.36.5

Description: Lobster; hatched border.

Discussion: The motif is repeated on catalogue number 36 and appears on a silver ring from the Selinous group (Boardman, *Intaglios and Rings*, no. 65 = Getty Museum 81.AN.76.65) and on a bronze ring from Sidon (*BMC Rings*, no. 1230 = Boardman, *GGFR*, pp. 231, 425, no. 898, fig. 251).

Provenance: From Gela.

Bibliography: E. T. Buckley, *GettyMusJ* 1 (1974), p. 28, no. 5, fig. 5 (there published as 72.AI.36.3); B. Strelka, *GettyMusJ* 8 (1980), pp. 167–170.

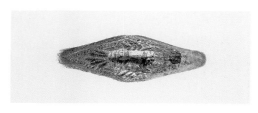

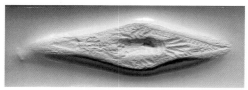

36 Silver ring, Type F

Greatest diameter of hoop, 21.8 mm; weight, 4.6 g
Greek (Sicily), second half of the sixth century B.C.
72.AM.36.6

Description: Same type as catalogue number 35, above; hatched border.

Provenance: From Gela.

Bibliography: E. T. Buckley, *GettyMusJ* 1 (1974), p. 28, no. 6, fig. 6 (there published as 72.AI.36.10); B. Strelka, *GettyMusJ* 8 (1980), pp. 167–170.

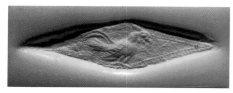

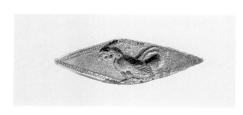

37 Silver ring, Type F

Greatest diameter of hoop, 22.5 mm; weight, 2.9 g
Greek (Sicily), second half of the sixth century B.C.
72.AM.36.7

Description: Cock standing right; hatched border.

Provenance: From Gela.

Bibliography: E. T. Buckley, *GettyMusJ* 1 (1974), p. 28, no. 7, fig. 7 (there published as 72.AI.36.4); B. Strelka, *GettyMusJ* 8 (1980), pp. 167–170.

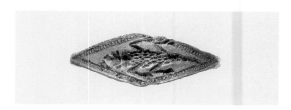

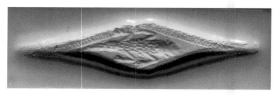

38 Silver ring, Type F

Greatest diameter of hoop, 21.2 mm; weight, 2.9 g
Greek (Sicily), second half of the sixth century B.C.
72.AM.36.8

Description: Lizard (or perhaps crocodile, as suggested by Buckley) viewed from above; hatched border.

Provenance: From Gela.

Bibliography: E. T. Buckley, *GettyMusJ* 1 (1974), pp. 28–29, no. 8, fig. 8 (there published as 72.AI.36.8); B. Strelka, *GettyMusJ* 8 (1980), pp. 167–170.

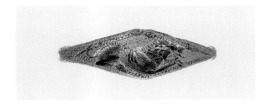

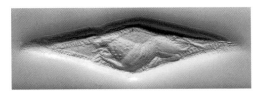

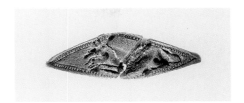

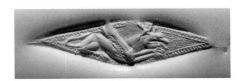

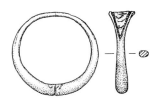

39 Silver ring, Type F

Greatest diameter of hoop, 22.8 mm; weight, 4.75 g
Greek (Sicily), second half of the sixth century B.C.
72.AM.36.9

Description: Recumbent lion facing left; hatched border.
The upper edge of the bezel is engraved with a herring-bone pattern.

 The alloy is 83% silver and 16% tin.

Provenance: From Gela.

Bibliography: E. T. Buckley, *GettyMusJ* 1 (1974), p. 29,
no. 9, fig. 9 (there published as 72.AI.36.2); B. Strelka,
GettyMusJ 8 (1980), pp. 167–170.

40 Silver ring, Type F

Greatest diameter of hoop, 22.2 mm; weight, 3.1 g
Greek (Sicily), second half of the sixth century B.C.
72.AM.36.10

Description: Recumbent griffin facing right; hatched
border.

The bezel is broken.

Provenance: From Gela.

Bibliography: E. T. Buckley, *GettyMusJ* 1 (1974), p. 29,
no. 10, fig. 10 (there published as 72.AI.36.12); B. Strelka,
GettyMusJ 8 (1980), pp. 167–170.

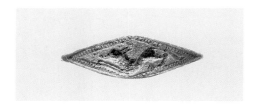

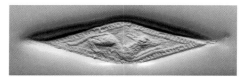

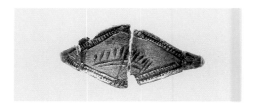

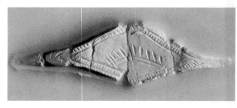

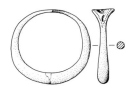

41 Silver ring, Type F

Greatest diameter of hoop, 20.5 mm; weight, 2.15 g
Greek (Sicily), second half of the sixth century B.C.
72.AM.36.11

Description: Dog (or perhaps griffin, as suggested by Buckley) facing right; hatched border.

The surface is very corroded.

Provenance: From Gela.

Bibliography: E. T. Buckley, *GettyMusJ* 1 (1974), p. 29, no. 11, fig. 11 (there published as 72.AI.36.9); B. Strelka, *GettyMusJ* 8 (1980), pp. 167–170.

42 Silver ring, Type F

Greatest diameter of hoop, 21.8 mm; weight, 2.7 g
Greek (Sicily), second half of the sixth century B.C.
72.AM.36.12

Description: Closed eye with long lashes; hatched border.

Provenance: From Gela.

Bibliography: E. T. Buckley, *GettyMusJ* 1 (1974), p. 29, no. 12, fig. 12 (there published as 72.AI.36.13); B. Strelka, *GettyMusJ* 8 (1980), pp. 167–170.

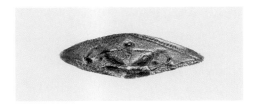
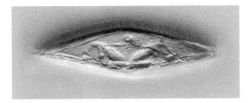

43 Silver ring, Type F

Greatest diameter of hoop, 21.1 mm; weight, 2.1 g
Greek (Sicily), second half of the sixth century B.C.
72.AM.36.13

Description: Frontal biga; the facing bust of the driver is shown between two horse's heads facing in opposite directions.

Discussion: The device is found on a gold ring from Cyprus, now in London (Boardman, *AK*, p. 24, M 3 = *BMC Rings*, no. 7). Buckley identifies this device as the biga of Helios rising from the horizon, a motif also found on Attic vases (see G. F. Pinney and B. S. Ridgway, *JHS* 101 [1981], pp. 141–144).

Provenance: From Gela.

Bibliography: E. T. Buckley, *GettyMusJ* 1 (1974), p. 29, no. 13, fig. 13 (there published as 72.AI.36.6); B. Strelka, *GettyMusJ* 8 (1980), pp. 167–170.

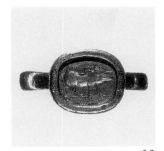
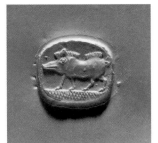

3:2

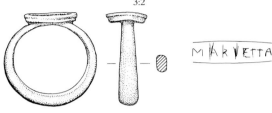

44 Heavy gold ring with engraved bezel

Bezel, 13.7 × 12.0 × 2.4 mm; greatest diameter of hoop, 25.1 mm
Greek or Graeco-Phoenician, late sixth–fifth century B.C.
85.AM.274

Description: Boar standing left on cross-hatched exergue.

The bezel has an added frame around the engraved device and is attached by a tang to a tapering hoop, which is rounded on the outside and flat on the inside. Graffito of uncertain but probably modern date on the inside of the hoop: MARIETTA.

Discussion: The shape and style of the ring are unusual. Boardman has noted similarities to Phoenician techniques, and western Phoenician gold rings from Tharros and Carthage are of identical shape, although they depict Phoenician motifs (Boardman, *AK*, p. 5 n. 7, pl. 1C; *Oxford Stamp Seals*, no. 580; G. Quattrocchi Pisano, *I gioielli fenici di Tharros nel Museo Nazionale di Cagliari* [Rome, 1974], no. 120; *Archeologie Vivante* 1, no. 2 [1968–1969], pp. 69, 74, XII). The shape of the ring and the style of the engraving suggest a probable western Phoenician rather than Greek origin.

Provenance: Ex-Moretti (Lugano), Wyndham Cook, and Robinson collections.

Bibliography: *Cook coll.*, p. 5, no. 2, pl. I; and the Cook sale catalogue, Christie, Manson & Woods, London, July 14, 1925, lot 14; Boardman, *AK*, p. 5 n. 8; Boardman, *GGFR*, p. 403.

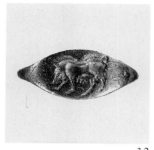
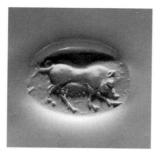

45 Gold ring, Type N

Bezel, circa 18.5 × 9.7 × 2 mm; greatest diameter of hoop, 24.5 mm
Greek, circa 500 B.C.
85.AM.272

Description: Sow with seven dugs walking right; hatched border.

The ring is very worn.

Discussion: For boars and sows on contemporary Late Archaic gems, a popular motif, see catalogue number 15, above.

Provenance: Ex-Moretti (Lugano) and J. Hirsch collections (Hess-Schab, Lucerne, December 7, 1957, lot 86).

Bibliography: Boardman, *AK*, p. 27, N 39.

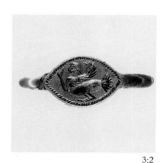
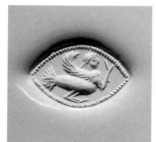

46 Hollow gold ring, Type M

Bezel, 14.2 × 10.0 mm; greatest diameter of hoop, 26.5 mm
Greek, circa 500 B.C. or slightly later
85.AM.269

Description: Siren standing right, arms raised; hatched border.

The engraved bezel is added above a hollow, boxlike compartment, which is part of the tapering hoop.

Provenance: Ex-Moretti collection (Lugano).

Bibliography: Boardman, *GGFR*, p. 404, Type M, 2 bis.

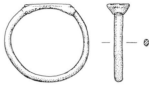

47 Bronze ring, Type D

Greatest diameter of hoop, 22.5 mm
Greek (South Italy or Sicily?), mid-sixth century B.C.
78.AC.392.2

Description: Man seated right, catching a fish with a rod(?).

Discussion: The identification of the motif is uncertain, and no other representations are known on Greek gems or rings of this date, although the scene is common on Roman gems.

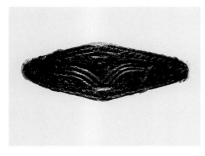

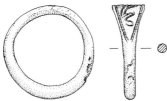

48 Bronze ring, Type F

Greatest diameter of hoop, 25.3 mm
Greek (South Italy or Sicily?), second half of the sixth
century B.C.
78.AC.392.I
Description: Uncertain (floral?) device; hatched border.

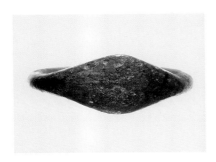

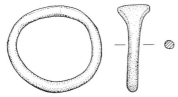

49 Bronze ring, Type F

Greatest diameter of hoop, 24.8 mm
Greek (South Italy or Sicily?), second half of the sixth
century B.C.
78.AC.392.3
Description: Plain.

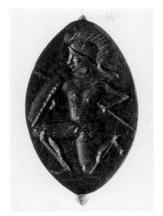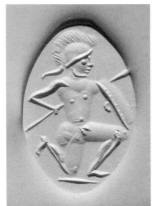

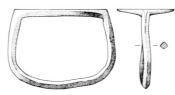

50 Bronze ring, Type I,
with faceted hoop

Bezel, 25.2 × 15.5 mm; greatest diameter of hoop, 28.5
mm
Greek, first half of the fifth century B.C.
84.AN.I.8
Description: Warrior, nude with plumed helmet and
carrying spear and shield, running right; short groundline.
Black patina, excellent condition.
Discussion: Type I rings are the continuation of the Late
Archaic Type N rings and are most common in the
first half of the fifth century (see Boardman, *GGFR*, p.
212). A near-duplicate of the Getty ring is in the Fitzwil-
liam Museum, Cambridge.
Provenance: From Asia Minor.

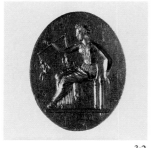
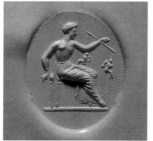

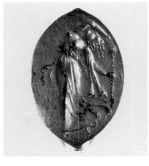
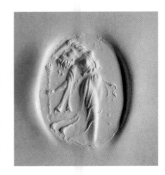

3:2 3:2

51 *Gold ring, Type VIII*

Bezel, 22.3 × 17.6 mm; greatest diameter of hoop, 20.7 mm
Greek, mid-fourth century B.C.
85.AM.277

Description: Woman (Aphrodite?) seated on stool right, holding a balance containing two small erotes. She wears a belted chiton with a himation draped over her legs; she has bracelets on both wrists; her hair is rolled; thick groundline.

Discussion: *Erotostasia* scenes occur on at least three other rings, including a second example in Malibu (Boardman, *Intaglios and Rings*, no. 79 = Getty Museum 81.AN.76.79), one in Boston (Beazley, *Lewes House*, no. 53 = Boardman, *GGFR*, pl. 666), and another in Reggio di Calabria (inv. no. 10605; A. de Franciscis, *Klearchos* 1 [1959], p. 77, figs. 1–2, from a fourth-century tomb at Grisolia). The meaning of the scene is unclear, but representations occur on fourth-century Attic and South Italian vases and other objects, including a silver plaque from Athens, as well as on rings, and may symbolize some aspect of love related to the Homeric weighing of souls, *psychostasia*. On the motif, see Beazley, *Lewes House*, p. 50; Boardman, *GGFR*, pp. 216, 296; de Franciscis (above), pp. 76–84; J. Frel, *Klearchos* 5 (1963), pp. 125–128; and *LIMC*, vol. 2, p. 120, nos. 1246–1249, s.v. Aphrodite.

Provenance: Ex-Moretti collection (Lugano).

52 *Gold ring, Type VII*

Bezel, 19.0 × 12.5 mm; greatest diameter of hoop, 22.0 mm
Greek, fourth century B.C.
85.AM.279

Description: Maenad, her head thrown back in ecstasy, dancing to right; her left arm is thrown back and her right holds a thyrsos; the drapery swirls around her.

Discussion: The motif becomes especially popular on rings during the fourth century (see Boardman, *GGFR*, pp. 216–217, pls. 673, 684–685, 708; p. 419, nos. 564–565 = *De Clercq coll.*, p. 2, nos. 2830–2831; and the silver example below, cat. no. 57).

Provenance: Ex-Moretti collection (Lugano).

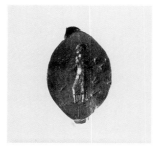
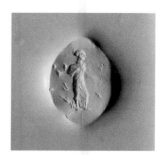

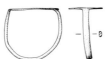

53 *Gold ring, Type IV*

Bezel, 12.3 × 8.9 × 0.7 mm; greatest diameter of hoop, 15.5 mm
Greek, fourth century B.C.
85.AN.370.12

Description: Woman standing right; she wears a long chiton beneath a himation, which is wrapped around her. Her hair is held in a top knot; thin groundline.

The hoop is flat on the sides and inside, rounded on the outside.

The hoop is slightly bent with some scratches.

Provenance: From Asia Minor.

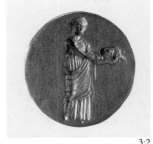

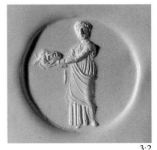

3:2

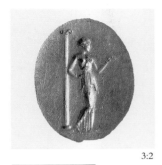

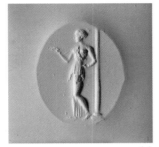

3:2 3:2

54 *Gold oval bezel*

22.5 × 17.4 × 1.2 mm
Greek, late fourth century B.C.
85.AN.370.13

Description: Woman standing left before a tall column with Ionic capital. Her left hand is on her hip and her right is held out in front of her; she wears bracelets and an anklet, and her hair is bound in a top knot. Groundline.

The back of the bezel has many short incisions and much corroded iron.

Discussion: The fine detail and elongated, "statuesque" figure place this example in Boardman's Salting Group of late fourth-century rings (see Boardman, *GGFR*, p. 224). Figures of Aphrodite in a similar pose before a column are seen on two examples (Boardman, *GGFR*, pls. 734, 736), and the treatment of drapery is especially close to another ring in this group depicting Kore (Boardman, *GGFR*, pl. 735).

The bezel was made separately and then set into a ring in the manner of Vienna 217, from Campania (Boardman, *GGFR*, pl. 734), and the Ptolemaic ring in Oxford, from Corfu, which has a gold bezel set into an iron ring (*Oxford Gems*, no. 282).

Provenance: From Asia Minor.

55 *Gold ring, Type IX*

Bezel, 22.3 × 20.5 mm; greatest diameter of hoop, 23.1 mm
Greek, late fourth century B.C.
85.AM.276

Description: Actor standing left, his head turned three-quarter facing, holding a mask. Behind him is a graffito read ΣΑΜΗ by Leo Mildenberg, see Hoffmann and Davidson, *Greek Gold*, p. 257.

Provenance: From Greece. Ex-Moretti collection (Lugano).

Bibliography: Hoffmann and Davidson, *Greek Gold*, p. 257, no. 116; Boardman, *GGFR*, pl. 745.

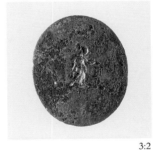

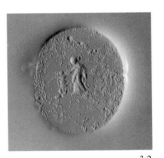

3:2 3:2

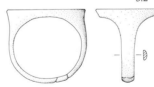

56 *Gilt bronze ring, Type XI*

Bezel, 20.9 × 17.1 mm; greatest diameter of hoop, 20.7 mm
Greek, late fourth–early third century B.C.
85.AN.444.26

Description: Woman standing left before a thymiaterion; thick groundline.

Considerable corrosion through the gilding.

Discussion: Round rings with small figures are typical of Early Hellenistic works (see Boardman, *GGFR*, pl. 791; *New York*, no. 90; E. M. De Juliis, ed., *Gli ori di Taranto in età ellenistica*, exh. cat., Milan, Brera Museum, December 1984–March 1985 [Milan, 1984], p. 289, no. 209, for a similar plated example).

Provenance: From Asia Minor.

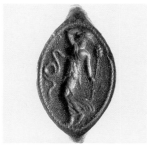
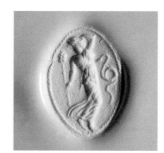
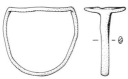

57 Silver ring, Type IV

Bezel and hoop, 15.3 × 10.9 mm; greatest diameter of ring, 20.0 mm
Greek, fourth century B.C.
81.AN.76.154

Description: Maenad, head thrown back, dancing right, holding thyrsos; coiled snake before her; tremolo border.

Discussion: For the type, see catalogue number 52, above.

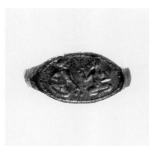
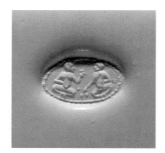
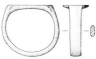

58 Silver ring, small and simple variety of Type V

Bezel, 11.6 × 7.2 mm; greatest diameter of hoop, 14.8 mm
Greek, fourth century B.C.
85.AN.370.14

Description: Two babies sitting facing front, playing astragaloi; combination linear and dotted border.

The hoop and the back of the bezel are faceted.

Discussion: The style is crude and not paralleled on known silver rings, most of which come from Western sites rather than Asia Minor. However, the shape of the ring speaks for a fourth-century date.

Two youths play knucklebones on a Classical gem in Berlin, from Asia Minor (Boardman, *GGFR*, pp. 201, 291, pl. 543), and a seated baby Eros plays on a fourth-century gem in Boston, also from Asia Minor (Boardman, *GGFR*, pl. 604 = Beazley, *Lewes House*, no. 56). Pairs of babies playing knucklebones, often before a cult statue, become a frequent type on bronze coins of cities in Asia Minor during the Roman period (for the motif, see F. Imhoof-Blumer, *Nomisma* 6 [1911], pp. 4–7, pl. 1.8–16).

Provenance: From Asia Minor.

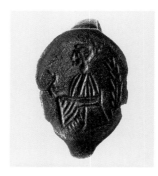
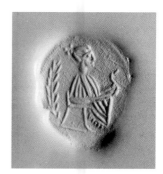

59 Silver ring, simple and flimsy variety of Type IV

Bezel, 16.1 × 12.6 mm; greatest diameter of hoop, 20.5 mm
Greek (Sicily), fourth century B.C.
84.AN.1.23

Description: Woman seated right, holding a bird, a branch behind; groundline; tremolo border.

The ring has a thin bezel and ribbon hoop.

Slightly bent with a chip from the edge.

Discussion: This ring and the next, which is probably by the same hand, belong to a group of fourth-century silver rings of inferior quality most frequently found at Western sites and probably made there. Boardman has named the class the Common Style (Boardman, *GGFR*, p. 228). Similar seated women are seen on other rings of the group (see Boardman, *GGFR*, pls. 778–779).

Provenance: From Sicily with catalogue number 60, below.

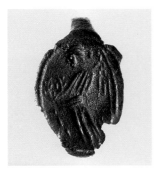
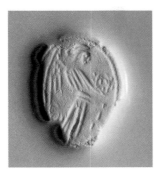

60 Silver ring, same shape as catalogue number 59

Bezel, 16.4 × 12.1 mm; greatest diameter of hoop, 20.4 mm
Greek (Sicily), fourth century B.C.
84.AN.1.24
Description: Nike standing right, holding wreath with fillets; tremolo border.
Slightly bent with a chip from the edge.
Discussion: For similar rings with Nike in the Common Style, see Boardman, *GGFR*, pls. 771, 775; and *BMC Rings*, no. 1072, from Naples.
Provenance: From Sicily with catalogue number 59, above.

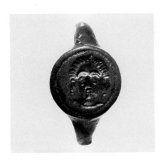
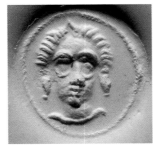

61 Silver ring, Type X

Bezel, 10.5 × 9.7 mm; greatest diameter of hoop, 18.3 mm
Greek (Sicily), fourth century B.C.
83.AN.437.13
Description: Facing bust of a woman with large pendant earrings; tremolo border.

Discussion: Also belonging to the Western Common Style; see the two similar examples in Oxford (Boardman, *GGFR*, pl. 784 = *Oxford Gems*, no. 150, from Vicarello) and Villa Giulia (Vollenweider, *Porträtgemmen*, pl. 27.12).
Provenance: From Sicily.

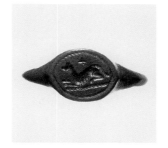
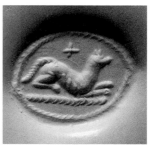

4:1

62 Silver ring, Type X

Bezel, 9.8 × 7.7 mm; greatest diameter of hoop, 18.8 mm
Greek (Sicily), fourth century B.C.
84.AN.1.25
Description: Dog lying right on tremolo groundline, star above; tremolo border.

Discussion: Common Style; see the related gold examples, one ex-Guilhou and Harari collections (*Harari coll.*, no. 14 = Boardman, *GGFR*, p. 418, no. 545 = *Guilhou coll.*, no. 162) and the other on the Basel market (Münzen und Medaillen, Basel, *Sonderliste* M, 1970, no. 105).
Provenance: From Sicily.

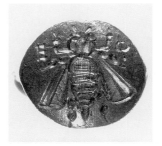
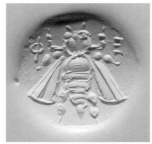
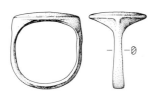

63 Gold ring, variety of Type IX with slightly convex bezel

Bezel, 18.1 × 15.6 mm; greatest diameter of hoop, 19.1 mm
Greek, third century B.C.(?)
85.AM.278

Description: Bee seen from above; inscribed ΕΦ on either side.

Discussion: The device, including the abbreviated ethnic, copies the famous coin type of Ephesos, which was used from the fifth century B.C. until the Late Hellenistic period. Such a device on a ring along with the ethnic of the city is curious, but at least two other very similar examples are known, including one found at Cologne (Henkel, *Römische Fingerringe*, no. 50, pl. 3, without the ethnic; the other ring, K. Schefold, *Meisterwerke griechischer Kunst* [Basel, 1960], p. 318, no. 608). The shapes of all three examples are similar and differ from the conventional fourth-century rings, as does the engraving style, suggesting a slightly later date. They may have been souvenirs from the Sanctuary of Artemis at Ephesos, whose cult enjoyed an especially widespread popularity. At least two contemporary gems with similar types are known, one a carnelian scaraboid engraved with a bee on one side and a stag on the other (*Munich*, pt. 1, no. 394), and the other an agate scaraboid with a bee in a wreath (*Munich*, pt. 1, no. 395).

Provenance: Ex-Moretti collection (Lugano).

WESTERN RINGS

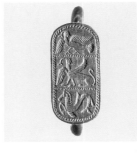
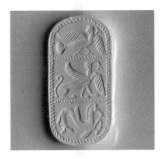

3:2

64 Gold ring with solid hoop, Type B I

Bezel, 19.0 × 9.1 mm; greatest diameter of hoop, 26.5 mm
Western Greek or Etruscan, second half of the sixth century B.C.
85.AM.268

Description: In three registers, a siren with head turned back, a sphinx with head turned back, and a hippocamp; registers divided by hatched lines and a hatched border around the entire composition.

The rim of the bezel is hatched.

Excellent condition.

Discussion: Boardman has discussed and compiled a list of the extensive series of Etruscan rings to which this and the next two rings belong (*AK*, pp. 7–16; Boardman, *GGFR*, pp. 155, 403). He suggests that the shape of the rings and the arrangement of decoration were originally Phoenician but were probably transmitted to Etruria by immigrant East Greeks. Similarities in style to Pontic vases are apparent.

The exact arrangement of these devices is not duplicated on another ring, but most rings of this shape (B I) are close in style and have similar animal types.

Provenance: Ex-Moretti collection (Lugano).

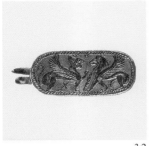
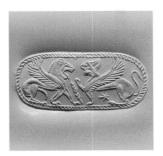

3:2

65 *Gold-plated silver hoop with added gold bezel, Type B II*

Bezel, 18.9 × 8.8 mm; greatest diameter of hoop, 23.4 mm
Western Greek or Etruscan, second half of the sixth century B.C.
82.AN.122

Description: Winged lion facing a sphinx with foreleg raised; a branch between them and a star below the sphinx; hatched border.

The gold plating of the hoop is damaged in part and encrusted with a thick silver chloride crust; the bezel is slightly bent.

Discussion: The device is close to Boardman, B II.29 = *BMC Rings*, no. 25.

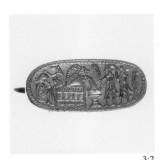
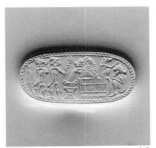

3:2 **3:2**

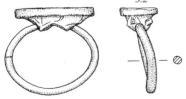

66 *Hollow, gold-plated silver hoop with gold bezel, Type B II*

Bezel, 21.3 × 10.1 mm; greatest diameter of hoop, 24.5 mm
Western Greek or Etruscan, second half of the sixth century B.C.
85.AM.271

Description: Two figures approaching a fountain; one holds a branch, and the other raises an arm; a tree is behind them. A lion's head spout on the fountain spills water into a two-handled vase resting on a stand; on the other end of the fountain, a dog-headed creature squats with outstretched arm. Below him, behind the fountain, squats a bearded figure holding a sword; hatched border.

The hoop is broken at one point.

Discussion: The scene nearly duplicates that on a ring in Paris (Boardman, *AK*, B II.2). The presence of the sword held by the squatting man on the Getty ring suggests that he is Achilles waiting in ambush for Troilos.

Provenance: Ex-Moretti collection (Lugano).

Bibliography: Boardman, *GGFR*, p. 403.

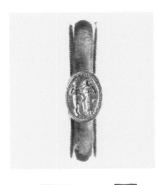
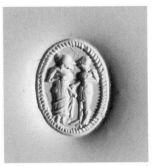

4:1

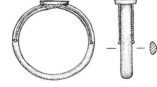

67 *Gold-plated silver ring with engraved oval bezel*

Bezel, 7.4 × 5.3 mm; greatest diameter of hoop, 21.7 mm
Greek (Western), first half of the fifth century B.C.
85.AM.270

Description: Nude male standing left facing a draped woman standing right; hatched border.

The bezel is attached over a projection on the hoop marked by engraved striations. The hoop does not taper; beaded wire terminating in larger beads is added along the inner circumference of the hoop on either side of the bezel.

Discussion: Boardman has placed this ring with his Group M Archaic rings, but perhaps it has more in common with his Group H rings, several of which have similar bezels and added beaded wire (see Boardman, *AK*, p. 21, H 1, H 3, and H 4). A Western Greek rather than Etruscan origin has been suggested.

Provenance: Ex-Moretti collection (Lugano).

Bibliography: Boardman, *GGFR*, p. 404, M 19.

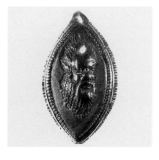
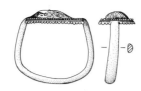

68 Gold ring with relief bezel

Bezel, 18.4 × 10.4 × 2.7 mm; greatest diameter of hoop, 21.4 mm
Etruscan, second half of the fifth century B.C.
85.AM.275

Description: Head of a satyr facing three-quarter right; he is balding with a long and curly beard.

The hoop is a band, flat on the inside and convex on the outside; it is joined to the oval, pointed bezel, which is decorated with a raised linear border between an inner beaded border and an outer border of tongues.

The bezel is worn.

Discussion: This example belongs to a large group of gold relief rings with many different devices discussed in detail by Boardman and named the Fortnum Group (*Papers of the British School of Archaeology at Rome* 34 [1966], pp. 10–17). Their Etruscan origin and later fifth-century date have been convincingly demonstrated.

Provenance: Said to be from Sicily. Ex-Moretti collection (Lugano).

Bibliography: Hoffmann and Davidson, *Greek Gold*, p. 246, no. 104; Boardman (above), pp. 12, xvi.

3:2

69 Hollow gold scarab in silver swivel ring

Scarab, 13.7 × 10.6 × 7.8 mm; diameter of hoop, 20.5 mm
Greek (South Italian), mid-fourth century B.C.
85.AM.273

Description: The device is in relief and depicts a three-quarter facing head of Hera wearing a stephane ornamented with three palmettes and a necklace with a row of pendants.

The scarab is hollow and does not have a silver core as stated by Hoffmann and Davidson. The hoop is a band, flat inside and convex with central ridge outside. The terminals are cups with wire, passed through the scarab, wound around.

The scarab is simple, with legs faintly indicated in relief; the elytra are separated from each other by three lines and from the thorax by two lines; the plinth is carelessly cross-hatched.

The hoop is covered with a silver chloride deposit; there is one repair, but nothing is missing. The scarab is somewhat worn.

Discussion: A number of gold scarabs with relief devices are known, most from the vicinity of Taranto (see the list, Boardman, *GGFR*, p. 428; to which add: G. Becatti, *Oreficerie antiche* [Rome, 1955], pl. 81.322 = G. M. A. Richter, *Engraved Gems of the Greeks and Etruscans* [London, 1968], no. 283 = E. M. De Juliis, *Gli ori di Taranto in età ellenistica*, exh. cat., Milan, Brera Museum, December 1984–March 1985 [Milan, 1984], no. 188; *Guilhou coll.*, no. 53 = *Harari coll.*, no. 20; and two further examples, Taranto, inv. 40.142, a seated woman, De Juliis [above], no. 181; and a gold scarab on a silver ring, seated woman, Münzen und Medaillen, Basel, *Sonderliste* M, 1970, no. 92). The two examples from Taranto are from tombs of the third quarter of the fourth century B.C. The Getty ring is closest in details of manufacture and style to the ring once on the Basel market.

The device represents Hera Lakinia, whose sanctuary was located near Kroton. She is pictured on a number of coins of Kroton and several other South Italian mints in the fourth century B.C. (see C. M. Kraay, *Archaic and Classical Greek Coins* [London, 1976], p. 200).

Provenance: From Taranto. Ex-Moretti (Lugano) and J. Hirsch collections (Hess-Schab, Lucerne, December 7, 1957, lot 87).

Bibliography: Hoffmann and Davidson, *Greek Gold*, p. 245, no. 103; Boardman, *GGFR*, p. 428.

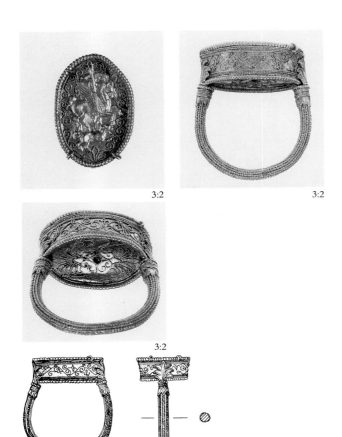

3:2

3:2

3:2

70 Gold ring with box bezel by the Santa Eufemia Master

Bezel, 20.4 × 14.2 × 7.7 mm; greatest diameter of hoop, 23.1 mm
Greek (South Italian), late fourth–early third century B.C.
88.AM.104 (Color plate 1)

Description: Upper device: Bellerophon on Pegasos to right slaying the Chimaira; the figures are of embossed, thin gold plaque, cut out to the shape of the device and added to the bezel; the border is filigree spirals and floral device below. Lower device: filigree back-to-back palmettes with tendril-spiral to left and bell-flower to right.

The hoop is made from eight short strands of loop-in-loop chain. The terminals are composed of eight teardrop-shaped filigree elements; a loop-in-loop band between a simple wire and a twisted wire; a single beaded wire; and a filigree acanthus leaf that joins the bezel. The bezel is in the form of an oval box with straight sides; the upper and lower rims are of beaded wire. Four loops, one of which is broken and another missing, were added to the upper rim of beaded wire for an uncertain purpose. The sides of the bezel are decorated with filigree florals bordered by loop-in-loop bands between simple wires.

Discussion: A number of rings of nearly identical shape

and style is known, most of which have been found in South Italy (see Boardman, *GGFR*, pp. 233, 428; Greifen-hagen, *Schmuckarbeiten*, pp. 74–75, pl. 56.11–12). Recently they have been discussed by Dyfri Williams (*Römische Mitteilungen* 95 [1988], pp. 75–95), who assigns most of them to a single South Italian goldsmith dubbed the Santa Eufemia Master, whose name derives from a hoard of jewelry found at Santa Eufemia de Golfo, near Monteleone in Calabria, in 1865 and now in the British Museum (F. H. Marshall, *Catalogue of the Jewellery in the British Museum* [London, 1911], nos. 2113–2129; and the gold relief scarab, *Harari coll.*, no. 20, now British Museum GR 1985.2–15.1). The hoard also contained bronze coins of Hiketas of Syracuse, providing a burial date early in the third century B.C., but Williams suggests an earlier date of manufacture, sometime in the second half of the fourth century. Similar rings appear to have been manufactured elsewhere; a very similar gold box bezel ring showing a kneeling Eros playing with an *iunx* wheel was found at Lindos (*The Hague*, no. 21), and Boardman notes a silver ring with gold relief device from Nisyros. Williams has attributed the Getty ring to the Santa Eufemia Master.

Provenance: Said to be from South Italy.

Bibliography: *GettyMusJ* 17 (1989), pp. 114–115, no. 23; H. Hoffmann, "Bellerophon and the Chimaira in Malibu," *Occasional Papers on Antiquities* (Getty Museum), vol. 8 (forthcoming).

3:2

3:2

71 Oval terracotta plaque, on each side of which is laid a gold foil device covered by a piece of convex glass; the terracotta plaque is pierced through for mounting, probably on a ring

24.3 × 18.7 × 8.4 mm
Greek (South Italian?), fourth century B.C.
88.AN.106

Description: Side A: Figure driving a quadriga right; the head of the horse farthest to the proper right is turned back; groundline. Side B: Hippocamp right.

Discussion: Several rings employing similar technique and devices are known, including two fine examples where

the gold device is placed on a blue glass background and covered with rock crystal, which are from datable contexts. One, depicting dancers and a *ketos* surrounded by fish, is from South Russia and dates from the first half of the fourth century B.C. (in Leningrad; Boardman, *GGFR*, p. 233, pl. 822; S. G. Miller, *Two Groups of Thessalian Gold* [Berkeley, 1979], p. 20, pl. 11e–f); a second is from a tomb of the later fourth century at Homolion in Thessaly and depicts Thetis with the arms of Achilles on a hippocamp and Eros on a dolphin (Miller [above], pp. 18–21, pl. 11c; Boardman, *GGFR*, pp. 233–234, 428); a third example, with glass covers, was on the New York market. Other rings, some of which are Hellenistic, have a fixed bezel with single gold device covered by glass (see Miller [above], p. 20 nn. 121, 127; Boardman, *GGFR*, p. 428). Especially close in technique to the Getty bezel is an example in Berlin said to be from Taranto. It has a bone or ivory oval plaque with gold figures of Thetis with the arms of Achilles on a hippocamp and a winged hippocamp on the other side, mounted in a gold frame but missing the crystal or glass covers (Greifenhagen, *Schmuckarbeiten*, p. 75, pl. 56.13–15; Hoffmann and Davidson, *Greek Gold,* pp. 240–241, no. 99; Miller [above], pp. 19–20, pl. 11a–b).

Miller has noted the close stylistic similarity between the Berlin and Homolion examples, while Boardman has seen the Homolion and Leningrad examples as coming from the same workshop. Greifenhagen has also noted the similarity of the frame of the Berlin example to that of the Santa Eufemia pendant in London (F. H. Marshall, *Catalogue of the Jewellery in the British Museum* [London, 1911], no. 2119; see cat. no. 70, above) and has suggested a Tarentine origin. The ring type was probably made both in Greece and Italy, and the Getty example is likely a South Italian work.

Provenance: Said to be from South Italy.

Bibliography: *GettyMusJ* 17 (1989), p. 115, no. 24.

BRONZE AND IRON RINGS

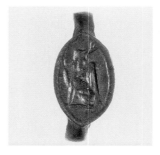
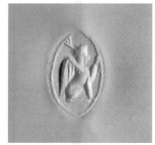

72 Bronze ring, Type VII

Bezel, 13.3 × 8.3 mm; greatest diameter of hoop, 19.2 mm
Greek, mid-fifth century B.C.
85.AN.444.28

Description: Sphinx seated right, foreleg raised; linear border.

The bezel is oval and pointed.

Discussion: A similar sphinx is found on a bronze ring in Berlin, Greifenhagen, *Schmuckarbeiten*, pl. 64.3–4 (the Hellenistic date is too late).

Provenance: From Asia Minor.

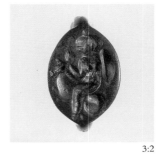
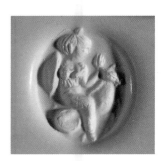

3:2

73 Bronze ring, Type II

Bezel, 18.2 × 12.7 mm; greatest diameter of hoop, 22.4 mm
Greek, late fifth century B.C.
83.AN.437.12

Description: Thetis, carrying a shield, riding a hippocamp right.

Thin brown patina; hoop broken at one point.

Discussion: The motif of Thetis carrying the arms of Achilles is popular on rings and is seen on fine examples in gold and silver (see Boardman, *GGFR*, pls. 675, 686). The Getty example is especially close in style and shape to a bronze ring in London (*BMC Rings*, no. 1261 = Boardman, *GGFR*, p. 425, no. 902).

Provenance: From Asia Minor.

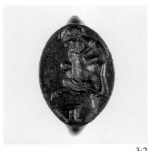

3:2

74 *Bronze ring, Type VI*

Bezel, 18.7 × 13.3 mm; greatest diameter of hoop, 23.6 mm

Greek, late fifth century B.C.

84.AN.1.20

Description: Fat, bearded Pan dancing to right; he has goat's legs, ears, and horns; he wears a cloak, but his erect phallus is visible; he holds a vine in his right hand; a stool with curved legs is before him. An incised inscription is to the right, reading downward: ΠΑΥ

Discussion: This example belongs to a group of bronze rings, noted by Boardman, that depict fat hunters, satyrs, and Pans (see Boardman, *GGFR*, p. 232, and especially the bronze ring in New York, *New York*, no. 44 = Boardman, *GGFR*, p. 426, no. 970, fig. 253).

Provenance: From Asia Minor.

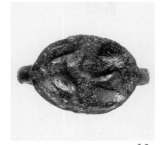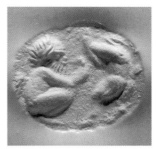

3:2

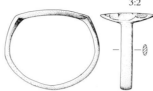

75 *Bronze ring, Type II*

Bezel, 19.1 × 14.5 mm; greatest diameter of hoop, 25.0 mm

Greek, late fifth century B.C.

85.AN.444.29

Description: Satyr squatting right playing pipes, while a goat dances before him.

Slightly corroded.

Provenance: From Asia Minor.

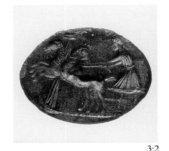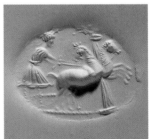

3:2 3:2

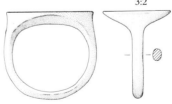

76 *Bronze ring, Type VI*

Bezel, 23.3 × 17.8 mm; greatest diameter of hoop, 24.5 mm

Greek, late fifth century B.C.

85.AN.370.15

Description: Charioteer in biga to right reaching the turning column in a race; dotted exergual line.

Dark green patina, excellent condition.

Discussion: A nearly identical bronze ring is in London (*BMC Rings*, no. 1257 = H. B. Walters, *Catalogue of the*

Bronzes, Greek, Roman, and Etruscan, in the British Museum [London, 1899], no. 2254, fig. 51). The motif of a racing quadriga is popular on late fifth-century Sicilian coins, most notably on a tetradrachm of Katane signed by the artist Euainetos (C. Kraay and M. Hirmer, *Greek Coins* [London, 1966], no. 42).

Provenance: From Asia Minor.

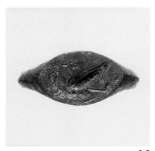 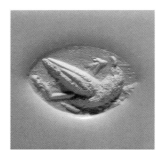

3:2

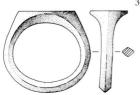

77 Bronze ring, Type VII

Bezel, 15.5 × 10.0 mm; greatest diameter of hoop, 23.0 mm
Greek, fourth century B.C.
82.AC.22.148

Description: Bird standing right, head turned left, with branch in its beak.

Green patina.

Discussion: For similar types, see M. Comstock and C. C. Vermeule, *Greek, Etruscan and Roman Bronzes in the Museum of Fine Arts, Boston* (Boston, 1971), no. 292; and fourth-century Athenian terracotta tokens impressed by rings, M. Lang and M. Crosby, *The Athenian Agora*, vol. 10, *Weights, Measures, and Tokens* (Princeton, 1964), p. 129, C 19–20, pl. 32.

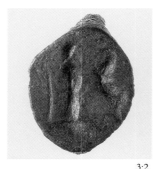 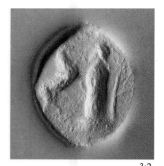

3:2 3:2

78 Fragmentary bronze ring, Type VII

Bezel, 22.2 × 18.0 mm
Greek, fourth century B.C.
85.AN.370.21

Description: Goat rearing to right before a herm, tree behind; groundline.

Most of the hoop is missing. Green patina, uncleaned.

Discussion: The same device is found on a ring from Athens in Munich (Boardman, *GGFR*, p. 426, no. 984, pl. 811) and on another found at Olynthos (D. M. Robinson, *Excavations at Olynthus*, vol. 10 [Baltimore, 1941], p. 138, no. 452, pl. 26 = Boardman, *GGFR*, p. 426, no. 985).

Provenance: From Asia Minor ("Troad").

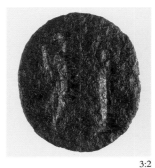 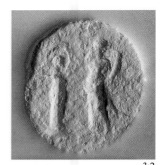

3:2 3:2

79 Iron ring, close to Type XI

Bezel, 25.9 × 21.5 mm; greatest diameter of hoop, 24.2 mm
Greek, fourth century B.C.
85.AN.370.20

Description: Tyche, holding a cornucopia, standing left before herm.

Corroded.

Discussion: Herms are popular on rings, but representations of Tyche are rare before the Hellenistic period.

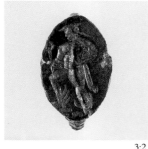
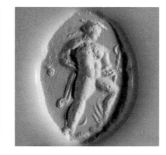

3:2

80 Fragmentary bronze ring of uncertain shape

Bezel, 19.3 × 12.6 mm
Greek, fourth century B.C.
85.AN.444.32

Description: Hermes advancing right; his feet are winged; he wears petasos and chlamys and holds a kerykeion.

The hoop is missing. Corroded.

Provenance: From Tunisia.

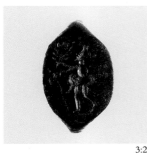
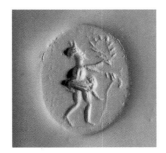

3:2

81 Bronze ring, Type VII

Bezel, 16.1 × 12.5 mm; greatest diameter of hoop, 21.5 mm
Greek, fourth century B.C.
85.AN.444.27

Description: Comic actor with padded belly and phallus walking right; he holds a wreath and a walking stick; groundline.

Black patina, good condition.

Discussion: The motif is rare on rings, but two unpublished examples are very similar (both in private collections; casts in Oxford). Representations of such actors in South Italian phlyax plays are the best known, but the ring need not be Western (for various types of actors, including *deikolistai* and *phlyakes*, see Athenaeus 14.621–622). Similar actors are represented on Attic terracottas of the second quarter of the fourth century (see A. D. Trendall and T. B. L. Webster, *Illustrations of Greek Drama* [London, 1971], p. 127, IV, 9).

Provenance: From Beirut.

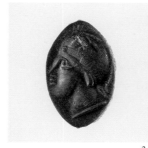
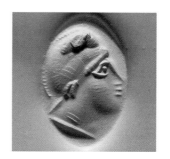

3:2

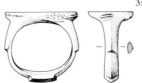

82 Bronze ring; the shape resembles Type VIII

Bezel, 20.0 × 12.6 mm; greatest diameter of hoop, 20.5 mm
Greek, fourth century B.C.
84.AN.1.22

Description: Helmeted head right; the helmet may be of Phrygian type.

Molded projections are added at the sides and bottom of the hoop.

Thin brown patina. There is a hole in the engraved device (upper helmet).

Provenance: From Asia Minor.

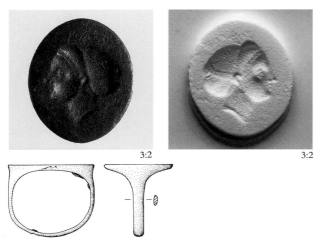

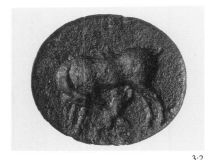

3:2 3:2

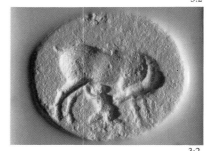

3:2

3:2

83 Iron ring, once silver plated, Type XI

Bezel, 23.8 × 18.6 mm; greatest diameter of hoop, 23.3 mm
Greek, mid-fourth century B.C.
84.AN.1.21

Description: Female head right, hair held in sakkos.

Traces of the silver plating remain on the inside of the hoop; the device is worn.

Discussion: Female heads with their hair held in a sakkos, as well as with more elaborate hair styles, become popular on Attic reliefs and as coin and ring types, especially in Italy and Sicily, in the late fifth and fourth centuries B.C. In Asia Minor, the fourth-century tetradrachms of Kyzikos display a head of Kore that is close in style to that on the Getty ring (see Babelon, *Traité*, pl. 178.16). Several gold rings are also of similar style (see Boardman, *GGFR*, p. 222, pl. 714; Sternberg, Zurich, auction 12, November 19, 1982, lot 975, which is from Asia Minor).

Provenance: From Asia Minor.

84 Iron ring, Type XI

Bezel, 27.9 × 24.5 mm; greatest diameter of hoop, 27.9 mm
Greek, mid-fourth century B.C.
81.AN.17

Description: Hind, standing right with her head turned back, suckling the child Telephos.

Corroded.

Discussion: The device is duplicated on a near-contemporary scaraboid in Rhode Island (T. Hackens, *Museum of Art, Rhode Island School of Design: Catalogue of the Classical Collection, Classical Jewelry* [Providence, 1976], p. 146, no. 76, and see note 1 there for the motif) and is similarly represented on two other gems (*Munich*, pt. 1, no. 284; and Boardman, *GGFR*, pl. 569, lost).

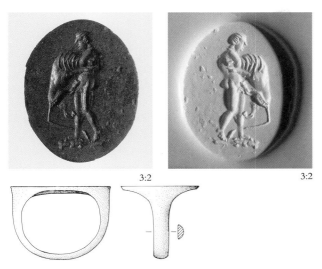

3:2 3:2

85 Bronze ring, Type IX

Bezel, 26.3 × 20.3 mm; greatest diameter of hoop, 26.0 mm

Greek, second half of the fourth century B.C.

85.AN.370.16

Description: Herakles standing right strangling lion; his club serves as the groundline.

Green patina; good condition with slight pitting.

Discussion: A bronze ring in New York (*New York*, no. 72 = Boardman, *GGFR*, p. 426, no. 957) shows a similar motif but is slightly earlier and not very close in style.

Provenance: From Sicily. Sternberg, Zurich, auction 13, November 17, 1983, lot 375.

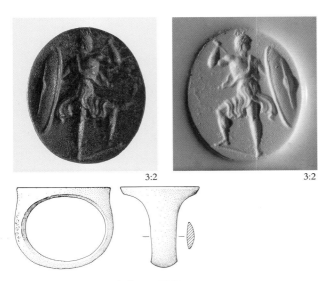

3:2 3:2

86 Iron ring, Type XI

Bezel, 25.1 × 21.0 mm; greatest diameter of hoop, 26.5 mm

Greek, late fourth–early third century B.C.

85.AN.370.18

Description: Celtic warrior facing right, leaning back slightly with his weight on his bent right leg; his left leg is turned frontally; he hurls a spear with his right hand and holds a long Celtic shield with vertical rib and central boss. He is unbearded with long hair and wears laced boots and a short chiton, which swirls around him and exposes his chest; he stands on a short groundline.

Discussion: The Celts fought in Italy and Sicily in the first half of the fourth century and invaded Greece and Asia Minor at the beginning of the third century B.C., eventually settling in what became Galatia. They were frequently employed as soldiers by the Hellenistic kings (see G. T. Griffith, *Mercenaries of the Hellenistic World* [Cambridge, 1935], pp. 166, 199, 252–253; G. Nachtergael, *Les Galates en Grèce et les sôtéria de Delphes* [Brussels, 1977]), and Ptolemy II had to put down a revolt of his own mercenaries in 275 B.C. (Pausanias 1.7.1–2). Early representations of them in art are rare (see P. R. Bienkowski, *Die Darstellungen der Gallier in der hellenistischen Kunst* [Vienna, 1908]), and their only other early appearance on Greek gems is on a remarkable cylinder seal with Aramaic inscriptions, probably of the late fourth century, depicting the marshaling of soldiers, including Celtic mercenaries (Boardman, *GGFR*, p. 320, fig. 309, with further notes; the cylinder is in Boston, inv. no. 41.910). They can be distinguished by their pointed helmets and especially their distinctive oval shield with central rib (on the controversial identification of a Celtic shield used as a symbol on the coins of Ptolemy II, see H. Voegtli, *Schweizer Münzblätter* 23 [1973], pp. 86–89; H. W. Ritter, *Schweizer Münzblätter* 25 [1975], pp. 2–3; and D. Salzmann, *Schweizer Münzblätter* 30 [1980], pp. 33–39).

The representation on the Getty ring appears to be one of the earliest extant, along with some Etruscan versions on vases of the second half of the fourth century (see the Faliscan stamnos in Bonn, J. D. Beazley, *Etruscan Vase-Painting* [Oxford, 1947], pp. 7, 96–100, pl. 24.1; and some late fourth-century *kelebai* from Volaterrae, Beazley [above], p. 128 n. 1; M. Montagna Pasquinucci, *Le Kelebai volterrane* [Florence, 1968], p. 59, fig. 52, and p. 73, figs. 83–84; Bienkowski [above], p. 30, fig. 44; and for a possible Ptolemaic sculptural type, H. P. Laubscher, *AK* 30 [1987], pp. 133–154). The ring shape strongly suggests a date no later than the early third century B.C., and the classicizing style of the figure, which copies the pose of Amazons on late fifth-century sculptural works, also speaks for a relatively early date. The representation, although showing some familiarity with the Celts, differs markedly from the types that became prevalent after the famous late third-century Pergamene sculptures. It may have been created to commemorate the Ptolemaic victories over the Celts in 275 B.C., although the style allows an earlier date.

Provenance: From Asia Minor.

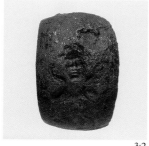

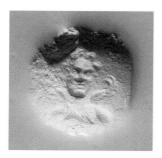

3:2

87 Iron ring in the shape of a convex band

Greatest width of band, 14.8 mm; greatest diameter of hoop, 22.8 mm
Greek, third century B.C.
85.AN.370.19

Description: Facing bust of young Eros.

The band of the ring is not flattened and only slightly wider and thicker at the engraving.

Some corrosion and accretions.

Discussion: The shape of the ring is unusual, but parallels are known (a fine gold ring in Rhode Island: T. Hackens, *Museum of Art, Rhode Island School of Design: Catalogue of the Classical Collection, Classical Jewelry* [Providence, 1976], p. 93, no. 36; a gold ring from Kerch now in Leningrad, Boardman, *GGFR*, p. 220, pl. 682; a gold ring with flying Eros, *Guilhou coll.*, no. 484; a silver ring with bird flying above a rose, *BMC Rings*, no. 1103; Paris, de Luynes, no. 528; a bronze ring with female head, from Smyrna, *Oxford Gems*, no. 289; and a bronze ring also from Kerch, T. W. Kibaltchitch, *Gemmes de la Russie méridionale* [Berlin, 1910], nos. 360, 431). The gold example in Rhode Island also depicts a bust of Eros, and Hackens' suggested date in the third century is convincing. The gold ring in Leningrad is somewhat earlier. The provenance of the Getty and Oxford rings and the several examples from Kerch suggest a workshop in Asia Minor, perhaps located on the Black Sea coast.

Provenance: From Asia Minor.

PTOLEMAIC RINGS

Many examples of intaglio and relief rings depicting a woman with melon coiffure are known, but they have not yet been studied in detail. The best discussion is by O. Neverov, who published a number of different types found at Black Sea sites ("A Group of Hellenistic Bronze Rings in the Hermitage," *Vestnik drevnei istorii* 127 [1974], pp. 106–115, with English summary; also J. Spier, *JWalt* 47 [1989], p. 21 n. 17; *Geneva*, vol. 3, p. 164, no. 218, and notes; J. Charbonneaux, *Monuments et mémoires. Fondation E. Piot* 50 [1958], p. 95, figs. 7–8, in the Louvre; Oxford, gold intaglio set into an iron ring from Corfu, *Oxford Gems*, no. 282; *BMC Rings*, nos. 1267–1269, 1275, 1277–1278; A. Krug, *Muse* 14 [1980], p. 35, fig. 5, for two examples in the Ägyptisches Museum, Berlin; *Guilhou coll.*, no. 797; many others remain unpublished). There can be little doubt that they represent a Ptolemaic queen, either Arsinoë II (278–270 B.C.) or Berenike II (246–222/221 B.C.), but many may be posthumous; they were probably made for officials throughout the Ptolemaic territories. Less common are examples depicting a male figure (Ptolemy II and III—Neverov [above], figs. 1–5; *Geneva*, vol. 3, no. 218; *Guilhou coll.*, nos. 804, 806–807; E. Boehringer, *Corolla L. Curtius* [Stuttgart, 1937], pp. 114–147, the portrait he identifies as Philetairos is probably Ptolemy III; Ptolemy IX—University College, London, UC 17231, H. Kyrieleis, *Bildnisse der Ptolemäer* [Berlin, 1975], p. 68, pl. 55.15–16), Dionysos (Fogg Art Museum 1986.543; *BMC Rings*, no. 1266; perhaps Ptolemy IV), or other gods and goddesses. Occasionally the rings are of distinctively Egyptian shape (see Boardman, *GGFR*, p. 214, Type XVII). Examples carved from ivory and bone (L. Marangou, *Athenische Mitteilungen* 86 [1971], pp. 163–171; E. Alföldi-Rosenbaum, in *Eikones: Studien zum griechischen und römischen Bildnis. Hans Jucker Festschrift* [Bern, 1980], pp. 37–38) and marble (P. Denis, *AA*, 1984, pp. 569–572) also exist.

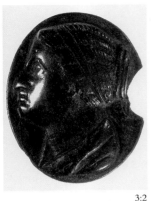

3:2

88 Fragmentary bronze relief ring

Bezel, 31.5 × 24.2 × 4.4 mm
Greek, third–second century B.C.
81.AN.76.208

Description: Portrait of draped woman with melon coiffure left.

Only the bezel with traces of the hoop is preserved. The bezel is worn and chipped behind the head.

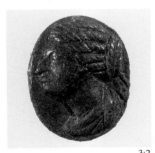

3:2

89 Bronze ring with relief bezel

Bezel, 23.2 × 18.3 × 4.0 mm; greatest diameter of hoop, 21.5 mm
Greek, third–second century B.C.
83.AN.437.14

Description: Portrait similar to catalogue number 88, above.

Provenance: From Asia Minor.

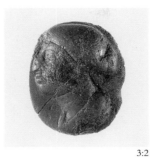

3:2

90 Fragmentary bronze relief ring

Bezel, 21.1 × 17.3 × 4.5 mm
Greek, third–second century B.C.
85.AN.370.22

Description: Portrait similar to catalogue number 88, above.

Only traces of the hoop remain.

Provenance: From Asia Minor.

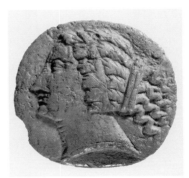

3:2

91 Bone ring with relief bezel

Bezel, 29.0 × 27.9 × 5.0 mm
Greek, second–first century B.C.
81.AI.180.7

Description: Portrait similar to catalogue number 88, above.

Much of the hoop is missing.

Discussion: For the class, see L. Marangou, *Athenische Mitteilungen* 86 (1971), pp. 163–171.

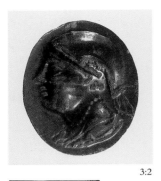 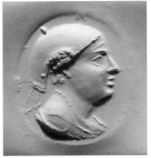

3:2 3:2

92 *Bronze intaglio, oval and flat*

24.1 × 20.2 × 3.0 mm
Greek, third–second century B.C.
81.AN.76.207

Description: Portrait bust of Berenike II (246–222/221 B.C.) to right; she wears a veil and necklace; some drapery visible on her shoulders.

Discussion: The style and technique correspond to the series of Ptolemaic metal rings, the closest example being a bronze ring with engraved bezel depicting the same woman with veil (Furtwängler, *AG*, pl. 61.48, from Cappadocia). The intaglio was no doubt set into a ring in the manner of the fine gold bezel in a large iron ring in Oxford (*Oxford Gems*, no. 282); another bronze bezel of similar shape depicting the queen with melon coiffure is in University College, London (UC 2454; W. M. Flinders Petrie, *Objects of Daily Use* [London, 1927], p. 20, no. 324, pl. 16). A woman with the same features and headdress on two amethyst gems has been identified as Arsinoë II (278–270 B.C.) by Vollenweider (*Oxford Gems*, pp. 79–80, no. 283; *Geneva*, vol. 2, no. 40; and the carnelian, Furtwängler, *AG*, pl. 38.21 = Jucker and Willers, *Gesichter*, p. 280, no. 129; see also the glass gem from Pompeii, *Naples*, no. 215, and a duplicate in the American Numismatic Society, New York). A very fine ivory relief ring in Athens also appears to show the same woman, whom Marangou more convincingly calls Berenike II (L. Marangou, *Athenische Mitteilungen* 86 [1971], pp. 164–166, no. 1, pl. 78.2–3).

NEAR EASTERN AND PHOENICIAN SEALS

THE LYRE-PLAYER GROUP SEALS

Gems of this extensive group, usually scaraboids of green or red serpentine, are non-Greek works, probably made in a Cilician workshop in the second half of the eighth century B.C. They have a very wide distribution, including Cyprus, Rhodes, Crete, the Cycladic Islands, Euboea, the Peloponnesos, and eastern Anatolia and Syria (see J. Boardman and G. Buchner, *Jahrbuch des Deutschen Archäologischen Instituts* 81 [1966], pp. 1–62; J. Boardman, *AA*, 1990, pp. 1–17; Boardman, *GGFR*, pp. 110, 399; Boardman, *Intaglios and Rings*, nos. 212–213; Zazoff, *AG*, pp. 61–62). Especially significant is the very large number found in tombs at Pithekoussai on the island of Ischia, which was an early Euboean settlement, and Boardman has suggested that they may have been brought west via the Euboean trading post at Al Mina in North Syria. They are notable for being the earliest and most numerous examples of Eastern scaraboids imported to Greece in the Archaic period.

3:2 3:2

93 *Dark brown serpentine scarab*

20.0 × 14.9 × 9.5 mm
North Syrian (Cilician), second half of the eighth century B.C.
85.AN.370.3

Description: Standing lyre player, a kneeling figure, and two other standing figures, all to right, approach a seated figure; groundline with hatched horizontal band below; linear border.
The scarab back is only summarily worked.
Excellent condition.

Discussion: This example, with its multiple-figure scene,

is one of the finest examples known and includes the often depicted lyre player who gives his name to the group. It is very similar to one once in Munich (J. Boardman and G. Buchner, *Jahrbuch des Deutschen Archäologischen Instituts* 81 [1966], p. 42, no. 162, fig. 66; Boardman, *GGFR*, p. 110, fig. 158) and another in the Getty (cat. no. 94, below). The scarab back is rare for the group.

Provenance: From Asia Minor.

Bibliography: J. Boardman, *AA*, 1990, p. 14, no. 120 bis.

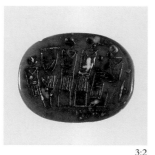
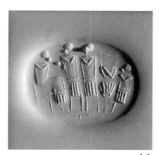

3:2 3:2

94 *Green serpentine scaraboid*

20.5 × 16.9 × 11.1 mm
North Syrian (Cilician), second half of the eighth century B.C.
84.AN.1.3

Description: Standing lyre player and two other figures, to left, approach a seated figure.

The surface is worn.

Discussion: A near duplicate of the scaraboid once in Munich (see cat. no. 93, above).

Provenance: From Asia Minor.

Bibliography: J. Boardman, *AA*, 1990, p. 14, no. 120 ter.

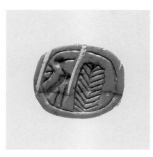
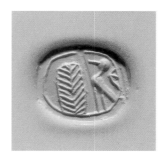

95 *Green serpentine scaraboid*

12.8 × 11.2 × 6.3 mm
North Syrian (Cilician), second half of the eighth century B.C.
84.AN.1.4

Description: Bird standing left before a hatched leaf; linear border.

Discussion: Birds are a popular motif in this series (see J. Boardman and G. Buchner, *Jahrbuch des Deutschen Archäologischen Instituts* 81 [1966], nos. 28, 38; Boardman, *Intaglios and Rings*, nos. 212–213 = Getty Museum 81.AN.76.212–213).

Provenance: From Asia Minor.

Bibliography: J. Boardman, *AA*, 1990, p. 14, no. 120 quater.

SYRO-PHOENICIAN SEALS

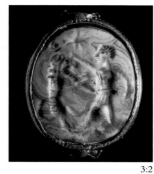
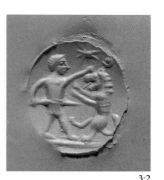

3:2 3:2

96 *Agate scaraboid, mottled white/gray/ orange, with high domed back in gold collar*

21.5 × 16.8 × 11.7 mm
Syro-Phoenician(?), sixth century B.C.
83.AN.437.7

Description: Unbearded hero in a short tunic fighting a lion; he holds the lion's head with his left hand and a sword in his right; star and disc in crescent above; thick groundline.

The mount has eight S-shaped filigree spirals, rows of granulation, and pyramidal clusters of granulation around the rims of the string holes. The gold work is worn.

Discussion: The motif is popular in Near Eastern glyptic, but it is difficult to find parallels to the style. A smaller version in a similar material, said to be from Israel, is in the Fogg Art Museum (inv. no. 1986.544, unpublished; see also M. de Clercq, *Collection de Clercq*, vol. 2, *Antiquités Assyriennes: Cylindres orientaux, cachets, briques, bronzes, bas-reliefs, etc.* [Paris, 1903], pl. 3.55; and the chalcedony scaraboid, *Geneva*, vol. 3, no. 114).

GRAECO-PHOENICIAN SCARABS

An extensive series of scarabs, mostly in "green jasper," has long been recognized as Phoenician works (usually called "Graeco-Phoenician" or "Graeco-Punic"). The scarabs have been found primarily at Phoenician sites both in the East and the West (a study by John Boardman is awaited; the best surveys of the group to date, with further bibliography, include Furtwängler, *AG*, vol. 3, pp. 108–115; W. Culican, *Australian Journal of Biblical Archaeology* 1 [1968], pp. 50–54; Boardman, *Escarabeos*; Boardman, *Intaglios and Rings*, pp. 35–36; Boardman, in *BMC Tharros*, pp. 98–105, with a scientific analysis of the scarab materials, pp. 106–107; J. H. Fernández and J. Padro, *Escarabeos del Museo Arqueológico de Ibiza* [Madrid, 1982]; Zazoff, *AG*, pp. 85–98; *Oxford Stamp Seals*, vol. 3, pp. 70–72). Western Phoenician colonies, especially Carthage, Sardinia, and Ibiza, as well as other locations in North Africa, Spain, and Sicily, have yielded most of the examples, and some are from recorded contexts. Examples from Eastern sites and Phoenicia itself are much less well attested (see Culican [above], pp. 50–54; Zazoff, *AG*, p. 87 nn. 8–11; *Oxford Stamp Seals*, p. 71), although the Getty examples add a number from Asia Minor. The large number of scarabs from Western sites, especially Tharros on Sardinia, has led some to believe they were manufactured there, but there seems to be no discernible differences in iconography, style, or manufacture between Eastern and Western examples. For the present the question of where they were manufactured must remain open.

The scarabs display a wide range of devices, some Phoenician, some egyptianizing, and others Greek. The Greek types are mostly copied directly from Archaic Greek scarabs. The tomb groups from Tharros, Carthage, and Ibiza demonstrate that the different styles are found together and that the hellenizing scarabs need not follow the Eastern types. The earliest examples may date from the late sixth century, but the majority are from fifth-century and later tombs.

97 Blue frit ("Egyptian Blue") scarab

16.5 × 12.8 × 8.5 mm
Phoenician, late sixth–fifth century B.C.
83.AN.437.3
Description: Two goats, their heads reverted, rearing before a "sacred tree," composed of a cup spiral containing a palmette surmounting two levels of volute-columns; a winged disc is above; linear border.

The device is cast slightly off-center.

The scarab is worn.

Discussion: A similar device is on a green jasper scarab found in Tomb 11 at Tharros (*BMC Tharros*, p. 169, 11/15, pl. 57d; *BMC Gems*, no. 423). Animals and monsters (lions, griffins, and sphinxes) flank a sacred tree in this manner on a number of relatively early (late sixth-century) hard-stone Phoenician scarabs (see Boardman, *AGG*, pp. 23–24, nos. 22–26, 28–30). On the material ("Egyptian Blue"), see *BMC Tharros*, p. 106.

Provenance: From Asia Minor.

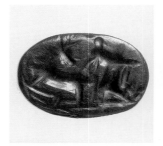 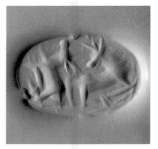

98 Green jasper scarab

17.6 × 11.9 × 8.1 mm
Phoenician, sixth–fifth century B.C.
82.AN.162.11

Description: Two recumbent stags.

The scarab is very simple, with no legs indicated and only summary incisions to distinguish elytra from thorax and thorax from head.

The back is worn; there is a large chip from the back around the hole and a smaller one from the front.

Discussion: The shape of the scarab is unusually crude, as is the engraving and device. For the style of the engraving, see a carnelian scarab from Ibiza (Ibiza 4103; Boardman, *Escarabeos*, no. 228; J. H. Fernández and J. Padro, *Escarabeos del Museo Arqueológico de Ibiza* [Madrid, 1982], p. 112, no. 39).

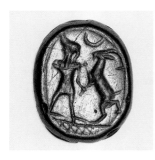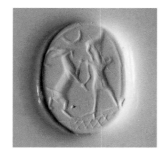

99 Green jasper scarab

17.1 × 13.5 × 10.4 mm
Phoenician, fifth century B.C.
84.AN.1.10

Description: Figure wearing a short skirt and peaked headdress holding a rearing goat; crescent above; hatched exergue and linear border.

The engraving is shallow and crudely modeled, without the apparent use of the drill. The elytra are separated by a shallow groove.

Discussion: The type is purely Phoenician and is repeated on a green jasper scarab once in the de Clercq collection (*De Clercq coll.,* no. 2766), probably from an Eastern site.

Provenance: From Asia Minor.

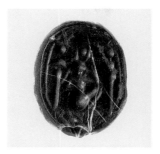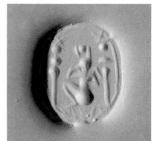

100 Green jasper scarab

17.0 × 12.8 × 9.0 mm
Phoenician, fifth century B.C.
84.AN.986

Description: Harpokrates sitting left between two petal-candelabra; cross-hatched exergue; linear border.

No carination; a thick incision separates the humped thorax from the elytra.

Discussion: For a discussion of the device, which appears on a blue glass scaraboid from Cyprus, see W. Culican, *Australian Journal of Biblical Archaeology* 1 (1968), pp. 80–81, fig. 10.

Provenance: From Asia Minor.

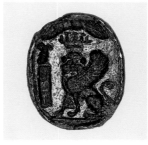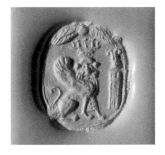

101 Flat dark brown jasper, probably cut down from a scarab

16.3 × 13.1 × 3.0 mm
Phoenician, fifth century B.C.
85.AN.444.21

Description: Sphinx with Bes head seated right, the head turned to front; he wears a crown of *uraei*. To the right, a column surmounted by palm capital; a winged disc above; linear border.

Discussion: A similar motif is seen on a carnelian scarab from Amrit (*De Clercq coll.,* no. 2600).

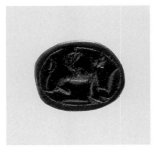
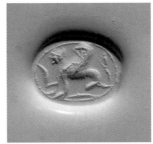

102 Green jasper scarab

12.7 × 10.5 × 7.5 mm
Phoenician, fifth century B.C.
83.AN.437.6

Description: Sphinx with curved wing sitting left; *uraeus* to left; linear border.

The scarab is very simple and without carination.

Discussion: For the motif, see Boardman, *Escarabeos*, nos. 151–152; and in good Greek style, *New York*, nos. 18–19.

Provenance: From Asia Minor.

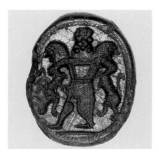
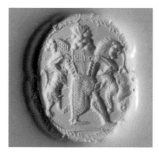

103 Black jasper scarab

18.9 × 14.8 × 11.2 mm
Phoenician, fifth century B.C.
83.AN.437.5

Description: Bes standing right, his head turned to front, holding two lions around their necks; he wears a slit skirt and a crown of plumes; groundline; hatched border.

The beetle has hatched lines outlining the elytra and thorax, separating the elytra, and between the elytra and the thorax; the legs are hatched.

The scarab appears to be burnt.

Discussion: Bes as *posis theron* is a popular motif on Phoenician scarabs. The type is more frequent in the East than the West and is found on scarabs in carnelian and chalcedony from Phoenicia (*De Clercq coll.*, nos. 2767–2768) as well as in green jasper (from 'Atlit, W. Culican, *Australian Journal of Biblical Archaeology* 1 [1968], p. 52, pl.

1.8; Syria, *Munich*, pt. 1, no. 216; Bes with goats, from Byblos, *De Clercq coll.*, no. 2772; and from Ibiza, Boardman, *Escarabeos*, no. 89). A green jasper example was also found at Tharros (*BMC Gems*, no. 368; *BMC Tharros*, p. 158, 8/18, pl. 59b). There are other examples from uncertain sites (see *Geneva*, vol. 3, no. 126; Paris, Zazoff, *AG*, p. 90 n. 36, pl. 21.3–4; and cat. no. 104, below).

Provenance: From Asia Minor.

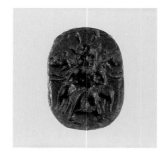
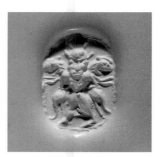

104 Green jasper scarab

14.7 × 10.8 × 7.9 mm
Phoenician, fifth century B.C.
84.AN.1.9

Description: Bes-Gorgon standing left, head turned to front, holding two lions; he has animal ears and two snakes rise from his head; he wears a slit skirt; linear border.

The back of the scarab is pinched, and the elytra are separated from the thorax and slightly humped.

Discussion: Early Greek scarabs conflated Bes and Gorgons (see Boardman, *AGG*, pp. 28–29), and this Phoenician example appears to be influenced by the Greek versions. For the motif, see catalogue number 103, above.

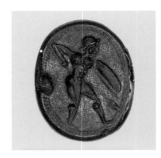
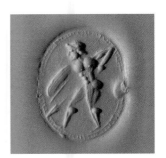

105 Green jasper scarab

17.3 × 13.5 × 9.5 mm
Phoenician, fifth century B.C.
84.AN.1.11

Description: Nude warrior advancing left, holding shield and down-turned spear; hatched border.

Hatched lines divide elytra from thorax and thorax from head; incised line divides the elytra.

Discussion: Warriors in various poses copied from Greek gems are popular on Phoenician green jasper scarabs (see Boardman, *Escarabeos*, nos. 163–178; *BMC Tharros*, p. 103, 3/23, 5/28, 10/20, pl. 62e–g). The pose of this figure is not attested on green jasper scarabs but is seen on a Late Archaic Greek scaraboid now in the Getty Museum (Boardman, *Intaglios and Rings*, no. 23 = Getty Museum 81.AN.76.23).

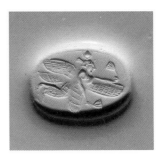

107 Green jasper scarab

14.6 × 11.0 × 8.5 mm
Phoenician, fifth century B.C.
85.AN.370.23

Description: Isis, with four wings, flying right; she is disc-crowned and holds a lotus flower in each hand; linear border.

Discussion: The same motif is found on a Phoenician "serpentine-chlorite" scarab in Geneva (*Geneva*, vol. 3, no. 180; there incorrectly described as Cypriot, seventh century). Isis holding two lotus flowers, often winged but not flying, is a frequent type (see Boardman, *Escarabeos*, nos. 36–40; J. H. Fernández and J. Padro, *Escarabeos del Museo Arqueológico de Ibiza*, [Madrid, 1982], p. 63, no. 15; *Oxford Stamp Seals*, no. 493). This is the only green jasper scarab in the Getty Museum that is thought to be from a Western Punic site.

Provenance: From Tunisia.

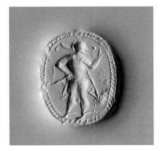
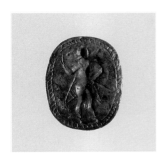

106 Mottled green jasper scaraboid

14.2 × 11.3 × 7.6 mm
Phoenician, fifth century B.C.
82.AN.162.13

Description: Bearded Hermes(?) standing left, his head turned back; his head and feet are winged, and he wears a chlamys; hatched border.

The top of the scaraboid is carinated (an unfinished scarab?).

Discussion: The engraving is very crude, thus the identification is uncertain. The feet and head do appear to be winged, however, and the chlamys is correct for Hermes, who is seen on a green jasper scarab in London (*BMC Gems*, no. 316). Figures who are winged in a similar manner, although probably not Hermes, are seen on Greek gems (see Boardman, *AGG*, p. 32, nos. 40–41), and an early fifth-century Graeco-Persian gem in New York certainly depicts Hermes with winged cap and feet (Boardman, *GGFR*, pl. 845; *New York*, no. 33).

GRAECO-PERSIAN GEMS

After the Persian conquest of Lydia and East Greece in the second half of the sixth century, western Asia Minor fell under Persian control. Gems that combine Greek style with Persian motifs were produced throughout the fifth and fourth centuries B.C., and these have attracted considerable scholarly discussion regarding the identity of their artists and place of their manufacture (for the extensive bibliography, including discussions by Furtwängler, Moortgat, Maximova, Richter, Seyrig, and Nikulina, see Boardman, *GGFR*, pp. 430–431, and Zazoff, *AG*, pp. 163–167). Following the long tradition of glyptic in the East, Achaemenid cylinder and stamp seals were produced in Persia, Assyria, Babylonia, and elsewhere in the Eastern empire (see cat. no. 108, below), but in western Asia Minor, the scaraboid shape was preferred, with only the occasional use of cylinder seals and tabloids. The exception is a series of eight-sided pyramidal stamp seals (such as cat. no. 109, below) of the late sixth and fifth centuries that may have been made at the Lydian capital, Sardis (see the full discussion and list by Boardman, *Iran* 8 [1970], pp. 19–45). Later series of fifth- and fourth-century scaraboids were no doubt continued at Sardis, as well as at other Achaemenid centers in Asia Minor, but probably not in the Greek cities. Greek influence is apparent, however, throughout the entire series, although the devices mostly reflect Persian taste. Persians fighting or hunting are especially popular, and various studies of animals are the most frequent type. Only occasionally are purely Greek types copied.

The style and the engraving technique are distinctive. Figures tend to be highly stylized with shallow engraving and frequent use of the small drill, which produced a pelletlike effect for the facial features, joints, and other details. This technique is already seen on the early series of Lydian-Achaemenid pyramidal stamp seals. Blue chalcedony is the favored material. Rings with engraved bezels were also made in Graeco-Persian workshops (cat. nos. 136–139, below), as were several series of glass conoids and scaraboids (cat. nos. 129–133, below) and a distinctive series of blue glass tabloids (cat. nos. 134–135, below). Boardman has most successfully grouped the various workshops and given them names, which are generally followed here;

further precision in attributions could still be reached, however (Boardman, *GGFR*, pp. 431–440, listing more than four hundred examples; Boardman, *Intaglios and Rings*, nos. 83–109; and see Zazoff, *AG*, pp. 169–192, for further observations).

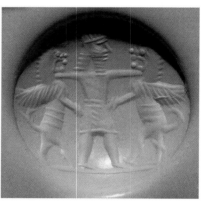

108 *Blue chalcedony conoid stamp seal*

Height, 25.2 mm; diameter of the face, 24.5 mm
Achaemenid (Eastern), fifth century B.C.
81.AN.76.205

Description: Persian royal hero holding two winged and horned lions of Achaemenid type by their necks; groundline.

The face of the seal is convex.

Discussion: This stamp seal does not belong to the Graeco-Persian series and is probably from a Babylonian workshop, where the shape is more common (see *Geneva*, vol. 1, no. 89, with references).

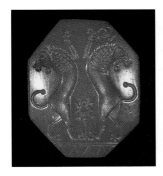
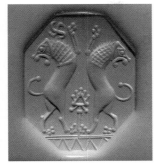

109 Blue chalcedony eight-sided pyramidal stamp seal with slightly convex face

19.3 × 15.3 mm; preserved height, 18.0 mm
Lydian-Achaemenid, early fifth century B.C.
81.AN.76.86

Description: Two rampant lions standing, their heads reverted, over a floral pattern; double exergual line below, which is a zigzag pattern. A tetraskeles "linear device" is in the upper left field; the same device is lightly incised in the lower left field, but that position was evidently rejected. The top half is broken, but enough is preserved to show it was once pierced through.

Discussion: This popular Achaemenid motif is seen on a number of other pyramidal seals of the same class (see Boardman, *Iran* 8 [1970], p. 28, nos. 33–40, where the personal "linear devices" are also discussed).

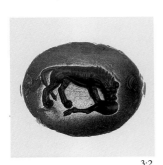
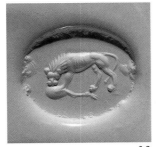

110 Carnelian scaraboid, Type A

22.2 × 18.2 × 10.5 mm
Graeco-Persian, late fifth century B.C.
84.AN.1.14
Description: Lion standing left, tearing a limb; his head is turned to front.

There are a few chips around the face, but the scaraboid is generally in very good condition.

Discussion: The gem is best placed in Boardman's broad Greek Style (see others in the same style: Boardman, *GGFR*, p. 432, nos. 80–81; and in a poorer style, Boardman, *GGFR*, p. 437, no. 343, pl. 970). Purely Greek examples are also common (see Boardman, *GGFR*, pl. 619; Boardman, *Intaglios and Rings*, no. 50 = Getty Museum 81.AN.76.50, with further notes).

Provenance: Formerly collection of J. Henry Middleton, Cambridge, who was Slade Professor of Fine Art, fellow of King's College, director of the Fitzwilliam Museum, and author of *Ancient Gems: The Engraved Gems of Classical Times, with a Catalogue of the Gems in the Fitzwilliam Museum* (Cambridge, 1891); Christie's, May 20, 1981, lot 97.

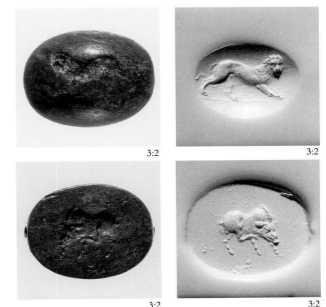

3:2 3:2

3:2 3:2

111 Lapis lazuli scaraboid, Type A

24.0 × 18.4 × 9.9 mm
Graeco-Persian, fourth century B.C.
83.AN.437.9 (Color plate 2)

Description: Convex top: Lion standing right, his head turned to front; groundline. Flat bottom: Boar standing right, twisting three-quarters to front; he scratches his head with his right hind leg; thin groundline.

Discussion: The engraving of this stone, notably the modeling and detailing of musculature and hair, is exceptionally fine and stands apart from most Graeco-Persian gems. The closest stylistic parallel is a carnelian scaraboid depicting a lion catching a stag, which Boardman categorizes as Greek rather than Graeco-Persian (once Robinson collection, *Burlington Fine Arts Club: Exhibition of Ancient Greek Art* [1904], M 157 = Boardman, *GGFR*, p. 414, no.

359, as fourth-century Common Style). The material, lapis lazuli, was rare and highly prized in antiquity; it is not previously attested for Graeco-Persian gems and only rarely for Greek gems in this period (see Boardman, *GGFR*, p. 408, no. 45; p. 412, no. 269, pl. 594). The devices, however, are best at home in the western Persian Empire. The lion with head turned to front is seen on several small fourth-century silver coins from Cilicia (E. Levante, *Sylloge Nummorum Graecorum, Switzerland*, vol. 1, *Levante-Cilicia* [Bern, 1986], nos. 189–190 from Myriandos, and no. 215), which often display purely Achaemenid motifs as well, and on coins of Amathous in Cyprus (Babelon, *Traité*, nos. 1272–1276, pl. 133.9–17). An exceptionally fine style boar with head slightly turned to front is depicted on a Graeco-Persian carnelian cylinder seal in Oxford (Boardman, *GGFR*, p. 433, no. 94, pl. 872, Greek Style), and boars in similar style are shown on early fourth-century coins of Aspendos in Pamphylia, again an area within the Persian Empire (see esp. C. M. Kraay, *Archaic and Classical Greek Coins* [London, 1976], no. 1005, in Oxford).

Provenance: From Asia Minor.

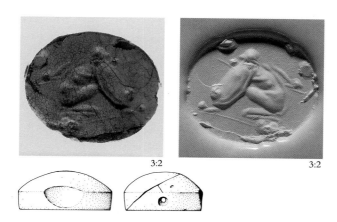

3:2 3:2

112 Chalcedony(?) scaraboid, Type A

25.3 × 21.9 × 10.7 mm
Graeco-Persian, fourth century B.C.
84.AN.1.13

Description: Nude hoplite kneeling behind his shield left; he wears a helmet with broad brim and holds a spear; groundline.

The scaraboid is burnt and discolored so that it is now light brown; it is partially fractured with pieces missing from the back, sides, and face.

Discussion: The motif of a warrior crouching behind his shield is already seen on Attic reliefs and vases by the end of the sixth century B.C. and occurs on Greek gems in the fifth century (see Boardman, *GGFR*, pl. 534; also a clay sealing from Selinous, *Notizie degli Scavi*, 1883, pl. 5, XLII). However, it also achieves great popularity in Achaemenid Asia Minor and is found on a number of gems (Boardman, *GGFR*, p. 436, no. 291, pl. 954 = *Leningrad*, no. 45; no. 292 = *BMC Gems*, no. 528; and Boardman, *Intaglios and Rings*, no. 91 = Getty Museum

81.AN.76.91; two others, London market, 1986) and coins (electrum stater of Kyzikos, Babelon, *Traité*, no. 2630, pl. 174.4; coins of the Persian satrap Orontas struck at Klazomenai, circa 362 B.C., Babelon, *Traité*, no. 63, pl. 88.22; coins of Tarsos struck under the Persian satraps in the fourth century, Babelon, *Traité*, nos. 514–516, pl. 105.12–15). The Getty gem is of very good style, without the typical Graeco-Persian drillwork, and could be from a Greek workshop.

Provenance: From Asia Minor.

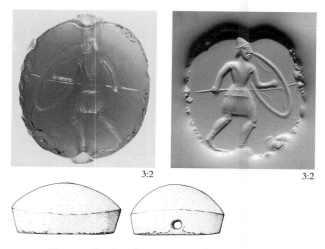

3:2 3:2

113 Gray chalcedony scaraboid, Type A

28.3 × 24.6 × 14.0 mm
Graeco-Persian, fourth century B.C.
85.AN.370.25

Description: Bearded hoplite advancing right; he wears a pilos helmet, armor, and greaves and carries a shield and spear; groundline.

There are some chips around the face.

Discussion: Hoplites appear frequently on Graeco-Persian gems, sometimes being defeated by Persians (in addition to the kneeling hoplites cited above, see Boardman, *GGFR*, p. 432, nos. 52–55; p. 436, nos. 290, 293). Closest in type to the Getty gem is a scaraboid in Bologna (Boardman, *GGFR*, p. 433, no. 118, Bolsena Group; *Bologna*, no. 1).

Provenance: From Iran.

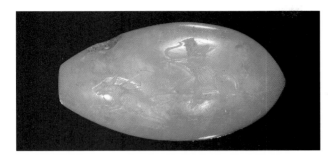

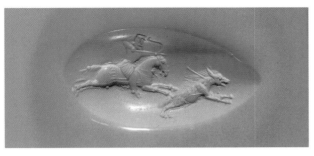

Boardman, *GGFR*, p. 433, no. 133, pl. 888, in London). Hunting scenes, as on side A, are popular in this group. No other hyena hunt is known, but hyenas, sometimes wounded, are frequently seen, especially on multifaced tabloids (see Boardman, *GGFR*, pp. 433–434, nos. 106, 113, 120, 124, 151, 152, and 226; and the fine figure study of a seated hyena, Boardman, *Intaglios and Rings*, no. 92 = Getty Museum 81.AN.76.92).

The figure of Herakles on side B is a rare example of a purely Greek motif, probably copied from a Greek gem. It appears to derive from a type (from a statue?) seen on a Late Archaic, fifth-century scarab in New York (*New York*, no. 71; Boardman, *AGG*, no. 318, Group of the Beazley Europa), which depicts a very similar Herakles with raised club and outstretched arm holding a lionskin; however, on the New York gem, Herakles also holds a bow and is seen in three-quarter rear view. A striding Herakles copied from an Archaic Greek gem is found on a Lydian-Achaemenid carnelian scarab of circa 500 B.C. in New York (68.11.35; see D. von Bothmer, *Comptes rendus de l'Académie des inscriptions et belles-lettres*, 1981, p. 205); another Herakles is seen on a slightly later Lydian-Achaemenid pyramidal stamp seal (Boardman, *GGFR*, pl. 846); and a third, pictured having defeated the Nemean lion and receiving water from the nymph Nemea, is on an extraordinary Graeco-Persian scaraboid in London (Boardman, *GGFR*, pl. 856; *BMC Gems*, no. 524).

114 White chalcedony pendant

29.5 × 16.0 × 12.4 mm
Graeco-Persian, late fifth–fourth century B.C.
85.AN.370.24

Description: Side A: Persian horseman shooting an arrow at a wounded hyena. Side B: Nude, unbearded Herakles standing right; he holds a club in his raised right hand and a lionskin over his outstretched left arm; groundline.

Discussion: Three other pendants of this type are known, and they form the core of the Pendants Group distinguished by Boardman (Boardman, *GGFR*, pp. 316, 433–434, nos. 125–169; Boardman, *Intaglios and Rings*, nos. 88–90). As he notes, all the pendants and many of the other gems may be by the same hand (note the similarities in the treatment of the horsemen on the Getty pendant and

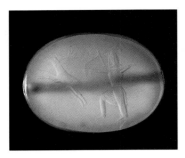

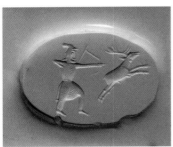

3:2

115 Blue chalcedony scaraboid, Type A

27.2×20.0×12.1 mm
Graeco-Persian, fourth century B.C.
84.AN.1.15
Description: Persian archer on foot, right, shooting a running stag.
Discussion: This gem, too, belongs to the Pendants Group (see cat. no. 114, above), where hunting scenes are common (see Boardman, *GGFR*, p. 433, no. 128, pl. 885, a Persian on foot hunts a boar, probably by the same hand).
Provenance: From Asia Minor.

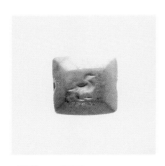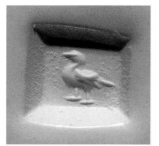

4:1

116 Carnelian(?) tabloid

9.1×8.9×4.8 mm
Graeco-Persian, fourth century B.C.
85.AN.300.4
Description: Bird standing left.
 The stone is engraved on the top only.

Discolored white.
Discussion: The tabloid is very small, but the engraving is fine and recalls the style of a tabloid in Paris, which likewise has a bird engraved on the top (Boardman, *GGFR*, p. 434, no. 150, pl. 893, Pendants Group). A Greek version is Boardman, *GGFR*, pl. 625, and for flying birds, see catalogue number 117, below.

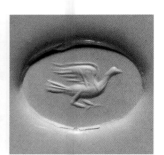

117 Blue chalcedony scaraboid, Type A

18.7×14.6×7.8 mm
Graeco-Persian, fourth century B.C.
84.AN.985
Description: Pigeon flying right.
There is a slight chip on the upper face.
Discussion: A dove in a similar pose serves as the emblem of Sikyon on its fifth- and fourth-century coinage (see C. M. Kraay, *Archaic and Classical Greek Coins* [London, 1976], nos. 301, 306, 308), and pigeons holding a rolled scroll fly on at least three Greek gems (Beazley, *Lewes House*, no. 81 = Boardman, *GGFR*, p. 409, no. 88; Boardman, *Intaglios and Rings*, no. 40 = Getty Museum 81.AN.76.40; Geneva, Vollenweider, *Deliciae Leonis*, no. 39).

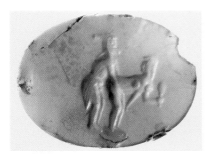

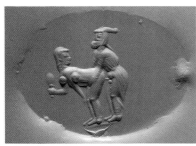

118 *White chalcedony scaraboid, Type A*

25.5×20.1×11.5 mm
Graeco-Persian, fourth century B.C.
85.AN.370.26

Description: Love making; a nude Persian woman standing left, bending over with one hand on her knee; the other hand holds a mirror; she turns her head back. The man stands behind her and is in full Persian costume; ground-line.

Slightly discolored; there is a large chip on the back and minor ones on the face.

Discussion: The scene is duplicated on a tabloid in Paris, probably by the same hand, which is assigned by Boardman to his Phi Group (Boardman, *GGFR*, p. 434, no. 178, pl. 906; another example was once in Munich, Boardman, *GGFR*, p. 434, no. 177; and a third, a blue chalcedony scaraboid from Iran, was on the London market in 1987).

Provenance: From Iran.

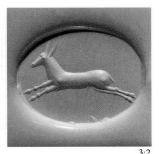

119 *White chalcedony scaraboid, Type A*

24.9×20.1×9.6 mm
Graeco-Persian, fourth century B.C.
83.AN.437.8

Description: Deer running left.

The interior of the stone appears fractured, but the surfaces are in excellent condition.

Discussion: The motif and style, a running animal with tubelike body and frequent use of the drill, fit exactly into Boardman's Wyndham Cook Group (Boardman, *GGFR*, p. 319).

Provenance: From Asia Minor.

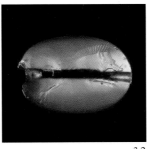

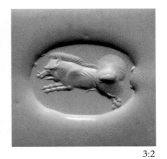

120 *Blue chalcedony scaraboid, Type A*

20.1×14.9×8.8 mm
Graeco-Persian, fourth century B.C.
84.AN.1.16

Description: Boar running left.

There is a chip at one end by the hole and one from the face, damaging the engraving.

Discussion: Like catalogue number 119, above, this gem is best placed in the Wyndham Cook Group, although the modeling is better than usual; it is close to an example in Paris (Boardman, *GGFR*, p. 436, no. 270, pl. 945; see also no. 271 there = *BMC Gems*, no. 551, and the better style Boardman, *GGFR*, p. 433, no. 93 = *New York*, no. 140; also terracotta impressions from Persepolis, E. F. Schmidt, *Persepolis*, vol. 2 [Chicago, 1957], pp. 40–41, nos. 73–74, pl. 14).

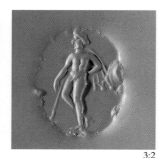

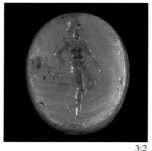
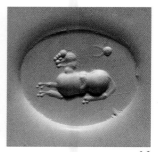

3:2 3:2

Group, where the motif is popular (see Boardman, *GGFR*, p. 437, no. 353, pl. 974; other tabloids with the same device, Boardman, *GGFR*, p. 438, nos. 369–371, fig. 310).
Provenance: From Iran.

3:2 3:2

121 *Pink agate scaraboid with high sides*

24.0 × 19.2 × 12.7 mm
Graeco-Persian, fourth century B.C.
85.AN.370.27

Description: Nude male figure standing left with legs crossed leaning on a spear; he wears a cloak and a turbanlike headdress of uncertain type; short groundline.
 Narrow drill hole.

Discussion: The identity of the figure is uncertain, but the hooked nose is a typical stylization for representing Persians. The style belongs to Boardman's Bern Group of late Graeco-Persian works, characterized by the summary, stylized work and the frequent use of the drill for modeling. The shape of the scaraboid and the narrow drill hole are also typical of the group (see Boardman, *GGFR*, p. 321; the shape is similar to that of a chalcedony gem of *a globolo* style, Boardman, *Intaglios and Rings*, no. 107 = Getty Museum 81.AN.76.107).
Provenance: From Iran.

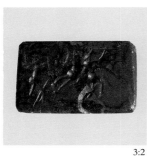
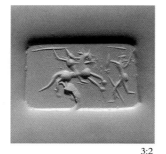

3:2 3:2

122 *Mottled jasper tabloid*

21.7 × 13.5 × 9.0 mm
Graeco-Persian, fourth century B.C.
85.AN.444.16

Description: Horseman, right, fighting a foot soldier.
 Engraved only on the bottom.
Discussion: The work is closely related to the Bern

123 *Gray chalcedony scaraboid of nearly hemispherical shape*

21.6 × 18.4 × 10.5 mm
Graeco-Persian, fourth–third century B.C.
85.AN.300.1

Description: Recumbent lion left; a "taurine" symbol in upper right field.
Discussion: Gems of this style are distinguished by the simple use of a large drill for the body modeling and a small drill for the details; Boardman uses the term *a globolo*. Animals, especially lions, zebu bulls, and monsters, including sphinxes and winged creatures, are the favorite motifs. They have a wide distribution, which is predominantly Eastern, including eastern Anatolia, Egypt, Syria-Phoenicia, Iran, Samarkand (K. Trever, *Pamyatniki Greko-baktriiskogo iskusstva* [Moscow and Leningrad, 1940], pp. 135–139, nos. 43–45, pl. 38), and a large number from Taxila (Boardman, *GGFR*, p. 438, nos. 397–399; others in the Victoria and Albert Museum, unpublished) and northern India. The style is remarkably consistent, however, and most workshops were probably in eastern Anatolia or Syria (see Boardman, *GGFR*, p. 322) rather than farther east.
 For similar lions (one winged), see Boardman, *GGFR*, p. 438, nos. 383–386, pls. 983–984. The "taurine" symbol, resembling a bucranium, appears frequently on gems of this class (see also a gold ring from the Oxus treasure, O. M. Dalton, *The Treasure of the Oxus* [London, 1964], no. 105), but its meaning is uncertain.

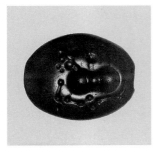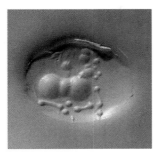

124 Chalcedony scaraboid, crudely shaped

15.2×12.4×6.8 mm
Graeco-Persian, fourth–third century B.C.
85.AN.300.2
Description: Winged sphinx with headdress right.
Discussion: *A globolo* style; two other similar examples are in Malibu (Boardman, *Intaglios and Rings*, nos. 108–109 = Getty Museum 81.AN.76.108–109).

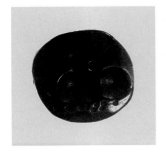

125 Orange carnelian scaraboid, unevenly shaped, the face nearly circular

13.9×13.3×5.2 mm
Graeco-Persian, fourth–third century B.C.
85.AN.300.3
Description: Recumbent zebu bull right.
Discussion: *A globolo* style; close to Boardman, *GGFR*, p. 438, no. 388, pl. 985.

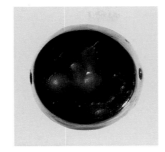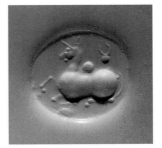

126 Dark brown agate scaraboid with high sides and circular face

Diameter of face, 15.8 mm; height, 8.0 mm
Graeco-Persian, fourth–third century B.C.
85.AN.300.5
Description: Recumbent zebu bull left; "taurine" symbol to right.
Discussion: *A globolo* style; close to Boardman, *GGFR*, p. 438, no. 391, pl. 986, and see above.

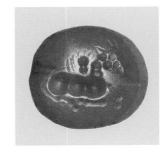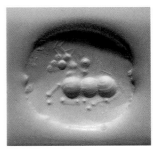

127 Pale blue chalcedony scaraboid, nearly hemispherical

15.6×14.4×8.2 mm
Graeco-Persian, fourth–third century B.C.
85.AN.444.19
Description: Recumbent zebu bull left.
 The face is slightly convex, and the sides are roughly finished.
Discussion: *A globolo* style; see above for the type.
Provenance: From Iran.

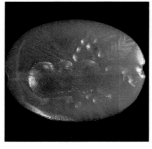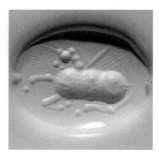

128 Orange carnelian scaraboid, hemispherical

18.8 × 14.3 × 7.7 mm
Graeco-Persian, fourth–third century B.C.
85.AN.444.20
Description: Recumbent winged zebu bull left.
 The face is slightly convex, and the sides are roughly finished.
Discussion: *A globolo* style, see above.
Provenance: From Iran.

ACHAEMENID GLASS CONOIDS, SCARABOIDS, AND TABLOIDS

Along with cylinder and stamp seals in hard stone, Achaemenid workshops in the East produced examples in glass. They have not been studied in detail, but a large number has been noted in catalogues (see Boardman, *GGFR*, p. 415, for a list; add: *Oxford Stamp Seals*, pp. 75–76, nos. 452, 458–460, 507–520, with literature; D. Barag, *Catalogue of Western Asiatic Glass in the British Museum*, vol. 1 [London, 1985], nos. 96–97, 99–106; *Geneva*, vol. 3, nos. 31–45; many cylinder seals also exist). The devices are usually the conventional Achaemenid types, with the royal hero fighting animals especially popular.

Another series of glass intaglios are tabloids of opaque blue glass the color of lapis lazuli. Despite a fair number appearing on the market, they have seldom been published, and the only examples from recorded archaeological contexts are the large number found in Soviet Georgia in tombs dating from the fourth through first century B.C. (and one from the fourth century A.D., information from Professor Boardman; see also Boardman, *GGFR*, pp. 322, 415, 438, no. 377 = *Geneva*, vol. 1, no. 147, which is incorrectly dated; M. N. Lordkipanidze, *Eirene* 9 [1971], pp. 104–105 n. 4, pl. 1; idem, *Gemmy gosudarstvennogo Muzeya Gruzii*, vol. 3 [Tbilisi, 1961], pp. 74–75, nos. 43–51, pl. VII; idem, *Korpus pamyatnikov gliptiki drevnei Gruzii*, vol. 1 [Tbilisi, 1969], pl. VI, nos. 76–101; and idem, *Tbilisi: Sites archéologique* [Tbilisi, 1978], color plate XII.5). At least a dozen others from uncertain sites, apparently in eastern Anatolia and Syria, have appeared on the market (all unpublished; impressions are in Oxford). They are all very similar in shape and color and may be from a single workshop, probably located in eastern Asia Minor or Syria. The shape is copied from a standard one, usually of chalcedony or jasper (see cat. no. 122, above), used in the Graeco-Persian series.

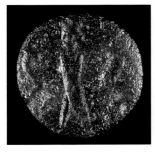
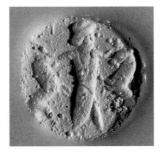

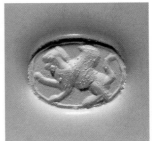
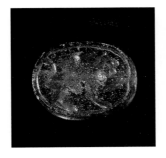

129 Green glass conoid

Height, 16.8 mm; diameter of the face flat, 17.9 mm
Achaemenid, fifth–fourth century B.C.
83.AN.437.11
Description: Royal hero right, holding two goats by the horns.
Discussion: Conoids of similar shape and motif include D. Barag, *Catalogue of Western Asiatic Glass in the British Museum*, vol. 1 (London, 1985), nos. 100–104; and *Geneva*, vol. 3, nos. 38–45.
Provenance: From Asia Minor.

131 Blue glass scaraboid with straight sides

14.3 × 11.4 × 6.5 mm
Achaemenid, late sixth–fifth century B.C.
84.AN.1.7
Description: Winged animal (lion?) standing left, one foot raised; linear border.
Excellent condition.
Discussion: The shape and style are particularly close to a glass scaraboid in Berlin from Adalia, which depicts a lion (*Berlin*, no. 204).
Provenance: From Asia Minor.

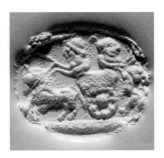
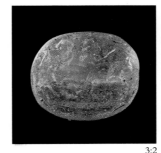

3:2

130 Pale blue glass conoid

Height, 20.0 mm; diameter of the face, 16.0 mm
Achaemenid, fifth–fourth century B.C.
84.AN.1.19
Description: The type is similar to catalogue number 129, above, but the royal hero holds two winged creatures; groundline.
The surface is corroded.
Provenance: From Asia Minor.

132 Colorless glass scaraboid

19.5 × 16.5 × 9.1 mm
Achaemenid, fifth–fourth century B.C.
85.AN.370.28
Description: Horse and chariot to left; the wheel has eight spokes; the driver holds a whip, and behind him stands a Persian to right who fights a standing lion; thick (cross-hatched?) groundline.
The surfaces are slightly corroded.
Discussion: The motif and the details are Achaemenid (other glass scaraboids in London, D. Barag, *Catalogue of Western Asiatic Glass in the British Museum*, vol. 1 [London, 1985], no. 97; Oxford, *Oxford Stamp Seals*, no. 513; Paris, L. Delaporte, *Arethuse* 5 [1928], p. 48, no. 24, de Luynes no. 195; and Berlin, *Berlin*, no. 208), but a very

similar scene also appears on Graeco-Phoenician green jasper scarabs (see Boardman, *Escarabeos*, nos. 80–81, from Ibiza).

Provenance: From Asia Minor.

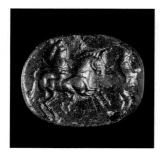 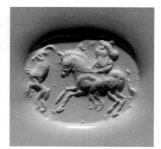

133 Brown glass scaraboid with straight sides

16.5 × 12.4 × 7.1 mm
Achaemenid, fifth–fourth century B.C.
84.AN.984

Description: Horseman, to left, pursuing a standing goat. There are small chips around the face, but the surfaces are in excellent condition.

Discussion: The style is close to the preceding examples (another scaraboid in green glass, purchased in Smyrna, *Oxford Stamp Seals*, no. 516). Hunting scenes are especially popular on Graeco-Persian hard-stone scaraboids (and see the motif on a bronze ring, Boardman, *GGFR*, p. 438, no. 413, pl. 992).

 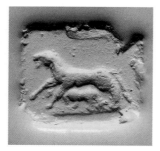

134 Opaque blue glass tabloid

17.2 × 15.1 × 8.8 mm
Achaemenid (Syrian?), fourth century B.C.
85.AN.444.17

Description: A horse to left with foal.
Worn, with some chips on the face.

Discussion: For the group of blue glass tabloids, see above p. 64. The same motif is found among the glass tabloids of this class from Soviet Georgia (see M. N. Lordkipanidze, *Gemmy gosudarstvennogo Muzeya Gruzii*, vol. 3 [Tbilisi, 1961], nos. 47, 49, pl. VII; idem, *Korpus pamyatnikov gliptiki drevnei Gruzii*, vol. 1 [Tbilisi, 1969], pl. VI, nos. 75, 77).

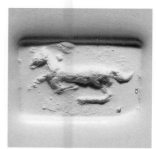 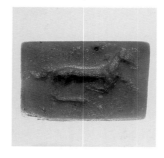

135 Opaque blue glass tabloid

17.1 × 11.3 × 7.3 mm
Achaemenid (Syrian?), fourth century B.C.
85.AN.444.18

Description: Horse running left.
Worn, with some chips from the face.

Discussion: For the group of blue glass tabloids, see above, p. 64 (the impression of a second example, said to be from Asia Minor, is in Oxford).

ACHAEMENID RINGS

Boardman has briefly discussed the series of gold, silver, and bronze rings that display Achaemenid motifs (Boardman, *GGFR*, pp. 322, 438–439; see also, *Oxford Stamp Seals*, pp. 85–86, with further literature). They are primarily from Eastern sites, and ring impressions have been found at Persepolis, Nippur, Ur, and Samaria. The ring shapes are similar to contemporary Greek ones but are usually simpler.

3:2

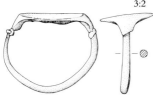

136 Silver ring, Type VII

Bezel, 18.2 × 15.0 mm; greatest diameter of hoop, 26.0 mm
Achaemenid, fourth century B.C.
85.AN.444.30
Description: Persian woman sitting left before a thymiaterion, holding a phiale.
The ring has an oval bezel and thin hoop; the bezel was attached to the hoop, and there is a thicker collar at one of the joins.
Worn.
Discussion: A very similar ring from Mersin is now in Munich (Boardman, *GGFR*, p. 438, no. 409, pl. 990; see also nos. 410–411, gold rings from the Oxus treasure).

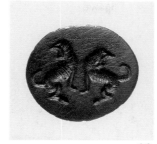
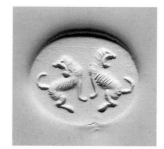

3:2 3:2

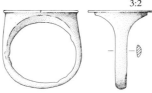

137 Bronze ring, Type VI, with large oval bezel, approaching Type XI

Bezel, 20.3 × 17.8 mm; greatest diameter of hoop, 21.2 mm
Achaemenid, fourth century B.C.
85.AN.370.17
Description: Two lions confronted with heads turned back.
Brown patina with some corrosion and scratches in the field.
Discussion: The motif is seen on an impression, perhaps from a ring, found at Persepolis (E. F. Schmidt, *Persepolis*, vol. 2 [Chicago, 1957], p. 41, no. 77, pl. 14).
Provenance: From Israel.

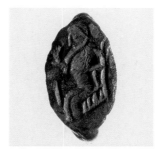
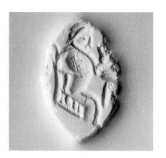

138 Bronze ring, Type III, with pointed oval bezel

Bezel, 17.2 × 9.8 mm; greatest diameter of hoop, 19.4 mm
Achaemenid, fourth century B.C.
85.AN.370.29
Description: Bearded male figure seated right before a thymiaterion.

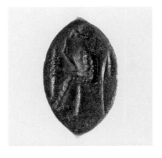
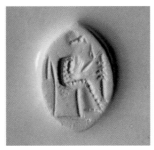

139 Fragmentary bronze ring, probably Type III

15.5 × 10.0 mm
Achaemenid, fourth century B.C.
85.AN.444.31
Description: Same type as catalogue number 138, above.
Only the bezel is preserved.

ETRUSCAN SCARABS

Influenced by Archaic Greek gems and probably also by immigrant Greek artists, the Etruscans enthusiastically accepted engraved scarabs. By the end of the sixth century B.C., scarabs were already produced in a number of workshops in Etruria, and their popularity continued until the second century B.C., when ringstones, which had been coming into fashion for some time, finally replaced them. Several thousand scarabs have survived, and most have been compiled by Zazoff (Zazoff, *ES*, and Zazoff, *AG*, pp. 214–259, with literature; for other Etruscan scarabs in the Getty Museum, see Boardman, *Intaglios and Rings*, nos. 121–148, 150–153, 155–204).

The earliest examples of Etruscan scarabs are close in style to Late Archaic Greek gems, although they already display the stylizations and subject matter especially popular in Etruria, which contrast with Greek types. The Archaic style is followed by a fifth-century Classical style (Zazoff's *Strenger Stil* being a misleading term), a more developed late fifth- and fourth-century style (*Freier Stil*), and a Late Etruscan, Hellenistic style (*Spätetruskischer Freier Stil*). Contemporary with the Free-Style scarabs of the fourth century and later is the most numerous class of scarabs, which is distinguished by the simple engraving technique using large and small drills for the modeling and details and thus named the *a globolo* style.

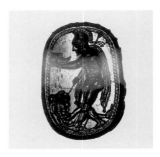
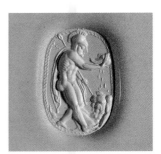

140 Banded agate scarab, brown and white

16.5 × 11.3 × 8.6 mm
Etruscan, early Free Style, early fourth century B.C.
L87.AN.114
Description: Warrior, nude but for a cloak tied at the neck

and wearing a crested helmet, standing right; he holds a spear over his left shoulder, and in his outstretched right hand is a severed, bearded head dripping blood; the decapitated body lies at his feet; hatched border.

The head of the scarab is carefully carved; a hatched border outlines the thorax; the elytra are outlined by a raised border and separated by a raised ridge with groove; the legs are in relief and realistically detailed; the winglets are small and V-shaped; the plinth is decorated with a tongue pattern.

Discussion: The mutilation of the bodies of enemies (*maschalismoi*) is especially common on Etruscan gems (see *Harari coll.*, no. 25; Furtwängler, *AG*, vol. 3, p. 201; Beazley, *Lewes House*, no. 90) and ringstones (see Martini, *Etruskische Ringsteinglyptik*, p. 34). This particular scene may represent Amphiaraos or Tydeus with the head of Melanippos.

Provenance: Ex-Harari, Southesk, and Montigny collections.

Bibliography: *Harari coll.*, no. 25; Zazoff, *ES*, no. 1108; *Southesk coll.*, no. A 6; W. Froehner, *Collection de M. de Montigny, Pierres gravées, vente 23–25 mai, 1887*, no. 176; Furtwängler, *AG*, pl. 20.21.

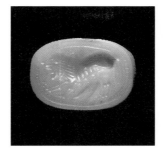
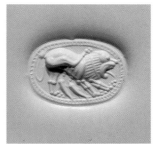

142 *Banded agate scarab, yellow on top, white in the middle, and gray below*

14.2×9.9×6.0 mm
Etruscan, early Free Style, early fourth century B.C.
82.AN.162.18

Description: Lioness standing right, her right hind leg raised, suckling two dolphins; hatched border.

The scarab has been cut down, but the double line separating the head from the thorax, the relief legs with hatched forelegs, and the hatched plinth are preserved.

Discussion: For a sow suckling dolphins on a scarab in Vienna, see *Vienna Gems*, vol. 1, no. 52.

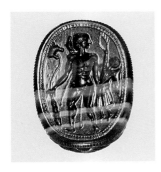
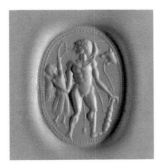

141 *Banded agate scarab*

18.3×13.7×9.0 mm
Etruscan, early Free Style, early fourth century B.C.
85.AN.123

Description: Herakles standing to front; his torso and right leg are frontal, his left leg in profile to right; his head, unbearded, is turned left. He wears a lionskin tied around his neck and leans on a club with his left hand. Nike flies upright to his left, holding his arm in her right hand and crowning him with a wreath. To the right is a lion's-head spout pouring water from its mouth; hatched border.

The scarab is carefully cut, with legs in low relief and detailed head; the elytra are outlined, and there is a low ridge; the thorax has a hatched edge; the plinth is hatched.

Discussion: For the motif, see Zazoff, *ES*, nos. 72, 183; *LIMC*, vol. 5, p. 239, no. 407, s.v. Herakles/Hercle.

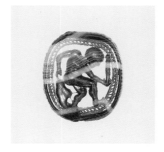
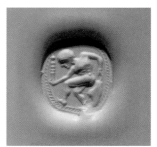

143 *Banded agate scarab, black and white*

12.7×10.9×8.2 mm
Etruscan, Free Style, fourth century B.C.
81.AN.76.9

Description: Diomedes carrying the Palladion left; hatched border.

The thorax of the scarab is hatched; the elytra are outlined; the winglets are V-shaped; the legs are in relief, and the forelegs are hatched; the plinth is hatched. The scarab is pierced lengthwise, but also from side to side below the forelegs, apparently for suspension.

Discussion: The identification is not certain, since the object carried is rendered in *a globolo* style, but the pose is most appropriate for this scene. Alternatively, Herakles can carry his club upright in this manner (see Zazoff, *ES*,

no. 100, and Sternberg, Zurich, auction 22, 1989, lot 490; see also *Thorvaldsen*, no. 57 = Zazoff, *ES*, no. 664, which may also represent Diomedes rather than Herakles). The style, which Zazoff has termed Transitional (Zazoff, *ES*, p. 88), combines the Free Style with elements of the *a globolo* technique.

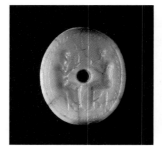

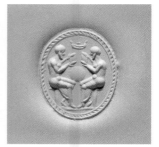

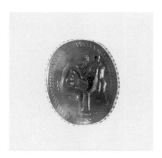 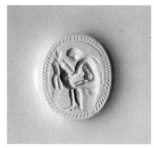

144 *Carnelian scarab*

12.5 × 10.3 × 7.0 mm
Etruscan, Late Etruscan Free Style, third–second century B.C.
82.AN.162.15

Description: Prometheus sitting left on rocks, constructing a man.

The scarab is nearly hemispherical; the legs, head, winglets, and outline of thorax and elytra are incised lines. The plinth is hatched.

There is a large chip from the face, disturbing the engraved device.

Discussion: The motif is popular on Late Etruscan and Italic ringstones (see Zazoff, *ES*, nos. 171, 1204 = *BMC Gems*, no. 956; also the Late Etruscan scarab, Boston 62.184, C. C. Vermeule, *Bulletin of the Museum of Fine Arts, Boston* 64, no. 335 [1966], p. 25, fig. 10; and cat. no. 200, below). The shape of the scarab is typical of the Late Etruscan Free Style (see Zazoff, *AG*, p. 240).

145 *Banded agate scarab*

13.5 × 11.5 × 7.0 mm
Etruscan, Late Etruscan Free Style, third–second century B.C.
82.AN.162.14

Description: Two bearded (bald?) men seated on stools reading from book rolls; their lower bodies are draped; a burning double-spouted lamp hangs from the ceiling; hatched border.

The top of the scarab is brown and the bottom white. The shape is similar to catalogue number 144, above, the elytra are outlined; the thorax is hatched; the winglets are distinguished by two diagonal lines; the legs are carved in low relief; the plinth is hatched. The scarab is pierced through the top and face rather than lengthwise.

Discussion: The type appears to be otherwise unattested.

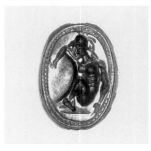 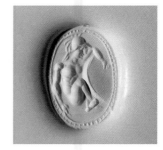

146 *Light brown and green agate scarab*

15.3 × 10.8 × 6.7 mm
Etruscan, Late Etruscan Free Style, third–second century B.C.
82.AN.162.16

Description: The Spartan hero Othryades (see Herodotos 1.82), nude and helmeted, sitting on groundline behind his shield, writing on it with blood.

The scarab is flatter and less round than the preceding two; the head and thorax are hatched; three grooves separate the outlined elytra; the winglets are distinguished by two parallel lines; the plinth is undecorated.

Discussion: The theme is found on Etruscan ringstones (Zazoff, *AG*, p. 257, pl. 66.4) and becomes very popular in the Roman Republican period (see ibid., p. 300; A. E. Knight, *The Collection of Camei and Intagli at Alnwick Castle, Known as "The Beverley Gems"* [privately printed, 1921], no. 181), but this example appears to be the only recorded scarab with the motif. For the motif on gems, see J. P. Guépin, *Bulletin van de Vereeniging tot Bevordering der Kennis van de Antieke Beschaving* 41 (1966), pp. 57–76, who suggests a fourth-century B.C. Tarentine prototype.

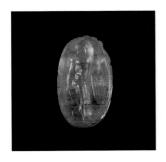
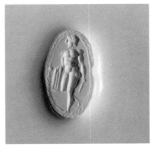

147 Light brown agate scarab

12.8 × 7.9 × 5.9 mm
Etruscan, Late Etruscan Free Style, third–second century B.C.
82.AN.162.17
Description: Nude youth standing left, holding a sword in his left hand and a garment draped over his right arm; hatched border.

The scarab is deeply undercut; the legs are in high relief; the elytra are outlined and the winglets distinguished by two incised lines; the thorax is hatched.

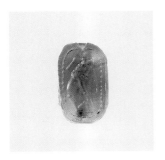
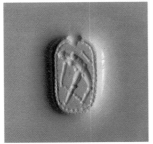

148 Carnelian scarab

11.3 × 6.8 × 5.2 mm
Late Etruscan or Italic, third–second century B.C.
82.AN.162.8
Description: Athlete scraping himself with a strigil; groundline; combination linear and pellet border.

The scarab is simple with elytra divided by crudely incised lines, hatched thorax, and crude legs in relief.
Discussion: The motif is a common one, but the style is difficult to categorize. The scarab may be from an Italic rather than an Etruscan workshop, although no very close parallels are apparent (see Zazoff, *AG*, pp. 302–305, for Italic scarabs; and the style of *BMC Gems*, no. 778).

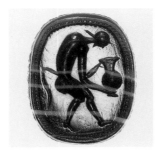
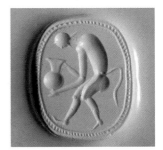

149 Banded agate scarab, black and white

18.3 × 14.8 × 9.1 mm
Etruscan, early *a globolo* style, fourth century B.C.
83.AN.437.15
Description: Satyr walking left, holding an amphora; hatched border.

The scarab is carefully cut; the legs are in relief; the thorax, elytra, and winglets are bordered by hatched lines; the head is hatched; the plinth is decorated with bands of diagonally hatched lines (see Zazoff, *AG*, p. 226, fig. 57g).
Discussion: The motif is a popular one (see Zazoff, *ES*, nos. 111, 227, 1272, 1274; Boardman, *Intaglios and Rings*, no. 136 = Getty Museum 81.AN.76.136).

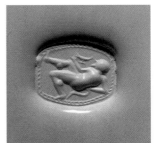
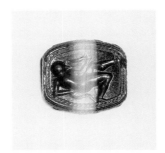

150 Banded agate scarab, black/white/black

11.5 × 10.2 × 8.3 mm
Etruscan, early *a globolo* style, fourth century B.C.
82.AN.162.10

Description: Satyr reclining left, leaning on his right elbow and holding a kylix in his left hand; he plays the kottabos game; hatched border.

The scarab is simple, with relief legs and hatched lines around the elytra; the winglets are distinguished by V-shaped marks; the plinth is hatched.

Discussion: The same scene is found on an earlier Etruscan scarab in Hamburg (Zazoff, *ES*, no. 56).

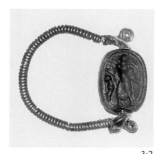
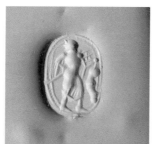

3:2

151 Carnelian scarab in gold ring

Scarab, 12.6×9.1×6.3 mm; greatest diameter of hoop, 20.3 mm

Etruscan, *a globolo* style, fourth–third century B.C.
80.AN.67

Description: Female(?) figure in a long dress holding a long staff (trident? kerykeion? thyrsos?) and an animal by the hind legs; hatched border.

The scarab is carefully cut, with relief legs, V-shaped winglets, and hatched thorax and plinth. The hoop is a gold wire with eye-shaped terminals; another gold wire is tightly coiled along its entire length; a third, short wire is passed through the scarab and then passes through the terminal "eyes," through two cup-shaped terminals, and ends in tight spirals.

Discussion: The figure may be a maenad, an uncommon type for Etruscan scarabs (see Zazoff, *ES*, no. 212.1044); the pose is also close to an Archaic Etruscan scarab depicting Hermes (see Zazoff, *ES*, no. 33).

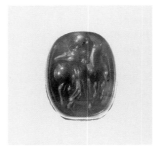
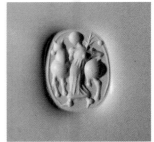

152 Carnelian scarab

12.2×10.1×7.2 mm
Etruscan, *a globolo* style, fourth–third century B.C.
81.AN.76.149

Description: Artemis, in long dress and holding a branch, standing by a deer.

The scarab is simple, with incised legs and outlined elytra with winglets distinguished by three diagonal lines; the plinth is plain.

Discussion: The motif is common on Etruscan scarabs (see Zazoff, *ES*, nos. 346–349).

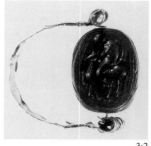
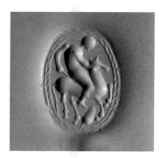

3:2

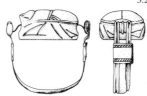

153 Carnelian scarab in gold ring

Scarab, 15.5×12.1×8.2 mm; diameter of hoop, 20.0 mm
Etruscan, *a globolo* style, fourth–third century B.C.
84.AN.987

Description: Horseman riding right, holding a spear in his right hand; an uncertain object is below; hatched border.

The scarab is simple, with incised legs, outlined elytra, and winglets distinguished by three diagonal lines; the plinth is plain. The hoop is a flat band with two parallel grooves running the length of the outside; two flat strips decorated with two parallel bands of hatched lines are wrapped around the hoop below the terminals, which

are pegged joints holding the wire that passes through the scarab.

Discussion: The motif is a common one (close to Zazoff, *ES*, no. 283; see also nos. 1208ff., and Boardman, *Intaglios and Rings*, nos. 186–188 = Getty Museum 81.AN.76.186–188). The ring shape is also seen on several other examples (Berlin, Greifenhagen, *Schmuckarbeiten*, pl. 57.19–21; *Berlin*, no. 269; *Vienna Gems*, vol. 1, no. 42; *BMC Rings*, no. 343 = Zazoff, *AG*, pl. 62.11).

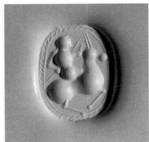

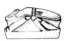

154 *Carnelian scarab*

14.5 × 11.2 × 8.5 mm
Etruscan, *a globolo* style, fourth–third century B.C.
84.AN.1.26

Description: Man, holding a spear, riding a stag right; hatched border.

The scarab is carefully cut, with relief legs, hatched thorax, outlined elytra, and V-shaped winglets with three incised lines; the plinth is plain.

Discussion: For the type, see Boardman, *Intaglios and Rings*, no. 189 = Getty Museum 81.AN.76.189.

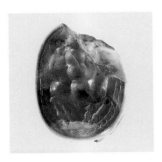
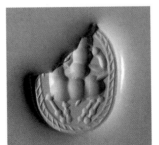

155 *Carnelian scarab*

15.6 × 12.5 × 9.5 mm
Etruscan, *a globolo* style, fourth–third century B.C.
82.AN.162.7

Description: Man riding a stag(?) left; hatched border.

The legs are in relief; the thorax is hatched and the elytra outlined; the winglets are distinguished by a single diagonal line; the plinth is plain.

There are large chips from the back and the face of the scarab. Bronze accretions remain in the drill hole.

Discussion: The type is like catalogue number 154, above.

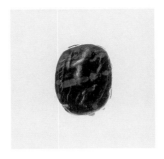
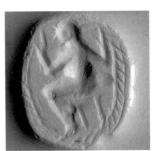

4:1

156 *Obsidian scarab*

10.2 × 7.9 × 6.1 mm
Etruscan, *a globolo* style, fourth–third century B.C.
82.AN.162.12

Description: Figure seated to left with both arms raised; hatched border.

The scarab is small and plump; the legs are in relief; the thorax is hatched; the elytra are outlined and separated by a central groove; the plinth is plain.

Discussion: The motif is uncertain but may represent Atlas, who is seen on another Etruscan scarab in a similar pose (*BMC Gems*, no. 616 = Zazoff, *ES*, no. 383).

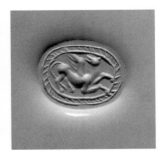

157 *Banded agate scarab, brown/white/ black*

12.5 × 10.2 × 7.5 mm
Etruscan, *a globolo* style, fourth century B.C.
82.AN.162.9

Description: Chimaira to right; hatched border.

The scarab is carefully cut, with relief legs and thorax and elytra outlined with double incised lines; the plinth is hatched.

Discussion: The motif is very popular on Etruscan scarabs (see Zazoff, *ES*, nos. 386–396; Boardman, *Intaglios and Rings*, nos. 182–183 = Getty Museum 81.AN.76.182–183).

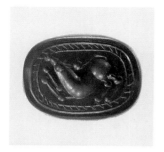

158 Carnelian scarab

16.0 × 12.1 × 8.8 mm
Etruscan, *a globolo* style, fourth–third century B.C.
82.AN.162.5

Description: Dog running right; hatched border.

The legs of the scarab are incised; the thorax is hatched; the elytra are outlined; the winglets are distinguished by two diagonal lines; the plinth is plain.

Discussion: Dogs are an especially popular motif on Etruscan scarabs (see Zazoff, *ES*, nos. 1386–1426; Boardman, *Intaglios and Rings*, nos. 195–196 = Getty Museum 81.AN.76.195–196; and cat. no. 159, below).

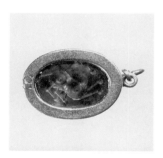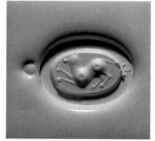

159 Carnelian scarab in modern gold setting

Scarab, circa 14 × 10.5 × 8 mm
Etruscan, *a globolo* style, fourth–third century B.C.
82.AN.162.6

Description: Dog running left; linear border.

The legs of the scarab are incised; two double incised lines separate the wing cases of the elytra and the elytra from the thorax.

Discussion: For the motif, see catalogue number 158, above.

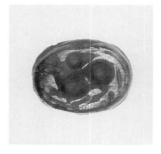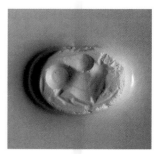

160 Brown agate scarab

13.2 × 10.7 × 8.7 mm
Etruscan, *a globolo* style, fourth–third century B.C.
82.AN.162.2

Description: Bull kneeling right, an uncertain object above; linear border.

The scarab is simple but unusual for its ridge carination; the legs are incised; the plinth is plain.

Worn, with chips from the back and face.

Discussion: Bulls are rare on Etruscan scarabs (see Boardman, *Intaglios and Rings*, no. 197, with notes), but do appear with Europa (Zazoff, *ES*, nos. 411–412), a scene which may be intended here.

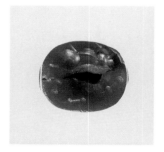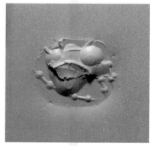

161 Carnelian scarab

12.3 × 10.3 × 7.1 mm
Etruscan, *a globolo* style, fourth–third century B.C.
82.AN.162.3

Description: Uncertain quadruped to left; no border.

Very simple scarab with incised lines distinguishing thorax from elytra and wing cases; three diagonal lines distinguish the winglets; there are no legs; the plinth is plain.

A large chip is broken from the face, damaging the device.

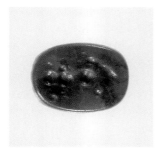
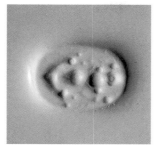

162 Carnelian scarab

13.4×10.0×8.5 mm
Etruscan, *a globolo* style, fourth–third century B.C.
82.AN.162.4

Description: Animal seen from above.

Very simple scarab with incised legs, outlined elytra and thorax; the plinth is plain.

The scarab is very worn.

Discussion: Animals are frequently shown in this manner on Etruscan scarabs (see Zazoff, *ES*, no. 1448 = Furtwängler, *Beschreibung*, no. 279, for a similar example; no. 1448, for a list of other examples).

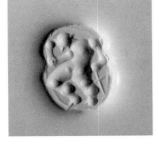

163 Carnelian scarab

13.2×10.1×6.8 mm
Etruscan, *a globolo* style, fourth–third century B.C.
84.AN.1.27

Description: Male figure to left, holding staff.

Very simple beetle; the legs are incised; incised lines distinguish thorax from elytra; three diagonal lines distinguish the winglets; the plinth is plain.

There is a chip from the back.

Discussion: For a similar representation, see Zazoff, *ES*, no. 1054 = Furtwängler, *Beschreibung*, no. 257; also Boardman, *Intaglios and Rings*, no. 173 = Getty Museum 81.AN.76.173, for the style.

ITALIC, LATE HELLENISTIC, AND ROMAN GEMS

While Greek and Etruscan gems can now be classified into categories generally acceptable in terms of chronology, style, and even workshop, the vast number of gems made in the Roman period present many problems in attribution and dating. Workshops were located in all parts of the empire, most working in similar styles that may have changed little over long periods of time. In the rare cases where artists or workshops are distinguishable by their distinctive style or technique, as with the many signed gems of the Augustan period (see Vollenweider, *Steinschneidekunst*), their geographic origins can seldom be established. There is clear evidence both that gems traveled widely and that gems of similar style were manufactured in many different centers, a situation that helps confound specific attributions. Even fundamental chronology is difficult, and the date of some Roman gems cannot be determined more precisely than "first to third century A.D."

Find sites of gems are largely inconclusive in regard to localizing workshops, since more often than not the gems found at each site do not display a uniform style (for a summary of find sites, see Zazoff, *AG*, pp. 261–268, Italic gems; and pp. 307–314, for Roman imperial gems; and most recently, Guiraud, *Gaule*, for gems found in France). There can be little doubt that local workshops existed in many large cities, and in some cases traces of workshops have been found, identifiable by unfinished gems in various states of preparation. Aquileia is one such site and was no doubt the center of a major workshop (see *Aquileia*, pp. 10–11), but Sena Chiesa's categorization of gems found there into a series of local workshops is not entirely convincing, since many may have been imports. A find of gems in a house at Pompeii has been viewed as evidence for a local gem engraver's workshop (see V. Spinazzola, *Pompei alla luce degli scavi nuovi di via dell'Abbondanza (anni 1910–1923)*, vol. 2 [Rome, 1953], p. 707, figs. 677–678; U. Pannuti, *Bollettino d'Arte* 60 [1975], pp. 178–190), but the gems exhibit no coherent style and are more likely the stock of a gem importer or collector; it is not possible to determine which of the many gems found in the city are local works, although they do provide a body of material with a useful terminus ante quem. Sardis

(from which Pliny *Naturalis Historia* 37.105 erroneously derives the word *sard*) certainly had workshops in the Roman imperial period, as a remarkable excavation find of unfinished gems and chips demonstrates (see *Bulletin of the American Schools of Oriental Research* 249 [1983], pp. 28–29, fig. 36), and an eighteen-year-old gem engraver (*daktylokoiiloglyphos*) from Sardis is named on a tombstone from Philadelphia in Lydia (see A. Kontoleon, *Athenische Mitteilungen* 15 [1890], pp. 333–334; Furtwängler, *AG*, vol. 3, p. 399; G. M. A. Hanfmann, *Sardis from Prehistoric to Roman Times* [Cambridge, Massachusetts, 1983], p. 10 n. 7); here too, however, the style of the local workshop cannot be distinguished. Henig in his studies of the gems found in Britain has occasionally noted possible local works, but only two finds are significant, a votive offering from Bath that may be the work of a local first-century-A.D. workshop (see M. Henig, in B. W. Cunliffe, ed., *The Temple of Sulis Minerva at Bath*, vol. 2, *The Finds from the Sacred Spring* [Oxford, 1988], pp. 27–33), and a remarkable mid-second-century-A.D. hoard found in 1985 at Snettisham in Norfolk of more than a hundred carnelian gems, some in silver rings, all apparently from the same workshop (ibid., p. 28; T. Potter, *Antiquity* 60 [1986], pp. 137–139; they are now in the British Museum, and publication is forthcoming). The locations of hundreds of other workshops are entirely unknown.

With the paucity of conclusions that can be drawn from find sites and archaeological evidence, various types of stylistic criteria must be used. These may include the types and shapes of gemstone, engraving style, iconography, and settings in datable rings and jewelry (see the discussions, Henig, *Roman Engraved Gemstones*, pp. 31–40, and idem, *Journal of Roman Archaeology* 1 [1988], pp. 142–152; *The Hague*, pp. 60–62; *Vienna Gems*, vol. 1, pp. 11–18; Guiraud, *Gaule*, pp. 35–60; G. Sena Chiesa and G. M. Facchini, in H. Temporini, ed., *Aufsteig und Niedergang der römischen Welt*, vol. 2.12.3 [Berlin, 1985], pp. 3–31). Already at the end of the nineteenth century, Furtwängler in his catalogue of the Berlin collection (Furtwängler, *Beschreibung*) saw the value of grouping gems by material and shape, and that catalogue remains as valid as most modern publications. Recently, Maaskant-Kleibrink (*The Hague*) has attempted an ambitious classification of gems by carefully studying the engraving techniques. Some convincing classifications are made, notably in the early groups (first century B.C. and Augustan

period), but attributions to specific workshops, geographical localization, and chronology are largely inconclusive. Nevertheless, this more careful approach to technical aspects is surely one key to future study.

The last few decades have seen a welcome flurry of publications of museum collections. However, most gems, indeed tens of thousands, remain in unpublished collections, and any conclusive study is a long way off. In the meantime, much could be learned from a variety of studies. Gems found in archaeological context are rare but always useful (see above). Careful attention to shapes and materials, which reflect changing tastes and have stylistic and chronological implications, are of primary importance. Especially useful would be a study of Roman portraits on gems, generally datable on stylistic grounds, which could demonstrate when certain shapes, materials, and engraving styles were current.

The Roman period gems in the Getty Museum are arranged by a variety of criteria. Several groups of second–first-century-B.C. gems attributable to Italian workshops have long been recognized. Some are closely related to the Late Etruscan workshops that also produced scarabs, and others are derivative of the latest Etruscan works, either in technique (*a globolo*), style, or iconography (cat. nos. 164–175, below). The gems catalogue numbers 171–175 belong to the so-called Ornavasso group, which can be distinguished by the *a globolo* technique derived from Etruscan scarabs and the use of strongly convex stones, usually sard or chalcedony. Animals are the preferred devices. The finds from Ornavasso date at least some of the group to the end of the second century B.C. (see Furtwängler, *AG*, vol. 3, p. 276, pl. 29.1–9; *Aquileia*, pp. 17–18, 25–26; *Vienna Gems*, vol. 1, p. 14; *The Hague*, p. 105; Guiraud, *Gaule*, p. 40, type A 3; Zazoff, *AG*, pp. 275–276 nn. 63 and 65, with further references; also a seal impression from Delos, datable before 69 B.C., M. F. Boussac, *Revue archéologique*, 1988, p. 338, fig. 69). Also typical of various Italic works is the use of drilled "pellets" for details (cat. nos. 176–196, below), hatched borders (cat. nos. 164–166, 184, below), and certain distinctive materials, notably banded agate (cat. nos. 167, 169–170, 176–177, 197, below) and white chalcedony (cat. nos. 181, 201, below) (but not garnet, which is more common in the East). Maaskant-Kleibrink has noted a distinctive engraving style (Republican Wheel Style, *The Hague*, pp. 154–155), which is useful for grouping

some gems datable to the mid-first century B.C. (cat. no. 204, below).

Many groups of gems (but only a few in the Getty collection) of the same period can be attributed to non-Italian workshops, probably located in Asia Minor and Syria. The distinction between Late Hellenistic and Early Roman gems becomes blurred and to a large degree a matter of terminology. Like most gems of the period, these gems are difficult to localize and date, but some individual workshops or styles can be recognized. The most common type is characterized by the use of convex garnets (cat. nos. 213–217, below), and these warrant further study. Several other gems in Malibu belong to workshops that cannot be precisely localized but that are distinctive nonetheless (cat. nos. 218–219, below).

During the second half of the first century B.C., the taste in gems turned to the highly classicizing, and the style is easily recognizable. A new range of iconographical types is also seen. However, although gems of this style are rare before the Augustan age, it is unclear how long the types remained current. Shapes and materials are perhaps the best guide for the imperial period, and certain trends in fashion are clear. Gems often have convex faces until the late first century A.D. when they tend to become flat. The more exotic stones, such as amethyst, rock crystal, citrine, and "plasma" are more typical of the first century than later, when jaspers come into fashion. Although carnelian is used in all periods, it can be convex (usually A 4–5) in the first century B.C. but almost always flat (F 1) in later times; it takes the shape of a truncated cone (F 3) only in the late second century A.D. and later.

The gems catalogue numbers 309–327 are in summary style, usually with wheel-cut modeling and little added detail. Because of its simplicity, the technique is often attributed to the later imperial period (second–third century A.D.), but the devices, as well as the materials and shapes of the gems, suggest a first-century date. The presence at Pompeii and Herculaneum of gems of this class confirms that many are indeed of this date, although they no doubt continued to be made well into the second century. They appear to be simpler versions of contemporary intaglios in fine classicizing style. A number of the examples in the Getty have a Tunisian provenance and are likely to be of Italian origin.

ITALIC GEMS: THIRD–FIRST CENTURY B.C.

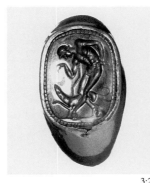 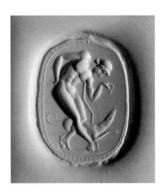

3:2

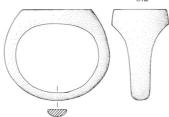

164 Red carnelian in hollow gold ring

18.1 × 13.2 mm; greatest diameter of hoop, 28.0 mm
Third–second century B.C.
85.AN.165

Description: Nude youth standing right, leaning on a crooked staff, his legs crossed and his right arm held behind him; he feeds a dog, which stands beside him and turns its head upward. They stand on a slightly raised, ledgelike exergue; hatched border.

The device is finely modeled, and there is frequent use of small drilled pellets for details. The stone is nearly flat.

Discussion: The motif is common on Archaic Greek gems (see Boardman, *AGG*, nos. 285–287) and also occurs on Etruscan scarabs (see Zazoff, *ES*, no. 91.742). The style, however, is archaizing and not typical of Late Etruscan ringstones (see the similar scene on an Etruscan ringstone, Martini, *Etruskische Ringsteinglyptik*, no. 169 = *Vienna Gems*, vol. 1, no. 124; and Guiraud, *Gaule*, no. 579). It is more likely an Italic work of the third–second century B.C. or perhaps even later, a date for which the ring shape is most suitable. The style, shape, and size relate the work to an intaglio in Berlin (Furtwängler, *Beschreibung*, no. 771).

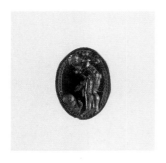
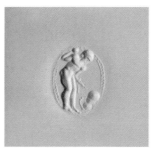

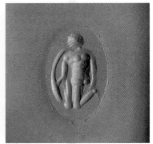

165 Dark brown sard, F 1

10.4×7.8×2.2 mm
Second–first century B.C.
82.AN.162.19

Description: Nude male figure standing right, leaning over; he holds a stone in his right hand; an uncertain object (a branch?) and a pile of stones lie at his feet; hatched border.

Discussion: The scene depicts a Hermes cult, in which travelers place stones on the "Hermes pile" at rustic sites. It is more clearly represented on an Etruscan ringstone in Vienna, where a herm is added, and it appears on Attic vases as well (*Vienna Gems*, vol. 1, no. 126, with literature and discussion; and add an Etruscan ringstone from the Northumberland collection, Sotheby's, London, auction December 13, 1990, lot 83; see also W. Burkert, *Structure and History in Greek Mythology and Ritual* [Berkeley, 1979], p. 41).

167 Banded agate, with pale, translucent brown and white stripes, F 1

13.3×8.7×1.3 mm
Second–first century B.C.
84.AN.1.28

Description: Warrior (of Capaneus type), holding a shield, collapsing to his knees. The technique is *a globolo*.

Discussion: For similar examples, see Martini, *Etruskische Ringsteinglyptik*, nos. 143–145, pl. 28.

Provenance: From Tunisia.

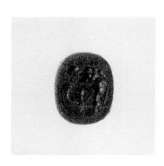
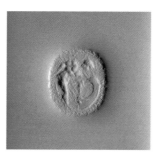
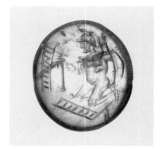
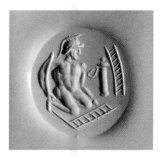

166 Black glass, F 5

10.3×8.1×1.8 mm
Second–first century B.C.
85.AN.370.30

Description: Argos bending over the prow of a ship; his left foot is raised and rests on the ship; hatched border.

The surface is very worn.

Discussion: The motif of Argos building his ship is popular on Etruscan and Italic ringstones (see Martini, *Etruskische Ringsteinglyptik*, nos. 95–98, pl. 19.4–5, for Etruscan ringstones; Furtwängler, *Beschreibung*, nos. 520–526, glass; *BMC Gems*, no. 772, an Italic scarab, and no. 1915, sard).

168 Pale amethyst, A 4, only slightly convex

15.9×13.9×3.5 mm
First century B.C.
83.AN.437.16

Description: Capaneus, nude with helmet and shield, collapsing to his knees; to right are a scabbard and a broken ladder.

Discussion: A duplicate in carnelian is in London (*BMC Gems*, no. 961).

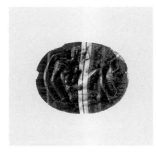
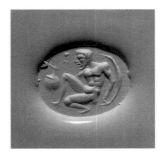

169 Banded agate, black/white/gray, F 1, but with rounded sides

12.3 × 10.0 × 2.8 mm
Second–first century B.C.
82.AN.162.21

Description: Kadmos (or a companion), holding a shield, sitting left, a serpent and a jug before him.

Discussion: The type is seen on Late Etruscan scarabs (see *BMC Gems*, no. 729, and notes) and remains popular on Italic gems (see Zazoff, *AG*, p. 257 n. 260, p. 300 n. 194).

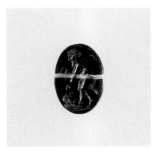
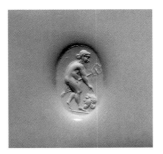

170 Banded agate, black/white/black, A 2

9.8 × 6.9 × 2.3 mm
Second–first century B.C.
82.AN.162.22

Description: Hermes Psychopompos, bearded and with chlamys and kerykeion, stooping over a bearded head; groundline.

Discussion: For the motif, see Furtwängler, *AG*, pl. 21.65–71; the Etruscan scarab, *BMC Gems*, no. 765; *Berlin*, no. 299, with notes; Zazoff, *AG*, p. 256 n. 249, p. 299 n. 190.

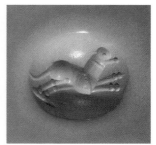

171 Brown chalcedony, C 3

15.5 × 13.6 × 5.6 mm
Late second–early first century B.C.
82.AN.162.23

Description: Dog running right; short groundline.

Traces of bronze adhering to the sides and back; there are some chips from the edges.

Discussion: For very similar dogs, see *The Hague*, no. 86; *Bologna*, no. 21; and M. Maaskant-Kleibrink, *Description of the Collection in the Rijksmuseum G. M. Kam, Nijmegen*, vol. 10, *The Engraved Gems* (Nijmegen, 1986), no. 2.

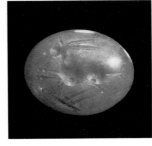
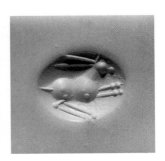

172 Brown chalcedony, B 3

14.7 × 12.1 × 3.8 mm
Late second–early first century B.C.
82.AN.162.24

Description: Hare running right; short groundline.

Discussion: The same style and subject, Furtwängler, *Beschreibung*, no. 1996; *Munich*, pt. 2, nos. 766–769; Guiraud, *Gaule*, no. 673.

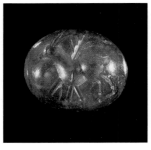
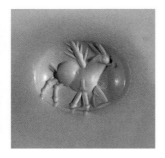

4:1

173 Brown chalcedony, B 3

13.8 × 11.7 × 3.7 mm
Late second–early first century B.C.
82.AN.162.25

Description: Deer standing right, a branch or tree behind; groundline.

Discussion: The same style and subject, Furtwängler, *Beschreibung*, no. 1991.

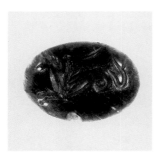
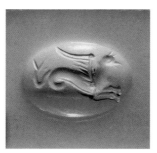

174 Brown sard, A 3

15.9 × 11.2 × 2.9 mm
Late second–early first century B.C.
81.AN.39.9

Description: Sea griffin to right.

Discussion: A similar creature is seen on an Italic gem in Berlin (Furtwängler, *Beschreibung*, no. 2168).

175 Carnelian, A 3

10.0 × 7.3 × 2.4 mm
Late second–early first century B.C.
79.AN.27.1

Description: Stork standing right, its head lowered; groundline.

The sides are unevenly finished.

The surface is worn.

Discussion: Similar examples include Furtwängler, *Beschreibung*, no. 2064, carnelian; *The Hague*, no. 88; *Munich*, pt. 2, nos. 773–776; *Hannover*, no. 224, glass.

Provenance: From Tunisia.

ITALIC PELLET-STYLE GEMS: FIRST CENTURY B.C.

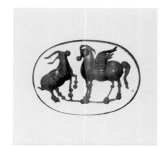
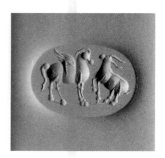

176 Brown agate with thin white bands, F 1

14.5 × 10.7 × 2.2 mm
Early first century B.C.
82.AN.162.26

Description: Winged horse standing right facing a goat; groundline.

Some bronze adhering to the back and sides.

Discussion: For the style, which is related to that of the Ornavasso group but appears on flat stones, see *Bologna*, no. 25; M. Maaskant-Kleibrink, *Description of the collection*

in the Rijksmuseum G. M. Kam, Nijmegen, vol. 10, *The Engraved Gems* (Nijmegen, 1986), no. 5; *Vienna Gems*, vol. 1, no. 142.

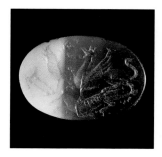

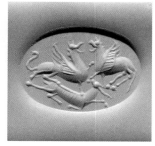

177 Brown and white agate, F 1

17.0 × 11.8 × 2.0 mm
Early first century B.C.
82.AN.162.27
Description: Two griffins, confronted, standing over a fallen stag.
Discussion: The style is the same as catalogue number 176, above.

178 Brown agate with thin white bands, F 1, with straight sides (approaching F 5)

12.3 × 8.6 × 2.2 mm
Second–first century B.C.
82.AN.162.28
Discussion: Lynx standing right; groundline.
Discussion: Similar to the banded agate, Furtwängler, *Beschreibung*, no. 6453; see also *Romania*, no. 79; and *BMC Rings*, no. 396, set in a gold ring from Zakynthos.

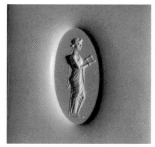

179 Banded agate, black with thin white band, F 1, but unusually elongated and pointed

13.8 × 6.3 × 2.3 mm
Mid-first century B.C.
85.AN.370.42
Description: Muse standing right, holding a book roll; groundline. Drilled pellets are used in the hair, hands, and elbows.
Discussion: A similar scene in the same material and from a related workshop, Furtwängler, *Beschreibung*, no. 918.
Provenance: From Syria.

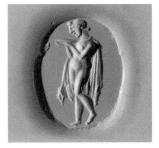

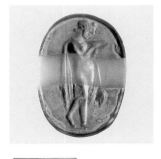

180 Banded agate, brown/white/brown, F 1, with sharply carinated top (approaching F 4)

17.5 × 12.3 × 2.7 mm
First century B.C.
82.AN.162.20
Description: Methe standing left, holding a bowl; groundline. Drilled pellets are used in the face, hair, and drapery. Slightly discolored.
Discussion: Methe, the personification of drunkenness, is a very popular type on Late Italic and early imperial gems and cameos (see *Naples*, pp. 30–31, for literature, and no. 40, a glass gem from Pompeii; also Henig, *Roman Engraved Gemstones*, no. 343; Guiraud, *Gaule*, nos. 305–309; *Hannover*, no. 886; *Göttingen*, nos. 202–203, glass, all with literature, and cat. no. 318, below; for cameos, see

Furtwängler, *Beschreibung*, nos. 11085, 11160, 11359). The representation is derived from a Hellenistic prototype, perhaps the painting by Pausias at Epidauros (Pausanias 2.27.3), and Kleopatra was said to have had the device engraved on an amethyst (*Anthologia Palatina* 9.752).

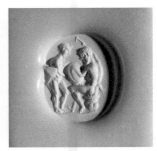
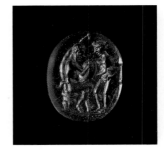

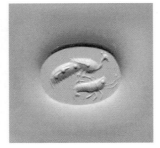

181 Translucent white chalcedony, F 1

11.2 × 8.4 × 1.3 mm
First century B.C.
85.AN.370.43

Description: Peacock standing right; a lobster below it. Drilled pellets are used in the head, body, legs, and tail of the peacock, and in the eye of the lobster.

Discussion: A peacock in similar style and material, *Thorvaldsen*, no. 501.

Provenance: From Tunisia.

183 Carnelian, F 1

12.5 × 10.0 × 2.5 mm
Mid-first century B.C.
84.AN.1.29

Description: Bearded satyr sitting on rocks, depicted in three-quarter rear view, hammering a shield; a young satyr stands before him holding the shield.

There is a large chip from the edge and face; the edges have been slightly filed.

Discussion: A similar stone, Furtwängler, *AG*, pls. 30, 34, and an earlier Italic version, *Braunschweig*, no. 12 (with notes). The type is ultimately derived from representations of Hephaistos in the same pose, which is seen on a late fifth- or fourth-century-B.C. Etruscan scarab (Sternberg, Zurich, auction 11, 1981, lot 1083); a Late Hellenistic version in garnet is in Baltimore (Walters Art Gallery 42.474). However, Hephaistos at his forge is already accompanied by satyrs on an early fifth-century-B.C. Attic red-figure vase by the Harrow Painter (J. D. Beazley, *Paralipomena*, 2nd ed. [Oxford, 1971], p. 354, no. 39 bis; J. Boardman, *Athenian Red Figure Vases: The Archaic Period* [London, 1975], p. 112, fig. 174).

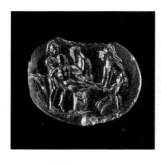
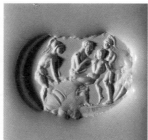

182 Carnelian, F 1

15.0 × 12.0 × 2.6 mm
Mid-first century B.C.
84.AN.1.30

Description: Two nude warriors wearing helmets, accompanied by the bearded King Priam, carrying the body of Hektor.

There are several large chips from the edges and face of the gem.

Discussion: A glass paste example of the type in similar style is in Vienna (*Vienna Gems*, vol. 2, no. 672, with further notes, including comparisons with representations on sarcophagi).

184 Brown circular sard, F 1, with nearly straight sides (approaching F 5)

Diameter, 14.0 mm; thickness, 1.9 mm
First century B.C.
84.AN.1.39

Description: In the slightly raised center (cut more deeply in the stone), Nike drives a biga right, surrounded by a hatched border; around this central tondo is a band with

the twelve signs of the zodiac within another hatched border.

Traces of iron adhere to the back, sides, and in the device.

Discussion: The style and subject are especially close to a carnelian gem once in the Marlborough collection and now in Baltimore (M. H. N. Story–Maskelyne, *The Marlborough Gems* [London, 1870], no. 274; Walters Art Gallery 42.1107).

Provenance: From Syria.

 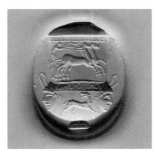

185 Banded agate, blue and brown, F 1(?)

15.7 × 12.6 × 2.5 mm
First century B.C.
89.AN.55 (Color plate 3)

Description: A kalyx-krater with tall, straight neck, small handles, and small foot; the neck is decorated with a biga galloping right and an upper hatched border; the body is decorated with a panther right with one foreleg raised and its head turned back; the shoulder of the body has a zone of zigzags containing pellets; there are masks (of satyrs?) at the base of the handles. There is frequent use of tiny drilled pellets.

The upper layer is blue, the lower brown, resembling nicolo.

The edges are filed down.

Discussion: Similar vase types with decoration have been noted by Furtwängler, *AG*, pls. 46, 56–59, 61–69; also *Karapanos coll.*, no. 577.

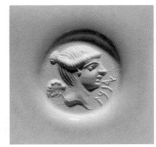 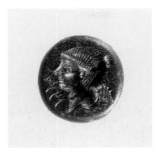

186 Dark brown sard, A 3, with high sides

12.8 × 12.2 × 2.6 mm
Mid–first century B.C.
85.AN.370.47

Description: Bust of Nike to right. Drilled pellets are used in her wing, eye, nose, and mouth.

To the right is the Punic inscription in careful letters meant to be read in impression: *qpnt* [Ziony Zevit] or *qrbn* [P. Bordreuil], in either case a female name.

Traces of bronze adhering to the sides; the surface is worn.

Discussion: The type and style is close to the glass gems in Berlin, Furtwängler, *Beschreibung*, nos. 4905–4908, and a carnelian once in the Cook collection (*Cook coll.*, no. 99). For another Punic inscription, see catalogue number 308, below.

Provenance: From Djerba, Tunisia.

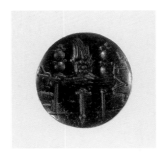 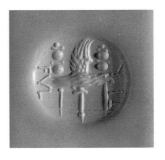

187 Black jasper, A 3, with high sides

13.8 × 13.4 × 2.7 mm
Mid–first century B.C.
83.AN.437.23

Description: Aquila before two standards; to left, reading downward: FVL; to right, reading upward, TIR.

Discussion: The same device is frequently found on Roman Republican coins, first on an issue of C. Valerius Flaccus in 82 B.C. (Crawford, *RRC*, no. 365), on an issue of Cn. Nerius in 49 B.C. (Crawford, *RRC*, no. 441), on coins of Octavian circa 42 B.C. (Crawford, *RRC*, no.

497/3), and the extensive issue of legionary denarii of Marc Antony (Crawford, *RRC*, no. 544; also no. 546/1).
Provenance: From Asia Minor.

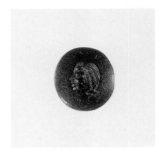

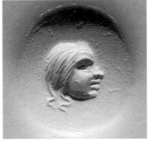

4:1

188 *Black jasper, A 3*

9.2×8.3×1.6 mm
Mid-first century B.C.
84.AN.1.55
Description: Mask of young satyr right. Small drilled pellets for the nose, lips, and chin.

The shape is the same variety as catalogue number 187, above.

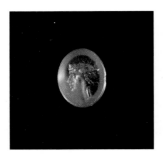

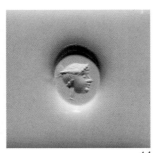

4:1

189 *Orange carnelian, F 1*

7.9×6.4×2.1 mm
Mid-first century B.C.
84.AN.1.54
Description: Female mask right. Small drilled pellets for eye, nose, mouth, and chin.
There is a small chip from edge.
Discussion: For the type and style, see Furtwängler, *AG*, pl. 26.75.

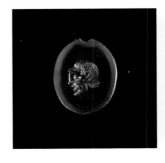

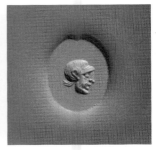

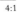

190 *Carnelian, F 1*

10.4×8.3×2.1 mm
Mid-first century B.C.
83.AN.437.34
Description: Mask of an old bearded man right. Small drilled pellets for the eye and nose.
There is a small chip from edge.
Discussion: For the type, see Furtwängler, *Beschreibung*, nos. 1937–1947, 5262–5267, 7016–7017; *Berlin*, no. 419; Furtwängler, *AG*, pl. 26.49; *New York*, no. 241.

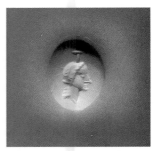

191 *Carnelian, C 3*

12.0×12.05×5.0 mm
Mid-first century B.C.
82.AN.162.31
Description: Female head with polos (Tyche?) right. Small drilled pellets for the nose and chin.
Traces of bronze adhering to the sides; the back is chipped.
Discussion: Gems with the same device and of related style, although without the use of drilled pellets, are notable for their unusual style and material. They include two from Pompeii (*Naples*, no. 217, amethyst, and no. 223, a convex garnet) and others in garnet (*The Hague*, no. 202) and amethyst (private collection, from Asia Minor).

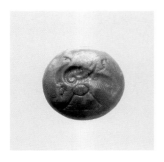

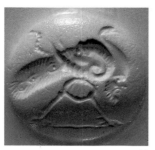

4:1

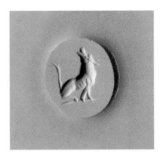

192 Carnelian, A 3

10.7 × 10.0 × 2.5 mm
Mid-first century B.C.
82.AN.162.30

Description: Composite figure of a peacock, with a peacock's head and tail, an elephant's head with ram's horn for the body, and a satyr mask for the breast; groundline. Small drilled pellets are used in the tail, trunk, joints, and eyes.

Slightly discolored.

Discussion: Similar examples include *Aquileia*, no. 1009; Furtwängler, *AG*, pls. 29.59, 46.37, 65.20; J. Boardman, *Engraved Gems: The Ionides Collection* (London, 1968), no. 50, carnelian; *The Hague*, no. 1084, in nicolo; M. Maaskant-Kleibrink, *Description of the Collection in the Rijksmuseum G. M. Kam, Nijmegen*, vol. 10, *The Engraved Gems* (Nijmegen, 1986), no. 84, amethyst-colored glass in a gold ring; and a later example in red jasper, Furtwängler, *Beschreibung*, no. 8537.

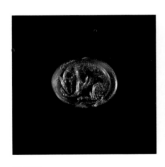

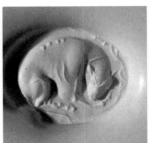

4:1

193 Red carnelian, F 1

8.7 × 7.1 × 2.8 mm
Mid-first century B.C.
82.AN.162.33

Description: Dog curled up and sleeping; the head is frontal; a thin tree is to the right. Small drilled pellets for the eyes, spine, and paws.

Traces of bronze adhering; chips from edge and back.

Discussion: The type is already found on Graeco-Persian gems (Boardman, *GGFR*, p. 433, no. 119, fig. 291), on a Hellenistic clay sealing from Kallipolis (P. Pantos, *Ta*

sphragismata tes Aitolikes Kallipoleos [Athens, 1985], no. 38), and on an Etruscan scarab (Furtwängler, *AG*, pl. 18.61). For Roman gems, see Furtwängler, *Beschreibung*, no. 7042, sard, nos. 5658–5661, glass; *Thorvaldsen*, no. 1403, glass, with notes; *Munich*, pt. 2, nos. 2010–2011, glass; *BMC Gems*, no. 2423, sard, less similar; *Berry coll.*, no. 179, carnelian; *Harari coll.*, no. 82, a convex banded agate; *Hannover*, no. 690, carnelian, and no. 1220, glass; Maddoli, *Cirene*, no. 814; and a popular type for cameos, see Richter, *Engraved Gems of the Romans*, no. 373, in Paris, and cat. no. 439, below; also M. Henig, *Oxford Journal of Archaeology* 7 (1988), pp. 253–255.

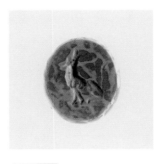

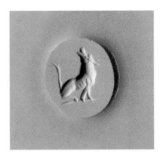

194 Chalcedony, F 5, with slightly incurving sides (approaching F 2)

12.5 × 10.9 × 2.8 mm
Mid-first century B.C.
80.AN.43.5

Description: Howling dog, seated right with head turned back and upward.

Disclored.

Discussion: Another howling dog in a different pose but in similar style, Furtwängler, *Beschreibung*, no. 7040; and see *Cologne*, nos. 415–416, red jasper; *Aquileia*, no. 1085; *Munich*, pt. 3, no. 2422.

Provenance: From Tunisia.

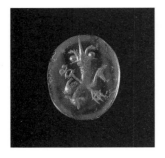
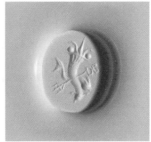

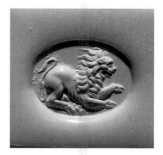

195 Orange carnelian, F 1

11.8×9.7×2.6 mm
Mid-first century B.C.
81.AN.118.3

Description: Cornucopia in front of crossed dolphin and caduceus-trident. Some use of small drilled pellets.

Traces of iron adhering to back, sides, and face.

Discussion: A similar example is in Cambridge, J. H. Middleton, *The Engraved Gems of the Classical Times, with a Catalogue of the Gems in the Fitzwilliam Museum* (Cambridge, 1891), Appendix, no. 53.

197 Brown and white banded agate, F 1

14.2×10.6×2.5 mm
Second–first century B.C.
82.AN.162.54

Description: Lion crouching right.

Traces of iron adhering to sides.

4:1

196 Carnelian, F 1

8.5×5.9×2.4 mm
Mid-first century B.C.
84.AN.1.51

Description: Two wrestlers, with trainer standing to left and herm to right; groundline. Drilled pellets are used for the heads of the figures and to model the bodies.

Traces of bronze adhering to the sides.

Discussion: The motif is very popular; a similar Italic gem with pellet-heads, *Hannover*, no. 1013; also *Munich*, pt. 3, no. 2396; and see Sena Chiesa, *Luni*, no. 37; *BMC Gems*, nos. 2137–2140; *The Hague*, no. 631; Furtwängler, *Beschreibung*, nos. 6914–6916, 4610–4613 (glass); *Thorvaldsen*, no. 979, glass; for wrestling erotes, see catalogue number 204, below.

Provenance: From Asia Minor.

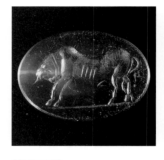
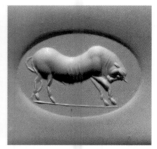

198 Light brown agate, flat face and convex back (close to F 6)

17.6×12.6×2.4 mm
Second–first century B.C.
81.AN.76.17

Description: Bull standing right, head lowered; groundline.

The sides are rough; it appears to have been cut down.

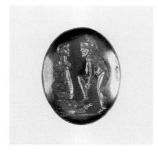
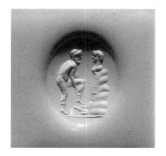
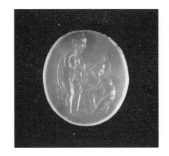
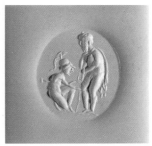

199 Carnelian, A 5, bottom only slightly convex

13.2 × 10.3 × 4.6 mm
First century B.C.
82.AN.162.56

Description: Bearded warrior arming before a pile of rocks surmounted by a male bust; the warrior wears a crested helmet; a sword and shield lie on the ground; groundline.

Discussion: The facial features of the warrior suggest an Italic origin for the gem. The motif, often identified as Achilles arming (see Henig, *Roman Engraved Gemstones*, no. 462, with literature), is common, but the figure is usually shown before a column and not before a bust (for a bust on rocks before the shepherd Faustulus finding Romulus and Remus, see *BMC Gems*, no. 988, an Italic sard).

201 Translucent white chalcedony, nearly transparent, F 1

13.9 × 11.8 × 1.9 mm
First century B.C.
85.AN.370.44

Description: Philoktetes, bearded and wearing a cloak, standing left, leaning on a staff, while his leg is bandaged by the kneeling Machaon, nude with plumed helmet and sword.

Discussion: Philoktetes is a popular subject in Greek, Etruscan, and Roman glyptic and appears already by the end of the fifth century B.C. (see Boardman, *GGFR*, p. 410, no. 161, pl. 540, for a late fifth-century example; *BMC Gems*, nos. 962–963, and *Berlin*, nos. 396–397, for some Roman gems). The arrangement of the figures on the Getty gem appears to be unparalleled, but related scenes are found on Etruscan scarabs (closest is a scarab in Florence, Zazoff, *ES*, no. 123, where the figures are seated; see also ibid., no. 1043 = *BMC Gems*, no. 730, where Machaon is bearded). A similar scheme is used to depict the wounded Aeneas treated by Iapyx, as related in the *Aeneid* (12.391), on a wall-painting from Pompeii (Naples, inv. 9009; see V. Sampaolo in *La collezione del Museo Nazionale di Napoli*, vol. 1 [Rome, 1986], pp. 63, 152–153, no. 209).

Provenance: From Asia Minor.

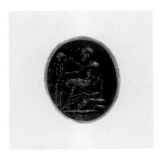
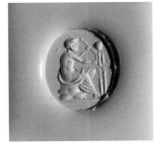
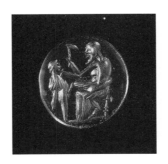
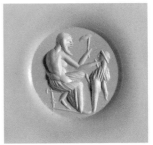

200 Dark green jasper, F 8

12.4 × 10.4 × 2.2 mm
First century B.C.
82.AN.162.69

Description: Prometheus sitting right on rocks and constructing a skeleton.

Traces of bronze adhering to the back.

Discussion: The type is derived from Etruscan scarabs (see cat. no. 144, above) and is popular on Italic gems (see Furtwängler, *AG*, pl. 21.54; *Thorvaldsen*, no. 848; and Furtwängler, *Beschreibung*, no. 7688).

202 Brown sard, F 1

13.1 × 11.9 × 1.8 mm
First century B.C.
83.AN.256.4

Description: Bearded sculptor sitting right, working on a Priapic herm; groundline.

Discussion: For the scene, popular on Italic gems, see *Aquileia*, no. 973; Furtwängler, *Beschreibung*, nos. 7685–7687, sards; *The Hague*, no. 277.

Munich, pt. 2, no. 1183; Maddoli, *Cirene*, nos. 310–312; see also the wrestlers, catalogue number 196, above. The style corresponds closely to Maaskant-Kleibrink's Republican Wheel Style (*The Hague*, pp. 154–155).

Provenance: From Asia Minor.

 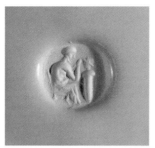

203 Carnelian, A 4, carelessly shaped

9.8×9.3×3.7 mm
Second half of the first century B.C.
82.AN.162.29

Description: Same type as catalogue number 202, above. The style is similar but cruder.

Discolored.

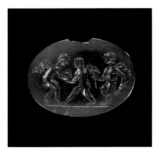

204 Carnelian, A 5

14.5×10.9×4.1 mm
Mid-first century B.C.
84.AN.1.52

Description: Two erotes wrestling; another, holding staff and branch, stands to left as referee; groundline.

There are small chips from the edge.

Discussion: The motif is very popular, see *The Hague*, nos. 387–388, with notes; *Naples*, no. 36, a carnelian from Herculaneum; *Aquileia*, nos. 345–351; *De Clercq coll.*, no. 3114, a carnelian in a gold ring, from Syria; *Vienna Gems*, vol. 1, nos. 437–438; *Braunschweig*, no. 61; *Göttingen*, no. 142; *Hannover*, nos. 837–838, 1464–1466; Furtwängler, *Beschreibung*, nos. 7496–7505, all carnelians, and no. 6440, with Aphrodite; *BMC Gems*, nos. 2913–2916, glass;

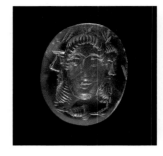 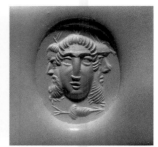

205 Carnelian, A 5

14.4×11.7×4.1 mm
Mid-first century B.C.
84.AN.1.56

Description: Triple mask; an unbearded satyr mask is shown frontal with a bearded satyr mask on either side in profile; a thyrsos is below.

Discussion: See Furtwängler, *Beschreibung*, nos. 5296–5304, glass gems, triple masks, but none very close.

Provenance: From Asia Minor.

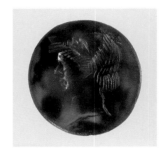 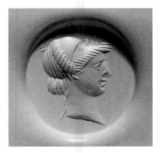

206 Carnelian, A 5

16.4×15.4×5.0 mm
Mid-first century B.C.
83.AN.437.36

Description: Head of youth right with a satyr mask on top of his head.

Traces of iron adhering to the back.

Discussion: The motif is already seen on fourth-century-B.C. Greek rings (Boardman, *GGFR*, p. 420, no. 604, fig. 227, and p. 425, no. 920, pl. 800) and is common on Roman gems (see *The Hague*, no. 647; *Munich*, pt. 2, no. 1863; *Munich*, pt. 3, no. 3583, glass; other masks: *BMC*

Gems, nos. 2290, 2597; Furtwängler, *Beschreibung*, nos. 6544–6546, 1909, sards, 1910–1915, glass).

Provenance: From Asia Minor.

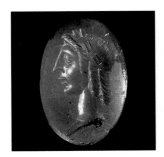
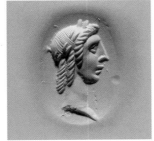

207 Carnelian, A 4 (the face only slightly convex)

17.2 × 11.3 × 5.0 mm
Mid-first century B.C.
85.AN.370.66

Description: Laureate head of Apollo right.
The edges have been cut down.

Traces of iron adhering on the back, sides, and face.

Discussion: The type derives from Ptolemaic models (see the garnet gems, J. Spier, *JWalt* 47 [1989], p. 32, nos. 37–40). The style of the Apollo head is especially close to that on the extensive series of coins issued by C. Piso Frugi in 67 B.C. (Crawford, *RRC*, no. 408); an agate gem of similar style, *Berry coll.*, no. 74; see also *LIMC*, vol. 2, pp. 391–392, nos. 106–118, s.v. Apollon/Apollo.

Provenance: From Asia Minor.

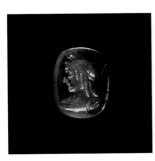
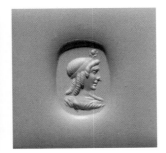

208 Carnelian, F 1, rectangular

9.8 × 7.5 × 3.0 mm
Mid-first century B.C.
85.AN.370.63

Description: Bust of Isis right.

Discussion: Although the shape and style of the gem are purely Roman, the unusual facial features of Isis, notably the hooked nose, suggest a portrait. If so, then Kleopatra VII may be intended (see H. Kyrieleis, *Bildnisse der Ptole-mäer* [Berlin, 1975], pp. 124–125, including the clay sealing from Edfu; R. R. R. Smith, *Hellenistic Royal Portraits* [Oxford, 1988], pp. 97–98); Ptolemaic queens were often depicted as Isis, including on an extensive series of garnets (see the discussion under cat. no. 21, above). For other Roman gems depicting Isis in similar style, see Furtwängler, *AG*, pl. 33.6–7; *Hannover*, no. 1045, nicolo.

Provenance: From Asia Minor.

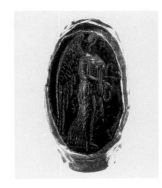
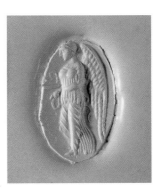

209 Carnelian of uncertain shape (only slightly convex) in gold ring

Gem, circa 17 × 10 mm; greatest diameter of hoop, 22.6 mm
Mid-first century B.C.
83.AN.437.39

Description: Winged Hygieia standing left, holding a bowl and a serpent; groundline.

Discussion: The same type (facing right) in very similar style, *BMC Gems*, no. 1694; the motif is common.

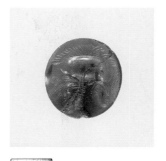
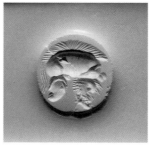

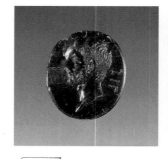
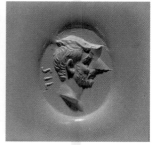

210 Carnelian, close to F 5, with straight sides but rounded at the bottom, perhaps cut down

11.2×10.3×2.0 mm
Mid-first century B.C.
80.AN.43.7

Description: Crested helmet composed of a sleeping dog for the bowl and ram and boar heads for cheek pieces.

Discussion: Vollenweider (*Geneva*, vol. 2, nos. 393–394, glass) has discussed the device and dated it circa 40 B.C. It is especially popular on gems of this period (see Furtwängler, *AG*, pl. 29.77, very close in style, also pl. 29.75; Furtwängler, *Beschreibung*, nos. 5956–5959, 6685–6687; *New York*, no. 543; *Munich*, pt. 2, nos. 1901–1904, glass; *Thorvaldsen*, nos. 520–522; *BMC Gems*, no. 2588).

Provenance: From Tunisia.

212 Carnelian, F 1

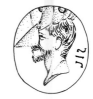

12.2×10.3×2.6 mm
Circa 40 B.C.
85.AN.444.6

Description: Portrait head of a man with short beard to right; to left, reading downward, SIL.

There is a large chip from the edge and upper face.

Discussion: The portrait may be of Brutus (see Vollenweider, *Porträtgemmen*, pp. 139–144, pl. 97.5, a carnelian in the Merz collection, Bern; and the glass gem cat. no. 406, below).

Provenance: From Asia Minor.

LATE HELLENISTIC, EASTERN GEMS

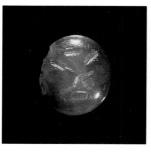

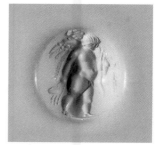

211 Carnelian, A 3

11.4×9.9×2.3 mm
Mid-first century B.C.
80.AN.43.1

Description: Right hand grasping a poppy and two ears of corn.

Worn with some chips from the edges.

Discussion: The type begins in the late republican period but remains popular well into imperial times; see *The Hague*, no. 463 with notes; *Aquileia*, nos. 1452–1454; *Munich*, pt. 2, no. 2165; *Kassel*, no. 93; *Hannover*, no. 716; Maddoli, *Cirene*, nos. 1012–1013; *Naples*, no. 336, from Pompeii, of similar style but holding a caduceus as well.

Provenance: From Tunisia.

213 Garnet (purple rhodolite), C 8

14.9×12.2×6.6 mm
Second–first century B.C.
85.AN.370.41

Description: Eros with the attributes of Herakles; he stands right, carrying a club and lionskin over his left shoulder and a bow case in his right hand; groundline. His body is plump and well modeled; the hair and face are detailed by short lines, and there is pelletlike drillwork in the wing and club.

Discussion: Near duplicates in the same material are in New York and Berlin (*New York*, no. 230, as Italic; Furt-

wängler, *Beschreibung*, no. 1111; see also Furtwängler, *AG*, pl. 27.64, a larger Hellenistic gem). The motif remains popular on Roman gems (see *BMC Gems*, no. 2862, glass; Guiraud, *Gaule*, no. 377, nicolo; *Thorvaldsen*, no. 30, carnelian, no. 725, glass, and no. 1890, a glass cameo; Furtwängler, *Beschreibung*, nos. 3020–3028, 3713, 11171, the last a cameo; and the cameo, *Harari coll.*, no. 43). For the motif, see S. Woodford, *JHS* 109 (1989), pp. 200–204.

Provenance: From Greece.

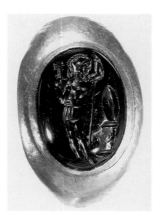
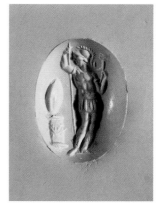
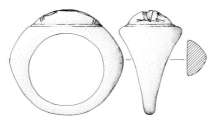

214 Garnet (purple rhodolite), C 3

11.3 × 7.6 × 5.0 mm
Second–first century B.C.
83.AN.256.7

Description: Eros standing on a flying butterfly, holding reins.

Discussion: A similar gem is Furtwängler, *AG*, pl. 34.47, probably also a garnet.

215 Garnet (red) with convex face, probably C 8, in large, hollow gold ring

Gem, circa 17.5 × 12.5 × 6.5 mm; greatest diameter of hoop, 30.1 mm
Second–first century B.C.
85.AN.370.77

Description: Warrior (Ares?) wearing armor and crested helmet; he stands frontally with his head turned left, leaning on a long spear held in his right hand and holding a sword in his left hand; to the left is a shield resting on a garlanded altar; groundline.

Discussion: For the same type on a slightly later plasma, *Berry coll.*, no. 63.

Provenance: From Syria.

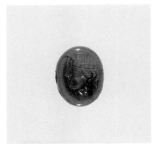

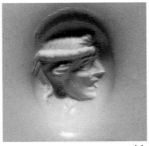

4:1

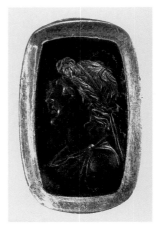

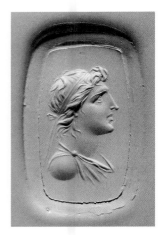

216 Garnet (purple rhodolite), C 3

8.4×6.5×3.9 mm
Second–first century B.C.
84.AN.1.53

Description: Female comic mask to right.

Discussion: A very similar example, Furtwängler, *Beschreibung*, no. 1950, garnet; Furtwängler, *AG*, pl. 26.58; and *De Clercq coll.*, nos. 3156–3162, all convex garnets depicting various masks, most in gold rings and all from Syria.

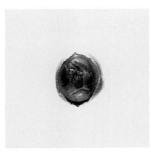

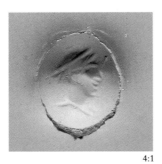

4:1

217 Garnet (red), B 3, in thin gold wire setting (from a ring?), with slightly concave back

8.1×7.1×2.3 mm with setting
First century B.C.
83.AN.437.28

Description: Bust of Hermes wearing petasos to right.
Provenance: From Asia Minor.

218 Carnelian, ruby red, in hollow gold ring

Gem, circa 22×13×3 mm; greatest diameter of hoop, 28.2 mm
First century B.C.
85.AN.124

Description: Draped bust of a Hellenistic king wearing diadem to right; probably Alexander the Great.

The gem is rectangular in shape, and the surface is slightly convex.

Discussion: Diademed heads with flowing hair in the manner of Alexander the Great are popular on gems in the Hellenistic period (see Furtwängler, *AG*, pl. 31.17, 19–20; pl. 32.1, 9), and some have been associated with other Late Hellenistic rulers, most notably Mithridates VI and other Pontic kings (see O. Neverov, *Sovetskaya arkheologiya* 12.1 [1968], pp. 235–239, figs. 1–3, an agate intaglio in a gold ring from Kerch, said to represent Mithridates VI; *Vienna Gems*, vol. 1, no. 35; *Geneva*, vol. 3, no. 220; and the cameo, *Oxford Gems*, no. 281, as late second–early first century B.C.). The popularity of the type continues well into Roman imperial times (see the red jasper, once Southesk collection, Furtwängler, *AG*, pl. 31.16 = Jucker and Willers, *Gesichter*, p. 280, no. 132, not necessarily as early as stated; perhaps Hadrianic, as suggested by M. N. Lordkipanidze, is a gem found in Soviet Georgia signed by the engraver Platon, in Tbilisi, *Korpus pamyatnikov gliptiki drevnei Gruzii*, vol. 1 [Tbilisi, 1969], pl. 8.117; Zazoff, *AG*, p. 321 n. 102, pl. 95.6; also the early imperial carnelian, cat. no. 225, and the cameo, cat. no. 431, below).

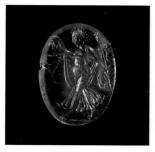
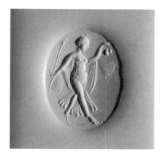

219 Carnelian, A 4, but only slightly convex

14.2 × 10.3 × 2.7 mm
First century B.C.
85.AN.370.67

Description: Maenad dancing right; she holds a kantharos in her left hand and a thyrsos in her right; her hair is wild and stands on end; her drapery swirls around her and is draped over her arms; groundline. Small drilled pellets are used to detail her face, breasts, finger, ankles, toes, the ends of drapery, and thyrsos.

Traces of bronze adhering to the sides; there is one chip from the edge.

Discussion: The style, with its fine modeling and unusual use of drilled pellets, is especially distinctive. The gem is very likely by the same hand as a once-celebrated carnelian gem depicting a satyr, which was said to have been found at Trebizond and was subsequently in the Robinson collection; it is now in Baltimore (Walters Art Gallery 42.108; *Burlington Fine Arts Club: Exhibition of Ancient Greek Art*, 1904, p. 216, M 155, pl. 110; *Catalogue of the Valuable and Important Collection of Engraved Gems, Camei and Intagli . . . Charles Newton Robinson*, Christie, Manson & Woods, London, June 22, 1909, lot 51). Both gems are said to be from Asia Minor, where the workshop may have been located.

Provenance: From Asia Minor.

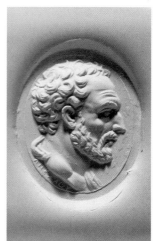
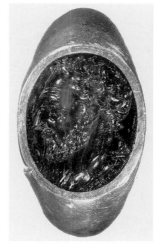

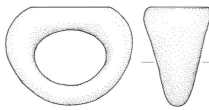

220 Carnelian in large gold ring; face of gem is flat (F 1?)

Gem, circa 19 × 15 mm; greatest diameter of hoop, 33.6 mm
First century B.C., probably last quarter
90.AN.13 (Color plate 3)

Description: Head of Demosthenes right, drapery over the left shoulder and back of neck; below the neck: ΑΠΕΛΛΟΥ. The ring is oval in section, of a shape related to Henkel, *Römische Fingerringe*, no. 146, where an example from Pompeii is cited. A signed work by the gem cutter Apelles.

There is some unusual flaking from the surface of the gem.

Discussion: The work is exceptionally fine, in high relief and with skillful modeling of the facial features. The placement of the name surely indicates it is the signature of the artist, and the style and motif, along with the shape of the gem and ring, suggest a late first-century-B.C. date, a time when fine, signed works were in vogue. The popularity of Demosthenes in the early Roman imperial period is clear from the multitude of surviving portraits in marble and bronze (see G. M. A. Richter, *The Portraits of the Greeks*, vol. 2 [London, 1965], pp. 215–223). Although his portrait is rare on gems (see ibid., pp. 222–223; and *Vienna Gems*, vol. 1, no. 343, a fine amethyst), Demosthenes is depicted on a fine intaglio in amethyst, again

with drapery on his shoulder, in three-quarter frontal view (see Vollenweider, *Steinschneidekunst*, p. 57, pl. 57.1–3); the gem is signed by Dioskourides, the famous gem engraver in the court of Augustus. The two gems by Dioskourides and Apelles are stylistically close and are most likely contemporary.

The letter forms of the signature are somewhat large and careless compared to most other signatures found on gems of the late first century B.C., which typically have small, neat letters terminating in drilled pellets; however, not all engravers signed so carefully, and the authenticity of the inscription should not be doubted. The letter forms are close to those on earlier Hellenistic gems, most notably those of Apollonios, who worked circa 200 B.C. (see Vollenweider, *AK* 23 [1980], pp. 151–153); nevertheless, the epigraphic evidence for dating is not precise, and the stylistic grounds for a first-century-B.C. attribution are strong.

A second signed gem of Apelles may exist. In the late eighteenth century, Domenico Bracci (*Memorie degli antichi incisori*, vol. 1 [Florence, 1784], pp. 142–145, pl. 27) recorded a carnelian ringstone in the collection of the Polish Prince Jablonowski, which was engraved with a facing comic mask and an inscription read as *Apsalou*. Not long after its publication, Ennio Quirino Visconti (*Opere varie*, vol. 2 [Milan, 1829], p. 125) noted that the Greek spelling was impossible and emended it, no doubt correctly, to *Apellou*. Unfortunately, Bracci's engravings, although very elaborate, are inaccurate, and neither the original gem nor even a cast appears to survive. However, both the signature of Apelles and the device of a mask, which also appears on a gem signed by Hyllos, a son of Dioskourides (Vollenweider, *Steinschneidekunst*, p. 70, pl. 78.3), are entirely plausible for an authentic work of the first century B.C.

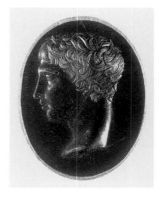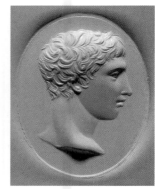

221 Dark green chalcedony in large gold ring

Gem, 22.4 × 17.3 mm; greatest diameter of hoop, 24.9 mm
Mid-first century B.C.
75.AM.61 (Color plate 3)

Description: Head of the Doryphoros of Polykleitos to right.

The face of the gem is flat, and the shape is uncertain. Excellent condition.

Discussion: The works of the fifth-century-B.C. sculptor Polykleitos were famous throughout the Classical period and were especially popular with the Romans, who had many copies made of his statues. The classicizing gems of the early imperial period sometimes reflect Polykleitan types, with the head of his Diadoumenos being the most popular (see cat. no. 231, below), but no other representations on gems appear to be known of one of his most famous works, the Doryphoros, also known as the Kanon (see H. von Steuben, *Der Kanon des Polyklet* [Tübingen, 1973]; A. Stewart, *JHS* 98 [1978], pp. 122–131; B. S. Ridgway, *Fifth Century Styles in Greek Sculpture* [Princeton, 1981], pp. 201–203; and for Roman versions, P. Zanker, *Klassizistische Statuen* [Mainz, 1974], pp. 7–9).

The gem is an exceptionally fine work of the second half of the first century B.C., a time when Greek gem cutters, a number of whom sign their gems, engraved classicizing devices for their Roman patrons. Several artists known by name produced similar works, but it is difficult to assign the Getty Doryphoros to a specific hand. Gnaios, who signs five known gems (see Furtwängler, *Kleine Schriften*, pp. 236–239; Vollenweider, *Steinschneidekunst*, pp. 45–46), produced several similarly classicizing types, including a Polykleitan athlete (once in the Marlborough collection and now in Baltimore, 42.109; Vollenweider, *Steinschneidekunst*, p. 45 n. 46, pl. 42.5) and a head of a young Herakles (*BMC Gems*, no. 1892), which is probably derived from a statue by Praxiteles, as Furtwäng-

ler notes. However, Gnaios is a finer artist, whose engraving style differs from that of the Getty gem, notably in the depth and modeling of the device. Closer in technique are the works of the engraver Solon and his circle (Furtwängler, *Kleine Schriften*, pp. 229–233; Furtwängler, *AG*, vol. 3, p. 354; Vollenweider, *Steinschneidekunst*, pp. 47–54, and 55–56, for a possible workshop), which typically have shallow cutting and precisely engraved details.

The ring is said to be from a hoard containing late first-century silverware, a gold diadem, and a gold aureus of Marc Antony with his son Antyllus (once Hunt collection; *Wealth of the Ancient World*, exh. cat., Kimball Art Museum, Fort Worth, 1983, p. 229, no. 120). The coin, which was in mint condition, suggests a date for the burial of circa 34 B.C.

Provenance: From Asia Minor.

Bibliography: A. Oliver, Jr., *GettyMusJ* 8 (1980), p. 165, figs. 21–22; *The J. Paul Getty Museum: Handbook of the Collections* (Malibu, 1988), p. 61D; *Polyklet: Der Bildhauer der griechischen Klassik*, exh. cat., Liebieghaus, Frankfurt am Main, 1990, pp. 629–630, no. 159.

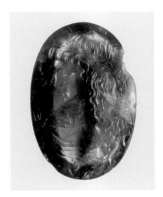
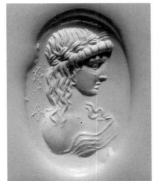

222 *Amethyst, A 2*

22.2 × 14.5 × 7.3 mm
Last quarter of the first century B.C.
84.AN.1.38 (Color plate 3)

Description: Female bust right, wearing a laurel wreath with fillets; her long hair falls over her shoulders; drapery covers her breasts but not her shoulder or arms.

Discussion: The style of the gem is very fine, and the size and material are also exceptional. A number of similar gems is known, the finest being a carnelian in Leningrad (O. Neverov, *Antique Intaglios in the Hermitage Collection* [Leningrad, 1976], no. 116; Furtwängler, *AG*, pl. 40.10; Vollenweider, *Steinschneidekunst*, p. 55, pl. 54.7), assigned by Neverov to the engraver Hyllos and by Vollenweider to the workshop of Solon. Other examples, of various degrees of quality, include the following: *Southesk coll.*, no. E 26, a sard ringstone in a medieval gold mount; *Southesk coll.*, no. C 39 = Bard collection, Sotheby's, London, July 11, 1977, lot 120, carnelian; *BMC Gems*, no.

1330 (misnumbered 1321 in the plates); Vatican, Museo Profano, inv. 2242, F. Fremersdorf, *Antikes, islamisches und mittelalterliches Glas sowie kleinere Arbeiten aus Stein, Gagat und verwandten Stoffen in den vatikanischen Sammlungen Roms*, Catalogo del Museo Sacro, vol. 5 (Vatican City, 1975), p. 120, no. 1084, pl. 84; Furtwängler, *Beschreibung*, no. 6954, a carnelian broken in half; *Thorvaldsen*, no. 1137; Munich(?), *Münchner Jahrbuch der bildenden Kunst*, 1914/1915, pl. A.1, carnelian; Paris, Cabinet des Médailles, Furtwängler, *AG*, pl. 38.40, a sard; Duke of Devonshire, Furtwängler, *AG*, pl. 38.41, a sardonyx; Furtwängler, *AG*, pl. 40.14; *Romania*, no. 67, carnelian of crude style; Münzen und Medaillen, Basel, *Liste* 483, November/December 1985, no. 260, agate.

The woman has variously been identified as Kassandra, a Sibyl, a priestess, and a Muse. The identification as Kassandra is based on the strong similarity to two fine, nearly identical gems in Boston (Beazley, *Lewes House*, nos. 93–94) that depict a kneeling Kassandra grasping the Palladion. The heads are indeed similar, but the Kassandra on the gems in Boston is not draped and is without fillets hanging from the wreath. The laurel wreath and fillets do speak for a priestess or oracle of Apollo, and either a Sibyl or Kassandra is appropriate.

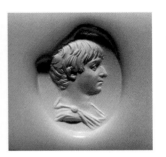
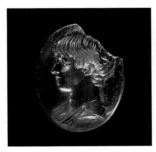

223 *Honey-colored sard, A 1, with flat bottom*

14.8 × 11.6 × 3.3 mm
Circa A.D. 20
83.AN.256.3

Description: Draped bust of a Julio-Claudian prince to right.

There is a large chip from the edge and face.

Discussion: The identity of the youth is difficult to determine. The hair style and features are close to those of Drusus and Germanicus, and a comparison with the outstanding portrait of Drusus on an amethyst in Baltimore (Walters Art Gallery, 42.140) suggests the two gems are closely contemporary. However, the youth on the Getty gem is certainly younger than Drusus, and a son of Drusus or Germanicus is likely.

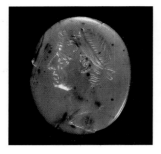 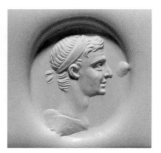 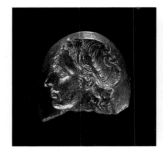 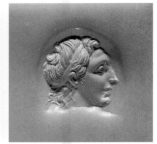

224 *Carnelian, F 7, bottom slightly flattened*

16.3 × 13.6 × 3.3 mm
Circa A.D. 20–40
81.AN.118.1

Description: Diademed head of Germanicus(?) right.

There are chips from the edge and face; harshly cleaned.

Discussion: The shape of the nose and chin and the hair brushed back from the forehead are distinctive and found on a cameo portrait in Leningrad (O. Neverov, *Antique Cameos in the Hermitage Collection* [Leningrad, 1971], no. 74; Megow, *Kameen*, p. 280, C 21, pl. 13.3). Neverov saw the individual as Tiberius, but Megow has argued that Germanicus is intended. He also suggests that two of the famous cameos in Vienna, the cameo glass portrait signed by the artist Herophilos and another large sardonyx cameo (Megow, *Kameen*, pp. 279–280, C 19–20, pl. 11.1–3, with literature; both are usually identified as Tiberius, Augustus, or Drusus; see also Megow, *AA*, 1989, pp. 446–448), represent Germanicus and were probably made shortly after his death in A.D. 19. Germanicus was honored posthumously, and as late as A.D. 40 his portrait appeared on coins of his son Caligula. If Germanicus is represented, this gem, too, is likely to be a posthumous work. However, the identification of the individuals on many cameos of this period is uncertain. The deified Augustus remains an alternative identification.

225 *Carnelian, A 2*

13.1 × 11.3 × 3.9 mm
First half of the first century A.D.
84.AN.990

Description: Diademed head of Alexander the Great right.

About a quarter of the carnelian is broken away, and there are further chips from the back.

Discussion: For the popularity of Alexander as a type on Late Hellenistic and Roman gems, see catalogue number 218, above, and the cameo, catalogue number 431, below. The engraving style is close to the portrait gem, catalogue number 223, above.

Provenance: Sternberg, Zurich, auction 11, 1981, lot 1118.

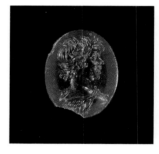 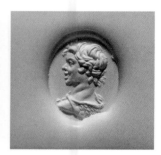

226 *Carnelian, F 1*

12.5 × 9.8 × 2.8 mm
First half of the first century A.D.
84.AN.1.35

Description: Bust of a young satyr wearing nebris to left, viewed from the back.

There is a chip from the edge and face.

Discussion: The motif is very popular throughout the imperial period (see T. Gesztelyi, *Acta Classica Universitatis Scientiarum Debreceniensis* 14 [1978], pp. 65–73; also Henig, *Roman Engraved Gemstones*, no. 252; and others could be added, including Beazley, *Lewes House*, no. 106, now Boston 23.588; *Vienna Gems*, vol. 1, nos. 476–477; *Thorvaldsen*, nos. 472–473; Christie's, London, auction May 20, 1981, lot 323; and a number of unpublished examples, including Walters Art Gallery 42.1017, red

jasper; Boston 09.535, from Cyrene; and Boston 52.527). Most of the examples are in red jasper and belong to the second century A.D., but the Getty examples (also cat. no. 227, below) are early first-century works in fine style. The style is especially close to that of the gems catalogue numbers 223 and 225, above, and should be roughly contemporary with them. A cameo signed by the artist Hyllos, who also engraved intaglios in the early first century, depicts a similar bust (Furtwängler, *Beschreibung*, no. 11063; Vollenweider, *Steinschneidekunst*, pp. 70–71, pl. 80.1–3; see also the glass cameo from Herculaneum, *Naples*, no. 49), as does an amethyst ringstone in Paris signed by the engraver Epitynchanos (Vollenweider, *Steinschneidekunst*, p. 76 n. 64, pl. 88.1–2).

Provenance: From Syria.

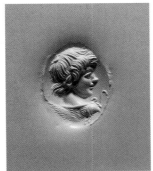
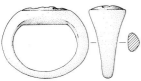

227 Amethyst in silver ring, convex

Gem, circa 12.5×9 mm; greatest diameter of hoop, 23.5 mm
First half of the first century A.D.
85.AN.370.80

Description: Bust of a young satyr wearing nebris right, viewed from the back; pedum to right.

The shape of the ring is more common in gold (see Henkel, *Römische Fingerringe*, nos. 141–142).

Excellent condition; the ring is uncleaned and covered with a thin layer of silver chloride.

Discussion: For the type, see catalogue number 226, above. A related pose is seen on a later red jasper in Berlin (Furtwängler, *Kleine Schriften*, p. 178, no. 14; and *Berlin*, no. 8509, not pictured). The fine style, the shape and material of the stone, and the shape of the ring all suggest an early imperial date.

Provenance: From Syria.

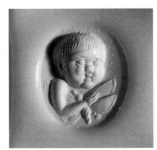
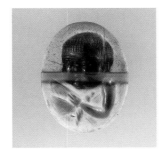

228 Banded agate, blue with white horizontal stripe, A 4 (only slightly convex)

15.3 × 11.6 × 4.0 mm
First half of the first century A.D.
84.AN.1.36

Description: Bust of Eros (whose wings are not denoted) facing three-quarter to front; he clasps a butterfly to his chest.

Partially discolored white.

Discussion: The device, representing Eros holding Psyche as a butterfly, is frequent on gems (see Furtwängler, *AG*, pl. 26.9; *De Clercq coll.*, no. 3116, a Late Hellenistic garnet, from Baghdad; Baltimore, Walters Art Gallery 42.895, carnelian, unpublished; Zazoff, *AG*, p. 263 n. 17, pl. 67.4, a glass gem in Cortona; and in glass, Furtwängler, *Beschreibung*, nos. 4754–4766; *Munich*, pt. 2, no. 1188; *Hannover*, no. 483; *Thorvaldsen*, no. 269, 1084; similar busts of Eros without the butterfly, *BMC Gems*, nos. 1022, 1115–1117). The high relief type appears to have been especially popular and was probably derived from metalwork (see the plaster medallion from Begram, Afghanistan, J. Hackin, *Nouvelles recherches archéologiques à Begram, 1939–1940* [Paris, 1954], p. 127, no. 112, figs. 305, 425, and 427, the last a gem once in the Nott collection in London).

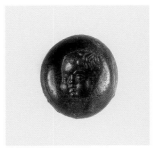
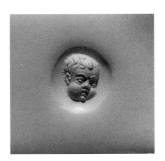

229 Sard, A 3

11.5 × 10.3 × 2.9 mm
First half of the first century A.D.
82.AN.162.32

Description: Head of a baby (Eros?) facing three-quarter right.

Traces of bronze adhering to the sides; worn.

Discussion: The type is related to catalogue number 228, above; see Furtwängler, *Beschreibung*, nos. 1796–1797, 5273, glass, 6959, banded agate; Baltimore, Walters Art Gallery 42.1332, banded agate, unpublished.

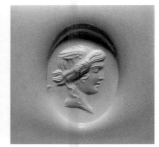
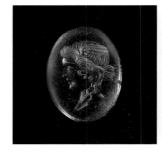

232 Carnelian, A 4, only slightly convex

13.3 × 10.1 × 4.5 mm
First half of the first century A.D.
85.AN.370.65

Description: Head of Medusa to right; her head is winged and her eyes are closed; some use of drilled pellets in the wing.

Discussion: The type is close to that of the chalcedony intaglio in London, signed by Sosokles (Vollenweider, *Steinschneidekunst*, p. 28 n. 12, pl. 18.1, 3; Furtwängler, *Kleine Schriften*, pp. 206–207, pl. 26.18) and the cameo signed by Diodotos in Paris (Furtwängler, *Kleine Schriften*, pp. 265–266; E. Babelon, *Collection Pauvert de la Chapelle* [Paris, 1899], no. 163). It is popular on gems and cameos (see Furtwängler, *AG*, pl. 38.29, 33, pl. 49.14, 16; *New York*, no. 388; *Thorvaldsen*, nos. 1107–1109; *Bibliothèque Nationale*, nos. 158–162; *Cook coll.*, no. 100).

Provenance: From Asia Minor.

230 Omitted

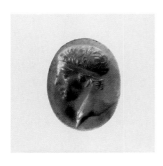
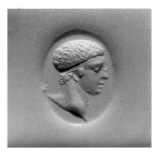

231 Sard, F 1

13.1 × 10.0 × 2.3 mm
First half of the first century A.D.
84.AN.1.37

Description: Head of the Diadoumenos of Polykleitos to right.

Partially discolored.

Discussion: The type is common on gems (see Furtwängler, *AG*, pl. 40.26–27, the latter, a signed glass paste = Furtwängler, *Kleine Schriften*, p. 179, no. 16 = Furtwängler, *Beschreibung*, no. 4982, also nos. 4983–4985; *Thorvaldsen*, no. 1140; *Munich*, pt. 3, no. 2397; Boston 62.1151, a carnelian from Asia Minor, C. C. Vermeule, *Bulletin of the Museum of Fine Arts, Boston*, 61 [1963], p. 10, no. 323, fig. 5). For the type in Roman sculpture, see P. Zanker, *Klassizistische Statuen* (Mainz, 1974), pp. 11–17, and on gems, see G. Horster, *Statuen auf Gemmen* (Bonn, 1970), pp. 62–71, pls. 14–15; see also the Doryphoros head, catalogue number 221, above.

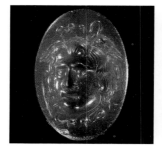
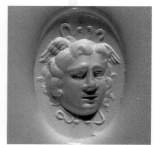

233 Carnelian, A 4, with straight sides and faceted bottom edge

18.5 × 12.9 × 5.0 mm
First century A.D.
83.AN.257.8

Description: Head of Medusa facing three-quarter right.

Traces of bronze adhering to the back and edge.

Discussion: For the subject and style, see *BMC Gems*, no. 1831, amethyst.

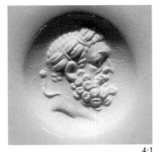

4:1

4:1

234 Banded agate, light brown/white/ dark brown, B 3

Diameter, 11.3 mm; thickness, 3.1 mm
First century A.D.
83.AN.437.26

Description: Wreathed head of bearded Herakles right.

Discussion: For a list of bearded heads of Herakles on coins and gems, see *Naples*, pp. 94–95; similar heads in glass paste, Furtwängler, *Beschreibung*, nos. 4946–4952.

236 Banded agate, white/brown/gray/ brown, C 3

12.9 × 11.7 × 6.9 mm
First century A.D.
85.AN.370.60

Description: Facing bearded satyr head; he is bald and wears an ivy wreath.

Discussion: Close in style to *De Clercq coll.*, no. 3177.

4:1

235 Banded agate, brown/blue/black, A 3 (with high sides, approaching A 4; perhaps cut down)

11.4 × 9.6 × 3.2 mm
First century A.D.
84.AN.1.40

Description: Facing bust of Isis.

Discussion: Facing busts of Isis on gems first appear in Ptolemaic times (see the clay sealing from Edfu, J. G. Milne, *JHS* 36 [1916], p. 89, no. 25); for a three-quarter facing bust of Isis, see *New York*, no. 377.

237 Banded agate, brown and white, C 3

10.3 × 8.8 × 5.6 mm
First century A.D.
83.AN.256.5

Description: Bearded satyr mask right.

Discussion: For the type, see Furtwängler, *Beschreibung*, no. 5227, glass paste.

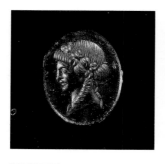
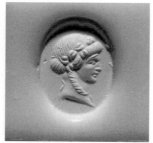

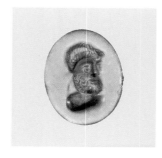
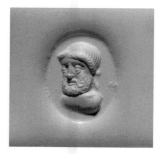

238 Sard, F 1

13.3 × 10.6 × 2.5 mm
First century A.D.
83.AN.437.25

Description: Head of unbearded Dionysos wearing ivy wreath to right.

Traces of iron adhering to the back.

Discussion: Furtwängler, *Beschreibung*, no. 6948, a carnelian, is particularly close in type and style; see also *BMC Gems*, no. 1556.

Provenance: From Asia Minor.

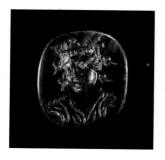
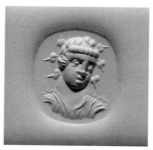

239 Carnelian, F 1, rectangular with rounded corners

13.9 × 12.0 × 2.2 mm
First century A.D.
85.AN.370.64

Description: Bust of unbearded Dionysos, wearing ivy wreath, facing three-quarter right.

Discussion: For similar types, see Furtwängler, *Beschreibung*, no. 6949, and *Thorvaldsen*, no. 1091, both nicolo.

Provenance: From Asia Minor.

240 Banded agate, upper layer blue and lower layer brown, F 1 (approaching F 4, with faceting between the blue and brown layers)

13.3 × 10.2 × 2.0 mm
First century A.D.
85.AN.370.61

Description: Bearded Dionysos herm facing three-quarter left.

Discussion: Italic versions in sard and glass, Furtwängler, *Beschreibung*, nos. 1784–1785, 6529; and early imperial examples, often in amethyst, Furtwängler, *AG*, pl. 41.4 = Vollenweider, *Steinschneidekunst*, p. 57 n. 59, pl. 57.10, in Florence; Furtwängler, *AG*, pl. 49.15; Paris, Richter, *Engraved Gems of the Romans*, no. 171, amethyst; *New York*, no. 322, amethyst; a carnelian ringstone in a medieval English mount, Henig, *Roman Engraved Gemstones*, M 14 = *BMC Gems*, no. 4049; and the very fine red jasper ringstone in London signed by the engraver Aspasios (Furtwängler, *AG*, pl. 49.15; Furtwängler, *Kleine Schriften*, pp. 249–250, pl. 27.11; Vollenweider, *Steinschneidekunst*, p. 31 n. 28, pl. 22.1–2).

Provenance: From Athens.

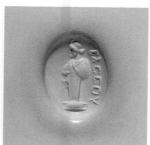
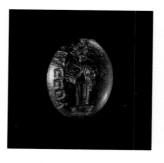

241 Carnelian, A 1, roughly shaped

11.4 × 8.9 × 4.0 mm
First century A.D.
76.AN.58

Description: Priapus herm left; to right, reading downward: BACCOY.

Discussion: A similar herm, *New York*, no. 339.

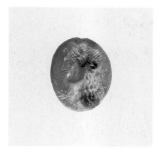
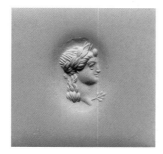

242 Carnelian, A 4

10.5×8.3×2.2 mm
First century A.D.
84.AN.1.41

Description: Head of Apollo wearing laurel wreath right, a laurel branch to right.

Trace of bronze adhering to the back.

Discussion: The type and style are especially close to *BMC Gems*, no. 1320.

Provenance: From Asia Minor.

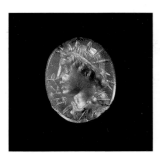
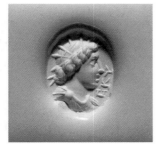

243 Carnelian, F 1

11.9×9.4×2.7 mm
First century A.D.
84.AN.1.42

Description: Draped and radiate bust of Helios right; to right, reading upward: CKY.

There is a chip from the edge; traces of iron adhering to the sides and back.

Discussion: For the type, see Henig, *Roman Engraved Gemstones*, no. 27, with literature; Maddoli, *Cirene*, nos. 472–480; Guiraud, *Gaule*, no. 50.

Provenance: From Asia Minor.

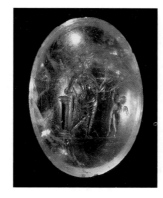
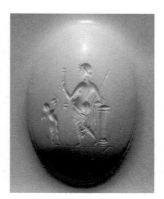

244 Amethyst, very pale, B 4

22.7×15.6×7.5 mm
First century A.D.
82.AN.162.34

Description: Venus Victrix, viewed from behind, standing left, leaning on a column; she holds a spear in her right hand and a sword in her left; to the left is a small Eros who offers her a helmet; groundline; hatched border.

Discussion: The motif, material, and style of engraving are consistent with a first-century date (for Venus Victrix, a very common device, see Henig, *Roman Engraved Gemstones*, no. 279, with literature; *New York*, nos. 300–301; J. H. Middleton, *The Engraved Gems of the Classical Times, with a Catalogue of the Gems in the Fitzwilliam Museum* [Cambridge, 1891], Appendix, no. 21, in Cambridge; Zazoff, *AG*, p. 330 n. 162; *Aquileia*, nos. 248–264; Guiraud, *Gaule*, nos. 320–326; *Caesarea*, nos. 43, 45; *BMC Gems*, nos. 1446, 2814–2815, 4056; she holds a sword on *BMC Gems*, no. 1444, and on catalogue number 246, below; accompanied by Eros on an unusual double-sided carnelian ringstone from Aquileia, Furtwängler, *Beschreibung*, no. 1014; *Thorvaldsen*, no. 712). The hatched border, typical of earlier Italic gems, is unusual at this date and may indicate an Italic origin. The composition of the scene, along with the size, shape, and material of the gem, recall an amethyst from Pompeii depicting a Muse accompanied by a small Eros (*Naples*, no. 60), which, however, does not have the hatched border and is not especially close in style. The device was said to have been on Caesar's seal (Dio 43.43).

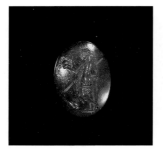
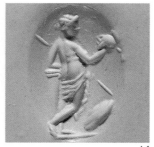

4:1

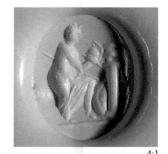

4:1

245 Plasma, A 1

11.7×7.1×3.3 mm
First century A.D.
84.AN.1.44

Description: Venus Victrix, viewed from behind, standing right, leaning on a column and holding a helmet and spear; a shield is at her feet; groundline.

Discussion: For the type, often in plasma, see catalogue number 244, above.

247 Plasma, A 1

8.9×7.0×2.8 mm
First century A.D.
82.AN.162.41

Description: Venus Victrix standing right, holding a helmet and spear; before her is a column surmounted by a vase; a shield rests against the column; groundline.

There is a chip from the edge.

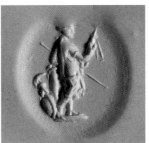

4:1

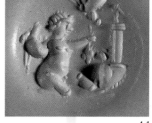

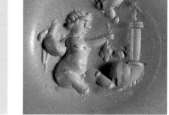

4:1

246 Nicolo, F 4

9.8×8.9×1.2 mm
First–second century A.D.
78.AN.373.5

Description: Venus Victrix, viewed from behind, standing right, leaning on a column and holding a spear and sword; a helmet and shield lie behind her at her feet.

Worn and badly chipped around the edge.

Provenance: From Tunisia.

248 Plasma, A 4

9.5×8.5×2.8 mm
First century A.D.
83.AN.437.19

Description: Eros seated right before a column surmounted by a Priapic statue; with a bunch of grapes, he taunts a mouse, who stands at the base of the column; a butterfly flies overhead.

Discussion: A similar seated Eros holding a butterfly, Furtwängler, *Beschreibung*, no. 8208, nicolo.

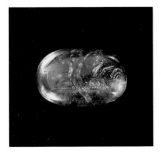
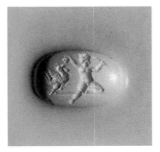

249 *Amethyst, B 1*

11.9 × 8.2 × 5.0 mm
First century A.D.
82.AN.162.36

Description: Boy (probably Eros, but no wings are shown) seated on a groundline holding a bunch of grapes in his right hand taunting a cock; he holds a palm branch in his left hand.

Discussion: A very similar scene, also with a wingless youth and cock, Sena Chiesa, *Luni*, no. 73, carnelian, and M. Maaskant-Kleibrink, *Description of the Collection in the Rijksmuseum G. M. Kam, Nijmegen*, vol. 10, *The Engraved Gems* (Nijmegen, 1986), no. 88, carnelian; see also Furtwängler, *Beschreibung*, nos. 6787–6788; *Hannover*, no. 815 E; *The Hague*, no. 454; Guiraud, *Gaule*, no. 318; W. Froehner, *Collection de M. de Montigny, Pierres gravées, vente 23–25 mai, 1887*, no. 266, red jasper; Henig, *Roman Engraved Gemstones*, no. 141, red jasper, with further literature.

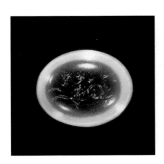
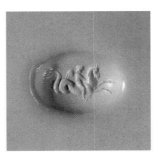

250 *Banded agate, brown and white, C 3, with high sides*

13.2 × 11.0 × 4.8 mm
First century A.D.
83.AN.257.2

Description: Eros riding a hippocamp right.

Discussion: The type is common on gems (see Henig, *Roman Engraved Gemstones*, nos. 127–129, with literature, which should read *BMC Gems*, nos. 1495–1496; also nos. 2860 and 3870, a glass cameo; *Sa'd Collection*, no. 177,

with literature; Furtwängler, *Beschreibung*, no. 8451; *Cologne*, no. 290; Guiraud, *Gaule*, nos. 344–349).

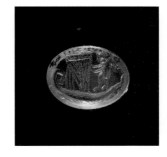
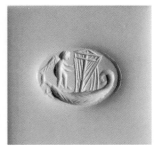

251 *Carnelian, A 4*

11.3 × 8.8 × 2.4 mm
First century A.D.
85.AN.370.68

Description: Eros standing right in the prow of a boat.

Discussion: For various representations of erotes in boats, see Furtwängler, *Beschreibung*, nos. 3809–3820, 6800 = *Berlin*, no. 452; *BMC Gems*, no. 2912; *Thorvaldsen*, no. 742; *New York*, no. 315; *Vienna*, vol. 1, no. 443; *Munich*, pt. 2, no. 1185; *Bologna*, nos. 84–85; Guiraud, *Gaule*, nos. 353–354.

Provenance: From Tunisia.

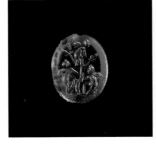
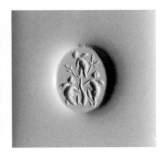

252 *Carnelian, F 1*

9.6 × 7.5 × 2.3 mm
First century A.D.
85.AN.370.69

Description: Three erotes at a tree; one has climbed into the branches, while another climbs a ladder, and the third kneels beside the tree holding a long stick.

There is a chip from the edge.

Discussion: For similar scenes, Furtwängler, *Beschreibung*, no. 8467, red jasper; *Hannover*, nos. 845–846, amethyst and plasma; Maddoli, *Cirene*, no. 304; and see *BMC Gems*, no. 1531, two erotes at a tree, hunting birds.

Provenance: From Tunisia.

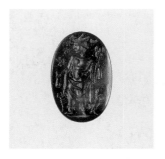
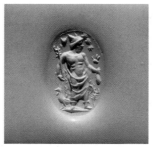

253 Carnelian, A 4

12.2×8.0×3.1 mm
First century A.D.
82.AN.162.44

Description: Hermes standing right, holding a caduceus in his right hand and a purse in his left; he is draped and wears a winged cap; at his feet are a cock, to left, and a scorpion, right; above him to left is a crescent, and to right are three stars; groundline.

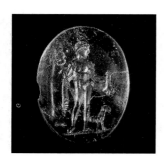
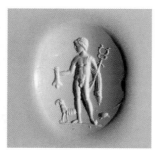

254 Amethyst, B 4, with rounded sides

16.2×12.3×4.9 mm
First century A.D.
82.AN.162.35

Description: Hermes standing left, a cloak wrapped around his left arm, holding a caduceus and a purse; a ram stands at his feet to left, and a turtle to right; groundline.

Traces of bronze adhering to the sides.

Discussion: For similar types, see *BMC Gems*, no. 1395, an amethyst from Trebizond, accompanied by a ram and a cock, and no. 2781, glass paste imitating amethyst; Furtwängler, *Beschreibung*, no. 2702, carnelian, ram but no turtle; *Aquileia*, nos. 165–192; *Thorvaldsen*, nos. 566–573; Henig, *Roman Engraved Gemstones*, no. 38, for literature.

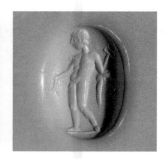

255 Banded agate, brown and white, C 3, with high sides

17.8×12.3×6.1 mm
First century A.D.
84.AN.1.47

Description: Hermes standing left, holding a purse in his right hand and a caduceus and cloak in his left hand; groundline.

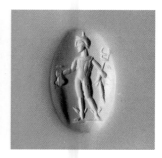
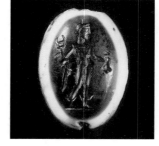

256 Banded agate, brown and white, C 4

17.0×12.2×5.4 mm
First century A.D.
81.AN.39.8

Description: Same type as catalogue number 255, above, but Hermes' feet are winged.

The stone is pierced lengthwise, which is unusual; traces of iron adhering to the back, sides, and in the drill hole.

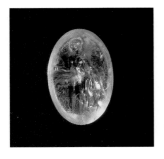
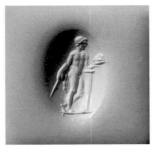

257 Rock crystal, B 4

13.5×8.9×4.9 mm
First century A.D.
81.AN.118.2

Description: Hermes standing right, leaning on a column; he wears a chlamys fastened around his neck and holds a ram's head on a dish in his left hand and a wand at his side in his right hand; groundline.

Discussion: The pose, with minor variants, appears to have been especially popular in the first century A.D. and is often found on the more precious stones, such as rock crystal, amethyst, and citrine (see Furtwängler, *Beschreibung*, no. 2713, an amethyst of nearly identical type, and nos. 2714–2716; *New York*, no. 290, amethyst; *Thorvaldsen*, nos. 562–565; Guiraud, *Gaule*, no. 194; also the summary version, cat. no. 309, below). The engraver Dioskourides cut the same device (without the column) on a carnelian ringstone now in London (Vollenweider, *Steinschneidekunst*, p. 63 n. 84, pl. 66.3–4).

Provenance: From Asia Minor.

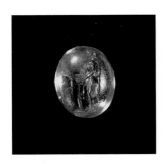
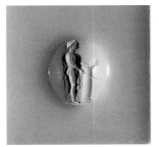

258 Citrine, B 4

9.8×8.3×5.1 mm
First century A.D.
85.AN.370.57

Description: Hermes standing right behind a column; he wears a chlamys and cap; his feet are winged; he holds a ram's head on a dish in his left hand and a wand before him in his right hand; groundline.

Discussion: A variant of catalogue number 257, above; it

is close in type to *Thorvaldsen*, no. 562, carnelian, and *Berry coll.*, no. 112, amethyst.

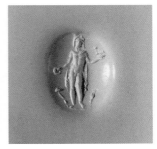
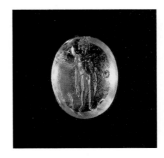

259 Citrine, A 4

11.7×9.0×3.5 mm
First century A.D.
85.AN.370.58 (Color plate 4)

Description: Bonus Eventus standing frontally; he wears a cloak fastened around his neck and holds a patera in his right hand and a stag on a dish in his left hand; at his feet are a poppy and an ear of corn; short groundline.

Discussion: The engraving is exceptionally fine, as on most citrine ringstones; for the type, see Furtwängler, *AG*, pl. 44.14, plasma, and *BMC Gems*, no. 1766, dark jasper.

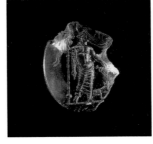
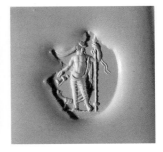

260 Amethyst, F 1

12.5×10.0×3.1 mm
First century A.D.
84.AN.1.46

Description: Dionysos standing left, holding kantharos and thyrsos with fillets; a panther stands at his feet; groundline.

Badly broken around the edge and face.

Discussion: For the type, see *Naples*, pp. 28–30, nos. 38–39, with literature on the representations on coins and gems; Henig, *Roman Engraved Gemstones*, no. 100, with literature; *Aquileia*, nos. 357–363; Guiraud, *Gaule*, no. 246; *The Hague*, no. 483, a convex amethyst.

Provenance: From Asia Minor.

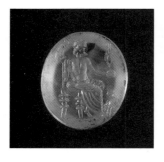
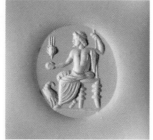

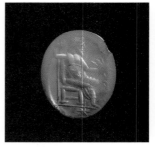
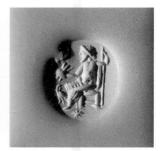

261 White agate, F 1

13.5×11.6×2.9 mm
First–second century A.D.
84.AN.1.45

Description: Zeus seated left, holding a scepter and patera, above which is an ear of corn; an eagle stands at his feet, its head turned back; groundline.

Traces of bronze adhering to the sides.

Discussion: The type is one of the most popular on gems; the objects that Zeus holds may vary; see Henig, *Roman Engraved Gemstones*, no. 7; *Sa'd Collection*, nos. 5–11; *New York*, no. 249; Maddoli, *Cirene*, nos. 12–19; *Romania*, nos. 85–97; *Bologna*, nos. 159–163; Guiraud, *Gaule*, nos. 1–6.

263 White chalcedony, A 2

11.5×9.4×2.7 mm
First–second century A.D.
80.AN.43.3

Description: Zeus seated left with eagle at his feet; he holds a thunderbolt instead of a patera; star in exergue. Worn.

Discussion: With a thunderbolt, Furtwängler, *Beschreibung*, no. 7132 (no star); *BMC Gems*, nos. 1243–1244.

Provenance: From Tunisia.

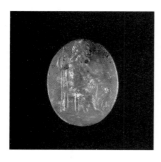
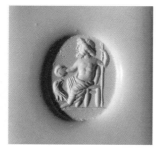

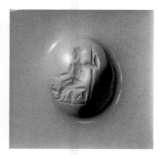
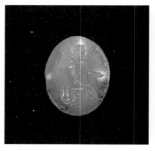

264 White chalcedony, B 1

11.5×9.0×5.0 mm
First–second century A.D.
79.AN.8.1

Description: Same type as catalogue number 263, above, but Zeus holds no object in his outstretched hand.

Provenance: From Tunisia.

262 Light brown agate, A 4, only slightly convex

12.0×9.6×2.1 mm
First century A.D.
81.AN.106.8

Description: Zeus seated left, holding a scepter and patera; an eagle stands left at his feet, its head turned back; groundline.

Traces of bronze adhering to the sides.

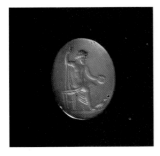
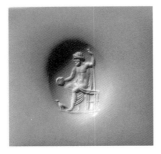

265 Light brown chalcedony, A 4, with low sides

11.3 × 8.8 × 3.1 mm
First–second century A.D.
82.AN.162.43

Description: Same type as catalogue number 263, above, but Zeus holds a patera.

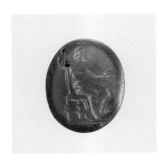
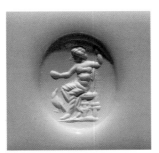

266 Carnelian, A 5

12.8 × 10.5 × 3.4 mm
First–second century A.D.
82.AN.162.45

Description: Same type as catalogue number 263, above.

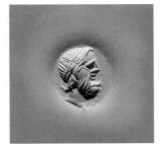

267 Carnelian, F 1

9.8 × 8.7 × 2.4 mm
First century A.D.
80.AN.43.8

Description: Bearded head of Zeus wearing laurel wreath to right.

Discussion: For the type, see *Naples*, p. 5, nos. 3–4, banded agate ringstones, from Pompeii.

Provenance: From Tunisia.

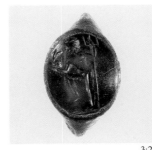
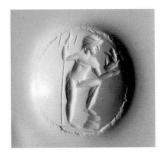

3:2

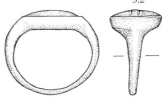

268 Carnelian in silver ring, probably B 5

Gem, circa 15 × 13 × 4.5 mm; greatest diameter of hoop, 24.5 mm
First century A.D.
78.AN.322.3

Description: Poseidon standing right, his left foot raised and resting on a rock; he holds a trident in his right hand and a dolphin in his left; groundline.

The ring is somewhat corroded.

Discussion: The type, popular in Hellenistic sculptural representations, continues on Roman gems; see Henig, *Roman Engraved Gemstones*, no. 18, with literature; close in style to *Berry coll.*, no. 108; also the glass gem catalogue number 423, below.

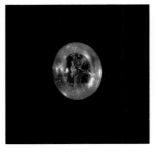
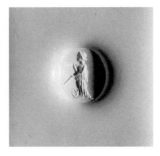

269 Amethyst, A 2

7.8×6.5×4.3 mm
First century A.D.
83.AN.437.27

Description: Nemesis standing left; she holds a wand in her left hand and pulls out her drapery with her right hand; a wheel is at her feet; groundline.

Discussion: For the type, usually winged, see Henig, *Roman Engraved Gemstones*, no. 291, and Appendix, no. 144; Furtwängler, *Beschreibung*, no. 7333, is also without wings; and no. 8438, a red jasper ringstone, shows two Nemeses without wings; also the red jasper ringstones, Guiraud, *Gaule*, no. 394, and catalogue numbers 334–335, below.

271 Banded white agate, F 2

15.3×9.8×2.7 mm
First–second century A.D.
85.AN.370.51

Description: Bust of Athena Parthenos right; she wears a triple-crested helmet decorated with griffin and sphinx, aegis, necklace, and earrings.

Discussion: The type is derived from the statue by Pheidias. An exceptionally fine example is on a gem signed by Aspasios, now in Rome (Furtwängler, *AG*, pl. 49.12 = Vollenweider, *Steinschneidekunst*, p. 31 n. 30, pl. 22.3–4), and it is found on other gems (Furtwängler, *AG*, pls. 38–39, 45–46; Furtwängler, *Beschreibung*, no. 6943; *Munich*, pt. 3, no. 2181) and cameos (*BMC Gems*, no. 3441, from Corfu; Furtwängler, *Beschreibung*, no. 11181, glass).

Provenance: From Asia Minor.

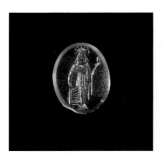
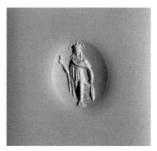

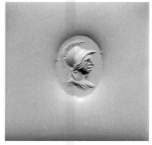

270 Carnelian, A 4

10.1×7.9×2.2 mm
First century A.D.
83.AN.437.30

Description: Spes standing facing front; she holds a flower in her right hand and her drapery in her left.

Discussion: The archaistic representation of Spes is very popular on gems and coins from the first through the third century A.D. (see Henig, *Roman Engraved Gemstones*, no. 340, with literature; *Harari coll.*, no. 81); she is usually shown in profile, but for other frontal representations, see *BMC Gems*, no. 1761, sard; Furtwängler, *Beschreibung*, no. 2443, plasma; and Maddoli, *Cirene*, no. 352.

272 Dark brown, almost black, sard, F 1

8.9×6.4×1.1 mm
First century A.D.
81.AN.106.6

Description: Head of Athena in crested Corinthian helmet right.

Discussion: For the type, see *Munich*, pt. 3, nos. 2182–2186, with literature; *Naples*, no. 22; *De Clercq coll.*, nos. 2919–2927.

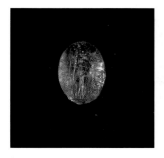
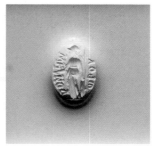

273 Amethyst, A 1

8.6 × 6.3 × 3.1 mm
First century A.D.
85.AN.370.59

Description: Athena standing left; she wears a crested helmet; her shield and spear stand to right; reading downward to left: MHNOΔ; and upward to right: WPOY.

Discussion: For the type and style, see *Berlin*, no. 457.

Provenance: From Asia Minor.

274 Carnelian, A 4, only slightly convex

16.5 × 12.3 × 3.7 mm
First–second century A.D.
82.AN.162.50

Description: Athena standing left; she wears a crested helmet and holds a Nike in her outstretched right hand and a spear in her left; a shield is by her side; groundline. Worn.

Discussion: The type is derived from the statue of Athena Parthenos by Pheidias, see Henig, *Roman Engraved Gemstones*, no. 234, with literature.

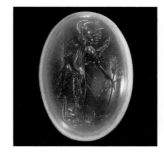
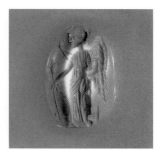

275 Banded agate, brown and white, C 3, nearly hemispherical

18.1 × 13.0 × 7.8 mm
First century A.D.
83.AN.437.29

Description: Pantheistic female deity; she combines the pose and attributes of Tyche, holding rudder and cornucopia, with the ear of corn and poppy of Demeter, the helmet of Athena, and the drapery of Nemesis; she is also winged; short groundline.

Discussion: The type is very popular on gems and is found, for example, on a large marble statue in Tunis (as noted by Fossing [*Thorvaldsen*], now Bardo Museum; on gems, see *Thorvaldsen*, nos. 670–675, 1722; *Munich*, pt. 3, nos. 2612, 2615, 3168–3169, with literature; *Sa'd Collection*, nos. 109–117, 425, with literature; Furtwängler, *Beschreibung*, nos. 2896–2901, 3623–3627, 7325–7332; *Aquileia*, nos. 609–615; Sena Chiesa, *Luni*, nos. 81–83; Guiraud, *Gaule*, no. 210; Maddoli, *Cirene*, nos. 61–63, 360; *Sofia*, no. 91; *BMC Gems*, nos. 1727, 3065–3066; *The Hague*, nos. 837–838; *Cologne*, no. 267; also the unusual pantheistic god, cat. no. 373, below).

Provenance: From Asia Minor.

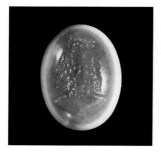
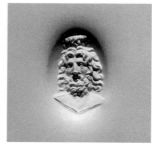

276 Banded agate, light brown/white/ gray/brown/gray, C 3, with high sides

15.0×11.1×6.3 mm
First century A.D.
83.AN.257.1

Description: Bust of Sarapis wearing kalathos facing three-quarter left.

Discussion: The earliest and finest example of the device on a gem is a carnelian ringstone in Berlin, which has been assigned to the second century B.C., but other similar examples belong to the first century A.D. (*Berlin*, no. 213, with further literature, including the fine Roman examples, *New York*, no. 146, rock crystal; *BMC Gems*, no. 1271, sard; *Munich*, pt. 1, no. 345, carnelian; *Vienna Gems*, vol. I, no. 27, sard; *Hannover*, nos. 1025–1026; Geneva, Vollenweider, *Deliciae Leonis*, no. 76, carnelian; *De Clercq coll.*, no. 2856, carnelian; Baltimore, Walters Art Gallery 42.1232, banded agate; Maddoli, *Cirene*, no. 448); for a study of the type, see W. Hornbostel, *Sarapis* (Leiden, 1973), pp. 161–167.

277 Banded agate, brown and white, C 3, with high sides

11.0×8.4×6.4 mm
First century A.D.
82.AN.162.51

Description: Harpokrates standing left; his right hand is raised to his mouth, and he holds a cornucopia; groundline.

Discussion: For the type and style, see *Thorvaldsen*, no. 1737, a similar banded agate ringstone of F 3 shape, and 1736, a nicolo ringstone; Furtwängler, *AG*, pl. 62.3; *BMC Gems*, nos. 1799–1804, 1803 being a banded agate ringstone of F 3 shape; Furtwängler, *Beschreibung*, nos. 6483, 8718–8719; *Munich*, pt. 3, no. 2677, banded agate; *Vienna Gems*, no. 455, banded agate; *Bologna*, no. 133, banded agate; *The Hague*, no. 501, amethyst; *Sa'd Collection*, no. 217, nicolo, with literature; *De Clercq coll.*, no. 3119; *Berry coll.*, no. 138, plasma; Maddoli, *Cirene*, no. 265; and the bust of Harpokrates on a glass gem, catalogue number 420, below.

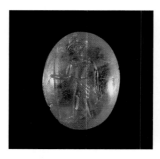
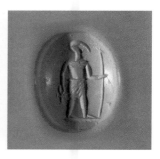

278 Amethyst, B 4

13.5×10.2×4.5 mm
First century A.D.
83.AN.437.55

Description: The Egyptian ibis-headed god Thoth standing right, holding a long staff in his left hand and an *ankh* in his right; groundline.

Discussion: Egyptian deities were already appearing on Roman gems and rings by the first century A.D., as Pliny states (*Naturalis Historia* 33.41), and as is demonstrated by the carnelian ringstone depicting Anubis in an iron ring found at Pompeii (*Naples*, no. 109). Depictions of Thoth are rare, but he appears on a rock crystal gem (*Southesk coll.*, no. K 16) and occasionally on magic gems (C. Bonner, *Studies in Magical Amulets, Chiefly Graeco-Egyptian* [Ann Arbor, 1950], nos. 45–46; A. Delatte and Ph. Derchain, *Les Intailles magiques greco-égyptiennes, Bibliothèque Nationale, Cabinet des Médailles* [Paris, 1964], no. 185; and on a gem from Askalon in Sir John Soane's Museum, London, C. C. Vermeule, "A Catalogue of the Classical Antiquities in Sir John Soane's Museum, London" [unpublished manuscript, 2nd version, 1973], no. 705).

Provenance: Münzen und Medaillen, Basel, *Liste* 379, July 1976, no. 88.

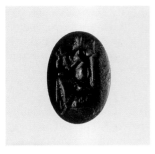
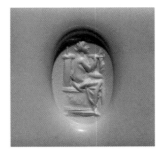

279 Plasma, A 2

12.7×8.4×3.3 mm
First century A.D.
82.AN.162.42

Description: Muse seated right on garlanded altar before a column, playing a lyre.

280 Plasma, A 1

10.0×7.9×3.0 mm
First century A.D.
84.AN.1.57

Description: Muse seated left holding a theater mask; groundline.

Discussion: For the type, see Henig, *Roman Engraved Gemstones*, Appendix, no. 147; Guiraud, *Gaule*, nos. 56–57, the latter plasma; and for a similar type with a seated actor, catalogue number 377, below.

281 Plasma, A 4 (the bottom is cut off-center, perhaps cut down from an A 1 shape)

10.2×7.3×3.1 mm
First century A.D.
82.AN.162.40

Description: Bearded satyr sitting right on a rock below a tree; he plays a lyre, and two goats jump before him; groundline.

Discussion: More commonly, a satyr holding a lyre sits before a rustic shrine, see Furtwängler, *AG*, pl. 42.60; Furtwängler, *Beschreibung*, no. 7401; *Thorvaldsen*, no. 825; *BMC Gems*, no. 1584; *Braunschweig*, nos. 101–102.

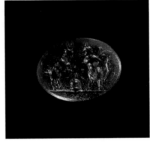
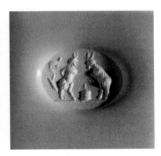

282 Carnelian, A 4

11.3×8.9×2.9 mm
First–second century A.D.
83.AN.256.1

Description: Pan and a goat butting heads over an altar; a tree to left; groundline.

Discussion: The motif is very popular; see Henig, *Roman Engraved Gemstones*, no. 145, with literature; add: Furtwängler, *Beschreibung*, nos. 4072–4074, 7429–7430; *The Hague*, no. 746; Guiraud, *Gaule*, no. 317. See also the more complex composition on the cameo, catalogue number 428, below.

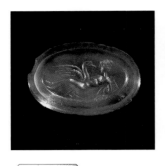
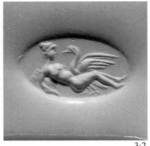

3:2

283 Banded agate, dark green on lighter green, F 2

20.0 × 13.6 × 4.1 mm
First–second century A.D.
83.AN.437.22

Description: Leda, reclining to right, and the swan.

Discussion: For the type, see Henig, *Roman Engraved Gemstones*, no. 478, with literature; *Aquileia*, nos. 732–733; *Berry coll.*, no. 67, from Sidon; Henkel, *Römische Finger-ringe*, no. 224, from the Rhineland; Guiraud, *Gaule*, no. 454; *Vienna Gems*, vol. 1, no. 497; *The Hague*, no. 288; Geneva, Vollenweider, *Deliciae Leonis*, no. 72, carnelian in a silver ring; *Sa'd Collection*, nos. 231–232, red jasper; Museo Nazionale Romano, R. Righetti, *Atti della Pontificia Accademia Romana di Archeologia, rendiconti* 30–31 (1957–1959), p. 223, fig. 61, carnelian.

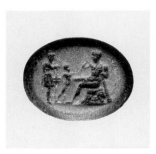
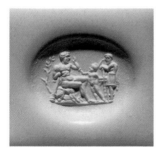

284 Nicolo, F 4

14.3 × 11.3 × 3.5 mm
First–second century A.D.
82.AN.162.57

Description: Herakles seated right before a tree on a rock covered with his lionskin; he leans on his club with his right hand and gestures with his raised left hand; before him stands the infant Telephos, who leans forward and raises his right arm to Herakles; behind the boy stands a shepherd, who leans on his staff, to which the youth is tied(?); groundline.

Discussion: The motif of Herakles finding his son Telephos in Arkadia is uncommon on Roman gems (see the Greek

ring, cat. no. 84, above), and the few known examples all differ in composition and details. The closest example is a gem in New York (*New York*, no. 413), which shows a seated Herakles holding the young Telephos on his knee and a shepherd behind. Another example, probably of first-century-B.C. date (*Vienna Gems*, vol. 1, no. 265), includes the hind, as does a cameo (*Cook coll.*, vol. 2, p. 78, no. 338). A glass gem in Berlin shows a standing Herakles holding his young son (Furtwängler, *Beschreibung*, no. 4172). On the Finding of Telephos fresco from Herculaneum and related iconography, see G. Hafner, *Aachener Kunstblätter*, 1969, pp. 231–237.

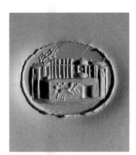
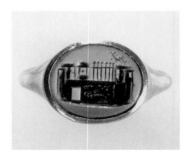

285 Nicolo in hollow gold ring, probably F 4

Gem, circa 12 × 10 mm; greatest diameter of hoop, 21.4 mm
First century A.D.
84.AN.857

Description: View of the walls and city of Troy; outside the walls, Achilles drags the body of Hektor behind his biga.

Discussion: The details of Hektor's body cannot be discerned, but the scene is common on gems (*Aquileia*, no. 739, glass imitating nicolo; *BMC Gems*, no. 1938, sard, and nos. 3201–3202, glass; *Vienna Gems*, vol. 2, no. 671, glass; Vollenweider, *Deliciae Leonis*, no. 210, carnelian; *Munich*, pt. 2, nos. 1350–1351, glass; Furtwängler, *Beschreibung*, no. 2329: carnelian, nos. 4272–4274: glass, and nos. 6887–6888: showing Troy without Achilles and Hektor; *LIMC*, vol. 1, p. 141, no. 607, s.v. Achilleus).

Provenance: From Syria.

Bibliography: *GettyMusJ* 12 (1984), p. 173, no. 36. B. D. Wescoat, *Poets and Heroes: Scenes of the Trojan War*, exh. cat., Emory University, Museum of Art and Archaeology, Atlanta, 1986, p. 46, no. 11.

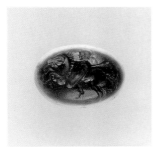

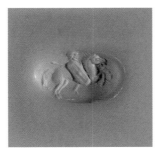

286 Banded agate, brown and white, C 3, with high, straight sides

12.1 × 8.7 × 5.6 mm
First century A.D.
82.AN.162.52

Description: Bearded and helmeted horseman riding right; he holds a spear and a long Celtic shield; short groundline.

Discussion: For the type, see *BMC Gems*, no. 2106; *Munich*, pt. 3, no. 2378, with literature; *The Hague*, no. 402, yellow jasper in a silver ring; *Braunschweig*, no. 136; *Sa'd Collection*, no. 286.

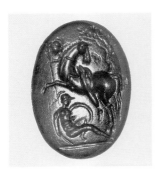

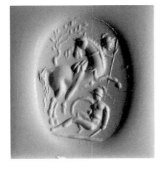

287 Carnelian, A 4

19.3 × 13.3 × 3.3 mm
First century A.D.
85.AN.370.49

Description: Horseman spearing a fallen warrior; the horse rears to right, its head turned left; the horseman wears a crested helmet; the fallen warrior also wears a crested helmet and carries a sword and shield; a tree stands behind the horse, left; groundline.

Discussion: The shape and material of the stone and the style of the engraving are similar to catalogue number 288, below.

Provenance: From Asia Minor.

288 Carnelian, A 4

18.1 × 13.1 × 2.6 mm
First century A.D.
85.AN.370.48

Description: Marsyas hanging from a tree, while two satyrs prepare to flay him; to the right, before a column, stands Apollo holding a lyre; groundline.

Discussion: Various groups depicting Marsyas, Apollo, and Olympos are common on Roman imperial gems of the first and second centuries, often of very good quality (especially close in style, type, and size are *Berry coll.*, no. 68, carnelian, and M. Henig, *Antiquaries Journal* 58 [1978], p. 376, pl. 76d; also see *BMC Gems*, no. 1313, rock crystal, and nos. 2744–2745, glass; Furtwängler, *Beschreibung*, no. 8233 = *Berlin*, no. 467, nicolo; Furtwängler, *Beschreibung*, nos. 8392–8393, red jasper, the second *Berlin*, no. 466; and Furtwängler, *Beschreibung*, no. 11371 = *Berlin*, no. 468, a remarkable plektron made of plasma; Paris, Richter, *Engraved Gems of the Romans*, nos. 253 and 255, nicolo and agate; also the fine sard ringstone in Naples, perhaps the work of the engraver Dioskourides, Vollenweider, *Steinschneidekunst*, p. 61, pl. 64).

Provenance: From Syria.

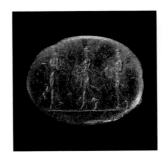

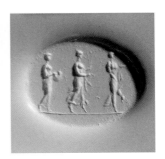

289 Carnelian, F 1

15.6 × 12.5 × 3.7 mm
First century A.D.
85.AN.444.25

Description: The three Seasons (*Horae*) walking right; groundline. They are represented as women; Summer on

the left carries fruit gathered in a cloth before her; Autumn carries stalks; and Spring, her head turned to front, carries a dish.

There are some chips from the edge; worn.

Discussion: The representation is rare on gems, but a first-century glass gem in Berlin shows a similar scene (Furtwängler, *Beschreibung*, no. 6262, who reverses the interpretation of Summer and Spring). An extraordinary gem in Berlin depicts a similar Summer (a 9-cm sard gem; Furtwängler, *Beschreibung*, no. 6712 = Furtwängler, *AG*, pl. 39.25 = *Berlin*, no. 464, with commentary; Vollenweider, *Steinschneidekunst*, p. 53, pl. 51.1, who attributes the gem to the engraver Solon; see also *Berlin*, no. 465, as Summer with Sirius); a large bronze statuette in London is also similar, suggesting a sculptural prototype (H. B. Walters, *Catalogue of the Bronzes, Greek, Roman, and Etruscan, in the British Museum* [London, 1899], no. 1513). Representations on gems of Autumn (*Thorvaldsen*, no. 685, plasma, as Summer; Furtwängler, *AG*, pl. 38.3 = Walters Art Gallery 42.1341, glass) and Winter (*New York*, no. 385; Sena Chiesa, *Luni*, no. 40; *Munich*, pt. 3, nos. 3141–3144; *Cologne*, no. 313, all glass) are also known. Close in style and iconography is a Roman cameo glass vase in Paris (*Bibliothèque Nationale*, no. 623, as eighteenth century; M.-L. Vollenweider, in *Vrai ou Faux? Copier, imiter, falsifier*, exh. cat., Bibliothèque Nationale, Paris, 1988, pp. 90–92, no. 24, as second century B.C.; correctly described by D. Whitehouse, *Journal of Glass Studies* 31 [1989], pp. 16–24) and representations on Arretine vases (a bowl from the workshop of Cn. Ateius, now in London, A. Oxe, *Arretinische Reliefgefässe vom Rhein* [Frankfurt, 1933], pp. 78–80, no. 132, pls. 32–34; and from the Perenniana workshop, M. T. Marabini Moevi, *Bollettino d'Arte* 42 [1987], pp. 1–36, with comments on possible Ptolemaic prototypes). Furtwängler suggested that the type may have been derived from metalwork (*AG*, vol. 3, p. 347), while Hanfmann has noted the difficulty in identifying the Classical prototypes of the three dancing Horae type (G. M. A. Hanfmann, *The Season Sarcophagus in Dumbarton Oaks* [Cambridge, Massachusetts, 1951], vol. 1, pp. 131–132 n. 151, figs. 80–81; vol. 2, pp. 138–139).

Provenance: From Asia Minor.

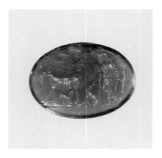
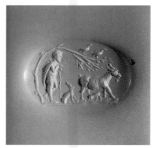

290 Plasma, deep green with no inclusions, A 4

14.6 × 10.8 × 2.6 mm
Late first century A.D.
85.AN.370.50 (Color plate 4)

Description: Goatherd, leaning on his staff, standing right below a tree, in which sit two birds; before him sits a dog, and a goat stands right, suckling a kid; groundline.

Discussion: Bucolic scenes like this first appear on Italic gems of the first century B.C., but Henig has convincingly argued that many pastoral genre scenes with shepherds and goatherds, notably in plasma, are most appropriate for the Flavian period and later (see Henig, *Roman Engraved Gemstones*, p. 33). This example is exceptionally fine and likely to date from the Flavian period (for similar scenes, see Henig, *Roman Engraved Gemstones*, nos. 497–500; Furtwängler, *Beschreibung*, nos. 8278–8280, all in nicolo). For the significance of the motif, see N. Himmelmann, *Über Hirten-Genre in der antiken Kunst* (Opladen, 1980).

Provenance: From Asia Minor.

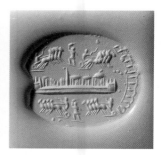

291 Carnelian, F 7

16.0 × 13.6 × 2.3 mm
First century A.D.
85.AN.370.62

Description: Circus race; around the spina are four chariots and two men on foot; the spina contains the metae, an obelisk, and other structures.

There is a chip from the edge; slightly discolored white.

Discussion: The type is popular on gems throughout the imperial period, mostly in red jasper of second- and early

third-century date. Occasionally the Circus Maximus in Rome can be identified by the presence of the statues of Cybele and Nike in the spina (see J. H. Humphrey, *Roman Circuses* [London, 1986], pp. 204–207; Henig, *Roman Engraved Gemstones*, nos. 513–514, carnelians, with literature; Furtwängler, *Beschreibung*, nos. 8485–8487, 8687, red jasper, and nos. 4602–4605, glass; *Berlin*, no. 483, with literature; *Aquileia*, no. 872, black jasper; *BMC Gems*, nos. 2125–2128, red jasper; *The Hague*, nos. 637, 716, 792; *Hannover*, nos. 1018–1021; Richter, *Engraved Gems of the Romans*, nos. 363–366; *Geneva*, vol. 2, nos. 407, 410–411, glass; *Lewis coll.*, no. 201, carnelian; *Southesk coll.*, F 17 = Bard collection, Sotheby's, London, July 11, 1977, lot 136, red jasper; Istanbul, Archaeological Museum 4014, an agate ringstone from Diyarbakır, *The Anatolian Civilisations*, vol. 2, exh. cat., Istanbul, 1983, C.110; Baltimore, Walters Art Gallery 42.1314, red jasper).

Provenance: From Syria.

292 Sard, A 4

11.8×9.5×3.9 mm
First century A.D.
85.AN.370.71

Description: Bearded comic mask facing three-quarter right.

Discussion: Close in style to the glass gem, *BMC Gems*, no. 3003; *The Hague*, no. 321, carnelian.

Provenance: Sternberg, Zurich, auction 10, November 26, 1980, lot 768.

293 Emerald, A 2

8.0×6.4×3.5 mm
First century A.D.
82.AN.162.39

Description: Unbearded comic mask facing three-quarter left.

There are small chips from the edge.

Discussion: A similar mask, but seen in profile, Furtwängler, *Beschreibung*, no. 5270, glass. Intaglios in emerald are very rare (Furtwängler, *Beschreibung*, no. 2324, with Nike, and no. 1035, engraved on four sides; *Berlin*, nos. 559–560, both by the same hand; no. 11118, a Medusa head cameo; *BMC Gems*, no. 1878, head of Herakles, no. 2699, inscribed; *Thorvaldsen*, no. 933, hero, no. 1054, bust of Apollo, no. 1096, head of a young satyr; *Lewis coll.*, no. 76, Silvanus; and a portrait bust of a second-century-A.D. woman in a gold ring in Oxford).

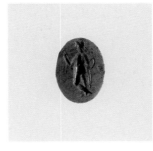
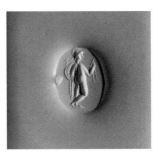

294 Composite mineral, A 1

9.4×6.8×1.6 mm
First century A.D.
78.AN.373.2 (Color plate 4)

Description: Theseus standing right, viewed from behind; he is nude except for a crested helmet; he holds the sword of his father, Aigeus, in his right hand and a shield and cloak in his left hand.

Discussion: For the type, popular on imperial intaglios, see Beazley, *Lewes House*, nos. 107, 123; Henig, *Roman Engraved Gemstones*, no. 455; *The Hague*, no. 712, all with further literature; *Naples*, no. 134, from Pompeii; Guiraud, *Gaule*, nos. 455–462.

Provenance: From Asia Minor.

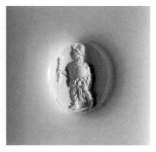

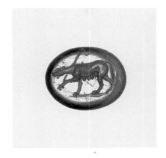

similar in pose and style to Furtwängler, *Beschreibung*, no. 3217, a convex carnelian ringstone.

295 Carnelian, A 4, bottom filed flat

9.9×7.5×3.3 mm
Circa A.D. 88
85.AN.370.70

Description: Herald of the *ludi saeculares* walking left; he wears a cap and holds a circular shield and staff; groundline.

Discussion: The costume of the figure identifies him as a herald of the Secular Games, which were held every hundred years. The gem may have been made to commemorate the games held under Domitian in A.D. 88, and the style supports this date. Coins with the same device were struck for the occasion (see H. Mattingly, *Coins of the Roman Empire in the British Museum*, vol. 2 [London, 1930], pp. 326–367, nos. 130–136; similar representations appear on coins of Augustus struck by M. Sanquinius in 17 B.C. in commemoration of the previous games, ibid., vol. 1 [London, 1923], p. 13, nos. 69–70).

Provenance: From Tunisia.

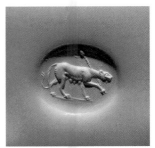

297 Carnelian, A 4, only slightly convex

10.8×8.8×2.1 mm
First century A.D.
82.AN.162.48

Description: Female panther walking right, a filleted thyrsos over her shoulder; groundline; some use of small drilled pellets.

Discussion: The style is very fine and appears related to a series of finely engraved banded agate ringstones that often depict animals (for panthers in similar style, see *BMC Gems*, no. 2336, agate; Baltimore, Walters Art Gallery 42.951, banded agate; Furtwängler, *Beschreibung*, no. 2040, carnelian; *Thorvaldsen*, nos. 1306–1309; Henig, *Roman Engraved Gemstones*, no. 641, with further literature).

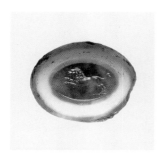

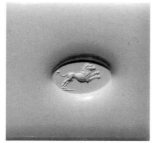

296 Banded agate, light brown/white/ gray/dark brown, F 3

14.1×11.3×6.6 mm; top, 8.1×5.1 mm
First century A.D.
82.AN.162.53

Description: Lion leaping right; short groundline. Traces of bronze adhering to the back.

Discussion: The fine, miniaturist style is typical of a class of banded agate ringstones. For the pose of the lion, see Henig, *Roman Engraved Gemstones*, no. 639, with literature;

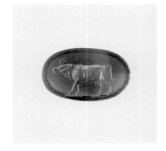

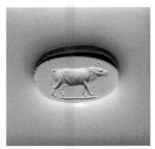

298 Brown agate, F 1

11.5×7.3×1.9 mm
First century A.D.
82.AN.162.55

Description: Bull standing right; groundline.

Discussion: The style is fine (see *The Hague*, no. 280; *BMC Gems*, no. 2366; *De Clercq coll.*, no. 2872, agate).

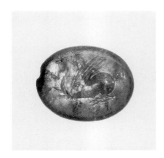 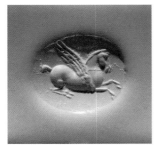

299 Amethyst, A 4

13.1 × 10.5 × 3.0 mm
First century A.D.
82.AN.162.37

Description: Pegasos, with bridle, flying right.
There is a chip from the side.

Discussion: For the style, see *Thorvaldsen*, no. 1570, a carnelian.

 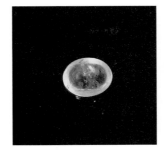

301 Rock crystal, A 2

6.4 × 5.3 × 2.3 mm
First century A.D.
79.AN.27.2

Description: Goat standing right; groundline.

Discussion: For the style, see Sena Chiesa, *Luni*, no. 125, a carnelian ringstone.

Provenance: From Tunisia.

 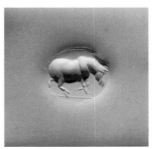

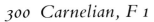

300 Carnelian, F 1

9.3 × 7.8 × 1.7 mm
First century A.D.
82.AN.162.49

Description: Grazing horse right; groundline.
The edges are slightly cut down and chipped.

Discussion: Similar in style to *Naples*, no. 260, from Pompeii; also *Thorvaldsen*, no. 1323; Furtwängler, *Beschreibung*, nos. 5482–5486; *The Hague*, no. 408; *Sa'd Collection*, nos. 348–349; Guiraud, *Gaule*, nos. 665–668; Maddoli, *Cirene*, nos. 702–707.

 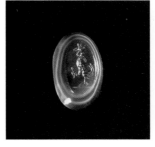

302 Banded agate, brown and white, F 2, unevenly shaped

10.9 × 6.7 × 3.9 mm
First century A.D.
82.AN.162.94

Description: Cock standing right, his left leg raised; groundline.

Discussion: For the type, see *Cologne*, no. 430, with literature; *Aquileia*, no. 1336.

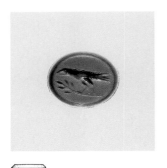
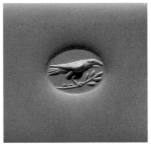

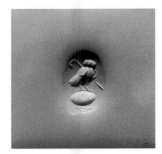
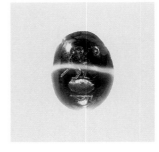

303 Nicolo, F 4

9.5 × 7.9 × 1.2 mm
First–second century A.D.
81.AN.39.4

Description: Raven standing right on a laurel branch.

Discussion: The bird is sacred to Apollo; see *The Hague*, no. 462, with literature, and no. 619; *Naples*, nos. 275–276, from Pompeii; *Aquileia*, no. 1309, nicolo; *BMC Gems*, no. 3391; Furtwängler, *Beschreibung*, no. 5826, glass paste imitating nicolo, and nos. 8330–8332, nicolos; *Thorvaldsen*, nos. 1465–1469, the first a nicolo; *Bologna*, no. 109, nicolo; Henig, *Roman Engraved Gemstones*, no. 674; Guiraud, *Gaule*, no. 770, a banded agate ringstone.

305 Banded agate, brown/white/brown, A 8

11.2 × 8.5 × 2.5 mm
First century B.C.–first century A.D.
85.AN.370.45

Description: Owl standing right on shield; a pedum is placed diagonally behind it. A short Kufic Arabic inscription was added at a later date (eighth or ninth century?) below: ALLAH.

There are some chips from the edge.

Discussion: The owl and the shield are attributes of Athena. An Italic version is in Munich (*Munich*, pt. 2, no. 779; and see Furtwängler, *Beschreibung*, no. 2055, on an amphora, as on the Hellenistic coinage of Athens), while Roman examples more typically show the owl accompanied by a shield and kerykeion (Furtwängler, *Beschreibung*, no. 5755, glass; and see *The Hague*, no. 231). For Arabic inscriptions added to earlier gems, see the Greek gem in London (*BMC Gems*, no. 2405 = Boardman, *GGFR*, pl. 612) and the Graeco-Persian scaraboid in Oxford (*Oxford Gems*, no. 178).

Provenance: From Syria, allegedly found with catalogue number 304, above.

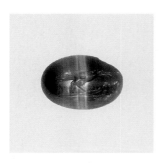
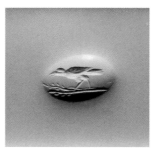

304 Banded agate, brown/white/brown, A 8

11.1 × 7.6 × 1.9 mm
First century B.C.–first century A.D.
85.AN.370.46

Description: Raven standing left on a branch.

Discussion: The type is the same as catalogue number 303, above. The shape and material are unusual but identical to the next example; the two were said to have been found together and are likely from the same workshop. Banded agates are usually of Italic manufacture but are seldom of this shape, which is more typical of Eastern garnets. A Syrian workshop, in view of the unusual shape and the provenance, is possible.

Provenance: From Syria, allegedly found together with catalogue number 305, below.

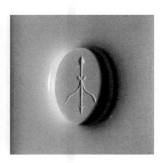

306 Citrine, F 6, with flattened bottom

10.9 × 7.3 × 3.0 mm
First century A.D.
83.AN.437.32

Description: Thyrsos with fillets.

Discussion: The type becomes popular in the Hellenistic period and is found on a garnet ringstone from Kerch and

an amethyst-colored glass gem, both in Oxford (*Oxford Gems*, nos. 340–341, with comments on the device as a royal symbol), and on a fine garnet in a gold ring in the Antikensammlung in Munich (unpublished); a rock crystal example from Herculaneum (*Naples*, no. 338) also appears to be a Hellenistic work. Early imperial examples are usually in fine stones, such as citrine and amethyst (see cat. no. 307, below; *Cologne*, no. 240, from the Rhineland; *Harari coll.*, no. 53; Naples 26403, cited in *Naples*, p. 176—all amethyst; *Munich*, pt. 3, no. 2364, sard; also Furt-wängler, *Beschreibung*, nos. 2278–2280, 6663).

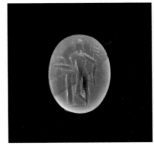
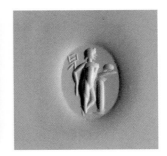

309 *Pink agate, F 1*

11.8 × 8.3 × 2.0 mm
First century A.D.
79.AN.8.6

Description: Hermes standing right, leaning on a column; he holds a caduceus in his right hand and a ram's head on a dish in his left hand; short groundline.

Discussion: For the type, see catalogue number 257, above; *Munich*, pt. 3, no. 2518, for the style.

Provenance: From Tunisia.

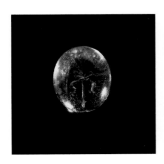
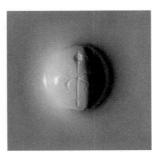

307 *Amethyst, A 4*

9.1 × 7.2 × 4.2 mm
First century A.D.
85.AN.444.14

Description: Same type as catalogue number 306, above.

Provenance: From Asia Minor.

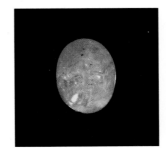
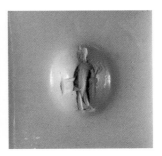

308 *Carnelian, A 4*

9.8 × 7.3 × 3.2 mm
First century B.C.–first century A.D.
83.AN.437.33

Description: Two-line inscription, meant to be read from the stone (not in impression). The top line is Punic: *hykt*, a female name [Ziony Zevit]. The bottom line is Latin: SEC. Partially discolored.

Discussion: For another Punic inscription, see catalogue number 186, above.

Provenance: From Tunisia.

310 *Rock crystal, B 1*

10.1 × 7.8 × 5.7 mm
First century A.D.
79.AN.126.7

Description: Hermes standing left, holding a purse in his right hand and a caduceus and cloak in his left hand; short groundline.

Discussion: See the carnelian ringstones from Pompeii and Herculaneum, *Naples*, nos. 70–71, 90 (the last as Bonus Eventus); Henig, *Roman Engraved Gemstones*, no. 38, is of similar style.

Provenance: From Tunisia.

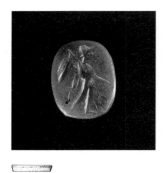
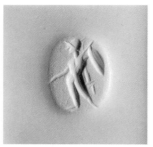

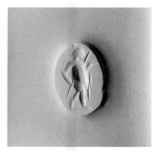
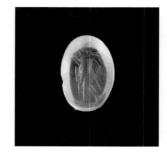

311 Carnelian, F 1

11.1 × 8.8 × 1.9 mm
First century A.D.
83.AN.353.4
Description: Ares standing left, holding a shield and transverse spear; groundline.
Worn.

313 White chalcedony, F 1, unevenly shaped

10.5 × 7.3 × 2.1 mm
First–second century A.D.
83.AN.353.3
Description: Ares walking right holding a spear and a trophy over his shoulder; groundline.
Discussion: For the type, see Henig, *Roman Engraved Gemstones*, no. 70, with literature; *Aquileia*, nos. 221–233; *Sa'd Collection*, no. 224.

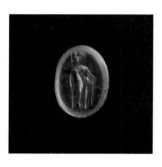
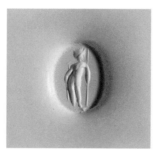

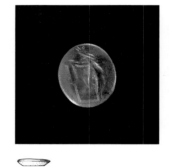
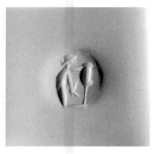

312 Carnelian, F 1

10.0 × 7.3 × 2.2 mm
First century A.D.
79.AN.8.5
Description: Ares standing left, holding an upright spear in his left hand and a shield at his side.
Discussion: For the type, see Henig, *Roman Engraved Gemstones*, no. 78, with literature; *Sa'd Collection*, nos. 220–221.
Provenance: From Tunisia.

314 Carnelian, A 4, convex, unevenly shaped

8.8 × 7.8 × 2.3 mm
First century A.D.
83.AN.353.10
Description: Aphrodite standing right, leaning on an upright oar and adjusting her sandal; groundline.
Discussion: For the type, see Henig, *Roman Engraved Gemstones*, no. 278, with literature; *Sa'd Collection*, nos. 227–228, with literature; *Aquileia*, nos. 266–267.

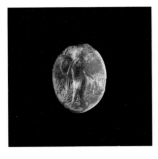
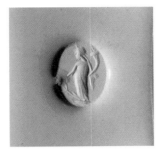

315 *Carnelian, F 1*

9.1×7.2×2.2 mm
First–second century A.D.
83.AN.353.1
Discussion: Tyche standing left, holding a rudder and a cornucopia; short groundline.
Partially discolored white; there is a chip from the edge.
Discussion: For similar examples from Pompeii and Herculaneum, *Naples*, nos. 81–87; for the type, see Guiraud, *Gaule*, no. 201, as first century A.D.; and Henig, *Roman Engraved Gemstones*, no. 314, with literature.

317 *Plasma, A 2*

9.1×6.2×3.4 mm
First–second century A.D.
79.AN.8.4
Description: Same type as catalogue number 316, above. The engraving is very crude.
Provenance: From Tunisia.

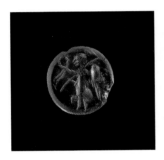
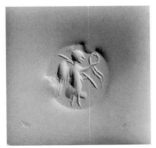

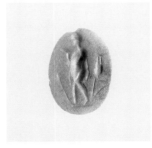

316 *Carnelian, F 1*

9.5×9.1×1.3 mm
First–second century A.D.
83.AN.353.11
Description: Nike walking right, holding a wreath in her right hand and a palm branch over her shoulder.
Traces of bronze adhering to the sides.
Discussion: The type is very common on gems, see Henig, *Roman Engraved Gemstones*, no. 295; *Sa'd Collection*, no. 125, for literature; also catalogue numbers 317 and 371, below.

318 *Carnelian, F 1*

12.1×8.2×2.3 mm
First century A.D.
78.AN.373.1
Description: Methe standing right, holding a cup; a vase is on a table to the left, and a branch is to the right; short groundline.
Discolored white.
Discussion: For the type, see catalogue number 180, above.
Provenance: From Tunisia.

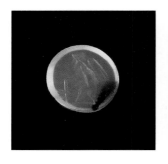

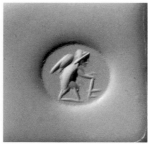

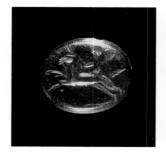

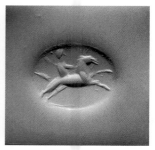

319 White chalcedony with black inclusions, F 1

9.8×9.0×1.9 mm
First century A.D.
81.AN.39.2

Description: Eros standing right, leaning on a pickax; groundline.

Discussion: Eros bound and forced to labor as a slave is a popular motif, the finest example being a first-century cameo signed by the engraver Aulos (lost; Vollenweider, *Steinschneidekunst*, pp. 40–41, no. 15, pl. 31.5; for examples on gems, see Henig, *Roman Engraved Gemstones*, no. 134, with literature; *Aquileia*, nos. 287–288; *Sofia*, no. 142; *BMC Gems*, no. 1504; Maddoli, *Cirene*, no. 316).

Provenance: From Tunisia.

321 Sard, A 3, with high sides and only slightly convex

12.5×10.5×2.4 mm
First century A.D.
79.AN.27.6

Description: Eros riding a horse right.

Discussion: The type is common (see Henig, *Roman Engraved Gemstones*, no. 109; *BMC Gems*, nos. 1488–1491, 2856, and nos. 3872, 3876—glass pastes).

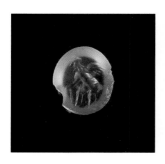

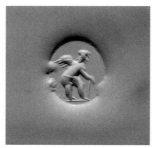

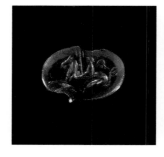

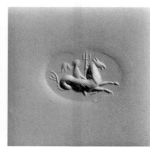

320 Carnelian, F 1

9.5×8.3×2.2 mm
First century A.D.
80.AN.43.10

Description: Same type as catalogue number 319, above.

There are a few chips from the edge.

322 Carnelian, F 1

11.2×7.8×2.5 mm
First century A.D.
79.AN.126.3

Description: Eros, holding a trident, riding a hippocamp right.

There are some chips from the edge.

Discussion: The motif is common (see cat. no. 250, above).

Provenance: From Tunisia.

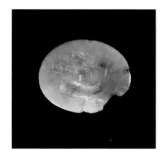 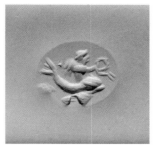

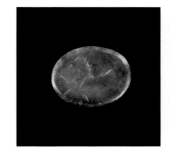 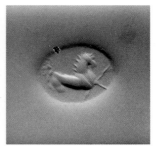

323 Blue chalcedony, F 1

12.1×9.7×2.1 mm
First–second century A.D.
79.AN.126.6
Description: Eros, holding a wreath, riding a dolphin right.
There is a chip from the edge.
Discussion: A popular motif, see Henig, *Roman Engraved Gemstones*, no. 132, with literature; *Sa'd Collection*, no. 174, with literature; *Sofia*, nos. 146–147; the example in plasma from Herculaneum, *Naples*, no. 27, where Eros rides a dolphin while playing the flute.
Provenance: From Tunisia.

325 White chalcedony, F 1

10.6×8.3×1.9 mm
First century A.D.
79.AN.126.8
Description: Hippocamp to right.
Traces of iron adhering to the sides and back, with some discoloration of the stone.
Discussion: For hippocamps on gems, see Henig, *Roman Engraved Gemstones*, no. 659, with literature; Guiraud, *Gaule*, nos. 807–811.
Provenance: From Tunisia.

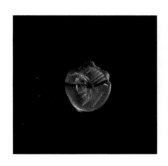 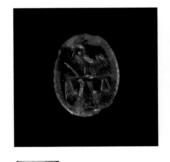

4:1

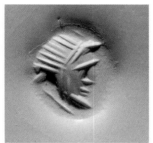 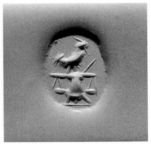

324 Carnelian, F 1

7.0×6.1×2.7 mm
First century A.D.
83.AN.353.9
Description: Mask of a bearded man right; a pedum below.
Discussion: Close in style to Furtwängler, *Beschreibung*, no. 7793, also carnelian.
Provenance: From Tunisia.

326 Carnelian, F 1

11.2×8.8×2.1 mm
First century A.D.
80.AN.43.6
Description: Cock standing on an overturned modius and scales.
Traces of bronze adhering to the sides and back.
Discussion: Close to Furtwängler, *Beschreibung*, no. 7901, a carnelian; for modius and scales without the cock, see Henig, *Roman Engraved Gemstones*, no. 404.

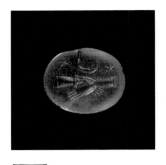

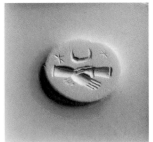

agate, signed by the engraver Antonianus, once in the Marlborough collection, Furtwängler, *AG*, pl. 65.50; Vollenweider, *Steinschneidekunst*, p. 79 n. 80).

Provenance: From Asia Minor.

327 Carnelian, F 1

10.9×9.2×2.8 mm
First century A.D.
79.AN.8.2

Description: Clasped hands; stars and crescent above.

Discussion: The *dextrarum iunctio* became a popular device on gems in the late first century B.C., symbolizing *concordia* and *fides*, usually with military significance (on the motif, see *Geneva*, vol. 2, nos. 466–468; *Naples*, pp. 173–174, with literature, nos. 334–335, from Pompeii; for other gems, see Henig, *Roman Engraved Gemstones*, no. 402, with literature; and cat. no. 394, below).

SECOND–THIRD-CENTURY-A.D. GEMS

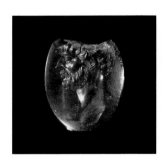

328 Carnelian, A 4

13.0×10.6×2.3 mm
Second quarter of the second century A.D.
85.AN.444.5

Description: Bust of a young, bearded man to right.

There is a large chip from the edge, disturbing the device.

Discussion: The style is very fine and probably belongs to the Hadrianic period. The portrait recalls Aelius but more likely represents a private individual (see the portraits of Hadrian, *Hannover*, no. 1090, agate; *Munich*, pt. 3, nos. 2806–2807, carnelian and garnet; Aelius, *BMC Gems*, no. 2038, garnet; Boston 01.7577, red jasper, unpublished; and Antinoös, *Hannover*, no. 1091, red jasper; and another in

329 Red jasper, F 2, but slightly convex

9.2×7.2×2.8 mm
Circa A.D. 120–140
85.AN.444.8

Description: Draped bust of a woman right; her hair is braided and wound around her head.

Traces of bronze adhering to the sides.

Discussion: The hair style was in fashion during the time of Trajan and Hadrian and was sometimes worn by the empress Sabina. For similar hair styles on gems, see *BMC Gems*, no. 2003, plasma, and no. 3257, glass; *Berry coll.*, nos. 97–98, carnelian; *Cologne*, nos. 201 and 391, with literature, carnelian; and Jucker and Willers, *Gesichter*, p. 285, no. 150, sard.

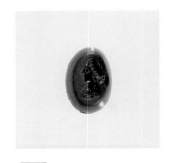

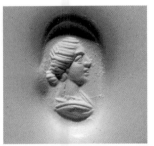

330 Nicolo, F 2

9.2×6.3×2.3 mm
Mid-second century A.D.
85.AN.444.7

Description: Draped bust of a woman right; her hair is pulled back in a bun; she wears a necklace.

There is a chip from the edge.

Discussion: For the type, see *Geneva*, vol. 2, no. 242.

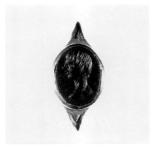
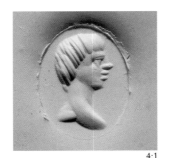

4:1

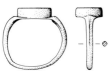

331 Red jasper in gold ring, probably F 1

Gem, circa 8×6 mm; greatest diameter of hoop, 17.0 mm
First half of the second century A.D.
84.AN.1.58

Description: Bust of a young male right.

The gem is set in a gold bezel, which joins the projecting shoulders of the hoop.

Discussion: The portrait is of an unknown youth. The hair style belongs to the early second century A.D. (see Furt-wängler, *Beschreibung*, no. 8512, red jasper; *The Hague*, no. 1169, dated too early; Jucker and Willers, *Gesichter*, p. 286, no. 154; *Geneva*, vol. 2, no. 243). The ring shape is second century (an early example of Henig, *Roman Engraved Gemstones*'s Type Xb).

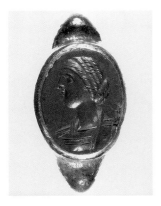
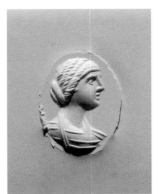

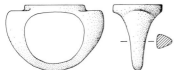

332 Red jasper in gilded silver ring, probably F 1

Gem, 15.0×11.0 mm; greatest diameter of hoop, 26.1 mm
Circa A.D. 200
84.AN.1.60

Description: Draped female bust right.

The ring shape is Henig, *Roman Engraved Gemstones*, Type X.

Discussion: The portrait and hair style closely resemble some coin portraits of Plautilla, the wife of Caracalla, of the beginning of the third century. For Plautilla on gems, see Richter, *Engraved Gems of the Romans*, no. 584, a plasma ringstone in Paris; also see Guiraud, *Gaule*, no. 510, red jasper.

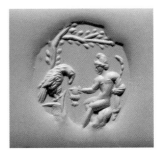

333 Red jasper, F 1

16.0×13.8×2.7 mm
Second century A.D.
85.AN.370.55

Description: Ganymede seated left on a rock offering a kantharos to an eagle, perched right below a tree; Gany-mede wears a Phrygian cap and cloak and holds a pedum in his left hand.

Chipped around the edge.

Discussion: The gem is particularly close to a red jasper, *Aquileia*, no. 44; see also Henig, *Roman Engraved Gemstones*, no. 473, red jasper, with literature; *Cologne*, no. 52, with literature; Guiraud, *Gaule*, no. 451; and *BMC Gems*, nos. 3422–3423, agate cameos; also H. Sichtermann, *Ganymed* (Berlin, 1953), pp. 93–95, for a list of gems.

Provenance: From Asia Minor.

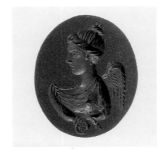
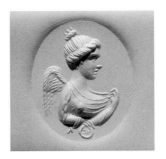

334 Red jasper, F 1

17.2×14.2×2.5 mm
Second century A.D.
84.AN.1.43 (Color plate 4)

Description: Bust of winged Nemesis, right, holding a small wheel in her right hand and pulling out her drapery with her left hand.

Discussion: One of the finest representations of the type is on a first-century aquamarine mounted in a gold ring found with a hoard of Byzantine jewelry at Pantalica, Sicily (location now unknown; P. Orsi, *Sicilia Bizantina*, vol. 1 [Rome, 1942], p. 137, fig. 60, pl. 9.1); another is on a carnelian ringstone in Geneva (Vollenweider, *Deliciae Leonis*, no. 249), and there is a clay sealing from Syria (Maaskant-Kleibrink, *Doliché*, p. 57, no. 104). The type also appears on first-century glass gems and cameos (see Furtwängler, *Beschreibung*, no. 2909, a glass gem, and nos. 11188–11191, glass cameos; and *Naples*, no. 92, a glass cameo from Pompeii). For a stylistically similar bust of Nike in red jasper, see *Harari coll.*, no. 80.

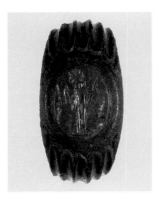
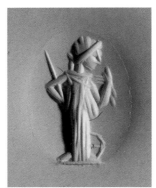

4:1

335 Red jasper in bronze ring, probably F 1

Gem, circa 10.5×7.5 mm; greatest diameter of hoop, 23.6 mm
Second–third century A.D.
78.AN.322.1

Description: Nemesis standing right; she holds a staff and pulls out her drapery; a wheel is at her feet; groundline.

The ring is decorated with a pattern of V-shaped grooves (for the shape, see Henkel, *Römische Fingerringe*, no. 206, in gold; no. 920, bronze, in Munich; and no. 1279, in Basel from Augst).

Discussion: For the type, see catalogue number 269, above.

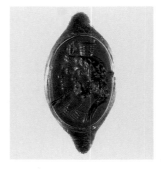

336 Red jasper in gold ring, probably F 2

Gem, 13.1×18.7 mm; greatest diameter of hoop, 21.5 mm
Second century A.D.
85.AN.370.81

Description: Jugate busts of Sarapis and Isis right.

For the ring shape, see Henkel, *Römische Fingerringe*, no. 203.

The gem is cracked but held in place by the ring.

Discussion: The type became popular on gems in the Hellenistic period (see W. Hornbostel, *Sarapis* [Leiden, 1973], pp. 135–139; and *Munich*, pt. 1, nos. 375–376, with literature) and remained so throughout the Roman imperial period (see a very similar red jasper in a gold ring from Constantinople, *Southesk coll.*, no. K 3; Furtwängler, *Beschreibung*, no. 8497; *BMC Gems*, no. 1791; *Romania*, no. 105; all red jasper).

Provenance: From Asia Minor.

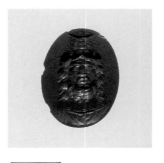
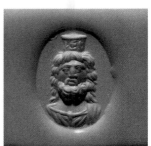

337 Red jasper, F 7, unevenly shaped

14.2×10.7×2.3 mm
Second century A.D.
83.AN.437.24

Description: Facing bust of Sarapis.

Discussion: Close in style to *Berry coll.*, no. 107, red

jasper; and Sarapis in profile, *Cologne*, no. 365, red jasper; for the type, see W. Hornbostel, *Sarapis* (Leiden, 1973), pp. 161–167.

 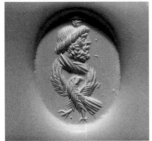

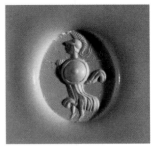 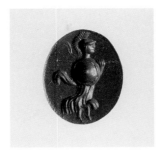

nos. 3000–3003; R. Nicholls, *The Wellcome Gems* [Cambridge, 1983], no. 44; *Lewis coll.*, no. 123; Philipp, *Mira et Magica*, nos. 11–12; and a later engraving on the back of an Etruscan scarab, *Berlin*, no. 293).

338 Heliotrope, F 1, with rounded sides

16.5 × 12.1 × 2.2 mm
Second century A.D.
82.AN.162.61

Description: Bust of Sarapis, right, above an eagle with wings spread.

Traces of bronze adhering to the back.

Discussion: For the type, see W. Hornbostel, *Sarapis* (Leiden, 1973), p. 222; Philipp, *Mira et Magica*, nos. 57–58, with literature; *Vienna Gems*, vol. 2, no. 1247, with literature; *Aquileia*, nos. 39–40; *BMC Gems*, no. 1273; *Lewis coll.*, no. 120; *Berry coll.*, no. 86; *Munich*, pt. 3, nos. 2671–2673; *Braunschweig*, no. 91; *Sofia*, no. 282; *Sa'd Collection*, nos. 37–38.

340 Red jasper, F 1

13.1 × 10.6 × 3.2 mm
Second century A.D.
82.AN.162.62

Description: Athena standing left; she wears a crested helmet and holds a spear and circular shield.

Traces of bronze adhering to the sides.

Discussion: The goddess is of Athena Alkis type, see *Naples*, pp. 14–15, for literature; also Henig, *Roman Engraved Gemstones*, no. 245, with literature; *Sa'd Collection*, nos. 149–150; *Aquileia*, nos. 141–148.

 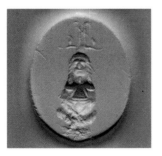

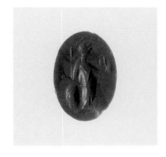 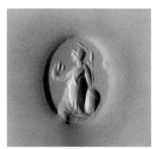

339 Lapis lazuli, F 1

18.0 × 13.7 × 2.6 mm
Second century A.D.
83.AN.437.44

Description: Facing Canopic Osiris.

There is some chipping in the device.

Discussion: A very similar example in green jasper is in Berlin, Philipp, *Mira et Magica*, no. 10, and another in lapis lazuli is in the Indiana University Art Museum (76.90.13); other representations on gems are usually shown in profile, often on convex agate ringstones (see *Vienna Gems*, vol. 2, nos. 1372, 1375, 1503; *De Clercq coll.*,

341 Yellow jasper, F 1

12.2 × 8.8 × 2.0 mm
Second century A.D.
80.AN.43.4

Description: Athena, helmeted, standing left, holding a Nike in her right hand and a spear and shield at her side; groundline.

There is a large chip from the edge and face, disturbing the device.

Discussion: For the Athena Nikephoros type, see Henig, *Roman Engraved Gemstones*, no. 234, with literature; *Sa'd Collection*, nos. 152–157; Guiraud, *Gaule*, no. 74; and *Naples*, pp. 12–13.

Provenance: From Tunisia.

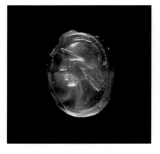

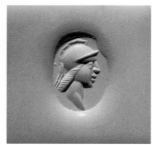

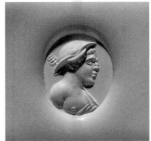

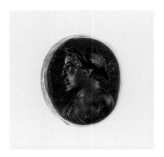

Traces of gilding remain on the ring.

Discussion: For the gem type, see catalogue numbers 254–255, above. The ring shape is close to Henkel, *Römische Fingerringe*, nos. 1301–1303, 1388.

342 Carnelian, F 2

12.5×9.2×3.0 mm
Second century A.D.
81.AN.106.9

Description: Helmeted head of Athena right.

There are some chips from the edge.

Discussion: The motif is common (see cat. no. 272, above). The style and shape of the gem suggest a second-century date.

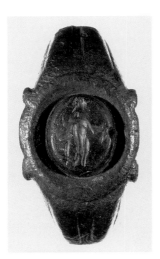

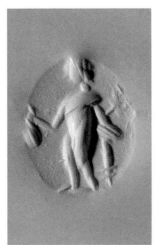

4:1

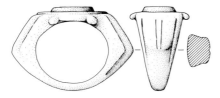

343 Carnelian in bronze ring, once gilt, probably F 2

Gem, circa 11.7×9.7 mm; greatest diameter of ring, 32.5 mm
Second century A.D.
82.AN.162.71

Description: Hermes standing left, holding a purse in his right hand and a caduceus and cloak in his left; groundline.

344 Red jasper, F 2

13.3×11.4×3.2 mm
Second century A.D.
85.AN.370.54

Description: Bust of Hermes right; there is drapery on his left shoulder, but his right shoulder and breast are bare; he wears a petasos and carries a caduceus over his left shoulder.

Discussion: The facial features indicate that an individual portrait in the guise of Hermes is intended. The brow, cheek, and chin are heavy, and the nose is large and flat. For other examples of individuals portrayed as Hermes, beginning with late Ptolemaic kings (see J. G. Milne, *JHS* 36 [1916], p. 91, nos. 68–75) and including Roman emperors, see *BMC Gems*, no. 2798, a first-century glass paste; Vollenweider, *Porträtgemmen*, pp. 202–203, pl. 148.15–16, 18, Augustus; J. Boardman, *Engraved Gems: The Ionides Collection* (London, 1968), no. 19, Augustus; *Hannover*, no. 1589, chalcedony, Commodus?; Henig, *Roman Engraved Gemstones*, no. 482, red jasper, Caracalla; the standing figure of Lucius Verus (or perhaps Commodus?) as Hermes, *Munich*, pt. 3, no. 2510; and Jucker and Willers, *Gesichter*, p. 284, no. 144.

Provenance: From Asia Minor.

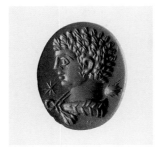
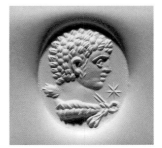

4:1

345 Red jasper, F 2

10.1 × 6.8 × 2.2 mm
Second century A.D.
83.AN.353.6

Description: Draped bust of Hermes right; he wears a winged cap and carries a caduceus over his shoulder.

There are chips from the back.

Discussion: For a slightly earlier example, see Guiraud, *Gaule*, no. 189, with literature.

Provenance: From Tunisia.

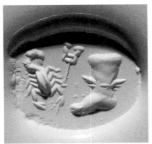

4:1

346 Red jasper, F 1

9.0 × 7.3 × 2.2 mm
Second century A.D.
85.AN.370.52

Description: Attributes of Hermes: a winged boot, a caduceus, and a scorpion.

There is a chip from the edge; traces of bronze adhere to the back and sides.

Discussion: For similar motifs, although none is identical and most are earlier, see Furtwängler, *Beschreibung*, nos. 8026–8030; Guiraud, *Gaule*, nos. 873–874; *Cologne*, no. 455, with further literature.

Provenance: From El Djem, Tunisia.

347 Red jasper, F 1, sides perhaps cut down

15.0 × 12.1 × 1.8 mm
Second century A.D.
82.AN.162.64

Description: Bust of young, unbearded Herakles right; he wears a lionskin knotted around his neck and carries a club over his shoulder; a star before him to right.

Discussion: Fine Late Hellenistic and early imperial examples of the young Herakles on gems include the first-century-B.C. carnelian ringstone signed by Onesas (now in Florence, Furtwängler, *Kleine Schriften*, p. 205, pl. 26.17; Furtwängler, *AG*, pl. 35.26) and the slightly later aquamarine ringstone signed by the engraver Gnaios (*BMC Gems*, no. 1892). The popularity of the type continued throughout the imperial period (see *BMC Gems*, nos. 1896, 1901–1902, red jaspers; Henig, *Roman Engraved Gemstones*, Appendix, nos. 150–151, red jasper).

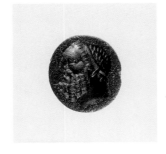
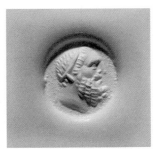

348 Black jasper, F 1, unevenly shaped

10.9 × 9.9 × 2.5 mm
Second century A.D.
77.AN.34

Description: Bearded head of Herakles right; he wears a taenia.

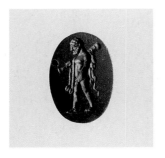 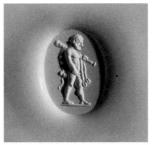

349 Red jasper, A 4

12.0 × 8.8 × 3.3 mm
Second century A.D.
82.AN.162.63

Description: Herakles Mingens standing right holding a club and lionskin over his left shoulder while urinating; groundline.

Discussion: For the type on gems, see Furtwängler, *AG*, pl. 27.22–24; Furtwängler, *Beschreibung*, nos. 1312–1316; *Thorvaldsen*, no. 238; *Vienna Gems*, vol. 2, no. 658, glass, with literature; *Hannover*, nos. 306–308, carnelian and glass; and Zazoff, *AG*, p. 266 n. 38, pl. 74.6, for an Italic agate in Naples.

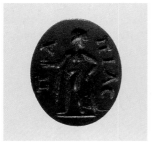 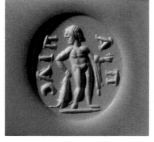

350 Red jasper, F 1

14.9 × 12.1 × 3.1 mm
Second century A.D.
82.AN.162.65

Description: Herakles standing to front, his head turned left; he leans on his club with his right hand and holds a lionskin over his left arm; groundline; around him is the inscription: ΠΑΠΙΑϹ.

Discussion: Very close in style to *Caesarea*, no. 55, also red jasper.

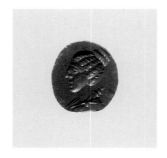 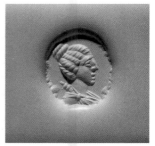

351 Red jasper, F 1

10.4 × 9.1 × 2.3 mm
Second century A.D.
83.AN.353.7

Description: Draped bust of Artemis, right, with quiver over her shoulder; her hair is braided and gathered in two strands on top of her head.

There are chips from the edge.

Discussion: For the type, see Furtwängler, *Beschreibung*, nos. 1855–1856, glass; and *New York*, no. 282, a Late Hellenistic garnet ringstone.

Provenance: From Tunisia.

352 Carnelian, F 1, rectangular

9.5 × 7.4 × 2.3 mm
First century A.D.
83.AN.437.31

Description: Artemis of Ephesos standing facing front; fillets hang from her arms, and two stags stand at her feet; short groundline.

Discussion: The cult of Ephesian Artemis was one of the most popular and widespread in the imperial period. Gems depicting the distinctive statue are very common, as are statues in marble, bronze, and other materials (see R. Fleischer, *Artemis von Ephesos und verwandte Kultstatuen aus Anatolien und Syrien* [Leiden, 1973]; *LIMC*, vol. 2, pp. 755–763, s.v. Artemis Ephesia). Most were likely made in Asia Minor (see a miscast glass gem found at Sardis, G79.8:8476, no doubt a locally made and discarded work; Ephesos Museum, cited by Fleischer [above]; Miletos Museum, carnelian ringstone, unpublished; a seal impres-

sion inscribed E—Φ from Delos, datable before 69 B.C., M. F. Boussac, *Revue Archéologique*, 1988, p. 316, no. 3, fig. 12; a first-century-B.C. garnet ringstone from Smyrna, once in the Evans collection, Drouot, Paris, auction May 8, 1905, lot 73; several examples from the Black Sea, T. W. Kibaltchitch, *Gemmes de la Russie méridionale* [Berlin, 1910], nos. 83 and 85, and O. Neverov, *Vestnik drevnei istorii* 147 [1979], p. 101, no. 30; cat. nos. 353–354, below; and many others on the market from Turkey), but they traveled widely throughout the ancient world (one of the finest examples, inscribed *Ephesion*, from Gorsium, now Tac in Hungary, Istvan Kiraly Muzeum, Székesfehérvár, J. Fitz, *Gorsium-Herculia* [Székesfehérvár, 1976], p. 98 and frontispiece, and I. Bilkei, *Alba Regia* 17 [1979], p. 32, no. 25; also *Aquileia*, nos. 101–104; Sena Chiesa, *Luni*, no. 49; Guiraud, *Gaule*, no. 73; *Sofia*, no. 50, from Bulgaria; Maddoli, *Cirene*, no. 151; and cat. no. 353, below, from Tunisia). There are many other examples (see Furtwängler, *Beschreibung*, nos. 2817–2821, 3593–3595, 6741, 7169, 7214–7219, 8418–8419; *BMC Gems*, nos. 1266, 1336–1342; *Berry coll.*, no. 116, a relatively early garnet ringstone; Richter, *Engraved Gems of the Romans*, nos. 90–92, in Paris and the Vatican; *New York*, no. 283; *Thorvaldsen*, nos. 1706–1708; *Romania*, no. 148; *Cologne*, nos. 309–310, the second a ring made of chalcedony; *Vienna Gems*, vol. 2, nos. 1455–1456; *Munich*, pt. 3, nos. 2172–2173, 2276–2277; *Kassel*, no. 141, jasper; *Braunschweig*, nos. 43–44; *Hannover*, nos. 767–768, 1397–1400; *The Hague*, nos. 516, 672–673, 786, 907; Geneva, Vollenweider, *Deliciae Leonis*, no. 421; A. Delatte and Ph. Derchain, *Les Intailles magiques greco-égyptiennes, Bibliothèque Nationale, Cabinet des Médailles* [Paris, 1964], pp. 179–183, nos. 236–240; and the list in Fleischer [above], pp. 35–37).

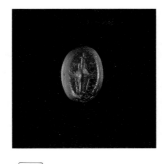
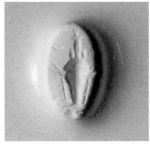

4:1

354 *Carnelian, F 2–3*

7.8 × 5.6 × 3.5 mm
Second century A.D.
84.AN.1.49
Description: Same type as catalogue number 353, above.
Provenance: From Asia Minor.

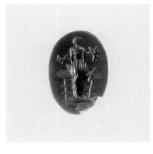
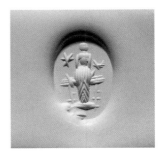

355 *Red jasper, F 1*

12.0 × 8.7 × 2.9 mm
Second century A.D.
84.AN.1.48
Description: Same type as catalogue number 353, above, but the positions of the star and crescent are reversed.
There is a chip from the edge.
Provenance: From Asia Minor.

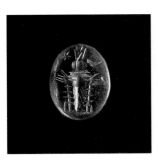
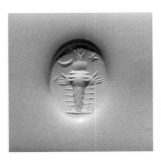

353 *Carnelian, A 4*

10.6 × 8.0 × 2.6 mm
First–second century A.D.
79.AN.8.3
Description: Artemis of Ephesos, as above, but without the stags; a crescent above left and a star above right; short groundline.
Provenance: From Tunisia.

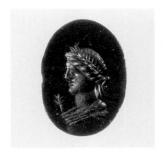
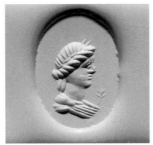

356 Green jasper, F 1

16.3 × 11.6 × 2.7 mm
Second century A.D.
81.AN.106.3

Description: Draped bust of Apollo wearing laurel wreath
to right; laurel branch before him.

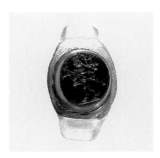
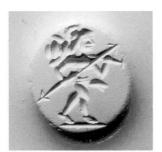

358 Carnelian, F 2, but slightly convex

9.0 × 8.0 × 3.4 mm
Second–third century A.D.
79.AN.27.4

Description: Very close to catalogue number 357, above,
in type, style, material, and shape.

Provenance: From Tunisia.

4:1

357 Carnelian in octagonal gold ring, nearly F 2, but slightly convex

Gem, circa 8.8 × 8.2 mm; greatest diameter of hoop, 17.2
mm
Second–third century A.D.
85.AN.370.82

Description: Ares, nude except for scarf (*subligaculum*)
around the waist, helmet and boots, walking right;
he carries a trophy over his shoulder and a spear;
groundline.

Discussion: For the type in general, see Henig, *Roman
Engraved Gemstones*, no. 70, with literature; closer in style
is Henig, *Roman Engraved Gemstones*, Appendix, no. 29,
and catalogue number 358, below; also Guiraud, *Gaule*, p.
37, nos. 125–131. Henig, *Roman Engraved Gemstones*,
dates polygonal rings of this type to the third century (see
Henig, *Roman Engraved Gemstones*, p. 39, Type IX).

359 White chalcedony, B 1, bottom slightly flattened

13.4 × 11.4 × 6.7 mm
Second–third century A.D.
82.AN.162.58

Description: Aphrodite Anadyomene standing three-
quarter right; she is half-nude, and she holds her hair in
her upraised hands; short groundline; inscription to left,
reading upward, ZEYC; to right, reading upward,
OYPANOY.

Discussion: For the type and its origins, see the discussion,
Naples, pp. 19–20, and the glass cameos from Boscotrecase
and Pompeii, nos. 23–24; for similar representations of
Aphrodite without inscription, see Zazoff, *AG*, p. 268 n.
43, p. 277 n. 71, p. 332 n. 182; Furtwängler, *AG*, pl. 43.6–
7; *De Clercq coll.*, nos. 2887–2892; *Munich*, pt. 2, no. 748,
Italic, and *Munich*, pt. 3, nos. 2175–2176; *The Hague*, nos.
1112–1113; Guiraud, *Gaule*, nos. 330–331; Maddoli,
Cirene, nos. 388–390. The type is common on magic
gems, usually with the inscription *aroriphrasis* (see A.
Delatte and Ph. Derchain, *Les Intailles magiques greco-
égyptiennes, Bibliothèque Nationale, Cabinet des Médailles*

132 ROMAN SECOND–THIRD-CENTURY-A.D. GEMS

[Paris, 1964], pp. 183–189, nos. 241–250; *Kassel*, no. 185; *Cologne*, no. 287; Zazoff, *AG*, p. 355 n. 46, pl. 112.1, for a lapis lazuli scarab in Florence). It is unclear why this gem appeals to "Heavenly Zeus," which is not ordinarily a magical epithet.

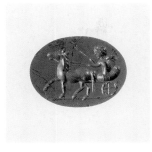

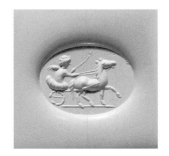

361 *Red jasper, F 1*

12.9×9.8×2.2 mm
Second century A.D.
83.AN.256.2

Description: Eros with whip driving a horse cart right; groundline.

Discussion: Other examples in red jasper, Furtwängler, *Beschreibung*, no. 8445; Henig, *Roman Engraved Gemstones*, Appendix, no. 74.

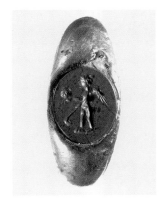

4:1

360 *Red jasper in hollow gold ring, probably F 1*

Gem, circa 10.7×8.7 mm; greatest diameter of hoop, 25.6 mm
Second century A.D.
78.AN.322.2

Description: Eros standing right, holding a theater mask in his left hand and a pedum in his right hand; short groundline.

The hoop is roughly circular but widens at the shoulders.

Discussion: For the type, see Henig, *Roman Engraved Gemstones*, no. 116, with notes; *Aquileia*, nos. 291, 336.

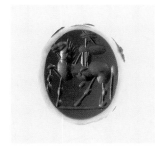

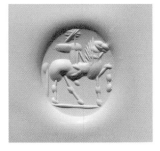

362 *Red jasper, related to F 2, but face is slightly convex*

14.5×12.3×4.5 mm
Second–third century A.D.
81.AN.106.2

Description: Eros(?) riding a horse right; groundline.
Traces of iron adhering to the back.

Discussion: For the type, see *The Hague*, no. 901; *Aquileia*, no. 330.

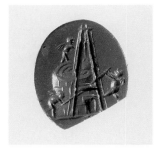
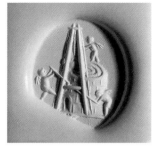

4:1

363 Red jasper, F 1

15.4 × 13.0 × 3.1 mm
Second century A.D.
85.AN.370.53

Description: Erotes erecting a building; one stands on top of a circular building composed of rectangular blocks and with an arched doorway; two other erotes use a lever to operate a winch, which lifts another stone block.

There is a large chip from the bottom of the edge, disturbing the device.

Discussion: No similar scene on gems appears to be attested. It does, however, recall the construction of a mausoleum as depicted on the Flavian-period relief of the Haterii in the Vatican.

Provenance: From Tunisia.

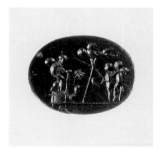
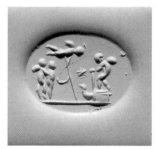

364 Black jasper, flat with center carination, between F 1 and F 4

14.7 × 11.2 × 1.8 mm
Second century A.D.
81.AN.106.5

Description: Erotes engaging in an uncertain activity; to the right, an Eros stands on a boxlike structure and operates a lever(?); a butterfly flies before him; to the left, another Eros holds a figure (a herm?) attached to a tall post, which is being erected by a third Eros, who flies above; groundline.

365 Carnelian, F 2, unevenly shaped

8.8 × 7.2 × 3.4 mm
Second century A.D.
79.AN.126.4

Description: Eros squatting right, playing the flutes.

Discussion: The same motif on a similar stone, *The Hague*, no. 900.

Provenance: From Tunisia.

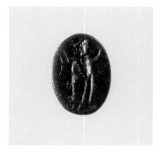
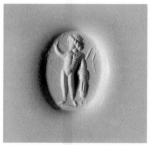

366 Heliotrope, F 1

11.6 × 8.3 × 2.4 mm
Second century A.D.
83.AN.353.2

Description: Helios standing left, his right arm raised; he wears a cloak tied around his neck and wrapped around his left arm and holds a whip in his left hand; short groundline.

Discussion: For the type, common on second–third century gems, see Henig, *Roman Engraved Gemstones*, no. 31, with literature; *Aquileia*, nos. 73–85; Guiraud, *Gaule*, nos. 43–49; *The Hague*, no. 481; *Munich*, pt. 3, nos. 2646–2647; *Hannover*, no. 1401; *Sa'd Collection*, no. 66, heliotrope.

Provenance: From Tunisia.

367 Carnelian, F 2

9.5 (length as preserved) × 12.9 × 2.5 mm
Second century A.D.
79.AN.27.3

Description: Tyche standing left, holding cornucopia and rudder.

Broken in half.

Discussion: For the type, see Henig, *Roman Engraved Gemstones*, no. 314, with literature; Furtwängler, *Beschreibung*, no. 2878, is particularly close in style.

Provenance: From Tunisia.

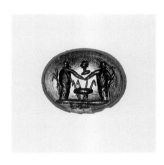

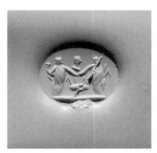

368 Dark brown agate, F 1

11.4 × 9.2 × 2.5 mm
Second century A.D.
85.AN.370.72

Description: Two Tychai standing to front, each holding a cornucopia; they join hands over a modius; above their clasped hands is a small bust of Helios facing right and above the modius a garbled inscription: XAPA; thick groundline.

The stone is broken in half and repaired; there is a chip from the edge.

Discussion: The type is a crude version of a common type, which is often accompanied by the inscription XAPA 'joy' (misinterpreted in *Kassel* and *LIMC*, vol. 1, p. 315, nos. 8–9, pl. 232.8, s.v. Aias); the inscription also appears on related gems depicting Nike and Tyche (see *BMC Gems*, nos. 1665, 3025) and clasped hands (Maddoli, *Cirene*, no. 989). Finer examples of the type, which all appear to be of second-century date, include Furtwängler,

Beschreibung, nos. 7167 and 8667, the second inscribed; *Sa'd Collection*, no. 119, with inscription; *Kassel*, nos. 82–83, the former with inscription; Henig, *Roman Engraved Gemstones*, no. 339; *Vienna Gems*, vol. 2, no. 1214; *The Hague*, no. 883; and *Braunschweig*, no. 113.

Provenance: From Sousse, Tunisia.

369 Heliotrope, F 1

12.6 × 9.9 × 2.5 mm
Second century A.D.
82.AN.162.60

Description: Hermes, nude, standing to front, his head turned right; he holds a caduceus and cloak in his right hand and in his left hand a wreath with which he crowns Tyche, who stands to right; she holds a cornucopia and rudder; groundline.

There is a chip from the edge.

Discussion: For the type, see *BMC Gems*, no. 1409 = *BMC Rings*, no. 1170, a sard in a silver ring from Baalbek, and no. 1410; *Thorvaldsen*, no. 1663, carnelian; *Vienna Gems*, vol. 2, nos. 1308–1309; *Munich*, pt. 3, no. 2623; *Braunschweig*, no. 112; *Bologna*, no. 179; Guiraud, *Gaule*, no. 416; *Sa'd Collection*, nos. 93–95; and from Soviet Georgia, M. N. Lordkipanidze, *Korpus pamyatnikov gliptiki drevnei Gruzii*, vol. 1 (Tbilisi, 1969), pl. 10.129.

3:2

370 Mottled jasper, red with inclusions of gray chalcedony, A 4

19.7 × 13.6 × 3.6 mm
First–second century A.D.
82.AN.162.59

Description: Nike walking right, carrying a palm branch over her left shoulder; she holds a wreath in her right hand and crowns Tyche, who stands left, holding a cornucopia and rudder; groundline.

There is a small chip from the edge.

Discussion: For the type, common on gems, see Henig, *Roman Engraved Gemstones*, no. 305, with literature; *Aquileia*, nos. 629–633; *Caesarea*, nos. 65–66; *The Hague*, nos. 674, 831–832, 878; *Sofia*, no. 82; *Bologna*, nos. 180–181; *Sa'd Collection*, no. 124.

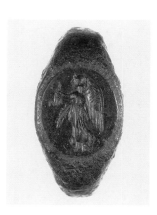

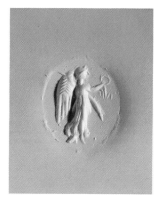

371 Mottled green and red jasper in iron ring, probably F 1

Gem, circa 12.5 × 10.5 mm; greatest diameter of hoop, 25.3 mm
Second century A.D.
84.AN.1.63

Description: Nike walking right, carrying a palm branch over her left shoulder and a wreath in her outstretched right hand.

The ring is large and carefully made; it is faceted below the bezel (for the shape, see Henkel, *Römische Fingerringe*, nos. 1466–1471).

Discussion: The type is extremely popular on gems (see Henig, *Roman Engraved Gemstones*, no. 295, with literature; also *The Hague*, nos. 444, 596, 812, 965, 1044; *Naples*, nos. 97–98; *Sa'd Collection*, nos. 125–140; Guiraud, *Gaule*, nos. 134–153; *Cologne*, nos. 115–116, from the Rhineland, and nos. 268–272, with literature).

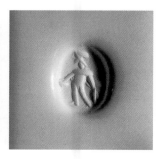

372 Carnelian, F 2, but with slightly convex face

10.2 × 7.2 × 3.0 mm
Second century A.D.
78.AN.373.4

Description: Bonus Eventus standing left, holding a patera in his right hand and two ears of corn in his left; groundline.

There are small chips from the sides and back.

Discussion: The type is very common on gems and coins (see Henig, *Roman Engraved Gemstones*, no. 203, with literature; *Vienna Gems*, vol. 2, nos. 1316–1321; *The Hague*, no. 522, with literature, nos. 933–936, 950; *Aquileia*, nos. 524–536; Sena Chiesa, *Luni*, no. 78; Guiraud, *Gaule*, nos. 227–245; *Cologne*, nos. 94 and 138, glass from the Rhineland, nos. 295–300; *Sa'd Collection*, nos. 211–212).

Provenance: From Tunisia.

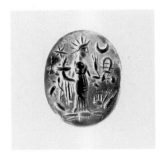
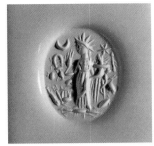

373 Dark brown sard, F 1

13.6×10.5×2.6 mm
Second century A.D.
85.AN.370.73

Description: Pantheistic deity standing left; the deity is winged, radiate, and wears a long chiton with aegis; in the right hand is a poppy, an ear of corn, and a sistrum, and in the left hand is a cornucopia; above left is a crescent, and above right is a star; in the field to left are a club, a caduceus, a lyre, and a turtle(?); in the field to right are a filleted thyrsos, a serpent-entwined staff, a stag, and a shield(?); the god stands on a thunderbolt.

Discolored slightly blue.

Discussion: Attributes of nearly all the gods, male and female, are employed for this pantheos. A goddess combining the attributes of Athena, Tyche, and Nemesis is common on gems (see cat. no. 275, above), as is a pantheistic Egyptian deity on magic gems (see C. Bonner, *Studies in Magical Amulets, Chiefly Graeco-Egyptian* [Ann Arbor, 1950], p. 156), but this type appears to be without parallel.

Provenance: From Syria.

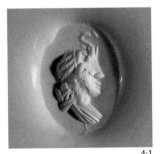

4:1

374 Heliotrope, F 2–3

9.5×7.3×3.0 mm
Second century A.D.
81.AN.39.3

Description: Draped bust of Africa, wearing an elephant headdress, to right.

There is a small chip from the edge; traces of iron adhering to the sides and back.

Discussion: Busts of Africa on gems include Furtwängler, *AG*, pls. 26.20, 41.47; Furtwängler, *Beschreibung*, nos. 4883–4892; *Thorvaldsen*, nos. 1075–1077; *BMC Gems*, nos. 1807–1808, 3088; *De Clercq coll.*, no. 2963; *Vienna Gems*, vol. 1, no. 222; *Munich*, pt. 2, nos. 945, 1773–1778; *The Hague*, nos. 316–317; Philipp, *Mira et Magica*, no. 9; *Sa'd Collection*, no. 165; Maddoli, *Cirene*, no. 488; and the three-quarter facing busts, *BMC Gems*, no. 1806 and *New York*, no. 383; also *LIMC*, vol. 1, p. 251, s.v. Africa; and on the development of the type in Roman art, J. M. C. Toynbee, *The Hadrianic School* (Cambridge, 1934), pp. 35–36.

Provenance: From Tunisia.

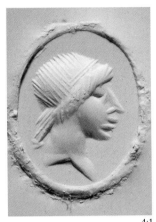

4:1

375 Carnelian in gilt bronze ring, probably F 1

Gem, circa 11×8.5 mm; greatest diameter of hoop, 28.3 mm
Second century A.D.
78.AN.341.3

Description: Female head right.
The hoop is large and sharply faceted.

Discussion: The identification of the head is uncertain. For another similar gilt bronze ring, see *BMC Rings*, no. 1320.

 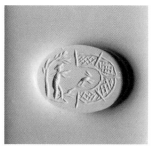

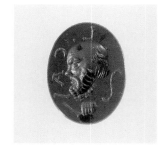 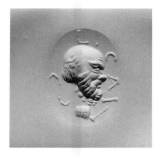

376 Mottled red and yellow jasper, F 1

12.3×9.6×2.3 mm
Second–third century A.D.
85.AN.370.56

Description: Youth standing right under a tree on a short groundline; next to him, a dog runs right, chasing a hare into a net.

Discussion: Although a dog chasing a hare appears often on gems (see Henig, *Roman Engraved Gemstones*, no. 624; *Sa'd Collection*, nos. 372–375), the full scene does not appear to be otherwise attested. In the third and fourth centuries the motif became popular on mosaics, and it is also found on fourth-century engraved glass bowls (see D. B. Harden, *Journal of Glass Studies* 2 [1960], pp. 45–81, which includes references to mosaics as well).

Provenance: From Tunisia.

378 Red jasper, F 1, sides cut down slightly

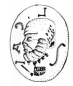

14.2×10.7×2.2 mm
Second century A.D.
82.AN.162.66

Description: Bearded satyr mask to right; a pedum, syrinx, and trumpet(?) below; starting above the mask and reading downward to right, L. CAI.

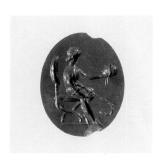 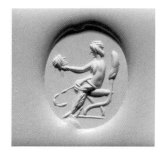

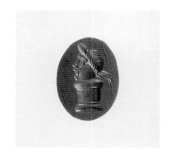 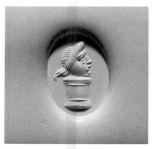

377 Red jasper, F 1

14.8×11.6×2.2 mm
Second century A.D.
83.AN.437.37

Description: Actor sitting left on a high-backed chair; he holds a theater mask before him in his right hand and a pedum in his left; groundline.

Discussion: The motif is common on gems, although it is sometimes unclear whether an actor or a Muse is intended (see *Munich*, pt. 2, no. 1824; *Munich*, pt. 3, no. 2758, with literature; *The Hague*, no. 684; Furtwängler, *Beschreibung*, nos. 4521–4522; *Thorvaldsen*, nos. 1009–1010; Henig, *Roman Engraved Gemstones*, Appendix, no. 147; *Sa'd Collection*, no. 273; Guiraud, *Gaule*, no. 55; and cat. no. 280, above).

379 Red jasper, F 1

11.9×8.5×2.6 mm
Second century A.D.
83.AN.437.35

Description: Comic mask to right on an altar.

Discussion: For the type, see *BMC Gems*, no. 1622 = *BMC Rings*, no. 546, nicolo in gold ring; *Vienna Gems*, vol. 1, no. 509; *Hannover*, no. 1615; *The Hague*, nos. 575, 654, two masks; Furtwängler, *Beschreibung*, no. 6552, a mask of an old man, no. 7407, with satyr, no. 7454, with Eros; also a lead token from Athens showing three masks on altars and the inscription *Theophoroumene*, a play by Menander, M. Lang and M. Crosby, *The Athenian Agora*, vol. 10, *Weights, Measures, and Tokens* (Princeton, 1964), p. 123, L 329, pl. 30, "third century A.D."; and on Greek imperial bronze coins of Asia Minor, for instance, F. Imhoof-Blumer, *Kleinasiatische Münzen* (Vienna, 1901), pl. 3.31, and idem, *Griechische Münzen* (Munich, 1890), p. 128, no. 366.

Provenance: From Asia Minor.

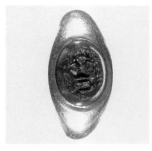

380 Red jasper in gold ring, F 2

Gem, circa 8.4×6.3 mm; greatest diameter of hoop, 18.3 mm
Second century A.D.
83.AN.437.38

Description: Facing comic slave mask.

The ring shape is close to Henkel, *Römische Fingerringe*, no. 203, and see T. Hackens, *Museum of Art, Rhode Island School of Design: Catalogue of the Classical Collection, Classical Jewelry* (Providence, 1976), no. 67.

There are some chips from the face.

Discussion: For the type, see Furtwängler, *Beschreibung*, no. 2220, a first-century nicolo; *Thorvaldsen*, no. 1251, garnet.

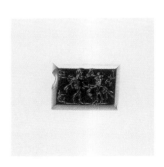
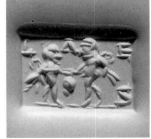

381 Green jasper, F 2, rectangular

9.2×6.6×1.8 mm
Second century A.D.
81.AN.39.5

Description: Two actors standing facing each other; they each carry a pedum and cloak over their arm and wear grotesque masks; the actor on the right carries an uncertain circular object in his left hand; groundline; a four-letter inscription along the top and in the bottom right corner, L A E S.

Discussion: The grotesque features indicate that the figures are actors in a farce rather than in the more usual New Comedy; such representations are unusual on Roman

gems, although the head of a mime is a frequent cameo type (see *Content coll.*, nos. 152–155); see also the bronze statuette in New York, which probably portrays such an actor (M. True, in *The Gods Delight: The Human Figure in Classical Bronze*, The Cleveland Museum of Art and other institutions, November 1988–July 1989 [A. P. Kozloff and D. G. Mitten, organizers], no. 28).

Provenance: From Tunisia.

382 Red jasper, F 1

12.9×10.6×2.8 mm
Second century A.D.
83.AN.256.6

Description: Two-handled krater, the body of which is composed of two masks; above the krater is a syrinx; below left is a pedum and syrinx, and right is a filleted thyrsos.

Discussion: The type is common on gems, especially in red jasper (see *BMC Gems*, nos. 2641–2642; Furtwängler, *Beschreibung*, nos. 8609–8611; *Munich*, pt. 3, no. 2351; *Hannover*, no. 1661; *The Hague*, nos. 574, 624; *New York*, no. 566; *Berry coll.*, no. 155; Henig, *Roman Engraved Gemstones*, no. 386; Guiraud, *Gaule*, no. 834).

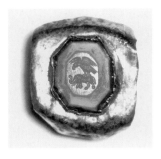
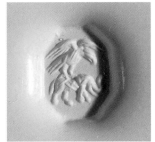

4:1

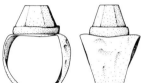

Hermes (see *Thorvaldsen*, nos. 1371–1376; Furtwängler, *Beschreibung*, nos. 3256, 5604–5608, 7868–7869; *Aquileia*, no. 1119; *Sa'd Collection*, no. 350).

383 Banded agate, green/white/dark green, in gold-foil ring, F 3, octagonal

Gem, circa 11×9×7 mm; greatest diameter of hoop, 18.5 mm
Second–third century A.D.
84.AN.1.61

Description: Eagle standing right on an elephant.
The ring is a thin gold band, widening at the bezel (for a heavy gold example of similar shape, see Henkel, *Römische Fingerringe*, no. 215).

Discussion: The device is unusual; *Göttingen*, no. 482, a glass gem, may depict the same scene.

Provenance: From Asia Minor.

385 Carnelian, close to A 6, but only slightly convex and poorly shaped

8.1×3.3×2.4 mm
Second–third century A.D.
78.AN.373.3

Description: Dolphin left; above: VITA; below: TIBI.

Discussion: For the type, see Henig, *Roman Engraved Gemstones*, nos. 645–646, with literature. The inscription, "life to you," suggests a date in the second century or later.

Provenance: From Tipasa, Algeria.

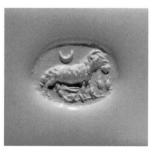

384 Lapis lazuli, F 5, with slightly convex sides

11.9×9.0×2.0 mm
Second–third century A.D.
82.AN.162.38

Description: Ram standing right; two ears of corn are to right, a crescent above, and uncertain objects below; groundline.

Discussion: The type is common on gems, and the ram is often accompanied by a kerykeion as an attribute of

386 Red jasper, F 2

12.9×10.8×3.2 mm
Second century A.D.
81.AN.106.4

Description: Mouse standing on a basin, which is supported by the tail of a dolphin; to the left is a poppy, and to right an ear of corn.

Discussion: A very similar example in red jasper, Furtwängler, *Beschreibung*, no. 8579.

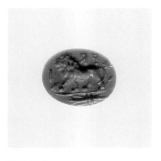
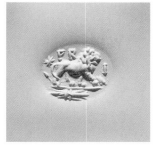

387 Yellow jasper, F 1

10.0×8.0×1.2 mm
Second–third century A.D.
82.AN.162.68

Description: Lion walking right on groundline, an animal head or limb under its right paw; in the exergue is a thunderbolt; above and behind the lion is a star; an inscription, above the lion: PR; to right: I.

Discussion: Lions with stars on gems may have magical connotations (see C. Bonner, *Studies in Magical Amulets, Chiefly Graeco-Egyptian* [Ann Arbor, 1950], nos. 74–75, 237–239, 365–366; Philipp, *Mira et Magica*, no. 136). Another example in yellow jasper, Guiraud, *Gaule*, no. 652; and in cruder style, Henig, *Roman Engraved Gemstones*, Appendix, no. 173.

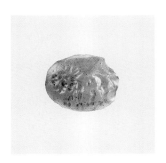
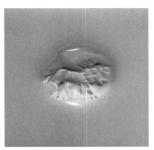

388 Carnelian, B 3

9.9×8.0×3.5 mm
Second–third century A.D.
82.AN.162.47

Description: Lion standing right.
Chipped around the edges and on the back.

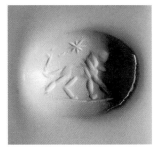
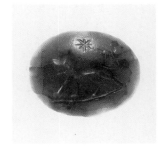

389 Carnelian scaraboid, Type A

15.1×12.1×6.2 mm
Third century A.D. (?)
84.AN.991

Description: Lion walking right; there is a star above; groundline.
 No drill hole.
There is a chip from the bottom.

Discussion: The shape of the stone is typically fourth–third century B.C., but the motif and style of engraving strongly suggest a third-century-A.D. date (see *The Hague*, no. 1064, also of odd shape); there is a close similarity to magic gems (see cat. no. 387, above). The stone may be an older, reused Greek scaraboid.

Provenance: From Tunisia.

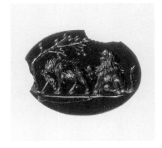
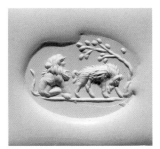

390 Mottled green and red jasper, F 1

15.9×12.3×2.5 mm
Second century A.D.
79.AN.126.1

Description: Lion, seated right, and boar, standing right, beneath a tree; groundline.
There are two chips from the edge.

Discussion: For boars and trees, see Henig, *Roman Engraved Gemstones*, no. 620, with literature; and *The Hague*, no. 756, where a dog confronts a boar under a tree.

Provenance: From Tunisia.

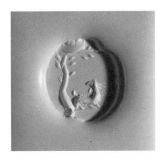

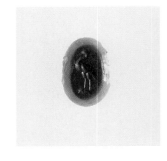
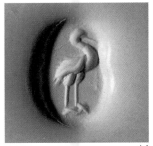

391 Red jasper, F 1

11.7×9.7×2.7 mm
Second century A.D.
81.AN.39.1

Description: Goat lying under a tree, his head turned back; groundline.

There are several chips from the edge.

Discussion: The same type, *Sofia*, no. 174, carnelian, from Novae, Bulgaria; more typically a goat rears below a tree, see Henig, *Roman Engraved Gemstones*, nos. 610–612, with literature; *Aquileia*, nos. 1134–1137; Guiraud, *Gaule*, no. 693; *BMC Gems*, no. 2375.

Provenance: From Tunisia.

393 Red jasper, F 2

9.7×6.7×2.6 mm
Second century A.D.
83.AN.353.8

Description: Stork standing right.

There are chips from the edge.

Discussion: Similar in style to *The Hague*, no. 725.

Provenance: From Tunisia.

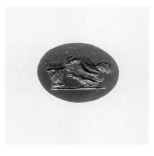
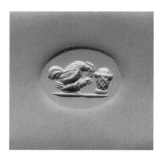

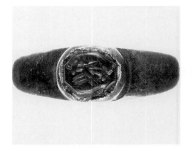
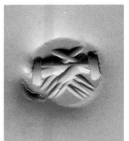

4:1

392 Red jasper, F 1

11.1×8.4×2.0 mm
Second century A.D.
82.AN.162.67

Description: Cock treading a hen; a basket to right; groundline.

Discussion: The type is already seen on Archaic Greek gems (see *BMC Gems*, nos. 555 and 759); see *Thorvaldsen*, nos. 1491–1492, glass, with literature; a cock faces a basket, Guiraud, *Gaule*, no. 755, red jasper.

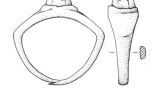

394 Carnelian in silver ring, F 3, octagonal

Gem, circa 6.8×5.5×3 mm; greatest diameter of hoop, 23.9 mm (the ends of the hoop overlap)
Third century A.D.
83.AN.437.41

Description: *Dextrarum iunctio*.

There are some chips from the edge.

Discussion: For the type, see catalogue number 327, above. A third-century example of similar style, in a gold ring, *Cologne*, no. 46 (= Henkel, *Römische Fingerringe*, no. 1810), found at Mainz.

Provenance: From Asia Minor.

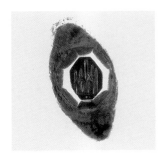
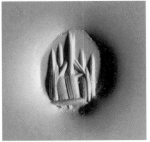
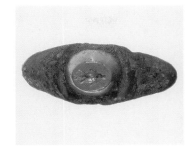
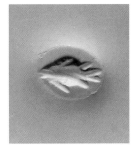

4:1

4:1

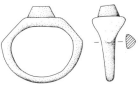

395 Red jasper in silver ring, F 3, octagonal

Gem, 8.6×7.3×circa 7 mm; greatest diameter of hoop, 20.0 mm
Third century A.D.
83.AN.437.40
Description: Mount Argaios?

For the ring shape, see Henkel, *Römische Fingerringe*, nos. 201, 203, in gold, 408, in silver; and catalogue number 336, above.

Discussion: The engraving is very crude, but perhaps it is meant to represent the sacred Mount Argaios in Cappadocia, which is frequently depicted on gems and coins (see *BMC Gems*, no. 1662, inscribed *Argaios*, 1664; *The Hague*, no. 758; *Kassel*, no. 73, with literature; and on the iconography of Mount Argaios, P. Weiss, *Jahrbuch für Numismatik und Geldgeschichte* 35 [1985], pp. 21–48, including a list of gems, pp. 30–31, which could be expanded).

Provenance: From Asia Minor.

396 Yellow jasper in silver ring, F 3

Gem, circa 7.5×6.1×4 mm; greatest diameter of hoop, 21.6 mm
Third century A.D.
84.AN.1.65
Description: Fish.

For the ring shape, with offset shoulders, see Henkel, *Römische Fingerringe*, nos. 440–441.

Discussion: Similar engravings in carnelian in similar rings are Henkel, *Römische Fingerringe*, no. 434, and Henig, *Roman Engraved Gemstones*, Appendix, no. 192.

Provenance: From Asia Minor.

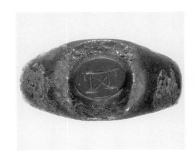
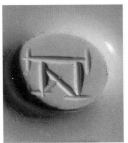

4:1

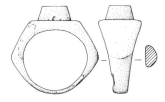

397 Red jasper in silver ring, F 3

Gem, circa 8.5×6.9 mm; greatest diameter of hoop, 23.0 mm
Third–early fourth century A.D.
84.AN.1.64
Description: Monogram (to be read as *Paulou*).

Discussion: For the ring shape, see Henkel, *Römische Fingerringe*, nos. 423–425, silver, and compare catalogue number 396, above.

Provenance: From Asia Minor.

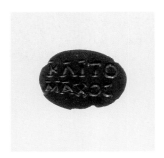

398 Red jasper, F 1

11.8 × 8.4 × 1.9 mm
Second century A.D.
80.AN.43.2

Description: Inscription: ΚΛΙΤΟ/ΜΑΧΟϹ (positive), the personal name Klitomachos.

There are small chips from the edge.

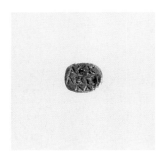 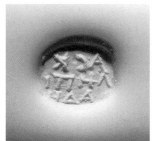

4:1

399 Silver disc, close to F 5, but with convex sides

5.3 × 4.4 × 1.1 mm
Second–third century A.D.
84.AN.1.50

Description: Inscription: ΑϹΚ/ΛΗΠΙ/ΑΔΗ (positive), the personal name Asklepiades.

Discussion: The intaglio was most likely set into a ring bezel (see the inscribed bezel on a gold ring, Henkel, *Römische Fingerringe*, no. 78).

ROMAN RINGS

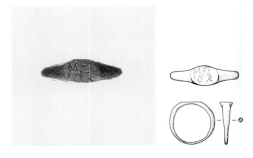

400 Gold ring with flat bezel

Greatest diameter of hoop, 12.0 mm; weight, 0.99 g
First–second century A.D.
84.AN.1.62

Description: The bezel has an inscription composed of punched dots: MEL/IOR.

Discussion: For rings of similar size and shape, see Henkel, *Römische Fingerringe*, nos. 58–65, the last with an engraved inscription.

Provenance: From Lebanon.

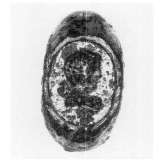

401 Gilt bronze ring with relief bezel

Length of bezel, 11.5 mm; greatest diameter of hoop, 20.8 mm
Second–third century A.D.
85.AN.370.85

Description: Relief bezel depicting a bust of Hermes right, with kerykeion over his shoulder.

Much of the gilding is missing.

Discussion: A very similar relief ring in gold with the head of Hermes, R. Zahn, *Sammlung Baurat Schiller* (Berlin, 1929), p. 29, no. 28, pl. 50; and another relief ring in silver of similar shape and style, with the head of Herakles, *BMC Rings*, no. 1172, said to be from Konya, Cappadocia.

Provenance: From Yugoslavia.

GLASS GEMS

Intaglios made of glass cast in molds were made in the Archaic and Classical periods (see cat. nos. 22–28, 129–135, 166) but became increasingly common in Late Hellenistic times and throughout the Roman imperial period. They usually imitate the color and shape of hard-stone intaglios and in most cases were cast from actual stones. The following include convex brown and purple examples (imitating sard and amethyst), imitations of black- and white-banded agate, and imitations of nicolo, while some others of blue glass do not copy actual stones. Well represented in the collection is an interesting series of banded green, white, and blue glass intaglios, which are usually cast from fine Italic stones. Portraits of Augustus are also found, and the entire series can be localized in Italy during the Augustan period (see *Vienna Gems*, vol. 2, p. 8; and Guiraud, *Gaule*, p. 46). Some have traces of gold foil in the device. More elaborate glass gems of the Augustan period are also known, and one such example, perhaps cast from a large intaglio by the engraver Aulos, is in the collection (cat. no. 424, below). Glass copies of contemporary cameos are also common (see cat. no. 436, below).

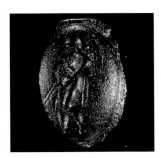
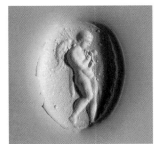

402 *Brown glass, A 3, miscast*

17.7 × 11.4 × 4.2 mm
Second–first century B.C.
84.AN.1.31
Description: Eros, nude, standing right, carrying a shield and two spears.
Discussion: A duplicate is *Munich*, pt. 2, no. 1142.

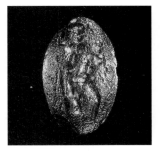

403 *Brown glass, A 3*

16.7 × 10.3 × 3.2 mm
Second–first century B.C.
84.AN.994
Description: Drunken Dionysos standing to front, supported by a satyr.
The surface is pitted and there are several chips from the edge.
Discussion: Two very similar examples in glass, *Hannover*, nos. 29–30, with literature; and see E. Pochmarski, *Dionysische Gruppen* (Vienna, 1990), pp. 66–67, pls. 24–25.
Provenance: From Tunisia.

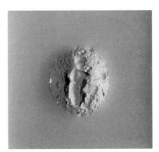
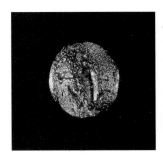

404 *Purple glass, A 3*

10.7 × 9.5 × 3.6 mm
Second–first century B.C.
84.AN.995
Description: Odysseus, bearded and with pilos cap, kneeling right presenting a cup (to Polyphemos).
The surface is pitted and there are some chips from the back.
Discussion: Other similar examples, most of which are Italic works, *Vienna Gems*, vol. 2, no. 686, with literature; Furtwängler, *Beschreibung*, nos. 1360–1369, all glass except nos. 1362 and 1365, carnelian; *BMC Gems*, nos. 3211–3213, glass; *Munich*, pt. 2, nos. 839–840, carnelian, nos. 1367–1371, glass; *Göttingen*, nos. 262–263, glass; *Kassel*, no. 31, glass.
Provenance: From Tunisia.

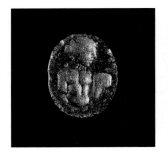
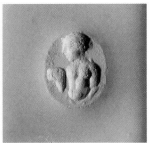

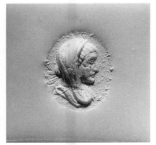

405 Brown glass, F 1

11.7 × 9.3 × 1.6 mm
First century B.C.
84.AN.993

Description: Half-figure of nude female with hair bound up; uncertain object (pipes?) to left.

The surface is slightly corroded and there are some chips from the back.

Discussion: Similar glass pastes, Furtwängler, *Beschreibung*, nos. 4811–4812; and *Munich*, pt. 3, no. 3546, Muse with mask.

Provenance: From Tunisia.

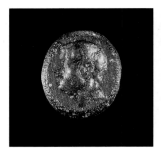
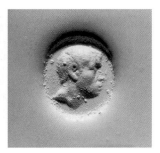

406 Brown glass, F 5, with rounded edge

12.5 × 10.6 × 2.7 mm
Circa 40 B.C.
80.AN.43.11

Description: Head of Brutus(?) right.

Discussion: The identification as Brutus has been discussed by Vollenweider, who lists a number of identical examples (Vollenweider, *Porträtgemmen*, pp. 139–144, pls. 95.1–4, 96.1–16, examples in London, Berlin, Leningrad, Geneva, and Brussels; Furtwängler, *AG*, pl. 47.22, 29; Furtwängler, *Beschreibung*, nos. 5069–5071; *Vienna Gems*, vol. 2, no. 792).

Provenance: From Tunisia.

407 Purple glass, F 4

14.2 × 12.1 × 2.9 mm
Late first century B.C.
84.AN.992

Description: Veiled bust of an elderly woman right.

Some corrosion, and there are chips from the sides and back.

Discussion: The portrait of the woman resembles that on the fine amethyst once in the Ionides collection (J. Boardman, *Engraved Gems: The Ionides Collection* [London, 1968], no. 17; Furtwängler, *AG*, vol. 2, p. 154, and pl. 31.22; Vollenweider, *Porträtgemmen*, pp. 223–224, pl. 162.1–2). The identification suggested by Furtwängler, a portrait of the elderly Arsinoë II, seems unlikely, as noted by Vollenweider, who suggests a Roman matron (another similar portrait on a glass gem, Vollenweider, *Porträtgemmen*, pl. 163.1 = Furtwängler, *Beschreibung*, no. 5188).

Provenance: From Tunisia.

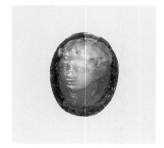
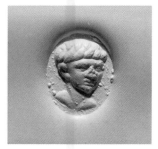

408 Brown glass, F 1

11.8 × 9.4 × 2.4 mm
Circa 40–30 B.C.
83.AN.437.21

Description: Bust of Octavian(?) facing three-quarter right.

Discussion: Similar to the glass gem, *Munich*, pt. 3, no. 3342. For glass gems of Octavian in similar style, see Vollenweider, *Porträtgemmen*, pp. 205–207, pl. 150; and for a double portrait, one in profile and the other three-quarter facing, see pl. 150.7–8.

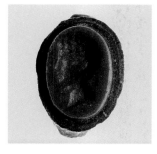
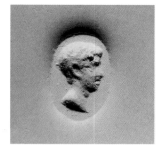
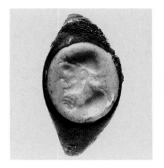
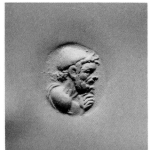

409 Opaque blue glass in fragmentary bronze ring, probably F 5

Gem, circa 12.8×8.8 mm
Circa 40–30 B.C.
78.AN.341.1a

Description: Head of Octavian right.

Discussion: For similar portraits of Octavian, see catalogue number 408, above, and Vollenweider, *Porträtgemmen*, pl. 150.

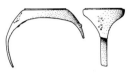

411 Pale blue, opaque glass in fragmentary bronze ring; gem is flat

Gem, circa 11.2×9.8 mm
Second half of the first century B.C.
83.AN.437.20

Description: Bust of Odysseus, bearded and wearing pilos, to right; there is drapery on his left shoulder, and he holds his left hand to his chin.

For the ring shape, see Henkel, *Römische Fingerringe*, no. 1141.

Discussion: The pose is seen on similar glass gems for busts of philosophers (Furtwängler, *Beschreibung*, nos. 5043–5051) and for Julius Caesar and Octavian (Vollenweider, *Porträtgemmen*, pls. 77, 78.1, 82, 140.1–2, 141.1–2). Other busts of Odysseus are found on contemporary glass gems of similar style (see Furtwängler, *Beschreibung*, nos. 4935–4944).

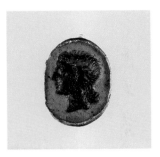
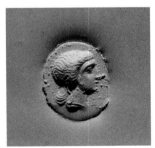

410 Glass imitating nicolo, in hollow gold ring; gem is flat

Gem, circa 11×8.5 mm; greatest diameter of hoop, 15.0 mm
Last quarter of the first century B.C.
84.AN.1.59

Description: Young female head right; her hair is drawn back at her neck, and she wears a necklace.

The gem has a light blue top layer and dark blue lower layer. For the ring shape, see Henkel, *Römische Fingerringe*, nos. 125–126.

Discussion: The portrait most resembles Antonia (see *Geneva*, vol. 2, no. 217, glass; *New York*, no. 479; Richter, *Engraved Gems of the Romans*, no. 511; *Hannover*, no. 1094; Furtwängler, *AG*, pl. 48.9).

Provenance: From Lebanon.

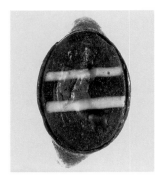
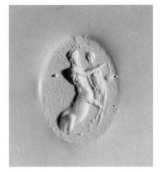

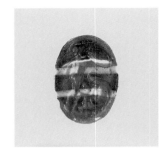
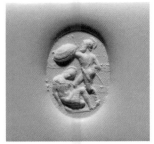

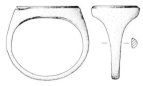

412 Two-piece cast glass in a bronze ring, F 1

Gem, circa 16.4×11 mm; greatest diameter of hoop, 22.4 mm
Second half of the first century B.C.
85.AN.370.83

Description: The Centaur Chiron, seated, teaching the young Achilles, who stands and holds a lyre.

The top is banded green/white/blue/white/green; traces of gold leaf remain in the device. For the ring shape, see Henkel, *Römische Fingerringe*, nos. 1096–1097, both bronze with glass gems.

Discussion: The fine, elongated figures indicate an Italic origin, and the glass was probably cast from an Italic stone (see the banded agate, *Berlin*, no. 398 = Furtwängler, *Beschreibung*, no. 6492 = Martini, *Etruskische Ringsteinglyptik*, no. 126; also *BMC Gems*, no. 1923, sard; Furtwängler, *AG*, pls. 24.65 and 43.10, 16, 19; *The Hague*, no. 396). Similar glass gems are common (see *Munich*, pt. 2, nos. 1381–1385, with literature; *Munich*, pt. 3, no. 3210; *Aquileia*, no. 737; Guiraud, *Gaule*, no. 438; Furtwängler, *Beschreibung*, nos. 4254–4259; *Thorvaldsen*, no. 900; *Vienna Gems*, vol. 2, no. 668; *Göttingen*, no. 290), as are later Roman imperial gems (see Furtwängler, *Beschreibung*, no. 8246; *Thorvaldsen*, no. 1753; *BMC Gems*, no. 3191; *Hannover*, nos. 959–960). On the motif, see H. Sichtermann, *Römische Mitteilungen* 64 (1957), pp. 98–110; W. Martini, *Opus Nobile: Festschrift U. Jantzen* (Wiesbaden, 1969), pp. 105–108; and *LIMC*, vol. 1, pp. 48–50, nos. 51–62, s.v. Achilleus.

Provenance: From Iran.

413 Two-piece cast glass, F 1

12.7×9.0×2.3 mm
Second half of the first century B.C.
85.AN.370.75

Description: Warrior, in three-quarter rear view, advancing left over the slumped body of a companion; the advancing warrior is bearded, nude, and wears a crested helmet; he carries a shield and spear; groundline; the fallen warrior wears armor. The scene may represent Ajax fighting for the body of Patroklos.

The top of the gem is banded green/white/blue/white/green and the bottom is green/blue/green.

Discussion: Like catalogue number 412, above, the style is Italic, and the glass is likely cast from an earlier gem (see the banded agate, *Berlin*, no. 339 = Furtwängler, *Beschreibung*, no. 623 = Martini, *Etruskische Ringsteinglyptik*, no. 129; also *Vienna Gems*, vol. 1, no. 107; other glass examples, Furtwängler, *Beschreibung*, no. 624; *Munich*, pt. 2, nos. 1798–1799).

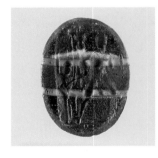
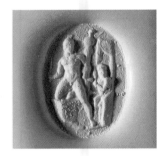

414 Two-piece cast glass, F 1

16.4×12.0×2.7 mm
Second half of the first century B.C.
84.AN.1.34 (Color plate 5)

Description: Diomedes and Odysseus with the Palladion. Diomedes, nude with helmet, kneels on an altar; he holds a sword and the Palladion. Behind him, Odysseus, wearing a pilos and carrying a sword, emerges from the curtained doorway of a sanctuary; groundline.

The top of the gem is banded green/white/blue/white/green and the bottom green/blue/green.

The gem was once in a fragmentary silver ring, which did

not come to the Getty Museum. However, the backing material that held the gem in place, a white gypsum, is preserved.

Discussion: An Italic carnelian is in Berlin (Furtwängler, *Beschreibung*, no. 6490 = Furtwängler, *AG*, pl. 30.63), and a number of other glass examples are known (*BMC Gems*, nos. 1068–1069; Furtwängler, *Beschreibung*, no. 4305; *Aquileia*, no. 743 = Richter, *Engraved Gems of the Romans*, no. 313, and no. 313 bis, Cades). The scene is related to that shown on the large gem in Oxford signed by the engraver Felix (see Boardman, *GGFR*, p. 372, pl. 1015, with literature; *Hannover*, nos. 966–971, glass examples, with literature), which shows Diomedes and Odysseus, having already stolen the Palladion, outside the walls of Troy and within what appears to be a Sanctuary of Poseidon. A dead figure (a priest?) lies on the ground, and Odysseus gestures to Diomedes, who kneels on an altar in the same manner as on the Getty gem. The location and meaning of the scene are not clear, but such representations are very common in the early imperial period, especially in the minor arts (see the list compiled by O. Kurz, in J. Hackin, *Nouvelles recherches archéologiques à Begram, 1939–1940* [Paris, 1954], pp. 130–133; and on the iconography, Boardman, *GGFR*, p. 365; and *LIMC*, vol. 3, pp. 403–404, no. 56, s.v. Diomedes I).

Provenance: From Syria.

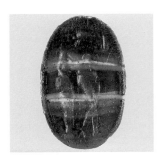
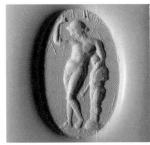

415 Two-piece cast glass, F 1

18.9 × 11.8 × 2.4 mm
Second half of the first century B.C.
85.AN.444.23

Description: Dionysos standing holding a thyrsos and leaning on a small statue of a satyr; groundline.

The top of the gem is banded green/white/blue/white/green and the bottom green/blue/green.

Discussion: Clearer representations, perhaps cast from the same gem, are on a banded black and white glass gem in Berlin (Furtwängler, *Beschreibung*, no. 3915) and on another found in France (Guiraud, *Gaule*, no. 254); see also E. Pochmarski, *Dionysische Gruppen* (Vienna, 1990), p. 71, pl. 25.4 (a gem in Munich).

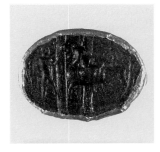
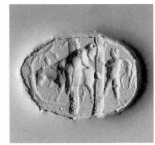
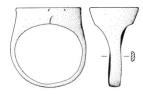

416 Two-piece cast glass in a hollow gold ring, probably F 1

Gem, circa 11.6 × 15.5 mm; greatest diameter of hoop, 20.3 mm
Second half of the first century B.C.
85.AN.174

Description: Drunken, elderly satyr reclining on a donkey left before a tree; a young satyr, wearing an animal skin tied around his neck, supports him; groundline.

The gem is banded green/blue/green. The shape of the ring is typical for glass gems of this class, see Henkel, *Römische Fingerringe*, nos. 125–126.

Discussion: Similar examples in glass, *Aquileia*, no. 437; Furtwängler, *Beschreibung*, nos. 3968–3969.

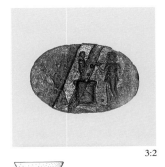
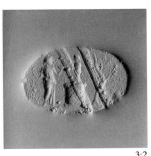

3:2 3:2

417 Two-piece cast glass, F 1

13.0 × 19.3 × 2.7 mm
Second half of the first century B.C.
84.AN.1.33

Description: Female figure, bearing a dish, approaching an altar surmounted by a statue of Dionysos; a tree is to right.

The gem is banded green/blue/green.

Discussion: Scenes of sacrifice at rustic Dionysiac shrines are often seen on gems and cameos (see Zazoff, *AG*, p. 301 n. 195, for literature; also *Naples*, pp. 33–34, for

literature, and no. 43, for a cameo from Herculaneum; especially similar is the sardonyx cameo in London, *BMC Gems*, no. 3492, and the amethyst gem, no. 2235).

Provenance: From Asia Minor.

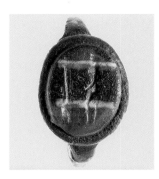 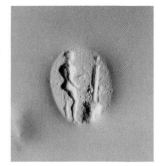

418 *Two-piece cast glass in fragmentary bronze ring, probably F 1*

Gem, circa 13 × 10 mm
Second half of the first century B.C.
84.AN.988

Description: Nude youth standing right before an altar; behind it is a column surmounted by a vase.

The gem is banded green/white/blue/white/green on top.

Discussion: A similar, but more detailed, example in black glass is in Berlin (Furtwängler, *Beschreibung*, no. 4713).

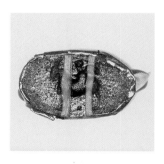 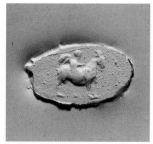

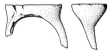

419 *Two-piece cast glass in fragmentary, hollow gold ring, F 1*

Gem, circa 9 × 14.5 mm
Second half of the first century B.C.
83.AN.437.17

Description: Small Eros riding a goat right.

The gem is banded green/white/blue/white/green on top.

Traces of gold leaf remain in the device. The ring is somewhat crushed, and much of the hoop is missing; however, the shape is clearly the same as the gold example above, catalogue number 416.

Discussion: The device is found on other gems and cameos (see T. W. Kibaltchitch, *Gemmes de la Russie méridionale* [Berlin, 1910], no. 270, from Olbia; *BMC Gems*, nos. 1492 and 3873, the second a glass cameo; Guiraud, *Gaule*, no. 336; *Vienna Gems*, vol. 1, no. 196, an Italic gem) and is used on a Roman denarius of 85 B.C. issued by M. Fonteius (Crawford, *RRC*, no. 353).

Provenance: From Asia Minor.

420 *Two-piece cast glass, F 5, with rounded edge*

13.3 × 11.4 × 2.5 mm
Second half of the first century B.C.
84.AN.1.32

Description: Bust of Harpokrates facing three-quarter left; he places his right hand to his lips and holds a cornucopia in his left hand.

The gem is banded green/white/blue/white/green on top and only green on the bottom.

Considerable gold leaf is preserved in the device.

Discussion: Other three-quarter facing representations of Harpokrates on gems include *De Clercq coll.*, no. 3118, a Late Hellenistic garnet ringstone from Syria; Philipp, *Mira et Magica*, no. 87, a nicolo ringstone in Berlin; and *BMC Gems*, no. 1800, a half-length figure in sard.

421 Cast glass in a hollow gold ring, probably F 1

Gem, circa 17 × 12 mm; greatest diameter of hoop, 19.6 mm
Second half of the first century B.C.
85.AN.370.79
Description: Zeus, nude, standing to front; he holds a scepter in his left hand and a thunderbolt in his right; groundline.

The gem is black with white stripe. The shape of the ring is like that of catalogue number 416, above.

The ring is slightly crushed, and yellow, sulfurous backing material is visible.

Discussion: A nearly identical sard, *BMC Gems*, no. 1253; and *The Hague*, no. 474, chalcedony, with literature.

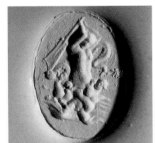

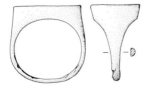

422 Cast glass in a hollow gold ring, probably F 1

Gem, circa 18 × 13 mm; greatest diameter of hoop, 20.3 mm
Second half of the first century B.C.
85.AN.370.78

Description: Skylla, facing three-quarter right, grasping a sailor and striking him with a steering oar.

The gem is black with white stripe. The shape of the ring is like catalogue number 416, above.

Discussion: The type was popular with gem engravers of the early imperial court and probably had political significance (see Vollenweider, *Steinschneidekunst*, p. 21 n. 29, pl. 11.5, a carnelian in Geneva, and pp. 70–71 n. 41, pl. 77.3, a carnelian in Venice, associated with the engraver Hyllos; the two, Furtwängler, *AG*, pl. 33.44–45, also 51; a carnelian once in the Nott collection, *Burlington Fine Arts Club: Exhibition of Ancient Greek Art* [1904], p. 197, M 81; *De Clercq coll.*, no. 2995, a convex carnelian). The device, in cruder style, also appears on a denarius of Sextus Pompey struck circa 42–40 B.C. (Crawford, *RRC*, no. 511/4). A number of similar glass gems also survives (*Aquileia*, no. 749; *Thorvaldsen*, no. 917, convex; *BMC Gems*, no. 3110; Furtwängler, *Beschreibung*, nos. 4341–4347).

The prototype may have been at Hellenistic Pergamon, see B. Andreae and B. Conticello, *Skylla und Charybdis: Zur Skylla-Gruppe von Sperlonga. Akademie der Wissenschaften und der Literatur-Mainz. Abhandlungen der geistes- und sozialwissenschaftlichen Klasse* 14 (Mainz, 1987); also the Hellenistic monument from Bargylia in the British Museum, see the forthcoming study by G. Waywell.

Provenance: From Syria.

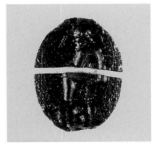

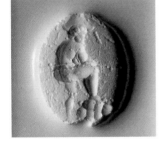

423 Cast glass, A 4

16.1 × 12.0 × 3.8 mm
Second half of the first century B.C.
83.AN.437.18

Description: Poseidon, viewed from the back, standing right and holding a trident in his left hand (the top of which is chipped and lost); his right foot is raised and rests on rocks, and his right arm is placed on his knee.

The gem is black with white stripe.

The surface is pitted, and there are several chips from the edge.

Discussion: For the motif, see catalogue number 268, above. Especially close in style is *Cologne*, no. 293, carnelian; also *Thorvaldsen*, no. 546, black jasper.

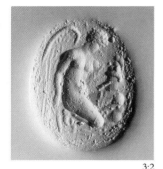
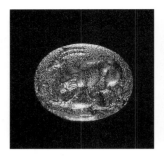

3:2

3:2

424 Green glass, A 2

25.2 × 19.3 × 9.4 mm
Last quarter of the first century B.C.
85.AN.370.74

Description: Nike kneeling right, about to sacrifice a bull;
she holds back the bull's head with her left hand and
holds a knife in her right hand.

The surface is somewhat pitted.

Discussion: A duplicate in glass of this fine work is in
London (*BMC Gems*, no. 3034 = Vollenweider, *Steinschnei-
dekunst*, pp. 42–43 n. 27, pl. 34.5; also a fragment, *Vienna
Gems*, vol. 2, no. 648). A second glass gem in London is
also very similar (*BMC Gems*, no. 3035 = Vollenweider,
Steinschneidekunst, pls. 34.3, 35.5). Vollenweider suggests
an attribution of the original to the engraver Aulos,
probably in commemoration of Augustus's Armenian
victory of circa 20 B.C., for which occasion coins were
struck with a similar type (H. Mattingly, *Coins of the
Roman Empire in the British Museum*, vol. 1 [London,
1923], p. 108, no. 671). Other contemporary gems have
similar devices, including a carnelian signed by Sostratos
(Vollenweider, *Steinschneidekunst*, p. 36 n. 65, pl. 27.2,
8; and see *BMC Gems*, no. 3032; Furtwängler, *Beschreibung*,
no. 3576), and the representation on a silver vessel from
Boscoreale, now in Paris, is especially close in style
and evidently copied from the same model (H. de Ville-
fosse, *Monuments et mémoirs: Fondation E. Piot* 5 [1899], pp.
50–51, pl. IV). The type is ultimately derived from Late
Classical prototypes (see Beazley, *Lewes House*, pp. 78–79,
pl. B.9; C. Smith, *JHS* 7 [1886], pp. 275–285).

Provenance: From Syria.

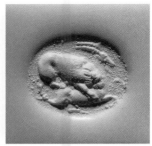
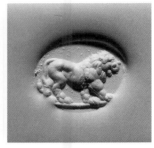

425 Dark blue glass, F 1

13.7 × 10.9 × 2.7 mm
First century A.D.
85.AN.370.76

Description: Lion, right, attacking a goat.

Discussion: For the same type in glass, see *Thorvaldsen*,
no. 1302.

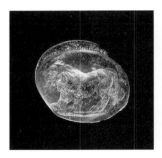

426 Pale blue glass, F 2, miscast

13.5 × 11.5 × 2.2 mm
First century A.D.
78.AF.324.2

Description: Lion walking right; groundline.

Discussion: Close in style to the Italic sard, *New York*, no.
502; see also the lions from Pompeii, *Naples*, nos. 245–
249 (including a fine amethyst ringstone and a cameo) and
the carnelian ringstone signed by Hyllos in Nicosia
(Vollenweider, *Steinschneidekunst*, pp. 69–71, no. 31, pl.
77.6).

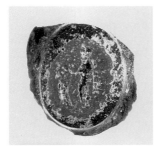
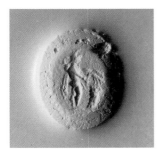

427 Blue on black glass, imitating nicolo, straight sides, but miscast

16.1 × 14.8 × 4.8 mm
First–second century A.D.
81.AN.39.6

Description: Ganymede standing right feeding an eagle, who stands on rocks, from a cup; he wears a Phrygian cap and a chlamys over his left shoulder and holds a pedum; groundline.

The surface is corroded.

Discussion: A similar scene, but reversed, on a glass gem in Berlin, Furtwängler, *Beschreibung*, no. 4138.

Provenance: From Tunisia.

ROMAN CAMEOS

As with Roman intaglios, no comprehensive study of the development and chronology of Roman cameos has yet been attempted, and many problems of attribution and dating are apparent. Even less carefully studied are the origins of the art in Hellenistic times. Nevertheless, recent publications have added much to our knowledge of the subject. In addition to the fundamental survey by Furtwängler (*AG*, vol. 3, pp. 152–159, 314–342, 365–369) and the fine catalogues of the collections in Paris (*Bibliothèque Nationale*) and Vienna (*Vienna Cameos*), new works have appeared on the cameo collections in Leningrad (*Leningrad Cameos*), Belgrade (*Belgrade*), and Florence (A. Giuliano and M. E. Micheli, *I cammei della collezione Medicea nel Museo Archeologico di Firenze* [Rome, 1989]). Cameos found at Pompeii and Herculaneum, especially useful for being closely datable, are included in *Naples*. Henig's catalogue of the large collection of cameos compiled by Derek Content (see *Content coll.*) is especially valuable both for the range of types illustrated and for Henig's commentary. Also important is Megow's careful study of imperial portraits on cameos (see Megow, *Kameen*), which helps demonstrate the significant role imperial patronage paid in the art of cameo cutting.

The collection in the Getty Museum is not large, but it does include an important late first-century-B.C. cameo attributable to the workshop of one of the finest gem cutters of the period, Sostratos (cat. no. 428); a large chalcedony bust of an imperial princess, probably Antonia, which was formerly in the Mayer and Herz collections (cat. no. 432); and a range of imperial varieties typical of the first century A.D. through the early years of the third century, which saw the final flourishing of the medium.

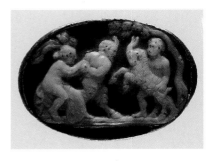

428 Sardonyx cameo in gold ring

Cameo 22.5 × 16.1 × circa 4 mm; greatest diameter of hoop, 25.7 mm
Last quarter of the first century B.C.
85.AN.175 (Color plate 5)

Description: Pan, restrained by a seated maenad, attempting to butt horns with a goat, which is held back by a young satyr. The maenad is nude but with drapery over her left leg; she holds Pan's hands behind his back, and a filleted thyrsos rests against her shoulder. A tree on the right bends over the main scene. Thick groundline.

The ring is hollow; the bottom of the bezel is faceted; and the hoop is thin.

Discussion: The style and subject of the cameo are close to others by the artist Sostratos, who signs at least three cameos and an intaglio. His work has been studied by Vollenweider, who compiled the signed pieces and attributed other unsigned works to him (Vollenweider, *Steinschneidekunst*, pp. 32–63, pls. 23–27; the Getty cameo is not cited; see also A. Giuliano, in N. Dacos, A. Grote, A. Giuliano, D. Heikamp, and U. Pannuti, *Il tesoro di Lorenzo il Magnifico* [Florence, 1980], pp. 44–48). The signed cameos include a winged goddess in a biga (in Naples), an Eros with a biga drawn by lionesses (in London), and a glass cameo depicting Aphrodite and Adonis; a carnelian intaglio in London shows Nike sacrificing a bull. Other cameos attributed by Vollenweider to Sostratos include the large sardonyx in Naples, once in the Medici collection, depicting the thiasos of Dionysos; a fragmentary cameo, also in Naples, with Centaurs drawing a chariot (with the engraved letters CΩ, very likely for Sostratos); a sardonyx in London showing a reclining Aphrodite accompanied by erotes in a style very close to the signed glass with Aphrodite and Adonis; and several others depicting erotes and Dionysiac scenes. A cameo once in the Sir Francis Cook collection and now in the Content collection (*Content coll.*, no. 120), which depicts a drunken silenos accompanied by Psyche in a cart drawn by two erotes, is especially close in style to the Getty cameo (note the treatment of the stocky legs) and probably by the same hand.

Two further works bearing a Sostratos signature are mentioned in the correspondence, probably written in 1630, between the painter Peter Paul Rubens and the noted Provençal antiquary Nicolas-Claude Fabri de Peiresc. Unfortunately, Peiresc's letter to Rubens discussing a fragmentary gem ("missing the heads") inscribed "Sostratos" has not been found, but Rubens's reply mentions the fragment (see M. Rooses and Ch. Ruelens, *Correspondance de Rubens*, vol. 5 [Antwerp, 1907], pp. 291–292, no. DCLXX). Neverov has plausibly identified the piece as the Meleager and Atalanta cameo now in the British Museum (O. Neverov, *The Burlington Magazine* 121 [1979], p. 428; O. M. Dalton, *Catalogue of the Engraved Gems of the Post-Classical Periods in the British Museum* [London, 1915], p. 28, no. 189); it is most likely a sixteenth- or seventeenth-century work with a false signature. However, in the same letter Rubens adds that in his own collection was a cameo depicting the laureate head of Octavian with the inscription COCTPATOY (see H. M. van der Meulen-Schregardus, *Petrus Paulus Rubens Antiquarius, Collector and Copyist of Antique Gems* [Alphen aan den Rijn, 1975], pp. 24, 132, no. G.51). The cameo is now lost (and no drawing appears to survive), but it may well have been a genuine, signed work of Sostratos, suggesting that he worked for the imperial court at the end of the first century B.C.

Characteristic of the works of Sostratos and his workshop is the preference for Dionysiac scenes and the portrayal of figures in complex poses, often in vivid motion and in twisting, three-quarter view. He is also a master of miniaturist detail, with carefully modeled bodies, faces, and drapery. Especially distinctive is the skilful use of tiny drilled "pellets" for details, a technique rarely found on other cameos.

The Getty cameo fits well into the artist's style and iconography. The multifigured Dionysiac scene is typical, as is the tension of the figures (Pan restrained by the maenad, and the goat restrained by a youth). The modeling and pose of the maenad and the treatment of her drapery recall the signed glass cameo of Aphrodite and Adonis, and the three-quarter facing head of the young satyr is especially distinctive. The cameo stands closest to the fine, unsigned cameo in Naples depicting the thiasos of Dionysos, where the modeling of the figures and the details of the heads are very close. There is also a tree of very similar shape, with the same stylization of the base of the trunk and leaves executed in the same technique with drilled details. Although not necessarily by Sostratos himself, whose finest work is perhaps the delicately modeled and detailed Eros with biga in London, it must be closely associated and likely from his workshop.

Provenance: Ex-Guilhou collection.

Bibliography: *Guilhou coll.*, no. 298.

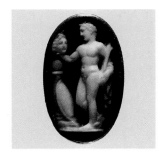

429 Sardonyx cameo, white on brown, in hollow gold ring

Cameo, circa 17.5 × 10 mm; greatest diameter of hoop, 20.6 mm
Late first century B.C.–early first century A.D.
87.AN.24 (Color plate 5)

Description: Perseus, his foot winged, standing left; he is nude, with a cloak over his left arm; in his left hand he holds a harp against his shoulder, and in his outstretched right hand he holds the head of Medusa; before him is his shield resting against a column surmounted by a globe.

Discussion: This particular composition has no close parallel on other cameos, but similar representations are found on intaglios, see *Thorvaldsen*, no. 856, glass; *Southesk coll.*, no. E 34; Furtwängler, *Beschreibung*, no. 4243. Cameos with different portrayals of Perseus include one in Leningrad (*Leningrad Cameos*, no. 51, Perseus with Andromeda) and another in a private collection (K. A. Neugebauer, ed., *Antiken in deutschem Privatbesitz* [Berlin, 1938], no. 253, from Asia Minor); *Bibliothèque Nationale*, no. 571, is not ancient.

Bibliography: *GettyMusJ* 16 (1988), p. 145, no. 12.

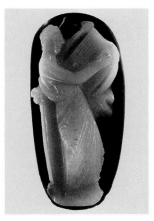

430 Sardonyx cameo

27.2 × 12.8 × 6.8 mm
Late first century B.C.–early first century A.D.
85.AN.444.33

Description: A Muse standing right, leaning on a column and playing a lyre.

Discussion: A near duplicate in sardonyx is in Naples, and

several glass cameos are also known, including the famous example in Florence signed by the Late Hellenistic artist Onesas (Furtwängler, *Kleine Schriften*, pp. 204–205 = Furtwängler, *AG*, pl. 35.23 = Zazoff, *AG*, p. 206, pl. 53.6; other glass cameos include *BMC Gems*, nos. 3846–3847; *Thorvaldsen*, no. 1886; *Munich*, pt. 3, no. 3517; and *Cologne*, no. 146, fragmentary). The type is also common on intaglios (Furtwängler, *Beschreibung*, nos. 2455, 3634; *Thorvaldsen*, nos. 683–684; *Aquileia*, no. 91; Guiraud, *Gaule*, nos. 60–61; *Munich*, pt. 3, no. 2344; *Göttingen*, nos. 16, 204; *Cologne*, no. 312; *Braunschweig*, no. 81; *The Hague*, no. 391).

Provenance: From Greece.

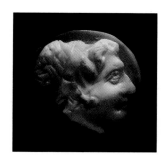

431 Sardonyx cameo, white and gray

16.0 × 13.0 × 8.8 mm
Late first century B.C.–early first century A.D.
84.AN.989

Description: Diademed head of Alexander the Great right. The lower edge is broken away, but otherwise the condition is good.

Discussion: For the popularity of the type in the Hellenistic and Roman periods, see catalogue number 218, above. A cameo in Oxford may depict a Late Hellenistic king (*Oxford Gems*, no. 281), while other cameos are of early imperial date (see *Bibliothèque Nationale*, nos. 224–225, which are similar in style; also nos. 222–223).

Provenance: From Asia Minor.

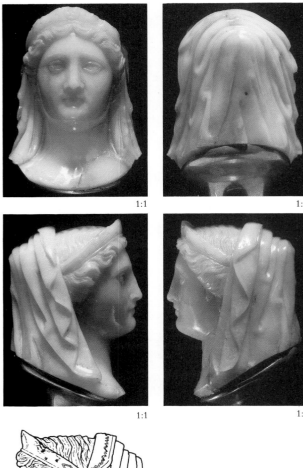

1:1 1:1

1:1 1:1

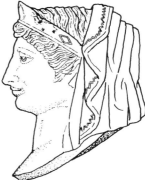

432 Chalcedony, carved in the round

Height, 5.0 cm
First quarter of the first century A.D.
81.AN.101

Description: Bust of Antonia(?); she is veiled and wears a diadem ornamented with a star and, in intaglio, a laureate head of Augustus within a circle.

There are a few chips from the diadem and cracks in the neck, otherwise excellent condition.

Discussion: The head had previously been identified as Livia, but E. Simon persuasively argues for the identification as Antonia Minor and is followed by Megow, *Kameen*. Simon also notes the similarity in the treatment of the eyes to the fine glass head of Augustus in Mainz (see D. B. Harden et al., *Glass of the Caesars*, exh. cat. [London,

1987], pp. 21–22, no. 1). Portraits carved in the round in precious stone were made throughout the imperial period (listed by Megow) and were probably once set into statues of precious metal, although none survives complete. A large (9 cm) chalcedony head of a goddess in similar style is in Vienna (*Vienna Cameos*, no. 113).

Provenance: Ex-Joseph Mayer and Bram Herz collections.

Bibliography: C. T. Gatty, *Catalogue of the Engraved Gems and Rings in the Collection of Joseph Mayer, F. S. A.* (London, 1879), no. 164, frontispiece; E. Simon, *AA*, 1982, p. 342, figs. 25–27; Megow, *Kameen*, p. 289, D 5, pl. 20.4–6; M. Henig, in M. Gibson and S. M. Wright, eds., *Joseph Mayer of Liverpool, 1803–1886* (London, 1988), p. 97, pl. 25b; *Catalogue of the Extensive Collection of Assyrian, Babylonian, Egyptian, Greek, Etruscan, Roman, Indian, Peruvian, Mexican, and Chinese Antiquities and Articles of Vertu Formed by Bram Herz, now the Property of Joseph Mayer, Esq., FSA, &c, &c, of Liverpool*, sale, S. Leigh Sotheby & John Wilkinson, London, February 7, 1859, and the fifteen following days, lot 964 (purchased by Charles Roach Smith for £175, the highest price realized at the sale).

433 Amethyst

18.8 × 12.1 × 6.0 mm
Early first century A.D.
82.AN.162.70

Description: Facing female head, circled by a ridge.

The back is chipped and slightly concave.

Discussion: A number of cameo heads of similar type, style, and size are known, and the group has been identified and discussed by Vollenweider (Vollenweider, *Steinschneidekunst*, pp. 12–16, pls. 3–7, listing examples in Paris, Florence, Lucerne, Geneva, Boston, Baltimore, and Cleveland). Most are in amethyst, with a few in agate, and all show the facing head or bust of a female with diadem and veil. The fine example in Cleveland is exceptionally large (44 mm), as is the example in Lucerne (31 mm), which is set in a medieval cross, but the others are about the size of the Getty example. In addition, there is an amethyst plaque with the facing bust of Artemis found at Labraunda (Izmir Archaeological Museum; Vollenweider, *Steinschneidekunst*, p. 14 n. 7, pl. 7.1–3); a large Selene

bust in agate found in Germany (Furtwängler, *Beschreibung*, no. 11103); a facing bust of Isis in carnelian (Jucker and Willers, *Gesichter*, p. 290, no. 161); a facing bust of Athena (see below, cat. no. 435); and garnet heads in Romania (*Romania*, no. 676) and Tbilisi (M. N. Lordkipanidze, *Gemmy gosudarstvennogo Muzeya Gruzii*, vol. 2 [Tbilisi, 1958], pp. 105–106, pl. II.5, in a gold ring). Stylistically, the Getty amethyst fits well into the main group distinguished by Vollenweider, but it differs in that the woman does not have a diadem and veil; her hair style is similar to that of the Artemis in Izmir.

Vollenweider has observed that the diademed and veiled heads are very close in style to representations of Arsinoë II and has placed the entire series in the Ptolemaic court of the third century B.C. Although the derivation of the type from representations of Ptolemaic queens is likely, such an early date for the group of amethysts is not entirely convincing, and an early Roman imperial date might be preferable. A garnet cameo that was once set into a ring depicts Berenike II in profile (Boardman, *Intaglios and Rings*, no. 59 = Getty Museum 81.AN.76.59), but it is the only example clearly datable to the Ptolemaic period that has so far come to light. Roman imperial women, however, are frequently depicted with diadem and veil, and examples include the large chalcedony bust in the Getty Museum (see cat. no. 432), and, most notably, a facing bust of Livia in plasma, which is very similar in style and technique to the group of amethysts (once Story-Maskelyne collection; Vollenweider, p. 66 n. 7, pl. 70.8 = Megow, *Kameen*, pp. 250–251, B 7, pl. 2.3). Megow has suggested that the amethyst in Paris (*Bibliothèque Nationale*, no. 14 = Vollenweider, *Steinschneidekunst*, p. 13 n. 4, pls. 5.7–8, 10, 6.1–3 = Megow, *Kameen*, p. 290, D 7, pl. 7.16) may depict Antonia. The types of materials used in the group (amethyst, agate, garnet, and plasma) are more typical of the early imperial period than of the Ptolemaic era, and the materials, style, technique, and function (note the ridge around the head or bust) are remarkably similar to the large series of facing Eros heads that are certainly of Roman imperial date (see cat. no. 434, below). They appear most commonly to have been set in rings, and some rings carved entirely from precious stone have similar facing female heads or busts on the bezel (see *Munich*, pt. 3, no. 2400, carnelian; *Vienna Cameos*, no. 28, rock crystal, late first century A.D.).

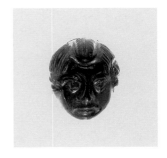

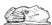

434 Garnet

11.8 × 9.5 × 5.5 mm
First century A.D.
83.AN.437.42

Description: Facing head of Eros, circled by a ridge. There is a flaw on the left cheek of Eros and chips at the lower right and on the back, which is flat and unpolished.

Discussion: Eros heads of this type are known in a variety of materials and are usually set in rings, although an unpublished carnelian example in Oxford is set in a gold frame as a pendant on a necklace. Some examples are datable to the early imperial period, while others are found in later rings (*Oxford Gems*, no. 358, carnelian, for associations with the late Ptolemaic court, generally unconvincing in view of the large number in Roman rings; *De Clercq coll.*, nos. 2434–2435, garnets in gold rings from Tartous; another garnet from Syria, in a private collection, is in a first-century gold ring; *Sofia*, no. 309, garnet in a gold ring from Novae, Bulgaria; *BMC Rings*, no. 531, plasma; once Gutman collection, *Allen Memorial Art Museum Bulletin* 18 [1961], no. 112, in a gold ring; Berlin, Greifenhagen, *Schmuckarbeiten*, p. 88, pl. 64.9, blue glass in a fragmentary bronze ring, "third century A.D."; *Sa'd Collection*, no. 414, chalcedony in a fragmentary gold ring, and nos. 412–413, carnelians; and others without rings, *BMC Gems*, no. 3660, chalcedony, from Ephesos, 3661, chalcedony; Furtwängler, *Beschreibung*, nos. 11122–11123; *Thorvaldsen*, nos. 1978–1979, chalcedony and plasma; *Content coll.*, nos. 112–116, in carnelian, topaz, amethyst, emerald, and garnet; *Leningrad Cameos*, nos. 18–25, 99–106; *Cologne*, nos. 203–204; *Belgrade*, no. 63; *Romania*, nos. 692–696; also similar heads wearing a Phrygian cap, *BMC Gems*, nos. 3565–3566, garnet).

Provenance: From Asia Minor.

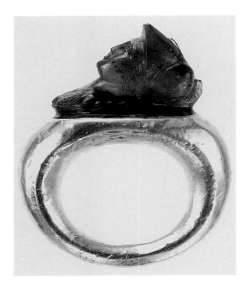

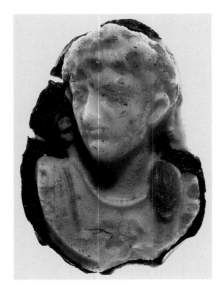

435 Plasma (green chalcedony) bust in hollow gold ring

Bust, 18.4 × 10.7 × circa 13 mm; greatest diameter of hoop, 28.2 mm
First century A.D.
88.AN.13 (Color plate 5)

Description: Facing bust of Athena wearing a crested Corinthian helmet and aegis; the bust rises from a slightly convex, oval plaque that is mounted in the bezel of the ring.

The hoop is like Henkel, *Römische Fingerringe*, no. 145, and Henig, *Roman Engraved Gemstones*, Type VI.

Discussion: Like catalogue numbers 433 and 434, above, this example belongs to a group of cameo busts carved in precious stone that served as ring bezels (see the discussion above). Another bust of Athena, in sardonyx, is in Leningrad (*Leningrad Cameos*, no. 474), along with two Hellenistic varieties in garnet set in gold rings, which were found at Kerch (*Leningrad Cameos*, nos. 11–12; Furtwängler, *AG*, vol. 3, p. 152); the type may ultimately derive from Late Classical gold relief rings (see the example with bust of Athena from Calabria, *BMC Rings*, no. 224).

Bibliography: *GettyMusJ* 17 (1989), p. 115, no. 25.

436 Glass cameo in three layers

36.5 × 25.2 × 12.1 mm
Early first century A.D.
81.AN.172

Description: Bust of a Julio-Claudian emperor facing three-quarter left; he is laureate and wears a cuirass ornamented with aegis; there is drapery on his left shoulder.

The gem has a dark purple background with white face and yellow for the high points (wreath and drapery). The back is flat.

There are a few chips from the edge; the surface is somewhat corroded.

Discussion: The features are indistinct, making a firm attribution impossible, but the style clearly points to the early imperial period. Augustus is seen in frontal view on a large chalcedony cameo in Paris (*Bibliothèque Nationale*, no. 233 = Megow, *Kameen*, p. 171, A 30, pl. 22.5, but no cuirass), and the pose is not unusual for early imperial cameo portraits (including a glass cameo depicting Agrippa, British Museum GR 1981.8-25.1). A three-quarter facing bust of Caligula in Leningrad is in a pose especially similar to that on the Getty cameo (*Leningrad Cameos*, no. 102 = Megow, *Kameen*, pp. 186–187, A 63, pl. 14.11). The portrait of Claudius on the large sardonyx cameo in Windsor Castle, although depicted in profile, is also close in style, and he wears a similar cuirass ornamented with aegis (Megow, *Kameen*, pp. 194–195, A 76, pl. 25).

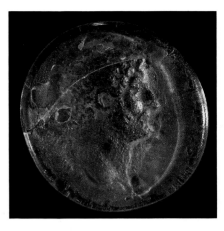

437 Colorless glass cameo, cast

26.1×25.0×3.5 mm
Second quarter of the second century A.D.
85.AN.444.9
Description: Head of the emperor Hadrian right.
The edges and back have been cleaned, and the surface is somewhat corroded; the back is flat; broken and repaired.
Discussion: The glass may have been cast from a coin.

438 Agate cameo, brown on white

10.2×7.8×2.5 mm
First century A.D.
79.AN.126.9
Description: Roman numeral: XVIII.
 The back is flat.
Discussion: A similar brown on white cameo with the Greek numeral KS = 26, is in Leningrad (*Leningrad Cameos*, no. 262, but its function is unknown). Gaming counters with engraved numerals are common in precious stone (see *BMC Gems*, nos. 3986–3993, all in rock crystal).

439 Banded agate cameo

13.9×10.3×7.9 mm
First century A.D.
82.AN.162.74
Description: Dog, viewed from above, reclining on his left side; his head is raised and looks forward; his front paws are stretched before him.
 The base of the cameo is orange-brown, and the upper layers white with darker bands. The sides of the base slope inward; the back is flat and polished.
Discussion: Cameos of this type were especially popular, and two examples from Pompeii demonstrate their first-century date (*Naples*, nos. 261–262, the first glass and the second agate; other examples include *BMC Gems*, no. 3676, agate, and no. 3677, sard; *Cook coll.*, vol. 2, no. 353, agate; *Karapanos coll.*, p. 183, no. 944, agate; *Cologne*, no. 417, agate; D. G. Mitten and A. P. Kozloff, eds., *Animals in Ancient Art from the Leo Mildenberg Collection* [Cleveland, 1981], pp. 197–198, nos. 185–186, agate; *New York*, no. 643, glass; Furtwängler, *Beschreibung*, nos. 11342–11344, glass; *Vienna Gems*, vol. 2, no. 1047, glass; *Thorvaldsen*, nos. 2000–2001, glass, both fragmentary; an agate from Taranto, C. C. Vermeule, "A Catalogue of the Classical Antiquities in Sir John Soane's Museum, London" [unpublished manuscript, second version, 1973], no. 565; and at least three others in agate in private collections). The same type was carved in Renaissance Italy (see *Vienna Cameos*, p. 165, no. 387, as Italian, sixteenth century; J. Kagan, *Western-European Cameos in the Hermitage Collection* [Leningrad, 1973], no. 3, as Italian, thirteenth century; and *Cologne*, no. 417, with literature).

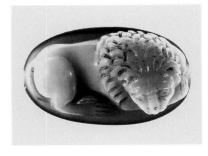

440 Sardonyx cameo

22.9×13.9×10.6 mm
First–third century A.D.
86.AN.739

Description: Lion reclining right, lying on his left side; his head is turned to front, resting on his forelegs.

Discussion: The type is unusual, and the closest parallel is a sardonyx cameo in Paris, on which the lion shares the same pose but is not so close in style (*Bibliothèque Nationale*, no. 364, as Sasanian); *Content coll.*, no. 169, shows a bull in a similar pose. The date is difficult to determine; the style is crude but that need not indicate a late date (see the large cameo of a walking lion in poor style from Pompeii, *Naples*, no. 248).

Bibliography: *GettyMusJ* 15 (1987), p. 166, no. 24.

is the preferred type (see *Bibliothèque Nationale*, no. 203; *BMC Gems*, no. 3685; *Belgrade*, no. 66; A. E. Knight, *The Collection of Camei and Intagli at Alnwick Castle, Known as "The Beverley Gems"* [privately printed, 1921], no. 116; Vollenweider, *Deliciae Leonis*, no. 255, two birds, as first century B.C.; N. Dacos, A. Grote, A. Giuliano, D. Heikamp, and U. Pannuti, *Il tesoro di Lorenzo il Magnifico* [Florence, 1980], pp. 76–77, no. 51, color pl. XIII, Naples inv. no. 25898, two birds; and Sternberg, Zurich, auction 12, 1983, lot 972, two birds; see also *Content coll.*, no. 173, a red and green parrot on white ground).

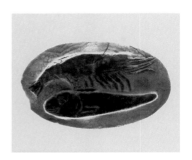

441 Sardonyx(?) cameo, discolored brown on white-pink

20.9 × 12.8 × 6.2 mm
First century A.D.
85.AN.370.87

Description: Shrimp to right above a fish to left. Carefully finished.

Discussion: For similar examples, see *Bibliothèque Nationale*, no. 206; *Leningrad Cameos*, no. 211.

Provenance: From Tunisia.

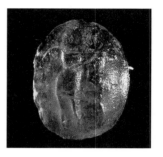

443 Colorless glass cameo, convex with flat back

16.7 × 13.0 × 5.0 mm
First century A.D.
85.AN.370.88

Description: Eros, facing right, and Psyche, facing left, embracing.

Discussion: Identical cameos in various colors of glass are very common and were studied by T. E. Haevernick, *Arheološki Vestnik Acta Archaeologica* 19 (1968), pp. 61–64, who cites examples in various collections from Yugoslavia, Hungary, and Greece, and others without provenance. Other examples include one from France (Guiraud, *Gaule*, no. 986) and one in a large tomb group, probably of first-century date, found near Vetralla, Italy (G. Bordenache Battaglia, *Corredi funerari de età imperiale e barbarica nel Museo Nazionale Romano* [Rome, 1983], pp. 71–72, no. 29, fig. 26); other examples, without provenance, Furtwängler, *Beschreibung*, nos. 11345–11347; *Munich*, pt. 3, nos. 3494–3498; *BMC Gems*, no. 3862; *Thorvaldsen*, no. 1894; *Leningrad Cameos*, nos. 439–440; *Lewis coll.*, Appendix, no. 64; R. Nicholls, *The Wellcome Gems* (Cambridge, 1983), no. 49.

Provenance: From Asia Minor.

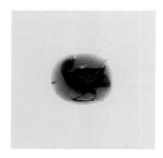

442 Agate cameo, blue on light brown

9.1 × 7.9 × 2.9 mm
First–second century A.D.
82.AN.162.75

Description: Bird standing left, its head turned back. The back is flat.

Discussion: A number of cameos is known with similar types in the same technique, in which the agate is cut in the opposite manner from the usual, creating a blue device on a light background. Either one or two blue birds

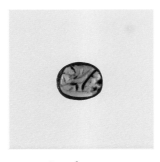

444 *Sardonyx cameo*

6.3 × 5.5 × 2.1 mm
Second–early third century A.D.
84.AN.1.68

Description: Two fishermen sitting in a boat; one holds the sail and the other leans over the side.
The back is convex.

Discussion: The same scene is found on cameos in Leningrad (*Leningrad Cameos*, no. 97, as third century A.D.; also no. 355); Augst (R. Steiger, *AK* 9 [1966], p. 47, no. 24, pl. 9.25, there incorrectly identified); and *Content coll.*, no. 146.

Provenance: From Asia Minor.

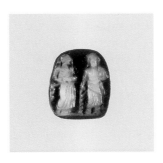

445 *Sardonyx cameo*

10.1 × 8.9 × 3.1 mm
Second–early third century A.D.
84.AN.1.69

Description: Hygieia, to left, standing facing right, and Asklepios, to right, standing facing front; Hygieia holds a serpent and dish, and Asklepios leans on a serpent-entwined staff.
The back is unfinished.

Discussion: A slightly larger, but very similar, cameo was on the Basel market (Münzen und Medaillen, Basel, *Sonderliste* K, December 1968, no. 177, "Antonine"); and see *Content coll.*, no. 88.

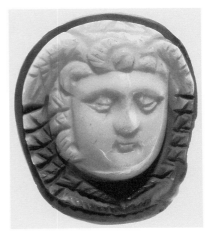

446 *Sardonyx cameo, dark gray and white*

29.3 × 24.3 × 13.0 mm
Second–early third century A.D.
83.AN.256.8

Description: Head of Medusa facing three-quarter right.
The back is unfinished.

Discussion: The Medusa head is the single most popular type on Roman cameos, and a very large number survives, including many that are unpublished. Cameos with Medusa heads were likely made in the Late Hellenistic period, but most surviving examples appear to be of relatively late Roman imperial date, primarily late second and third centuries A.D. They were variously set in pendants, rings, and earrings, each type of which is preserved in a number of examples, and they have been found in all parts of the Roman Empire (see *BMC Rings*, no. 467 = *BMC Gems*, no. 3548, in a ring, from Patras; *BMC Rings*, no. 544 = *BMC Gems*, no. 3547 = Henig, *Roman Engraved Gemstones*, no. 729, in a ring, from Wales; *BMC Gems*, nos. 3543, 3545–3546, 3549★, the last from Arras = Guiraud, *Gaule*, no. 991; Henig, *Roman Engraved Gemstones*, nos. 725–731; Henkel, *Römische Fingerringe*, nos. 244, 247, 254; *Vienna Cameos*, nos. 91–93, the second in a gold pendant, and the last in an iron ring; *Bibliothèque Nationale*, nos. 165–166, 168; Guiraud, *Gaule*, nos. 989–991; Furtwängler, *Beschreibung*, no. 11065, a fine style first-century example in a gold ring from Pedescia, and nos. 11114–11118; *Cologne*, nos. 373–376, the last in a gold mount; Augst, R. Steiger, *AK* 9 [1966], pp. 47–48, no. 25, pl. 9.26; *Leningrad Cameos*, nos. 134–138 and 302–352; *Sofia*, nos. 310–317, including examples in pendants and rings; *Belgrade*, nos. 17–29; *Romania*, nos. 687–691; *Sa'd Collection*, nos. 407–409; Geneva, Vollenweider, *Deliciae Leonis*, no. 459, in earrings, and no. 460, in a ring; *Geneva*, vol. 2, nos. 264–265, in earrings; *Content coll.*, nos. 156–164; also cat. nos. 447–448, below, and many

others could be added). This example is large and of good quality; for similar examples, see Henig, *Roman Engraved Gemstones*, nos. 725–726; Vollenweider, *Deliciae Leonis*, no. 458; and O. Neverov, *Antique Cameos in the Hermitage Collection* (Leningrad, 1971), no. 66.

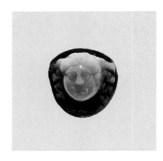

447 *Sardonyx in four layers*

10.0×9.6×5.4 mm
Second–early third century A.D.
83.AN.437.43

Description: Head of Medusa facing three-quarter left.
 The sardonyx is white, light blue, dark blue, and brown on the back. The back is unfinished.

Discussion: For the type, see catalogue number 446, above. Close in style is *Bibliothèque Nationale*, no. 168.

Provenance: From Asia Minor.

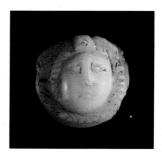

448 *Agate cameo, white*

13.1×12.1×6.2 mm
Second–early third century A.D.
84.AN.1.66

Description: Head of Medusa facing front, turned slightly right.
 The back is unfinished.
There are some chips from the edge and back.

Discussion: Same type as catalogue number 447, above, but cruder style.

Provenance: From Asia Minor.

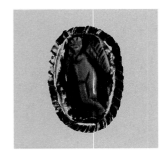

449 *Sardonyx cameo in gold frame*

Cameo, circa 11.1×7.5 mm
First half of the third century A.D.
84.AN.1.67

Description: Eros leaning left on an inverted torch.
 The frame is a gold oval box with crimped border, probably detached from an earring.

Discussion: The motif, with either one or two erotes leaning on torches, is one of the most common on cameos of this period (see *Content coll.*, nos. 101–109, including some mounted as earrings and pendants; *Leningrad Cameos*, nos. 367–375, the first in a ring; *Belgrade*, nos. 12–16; *Thorvaldsen*, no. 1889; *Bibliothèque Nationale*, no. 60; *Karapanos coll.*, p. 182, nos. 917–918; *Berry coll.*, no. 224; *Caesarea*, no. 101; *Sofia*, nos. 319–320; *Cologne*, no. 288; J. Boardman, *Engraved Gems: The Ionides Collection* [London, 1968], no. 63; Münzen und Medaillen, Basel, *Sonderliste K*, December 1968, no. 175; Henkel, *Römische Fingerringe*, nos. 200, 216, 1173; *BMC Gems*, no. 3475; *BMC Rings*, no. 562; F. H. Marshall, *Catalogue of the Jewellery in the British Museum* [London, 1911], no. 2656, in a gold earring from Olbia; Henig, *Roman Engraved Gemstones*, no. 736; *Vienna Cameos*, nos. 89–90; and cat. no. 450, below).

Provenance: From Asia Minor.

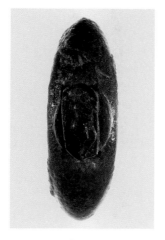

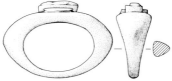

450 Sardonyx cameo in bronze ring

Cameo, 10.4 × 4.3 mm; greatest diameter of hoop, 29.1 mm
First half of the third century A.D.
85.AN.370.84

Description: Eros standing right (once leaning on an inverted torch, now cut away).

The cameo is discolored black and cut down on both sides. The ring has a green patina.

Discussion: The cameo was evidently cut down and reused for the ring, but other rings set with cameos of the same type are known (see *BMC Gems*, no. 562; *Cologne*, no. 288; *Sofia*, nos. 319–320; *Leningrad Cameos*, no. 367).

451 Sardonyx cameo

26.6 × 13.9 × 8.7 mm
First half of the third century A.D.
85.AN.370.86

Description: Helmeted and draped bust of Athena or Roma left.

Partially discolored white

Discussion: The cameo is stylistically close to a large (55 mm) sardonyx cameo in Paris that depicts a helmeted youth with spear and shield in rear view (*Bibliothèque Nationale*, no. 311); the identification as Crispus is unlikely. Also similar are the cameos, *Content coll.*, no. 130; *Karapanos coll.*, p. 176, no. 717; *Romania*, no. 667; and an example in a gold mount from Odessos (G. Toncheva, *Sovetskaya Arkheologiya* 1 [1968], p. 233, fig. 5).

Provenance: From Yugoslavia.

 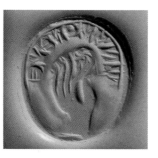

452 Agate cameo, brown on white

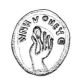

17.9 × 15.7 × 4.7 mm
First half of the third century A.D.
83.AN.257.26

Description: Hand pinching an ear; around: MNHMO-NEYE, 'remember.'

The back is convex and polished, an unusual feature.

Discussion: The type is common; see *Content coll.*, nos. 52–56, the first said to be from Jerusalem, citing examples in Carnuntum, Vienna, Leningrad, Florence, and elsewhere. As Henig notes, the gesture is alluded to in Vergil (*Eclogues* 6.3–4), and Pliny (*Naturalis Historia* 11.103) specifically states that the memory is located in the lobe of the ear. However, gems and cameos with the motif appear unattested before the late second century.

SASANIAN GEMS

The powerful Sasanian dynasty ruled Persia circa A.D. 224–651, frequently coming into conflict with the Roman and Byzantine empires. The Sasanians produced intaglios, both ringstones and hemispherical stamp seals, in enormous quantity; the materials used were generally the same as those used by the Romans, although with a somewhat larger variety. However, it is notable that Sasanian gems began to be produced only after the fashion for engraved gems had to a great degree fallen out of favor in the Roman Empire.

The Sasanians most often made use of traditional Persian devices, usually animals, but portraits, including royal ones, are not infrequent, and many gems bear a *tamga*, a traditional personal symbol or "linear device" that served as a signature. Inscriptions in Pahlavi are common. In addition, there are some gems with early Christian devices (see J. A. Lerner, *Christian Seals of the Sasanian Period* [Leiden, 1977], and cat. no. 453, below, showing the Sacrifice of Isaac). The chronological development of Sasanian gems is still controversial, but the many clay sealings from Tacht-E-Suleiman and Qasr-i Abu Nasr provide a large variety of gem devices datable to the later Sasanian period, mostly fifth and sixth centuries (see R. Naumann, in R. Göbl, *Die Tonbullen vom Tacht-E-Suleiman* [Berlin, 1976], p. 23; Frye, *Qasr-i Abu Nasr*, pp. 45–46; and the clay sealing, cat. no. 461, below); most of the Getty gems appear to be of this late period. The shapes of the gems often differ from Roman examples; they are discussed by Göbl. For a current bibliography and outline of Sasanian gems, see Zazoff, *AG*, pp. 363–373.

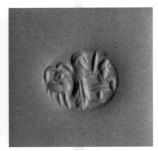

453 Orange carnelian, F 2

11.7 × 10.3 × 3.2 mm
Fourth–fifth century A.D.
82.AN.162.85

Description: Abraham standing right, holding a knife and preparing to sacrifice Isaac, who is seated right on an altar; a goat stands at the left.

Discussion: The motif is common in early Christian art and often appears on Sasanian gems; see the many examples discussed by J. A. Lerner, *Christian Seals of the Sasanian Period* (Leiden, 1977), pp. 18–22, 36–39, nos. 31–55; Horn and Steindorff, *Sassanidische Siegelsteine*, nos. 1078–1080; Göbl, *Siegelkanon*, pl. 2. 4.

454 Orange carnelian, B 3, convex (Göbl 4)

16.5 × 12.8 × 3.5 mm
Fifth century A.D.(?)
82.AN.162.81

Description: Female(?) figure standing right within an aedicula.

Discussion: The device is close to *BMC Stamp Seals*, p. 62, CB 2, dated fifth century A.D.; see also *BMC Stamp Seals*, p. 58, BE 5; p. 62, CB 1; and Göbl, *Siegelkanon*, pls. 1, 2a.

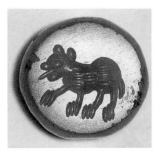
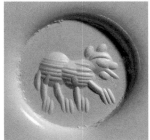

455 Milky chalcedony, hemispherical, pierced (Göbl I)

Height, 13.1 mm; diameter of face, 15.5 mm
Fifth–sixth century A.D.
83.AN.256.10

Description: Bear walking right.

Discussion: Close to *BMC Stamp Seals*, p. 95, FK 1–8; see also Horn and Steindorff, *Sassanidische Siegelsteine*, nos. 1294, 1296, 2158; A. Borisov and V. Lukonin, *Sasanidskie gemmy* (Leningrad, 1963), no. 749; Göbl, *Siegelkanon*, pl. 16.45b; and Frye, *Qasr-i Abu Nasr*, D.28(?), 67(?), and 297.

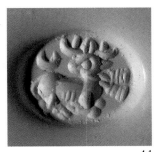

4:1

456 Banded agate, brown/white/black, F 4 (Göbl 3)

10.3 × 10.1 × 4.2 mm
Fourth–sixth century A.D.
82.AN.162.84

Description: Recumbent stag right, head turned left; crescent to left.

Discussion: Close to *BMC Seal Stamps*, p. 90, FA 1–7, especially 2–3; Horn and Steindorff, *Sassanidische Siegelsteine*, no. 862 (with crescent); *Karapanos coll.*, no. 623; see also Göbl, *Siegelkanon*, pl. 18.51; P. Gignoux, *Catalogue des sceaux, camées et bulles sasanides de la Bibliothèque Nationale et du Musée du Louvre*, vol. 2 (Paris, 1978), nos. 5.12, 6.26, 9.63, and the bulla 17.6; G. Gropp, "Some Sasanian Clay Bullae and Seal Stones," *American Numismatic Society*

Museum Notes 19 (1974), p. 121, B.13, pl. 21, and p. 122, D.1, pl. 22; *Hanover*, Hamburg no. 105; and Frye, *Qasr-i Abu Nasr*, D 263 (for the pose).

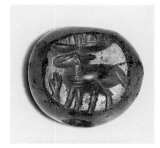

457 Rock crystal, hemispherical, pierced (Göbl III)

Height, 12.7 mm; face, 12.0 × 11.5 mm
Fifth–sixth century A.D.
82.AN.162.83

Description: Stag standing right, tree to right.

Discussion: Close to A. Borisov and V. Lukonin, *Sasanidskie gemmy* (Leningrad, 1963), no. 655 ("fifth–sixth century"); and G. Gropp, "Some Sasanian Clay Bullae and Seal Stones," *American Numismatic Society Museum Notes* 19 (1974), p. 121, C.3, pl. 22; see also *BMC Seal Stamps*, p. 92, FC 3; *Hannover*, Hamburg no. 106.

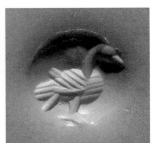

4:1

458 Orange carnelian, close to C 4, highly convex with short base (Göbl 4)

7.7 × 7.4 × 2.4 mm
Fifth–sixth century A.D.
83.AN.353.5

Description: Bird standing right.
There is a chip from the edge.

Discussion: See *BMC Seal Stamps*, pp. 99–100, HC 1–4

("partridge"), p. 102, HF 9–11; Horn and Steindorff, *Sassanidische Siegelsteine,* no. 900 ("goose"); Göbl, *Siegelkanon,* pl. 12.32 ("goose"); Frye, *Qasr-i Abu Nasr,* D.22, 43, 47, 73, 357, 366, 369, 370, 374, 384–385.

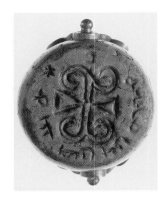
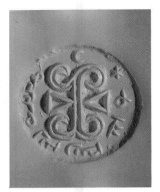

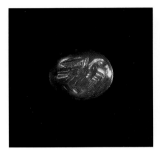
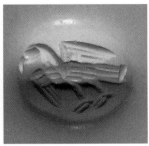

4:1

459 Orange carnelian (Göbl 4)

8.5 × 7.1 × 3.6 mm
Fourth–sixth century A.D.
81.AN.106.7

Description: Eagle, wings spread, standing left.

The gem is the same shape as catalogue number 458, above; it is in a fragmentary iron ring.

Discussion: See Horn and Steindorff, *Sassanidische Siegelsteine,* no. 892; Göbl, *Siegelkanon,* pl. 12.32; Frye, *Qasr-i Abu Nasr,* D.41, 58, 368.

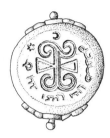

460 Gray stone, hemispherical (Göbl I)

Height, 18.0 mm; diameter of face, 21.5 mm
Fifth–sixth century A.D.
82.AN.162.86

Description: Large personal symbol (*tamga*), star and crescent above; Pahlavi inscription around.

In modern gold mount.

Discussion: The *tamga* is especially close to that on the sealing, Frye, *Qasr-i Abu Nasr,* D.269; see also the sealing from the mouth of a vessel from Tacht-E-Suleiman, D. Huff, *AA,* 1975, pp. 178–179, fig. 75. For similar symbols, see R. N. Frye, ed., *Corpus Inscriptionum Iranicarum,* pt. 3, vol. 6, portfolio 2, *Sasanian Seals in the Collection of Mohsen Foroughi* (London, 1971), nos. 43, 45, pl. 35; A. Borisov and V. Lukonin, *Sasanidskie gemmy* (Leningrad, 1963), nos. 190–195, 199–200 ("fourth–fifth century"); Horn and Steindorff, *Sassanidische Siegelsteine,* nos. 859, 1554–1564; G. Gropp, "Some Sasanian Clay Bullae and Seal Stones," *American Numismatic Society Museum Notes* 19 (1974), p. 120, B.1, pl. 21; *BMC Seal Stamps,* pp. 110–117, NB–NJ; Göbl, *Siegelkanon,* pl. 34.109; and in general, Frye, *Qasr-i Abu Nasr,* pp. 55–57, with further literature.

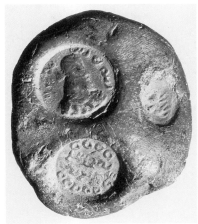

1:1

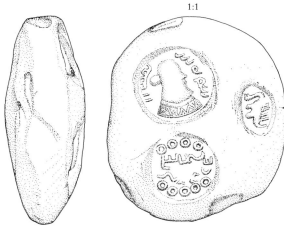

461 Clay sealing

58.2×49.0×22.0 mm
First half of the sixth century A.D. (H. Koch)
82.AD.25

Description: The sealing is stamped with five different
seals. One is a Pahlavi inscription naming the office
of priests at Xunan in the province of Ray. Another
impression shows the portrait of a priest named Dad-
farrox. Other impressions are less distinct, showing
a *tamga* and an animal.

String hole on the back.

Bibliography: H. Koch, *GettyMusJ* 13 (1985), pp. 27–32.

GREEK AND ROMAN SEALINGS

Clay sealings impressed by gems set in rings
survive in large quantity and are the only remains of
Greek and Roman archives once containing rolled
and sealed papyrus documents. The backs of the
clay sealings often bear striations from the papyrus,
and there is often a string hole. Significant Hellenistic
archives have been found at Selinous (Sicily), Kalli-
polis (Aitolia), Egypt, Nea Paphos (Cyprus), Herak-
lion (Crete), Seleucia (Syria), and Delos (for a
concise list of the finds, with bibliography, see
D. O. A. Klose, *Jahrbuch für Numismatik und Geldge-
schichte* 34 [1984], pp. 70–72; and J. Spier, *JWalt* 47
[1989], pp. 21–22 nn. 20–24); several of these archives
have each yielded more than 20,000 sealings.

There are fewer finds of large Roman archives.
Around four thousand sealings, probably of first-
century-A.D. date, were discovered at Cyrene (see
Maddoli, *Cirene*), and thousands more, probably
dating from the first century B.C. to the early second
century A.D., derive from an uncertain site apparently
located in eastern Asia Minor near present-day
Diyarbakır, perhaps at the site of ancient Doliche.
Although the exact location of the find site is
unknown, thousands of sealings, with many dupli-
cations of types, have steadily appeared for more
than sixty years. Examples in Paris (acquired as early
as 1929) were first published in 1940 (S. Ronzevalle,
Mélanges de l'Université Saint Joseph 23 [1940], pp.
69–77; H. Seyrig, ibid., pp. 85–107); others bearing
the city name of Nikopolis, purchased in Izmir,
were published by L. Robert (*Hellenica* 10 [1955],
pp. 293–294). A further group, in the Hague, was
published in 1971 by Maaskant-Kleibrink (see
Maaskant-Kleibrink, *Doliché*), and Klose's article on
another group appeared most recently (Klose
[above], pp. 63–76). Many pieces continue to surface
on the market, usually including a repetition of
known devices, which suggests a single archive.
Most, although not all, of the examples in the Getty
Museum appear to derive from the same source.

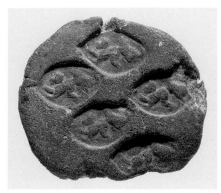

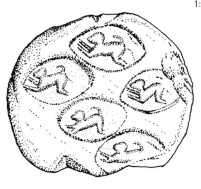

1:1

462 Black clay bulla, flat surface, high pinched back

Face, 50.1 × 45.3 mm; thickness, 26.1 mm
Uncertain date (Graeco-Persian, fourth century B.C.?)
85.AN.370.91

Description: Impression from an engraved ring, stamped five times. Animals?

Provenance: From Asia Minor.

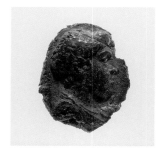

463 Brown clay

15.9 × 12.7 × 4.8 mm
Probably 116–107 or 88–80 B.C.
84.AN.1.95

Description: Diademed bust of Ptolemy IX(?) right. Striations on the back.

Bibliography: J. Spier, *JWalt* 47 (1989), p. 31, fig. 38 (citing garnet gems, rings, and other similar impressions from Edfu and Nea Paphos).

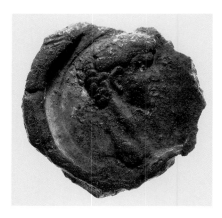

464 Brown clay

24.5 × 24.6 × 5.8 mm
A.D. 41–54(?)
85.AN.370.89

Description: Portrait of an emperor (Claudius?) right. Striations on the back. The gem was circular and flat and set in a ring.

Provenance: From Asia Minor.

465 Black clay

20.7 × 17.2 × 4.7 mm
Second–first century B.C.
85.AN.370.90
Description: Apollo, nude, standing right, playing a lyre.
The style is very fine.
 Striations and string hole on the back.
Provenance: From Asia Minor.

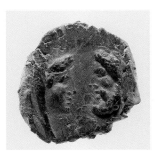

466 Dark brown clay

17.3 × 16.5 × 6.3 mm
First century A.D.
83.AN.437.62
Description: Confronted heads of a veiled woman right
and a bearded male left. Zeus and Hera?
 Striations on back.
Discussion: Like Maaskant-Kleibrink, *Doliché*, p. 27, no. 4
("Hellenistic").

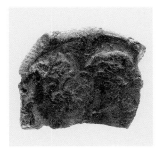

467 Brown clay

18.7 × 16.8 × 5.6 mm
First century A.D.
83.AN.437.64
Description: Laureate emperor's(?) head right facing the
helmeted head of Roma left.
 No striations.
Broken at the bottom.
Discussion: Like Maaskant-Kleibrink, *Doliché*, pp. 28–29,
no. 6 ("Augustus").

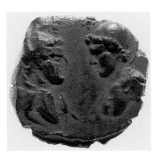

468 Red-brown clay

19.8 × 19.6 × 5.6 mm
First century A.D.
83.AN.437.61
Description: Confronted busts of the Dioskouroi, stars
above their heads.
 Striations on the back.
Discussion: Like Maaskant-Kleibrink, *Doliché*, pp. 29–30,
no. 8; D. O. A. Klose, *Jahrbuch für Numismatik und Geldge-
schichte* 34 (1984), nos. 24–27.

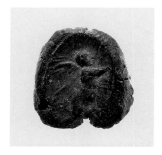

469 Black clay

15.0 × 14.2 × 4.0 mm
First century A.D.
84.AN.I.97

Description: Eros standing right, playing a lyre.
Striations on the back. From a convex gem in a ring.

Discussion: Like Maaskant-Kleibrink, *Doliché*, p. 42, no. 39.

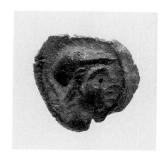

470 Red-brown clay

14.5 × 14.0 × 4.3 mm
First–second century A.D.
83.AN.437.63

Description: Head of Athena wearing a Corinthian helmet right.
Striations on the back. From a convex gem.

Discussion: See Maaskant-Kleibrink, *Doliché*, p. 54, nos. 89–90 (not identical); also D. O. A. Klose, *Jahrbuch für Numismatik und Geldgeschichte* 34 (1984), nos. 44–45; and catalogue number 471, below.

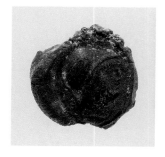

471 Dark brown clay

15.0 × 15.0 × 4.7 mm
First–second century A.D.
84.AN.I.94

Description: Helmeted head of Athena right.
Striations on the back.

Discussion: See catalogue number 470, above.

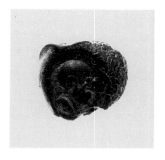

472 Black clay

12.3 × 11.5 × 4.0 mm
First–second century A.D.
85.AN.444.12

Description: Head of Socrates right.
No striations. From a flat gem in a ring.

Discussion: See Maaskant-Kleibrink, *Doliché*, p. 56, no. 98 (not identical).

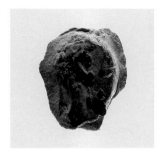

473 Brown clay

14.8 × 12.0 × 6.2 mm
First–second century A.D.
84.AN.1.92
Description: Male head, bearded and laureate, right.
No striations.
Discussion: See Maaskant-Kleibrink, *Doliché*, p. 59, no.
116 (similar style).

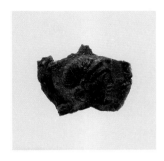

474 Black clay

13.1 × 13.0 × 4.0 mm
First–second century A.D.
84.AN.1.91
Description: Laureate head of Apollo(?) right.
Striations on back.
There are some breaks.
Discussion: See Maaskant-Kleibrink, *Doliché*, p. 59, no.
118 ("emperor").

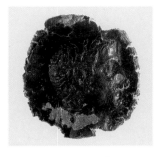
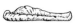

475 Brown clay

17.9 × 16.4 × 3.8 mm
Early first century A.D.
85.AN.444.10
Description: Laureate head of a Julio-Claudian emperor
right.
Striations on the back.

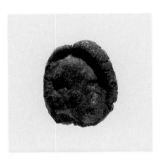
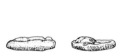

476 Black clay

12.6 × 10.5 × 3.4 mm
First century A.D.
84.AN.1.98
Description: Head of Homer right.
Striations on the back. The gem was convex.
Discussion: The style is very fine; the head of Homer is of
the so-called Apollonios of Tyanna type; see G. M. A.
Richter, *The Portraits of the Greeks*, vol. 1 (London, 1965),
pp. 48–50; the portrait on gems is rare: a seated Homer,
Furtwängler, *Beschreibung*, no. 8683; and a facing head, ex-
Morrison and Arthur Evans collections, Furtwängler,
AG, pl. 66.9.

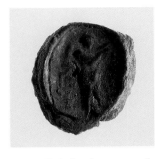

477 *Light brown clay*

16.0 × 14.5 × 4.0 mm
First century A.D.
84.AN.1.93
Description: Winged figure (Hygieia?) standing right,
holding an uncertain object.
 Striations on back. From a convex gem in a ring.

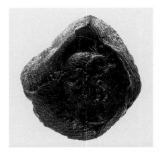

479 *Brown clay*

17.1 × 17.0 × 15.3 mm
First–second century A.D.
85.AN.444.13
Description: Satyr mask right.
 No striations. From a convex gem in a ring.

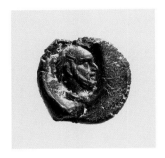

478 *Brown clay*

13.0 × 12.9 × 3.5 mm
First–second century A.D.
85.AN.444.11
Description: Balding satyr head right.
 No striations. From a convex gem.

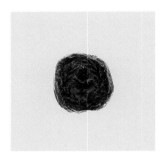

480 *Black clay*

8.7 × 8.4 × 3.6 mm
First–second century A.D.
84.AN.1.96
Description: Bunch of grapes within a wreath.
 Striations on back.

Patroklos	413(?)
peacock	181, 192
Pegasos	70, 299
Perseus	429
Persian	108, 114, 115, 121, 129, 130, 136
Philoktetes	201
pigeon	117
poppy	211, 259, 275, 373, 386
portrait	88–92, 212, 408, 461, 464
Poseidon	268, 423
Priam	182
Priapus	241
Prometheus	144, 200
Psyche and Eros	443
Ptolemy IX	463 (?)
quadriga	71
ram	12, 16, 192, 210, 254, 257, 258, 309, 384
raven	303, 304
Roma	451(?), 467
Sarapis	276, 336–338
satyr	68, 75, 149, 150, 183, 188, 192, 205, 206, 226, 227, 236, 237, 281, 378, 403, 415, 416, 428, 478, 479
scorpion	253, 346
sculptor	202, 203
sea griffin	174
Seasons	289
shrimp	441
siren	46, 64
Skylla	422
snake	24, 57
Socrates	472
sow	15, 45
Spes	270
sphinx	25, 64, 65, 72, 101, 102, 124, 271
stag	98, 115, 154, 155, 177, 259, 373, 456, 457
stork	175, 393
tamga	460, 461
Telephos	84, 284
Theseus	294
Thetis	73

Thoth	278
thyrsos	52, 57, 151, 205, 219, 260, 297, 306, 373, 382, 415, 428
Triton	29
Troilos	66(?)
Troy	285
turtle	254, 373
Tyche	79, 191, 275, 315, 367–370
vase	1, 66, 185, 247, 318, 382, 418
Venus Victrix	244–247
warrior	50, 82, 86, 105, 112 (hoplite), 113 (hoplite), 122, 140, 167, 182, 199, 215, 287, 413
youth	17, 147, 164, 376, 418
zebu bull, see bull	
Zeus	18, 261–267, 421, 466
zodiac	184

MATERIALS INDEX by Catalogue Number

INSCRIPTIONS INDEX by Catalogue Number

PROVENANCE INDEX by Catalogue Number

PREVIOUS COLLECTIONS INDEX by Catalogue Number

OTHER ANCIENT GEMS AND RINGS IN THE GETTY MUSEUM

In 1975 John Boardman published a private collection of 215 gems and rings in his catalogue *Intaglios and Rings*. The Museum subsequently acquired 206 gems from the collection. Not included in the Museum's acquisition were numbers 9, 17, 86, 149, 154, and 205–208 in Boardman's catalogue. Since they had been recently published, the gems acquired from that collection are not included in this catalogue. Boardman's publication may continue to be consulted as reference to the collection since the Museum's accession numbers are based on the catalogue numbers from *Intaglios and Rings*, and are formed as follows: 81.AN.76. + catalogue number. Thus number 27 in *Intaglios and Rings* is now Getty Museum 81.AN.76.27. Additional provenance information for some of the gems in this privately formed collection was provided by then Curator of Antiquities Jiří Frel:

3, 48, 50, 74, 95, 144: from Taranto

5: ex-Zoumboulakis collection

30: from Palermo

35, 83, 84: ex-Abbé Nayem collection

36: from Alexandria

43, 44, 46, 93: from Asia Minor

49: ex-Ephraim collection

80: ex-Jacob Hirsch collection

82, 116: from Sicily

120: from Motya

209: Ars Antiqua, Lucerne, auction IV, 1962, lot 143

CONCORDANCE of accession numbers and catalogue numbers

Accession number	Catalogue number	Accession number	Catalogue number	Accession number	Catalogue number
72.AM.36.1	31	79.AN.8.2	327	81.AN.39.1	391
72.AM.36.2	32	79.AN.8.3	353	81.AN.39.2	319
72.AM.36.3	33	79.AN.8.4	317	81.AN.39.3	374
72.AM.36.4	34	79.AN.8.5	312	81.AN.39.4	303
72.AM.36.5	35	79.AN.8.6	309	81.AN.39.5	381
72.AM.36.6	36	79.AN.27.1	175	81.AN.39.6	427
72.AM.36.7	37	79.AN.27.2	301	81.AN.39.8	256
72.AM.36.8	38	79.AN.27.3	367	81.AN.39.9	174
72.AM.36.9	39	79.AN.27.4	358	81.AN.76.9	143
72.AM.36.10	40	79.AN.27.6	321	81.AN.76.17	198
72.AM.36.11	41	79.AN.126.1	390	81.AN.76.86	109
72.AM.36.12	42	79.AN.126.3	322	81.AN.76.149	152
72.AM.36.13	43	79.AN.126.4	365	81.AN.76.154	57
75.AM.61	221	79.AN.126.6	323	81.AN.76.205	108
76.AN.58	241	79.AN.126.7	310	81.AN.76.207	92
77.AN.34	348	79.AN.126.8	325	81.AN.76.208	88
77.AO.77.1	13	79.AN.126.9	438	81.AN.101	432
78.AC.392.1	48	80.AN.43.1	211	81.AN.106.2	362
78.AC.392.2	47	80.AN.43.2	398	81.AN.106.3	356
78.AC.392.3	49	80.AN.43.3	263	81.AN.106.4	386
78.AF.324.2	426	80.AN.43.4	341	81.AN.106.5	364
78.AN.322.1	335	80.AN.43.5	194	81.AN.106.6	272
78.AN.322.2	360	80.AN.43.6	326	81.AN.106.7	459
78.AN.322.3	268	80.AN.43.7	210	81.AN.106.8	262
78.AN.341.1a	409	80.AN.43.8	267	81.AN.106.9	342
78.AN.341.3	375	80.AN.43.10	320	81.AN.118.1	224
78.AN.373.1	318	80.AN.43.11	406	81.AN.118.2	257
78.AN.373.2	294	80.AN.67	151	81.AN.118.3	195
78.AN.373.3	385	81.AI.180.7	91	81.AN.172	436
78.AN.373.4	372	81.AM.24	29	82.AC.22.148	77
78.AN.373.5	246	81.AM.25	30	82.AD.25	461
79.AN.8.1	264	81.AN.17	84	82.AN.122	65

82.AN.162.1	15	82.AN.162.38	384	82.AN.162.84	456
82.AN.162.2	160	82.AN.162.39	293	82.AN.162.85	453
82.AN.162.3	161	82.AN.162.40	281	82.AN.162.86	460
82.AN.162.4	162	82.AN.162.41	247	82.AN.162.94	302
82.AN.162.5	158	82.AN.162.42	279	83.AN.256.1	282
82.AN.162.6	159	82.AN.162.43	265	83.AN.256.2	361
82.AN.162.7	155	82.AN.162.44	253	83.AN.256.3	223
82.AN.162.8	148	82.AN.162.45	266	83.AN.256.4	202
82.AN.162.9	157	82.AN.162.47	388	83.AN.256.5	237
82.AN.162.10	150	82.AN.162.48	297	83.AN.256.6	382
82.AN.162.11	98	82.AN.162.49	300	83.AN.256.7	214
82.AN.162.12	156	82.AN.162.50	274	83.AN.256.8	446
82.AN.162.13	106	82.AN.162.51	277	83.AN.256.10	455
82.AN.162.14	145	82.AN.162.52	286	83.AN.257.1	276
82.AN.162.15	144	82.AN.162.53	296	83.AN.257.2	250
82.AN.162.16	146	82.AN.162.54	197	83.AN.257.8	233
82.AN.162.17	147	82.AN.162.55	298	83.AN.257.26	452
82.AN.162.18	142	82.AN.162.56	199	83.AN.353.1	315
82.AN.162.19	165	82.AN.162.57	284	83.AN.353.2	366
82.AN.162.20	180	82.AN.162.58	359	83.AN.353.3	313
82.AN.162.21	169	82.AN.162.59	370	83.AN.353.4	311
82.AN.162.22	170	82.AN.162.60	369	83.AN.353.5	458
82.AN.162.23	171	82.AN.162.61	338	83.AN.353.6	345
82.AN.162.24	172	82.AN.162.62	340	83.AN.353.7	351
82.AN.162.25	173	82.AN.162.63	349	83.AN.353.8	393
82.AN.162.26	176	82.AN.162.64	347	83.AN.353.9	324
82.AN.162.27	177	82.AN.162.65	350	83.AN.353.10	314
82.AN.162.28	178	82.AN.162.66	378	83.AN.353.11	316
82.AN.162.29	203	82.AN.162.67	392	83.AN.437.1	3
82.AN.162.30	192	82.AN.162.68	387	83.AN.437.2	6
82.AN.162.31	191	82.AN.162.69	200	83.AN.437.3	97
82.AN.162.32	229	82.AN.162.70	433	83.AN.437.4	16
82.AN.162.33	193	82.AN.162.71	343	83.AN.437.5	103
82.AN.162.34	244	82.AN.162.74	439	83.AN.437.6	102
82.AN.162.35	254	82.AN.162.75	442	83.AN.437.7	96
82.AN.162.36	249	82.AN.162.81	454	83.AN.437.8	119
82.AN.162.37	299	82.AN.162.83	457	83.AN.437.9	111

83.AN.437.10	23	83.AN.437.62	466	84.AN.1.35	226
83.AN.437.11	129	83.AN.437.63	470	84.AN.1.36	228
83.AN.437.12	73	83.AN.437.64	467	84.AN.1.37	231
83.AN.437.13	61	84.AN.1.1	2	84.AN.1.38	222
83.AN.437.14	89	84.AN.1.2	5	84.AN.1.39	184
83.AN.437.15	149	84.AN.1.3	94	84.AN.1.40	235
83.AN.437.16	168	84.AN.1.4	95	84.AN.1.41	242
83.AN.437.17	419	84.AN.1.5	10	84.AN.1.42	243
83.AN.437.18	423	84.AN.1.6	9	84.AN.1.43	334
83.AN.437.19	248	84.AN.1.7	131	84.AN.1.44	245
83.AN.437.20	411	84.AN.1.8	50	84.AN.1.45	261
83.AN.437.21	408	84.AN.1.9	104	84.AN.1.46	260
83.AN.437.22	283	84.AN.1.10	99	84.AN.1.47	255
83.AN.437.23	187	84.AN.1.11	105	84.AN.1.48	355
83.AN.437.24	337	84.AN.1.12	18	84.AN.1.49	354
83.AN.437.25	238	84.AN.1.13	112	84.AN.1.50	399
83.AN.437.26	234	84.AN.1.14	110	84.AN.1.51	196
83.AN.437.27	269	84.AN.1.15	115	84.AN.1.52	204
83.AN.437.28	217	84.AN.1.16	120	84.AN.1.53	216
83.AN.437.29	275	84.AN.1.17	25	84.AN.1.54	189
83.AN.437.30	270	84.AN.1.18	22	84.AN.1.55	188
83.AN.437.31	352	84.AN.1.19	130	84.AN.1.56	205
83.AN.437.32	306	84.AN.1.20	74	84.AN.1.57	280
83.AN.437.33	308	84.AN.1.21	83	84.AN.1.58	331
83.AN.437.34	190	84.AN.1.22	82	84.AN.1.59	410
83.AN.437.35	379	84.AN.1.23	59	84.AN.1.60	332
83.AN.437.36	206	84.AN.1.24	60	84.AN.1.61	383
83.AN.437.37	377	84.AN.1.25	62	84.AN.1.62	400
83.AN.437.38	380	84.AN.1.26	154	84.AN.1.63	371
83.AN.437.39	209	84.AN.1.27	163	84.AN.1.64	397
83.AN.437.40	395	84.AN.1.28	167	84.AN.1.65	396
83.AN.437.41	394	84.AN.1.29	183	84.AN.1.66	448
83.AN.437.42	434	84.AN.1.30	182	84.AN.1.67	449
83.AN.437.43	447	84.AN.1.31	402	84.AN.1.68	444
83.AN.437.44	339	84.AN.1.32	420	84.AN.1.69	445
83.AN.437.55	278	84.AN.1.33	417	84.AN.1.91	474
83.AN.437.61	468	84.AN.1.34	414	84.AN.1.92	473

84.AN.1.93	477		85.AN.174	416		85.AN.370.41	213
84.AN.1.94	471		85.AN.175	428		85.AN.370.42	179
84.AN.1.95	463		85.AN.300.1	123		85.AN.370.43	181
84.AN.1.96	480		85.AN.300.2	124		85.AN.370.44	201
84.AN.1.97	469		85.AN.300.3	125		85.AN.370.45	305
84.AN.1.98	476		85.AN.300.4	116		85.AN.370.46	304
84.AN.177	14		85.AN.300.5	126		85.AN.370.47	186
84.AN.857	285		85.AN.370.1	1		85.AN.370.48	288
84.AN.984	133		85.AN.370.2	4		85.AN.370.49	287
84.AN.985	117		85.AN.370.3	93		85.AN.370.50	290
84.AN.986	100		85.AN.370.4	7		85.AN.370.51	271
84.AN.987	153		85.AN.370.5	8		85.AN.370.52	346
84.AN.988	418		85.AN.370.6	17		85.AN.370.53	363
84.AN.989	431		85.AN.370.7	19		85.AN.370.54	344
84.AN.990	225		85.AN.370.8	20		85.AN.370.55	333
84.AN.991	389		85.AN.370.9	26		85.AN.370.56	376
84.AN.992	407		85.AN.370.10	27		85.AN.370.57	258
84.AN.993	405		85.AN.370.11	24		85.AN.370.58	259
84.AN.994	403		85.AN.370.12	53		85.AN.370.59	273
84.AN.995	404		85.AN.370.13	54		85.AN.370.60	236
85.AM.268	64		85.AN.370.14	58		85.AN.370.61	240
85.AM.269	46		85.AN.370.15	76		85.AN.370.62	291
85.AM.270	67		85.AN.370.16	85		85.AN.370.63	208
85.AM.271	66		85.AN.370.17	137		85.AN.370.64	239
85.AM.272	45		85.AN.370.18	86		85.AN.370.65	232
85.AM.273	69		85.AN.370.19	87		85.AN.370.66	207
85.AM.274	44		85.AN.370.20	79		85.AN.370.67	219
85.AM.275	68		85.AN.370.21	78		85.AN.370.68	251
85.AM.276	55		85.AN.370.22	90		85.AN.370.69	252
85.AM.277	51		85.AN.370.23	107		85.AN.370.70	295
85.AM.278	63		85.AN.370.24	114		85.AN.370.71	292
85.AM.279	52		85.AN.370.25	113		85.AN.370.72	368
85.AN.122	12		85.AN.370.26	118		85.AN.370.73	373
85.AN.123	141		85.AN.370.27	121		85.AN.370.74	424
85.AN.124	218		85.AN.370.28	132		85.AN.370.75	413
85.AN.164	11		85.AN.370.29	138		85.AN.370.76	425
85.AN.165	164		85.AN.370.30	166		85.AN.370.77	215

85.AN.370.78	422	85.AN.444.8	329	85.AN.444.26	56
85.AN.370.79	421	85.AN.444.9	437	85.AN.444.27	81
85.AN.370.80	227	85.AN.444.10	475	85.AN.444.28	72
85.AN.370.81	336	85.AN.444.11	478	85.AN.444.29	75
85.AN.370.82	357	85.AN.444.12	472	85.AN.444.30	136
85.AN.370.83	412	85.AN.444.13	479	85.AN.444.31	139
85.AN.370.84	450	85.AN.444.14	307	85.AN.444.32	80
85.AN.370.85	401	85.AN.444.15	28	85.AN.444.33	430
85.AN.370.86	451	85.AN.444.16	122	86.AN.739	440
85.AN.370.87	441	85.AN.444.17	134	87.AN.24	429
85.AN.370.88	443	85.AN.444.18	135	88.AM.104	70
85.AN.370.89	464	85.AN.444.19	127	88.AN.13	435
85.AN.370.90	465	85.AN.444.20	128	88.AN.106	71
85.AN.370.91	462	85.AN.444.21	101	89.AN.55	185
85.AN.444.5	328	85.AN.444.22	21	90.AN.13	220
85.AN.444.6	212	85.AN.444.23	415	L87.AN.114	140
85.AN.444.7	330	85.AN.444.25	289		